P9-DGH-749

A CHRONOLOGY OF PHOTOGRAPHY

A CHRONOLOGY OF PHOTOGRAPHY

A CRITICAL SURVEY
OF THE HISTORY OF PHOTOGRAPHY
AS A MEDIUM OF ART

ARNOLD GASSAN · HANDBOOK COMPANY · ATHENS OHIO

Copyright © 1972 by Arnold Gassan
Published by Handbook Company Athens, Ohio.
Library of Congress Catalog Number: 72-83426.
ISBN 0-912808-01-2.

Titles and chapter headings
designed by Karen Nulf.

All rights reserved, including those to copy
or reproduce this book or parts thereof
in any form for use by anyone other than
the original purchaser.

Manufactured in the United States of America.

VELOX

Do you appreciate its pictorial possibilities?

Steichen does

NEPERA DIVISION
Eastman Kodak Company
Rochester, N. Y.

Ask the dealer for a copy of the Velox Book

"The intellectual representatives of the nineteenth century on the other hand, have lost their faith in systems and programmes and see the meaning and purpose of art in a passive surrender to life, in seizing hold of the rhythm of life itself, in preserving the atmosphere and mood of it; their faith consists in an irrational, instinctive affirmation of life, their morality in a resigned acceptance of reality...For them art becomes a pursuit of the 'temps perdu' of life which is forever evaporating and beyond our grasp."

Arnold Hauser, *The Social History of Art*, Volume 3.

"All forms of expression have within them the seeds of their own destruction, and just as classicism tends to emptiness and lack of vitality, so naturalism tends to vulgarity."

Sir Kenneth Clark, *Landscape into Art.*

"That is why the camera seems to me, next to unassisted and weaponless consciousness, the central instrument of our time; and that is why I in turn feel such rage at its misuse; which has spread so nearly universal a corruption of sight that I know less than a dozen alive whose eyes I can trust even as much as my own."

James Agee, *Let Us Now Praise Famous Men.*

PREFACE

A Chronology of Photography may be a misleading title. It refers to the third part of this book, the comparison of events in the development of photography with events in other arts and in the world. It is reflected in the first part of the book, the essay on specific developments in the medium and how they were used by selected photographers.

The idea of the comparative chronology began with a class done under Professor Van Deren Coke, at the University of New Mexico. In that graduate seminar a chronological comparison was prepared and presented by Harold Jones. The excitement produced in us by the simple itemizing of events from each decade, the sense of discovery created by the list, led me to believe that others in our group were going to work up more material and publish the results. It has been five years now, and no one has done this, so I feel free to present my research.

My thought at first was only to expand the chronologies we had prepared. Then I began teaching a history of photography at Ohio University. During the past five years I found I needed more than the catalogue of events, though I discovered understanding is dependent on having the catalogue as a foundation. Knowledge of what has happened and when it happened is necessary to understanding. Personal response and appreciation of the photographs being studied is also necessary; it is not itself sufficient. Under-

standing comes with a sense of the structure of things.

There are varying ways to deal with objects created at different times. Some implications implicit in the chronology have been expanded in the essay on the history of photography. The first part of the book is my understanding of the implications of the chronology, of the relationships between the pictures and the times they were made, and a discovery of my own summary reactions to the pictures important in the history of photography as an art. Sometimes comparisons between pictures and important relationships between a photograph and an event i the world were discovered through examining the artifact in light of the chronology. Such a comparison, refined and re-examined each time it is presented to a class, is the stuff of the essay. The photographic objects as they exist in an historical frame, and the chronology proper, are the supports for my statements. The chronology is not exhaustive, it is arbitrary to a degree and reflects my own interests.

During the teaching of this history my thinking about specific photographs has changed; attempts to justify an image to a history class will do that. Other influences have been my own work as a photographer, making both straight and manipulated prints; experiences with the photograph seen quite formally, as *print* ; with readings in 19th and 20th century art history and esthetics; and with the camera itself, attempting to let it respond as a transparent membrane, resonating to vision. Finally, the intellectual discipline of historical analysis has returned me to the photograph itself—to a love for this unique, devalued, misunderstood and fantastic medium.

Since I began this work Professor Coke has moved from New Mexico to New York, and has been helpful in his new position as Director of *George Eastman House Museum*, Rochester. The staff of *The Gernsheim Collection*, now located at the University of Texas, also has been of assistance. My special thanks to Dr. James Wilson, for his experiments and his personal help and to Laird Gassan for her support and editorial assistance.

INTRODUCTION

No contemporary adult can look at a photograph without drawing comparisons—conscious and unconscious, emotional and analytical. No image exists in an esthetic or associational vacuum. For the medium this is a source of riches, and also a limitation.

Three elements become important in a discussion of a photograph. They are esthetic judgments, formal evaluation and historical placement, and personal understanding of the work.

Contemporary critical discussion in the arts has been based on formal standards. But some critics deal with the work in comparative and competitive terms. A term for this kind of evaluation has been suggested to me, "gallery esthetics." It refers to discussions of the work as a competitive object in the contemporary marketplace of art concepts and artifacts.

The formal elements of the work of art cannot always be discussed in this kind of marketplace vocabulary. Other terms can be created. I suggest Kubler's terminology of the prime object, of sequences and series as related to contemporary objects, is an important addition to the infrastructure on which we build our sense of esthetic scaling and placement of works of art.

In *The Shape of Time* Dr. George Kubler offers a terminology for dealing with objects in art history. His book is important, and

1

though densely written definitely worth reading. If specific *prime objects* are difficult to find with precision, nevertheless the concept and the attempt to find them clarifies thinking. Such thinking may eliminate destructive naiveity. It may also put a burden of intelligent choice on the young artist; in photography I believe this is not crippling. A little more thought will not hurt photographers.

Photography is essentially the recording of light. It may or may not also be the recording of an instant of time. The camera records light with more facility than any other medium. One can photograph a seemingly trivial event, and produce a dramatic visual statement because the light impinges on that event in an interesting way.

The photographer creates a latent image. After a time he makes it appear. The ensuing interval is always enough to allow memory to slip the print away from actuality. The illusion of actuality is therefore immense.

A photograph made for a given purpose cannot responsibly be judged by other standards; a documentary picture, for example, cannot be judged by esthetic standards. One may like it, be moved by the colors, modulations of tone and the like. That does not really make any difference; that photograph exists because it gives certain information.

However, a photograph may exist in more than one category. A documentary picture can also be a personal snapshot, sentimental and romantic. It may be a handsome color print; it may suggest a painting, or become a metaphor, suggesting other subjects, other meanings.

Things can be photographed which are trivial or transient, and often these impress the viewer as being important. Such images lie on the boundary between the snapshot and the poetic metaphor. A personal mnemonic, that is, a snapshot, may have the impact of a metaphor on a viewer. Of course a snapshot may never mean much to anyone else, because the image which was made *is* only a mnemonic, and has no transferrable content without a lengthy verbal paraphrase.

Snapshots do sometimes become poetic: this moment of time, seen in passage, disappearing, fragile—becomes a trigger for nostalgia, for contemplation, for revelation. Some pictures which originally

were snapshots become poetic when seen at a later time—a way of entering time past.

The subject of the photograph is often not so much a specific thing as it is an *ambience*.

Any kind of photograph can enter into the history of photography, provided it is judged to be important. Judgment is made by a few people and then substantiated by concurrence and habit. The photographs that illustrate this history of photography are there because of a concurrence of judgment about their value. Very few were made as *art*. Most were made for some other reason.

A large number of photographs enobled by reproduction and noted in histories are important mostly because they have survived the winnowing of time. Physical survival is sometimes sufficient justification of value because photographs have been treated as a trivial by product of technology and commerce during photographic history. No art history written by a responsible scholar discusses photography, until the 1960's. *American and Alfred Stieglitz*, by Waldo Frank, is a *festschrift*, not a critical study. Dr. Aaron Scharf's *Art and Photography* is quite recent. Mr. Van Deren Coke's *The Painter and the Photograph* is also recent and is similar to Scharf in that it is essentially an academic apology, showing photography was *there*, where art was being made. Helen Gardner provides a digest of Newhall's *History of Photography*. Paulsen's *Purposes of Art* mentions photography in some sort of useful context. And Nathan Knobler's *The Visual Dialogue* also touches on photography. In a long overview of the history of art, this scant attention is legitimate: the total history of art covers several thousand years, and photography has existed less than two hundred. But most problems of photographic esthetics are inherited from and extend problems of painting; it is not unlike the case of a subspecies of creature which has diverged from a parent line, yet shares common characteristics and is mutually fertile when needed.

The contemporary art is photography, if quantity be the measure. Film, television, contemporary illustration in printing—almost all *illustration* is photographic. This is not to the good. Syl Labrot noted that when the photograph is tied to illustration it has abdicated its freedom as a medium. As long as the photograph is illustrating a concept, a set of words, a problem, an event, or a particular public situation, it abdicates a degree of esthetic purity.

But 99% of the photographs found in a history or in the world are illustrative in nature. So much so that I doubt one can find any really important "pure" photographs until the late 1920's. At that time the photographs of clouds were made by Alfred Stieglitz. These are not illustrations, not tied to a verbal equivalent subject. Until that important watershed almost all photographs we have are specifically illustrative.

This is not the fault of photographers. This is their inheritance from art, from social and practical needs. There were few photographers who came to the medium with other than commercial training or art apprenticeships. There were few critics of art before the beginning of this century who could see beyond the problems of illustration.

Criticism before 1900 dealt almost exclusively with the subject of the painting, not with the medium itself. The question of how the visual statement related to the essential nature of the medium was seldom asked. Most criticism was concerned with the moral and social correctness of the story being told in the work of art. Read the hostile criticisms of the Impressionist exhibits, or the contemporary laudatory reviews of the Academy and Salon. Almost all the criticism is essentially political, on the suitability of the subject, which was delineated according to conventions of representation.

It is only with the work of key writers early in this century that other values enter criticism, reflecting in part the shifting attentions of the artists themselves. Friedlander, or Roger Fry, or Focillon are examples. Their concern with "formal values" in art becomes a companion to the changing intentions of the artists— less concerned with illusionistic rendering of stories and more with the problems of the medium.

Parallel investigations occur in poetry and in music. Schoenberg's serial music statements from the same time as Picasso's and Braque's images reflect similar formal values. And the *Three Short Piano Pieces: Op. 11*, is not far distant from the photograph *White Porch with Grape Vine*, by Stieglitz.

This new criticism responds to the work without concern in the old way for the subject of the work. Fry doesn't like the German Expressionists, for example. But he can speak responsively of their "energy." They offend him, but he recognizes what they are about

4

and takes it not as a personal insult so much as an identification of their involvement with coarse values.

These critics often use a vocabulary for the work of art, not in illusionistic terms, but in terms other than those relating to illustration. Illusion and illustration have been the backbone of art and comment on art until this century. See Ruskin's five volume study on painting and painters, Baudelaire's commentaries, and journals by Delacroix and Reynolds.

Questions arise when we discard or devalue illusion and illustration. They are formal problems: what are the limits of the medium? how are these limits expressed? can a critic discuss the nature of the medium? Photography is difficult to discuss because by nature photography is a chameleon: the photograph can copy quite successfully—especially when seen in a reproduction, as seen in a book, or a magazine, or slide—any style of two-dimensional art. There have even been handsome photographic base-reliefs made using photo-etching.

This ability of the medium to copy is due to the image being nominally optically accurate; it affirms our common perceptions of reality and our tradition of western art which until the *Demoisselles des Avignon* was mostly concerned with illusion and representation. That painting freed the photographer from doing what other arts were doing, because they were no longer doing it! Photography as of 1907 no longer had to compete with illusionistic painting. This is the opposite to the healthy reaction many artists had to the invention of photography, as summarized by Renoir who sighed with relief because now painters no longer *had* to paint portraits.

Illusion and representation, illusion and illustration...but little concern for formal problems, for what happens inside the boundary of the print. This was the critical attitude held by most photographers, historically and today. In photography there has been little concern for formal values, for shape and gestalt. This is exemplified by a comment Bruce Davidson made during a taped interview preceding the publication of *100th Street*, when he said apologetically that "some of the photographs were made in such a hurry that I didn't get the subject centered." This was a startling compositional concept 250 years ago when Watteau painted *Giles*; it focuses attention on the object and avoids conscious awareness of the print-as-object.

This is the extent of the esthetic involvement practised by most photographers. For most of the world and most photographers looking at the photograph, the photograph simply does not exist as a two-dimensional object. What it is is a magical window, thorugh which we leap (or fall). The initial response to the photograph is rarely conscious, a response to the print, but is to the actions revealed just beyond its magic window.

This mimetic possibility is the magic of the photographic image; it also changes the value of the image with time. Writing in the *New Yorker*, Sargent noted that nostalgia was important in our response to a photograph. As soon as the thing photographed is no longer attainable in the memory of those living, the image is invested with poignance. Something similar to this was also noted by McLuhan in his description of television's *Bonanzaland*—as a romanticization of the last time and culture we could no longer revisit or regain.

Nostalgia becomes important to a photograph because almost any event photographed in a clean, straightforward way happening *now* will have new emotional value *then*. When the event is unrepeatable and the subject unretrievable, nostalgia becomes operative. Even pictures of the dead and dying gain nostalgia as noted in Sargent's *New Yorker* review of an exhibition of Civil War photographs.

A separation of at least one generation of styles from the moment of the photograph to the moment of response seems needed for this change to be fully effective. When we are closer than that in time our reaction is often just the opposite, the pictures are "corny" or anti-nostalgic. There has to be enough separation in time to divorce one from the painful reality of the time; it is then no longer trivial, because it *is* no longer.

Other possibilities of response are dependent on our separation from reality. Many pictures create a response not unlike nostalgia; they are sentimental solely because we are isolated from the event by the magical window. Davidson's *100th Street* is an example of this.

Rarely, an artist or a patron works in anticipation of such change. Stan Brakhage, for example, was commissioned to make a film on the elevated railroad in New York. His patron realized that the subject was soon not to be and desired a poetically true record of

6

it. His film is a photographic document invested with the spirit of the event that was soon only memory. Danny Lyon photographed lower New York as it was being demolished in order to "save it" in much the same way.

Most of the documenting photographs from earlier times which we find to be delightful, interesting, or exciting are not formally speaking anything special. They are an access to that time. Their believability is most important. The painted or drawn image is always a handcrafted thing. Throughout the major part of its history the photograph avoided involving the viewer in an aware-ness of seeing a craft product. This willingness to participate in the mimetic illusion and to believe what is so palpably a machine-and-man-made image is photography's continuing esthetic puzzle.

The function of the photograph, that is, the way it works, is one way of classifying it. Other classifications are possible. There are types of image subjects: nudes, war reportage, landscape, cityscape, etc. And for the historian the photographic object must be con-sidered as a type of print.

The photographic print may be studied and classified almost with-out regard for the image contained. Then it becomes a commodity, a collector's item, or a source of information for curators. In a study of the medium a student rarely has a chance, unless he lives in New York, Chicago, or Rochester, to examine prints *as artifacts*. History of photography is taught most often by reproductions. These reproductions are second-hand events, divorced from the tactile reality of the originals.

How important this is, and how distorting it is to understanding and knowledge, becomes evident when Cameron's, Stieglitz's, or Hill and Adamson's original portraits are examined and compared with rich, ink-laden gravure reproductions. The esthetic responses to the print and to the printed reproduction are not the same; and the responses to the nominal subject of the images (the persons before the camera) is also not the same though that person is, of course, the same in either version of the photograph.

There is no purely documentary photograph. The documentary photograph is a catalogue of an event; it provides us with informa-tion. This classification is functional, and depends on our use of the image.

The pure *record* photograph disappears as soon as the photographer becomes selfconscious, and begins to *compose* the picture. This also is not compatible with the pure snapshot.

The documentary photograph was the first use of the latent image. Partly so because the temper of the times demanded this. The cult of the ruin was in force in England; artists made a life's work of painting and drawing ruins of English churches. The industrial revolution made photography possible, but the need for the documenting image was established in the culture. The photograph complemented that existing need. The delight in machines plus the need for images led to curious results. In the early 1800's there were lithographic prints offered for sale which were proudly advertized as having not been touched by human hands! For the first time in human history exhausting human labor was not necessary to the creation of an illustration or a documentary image. It is into this kind of social fever that photography arrived—almost as a solution to the need.

Photography was first used for documenting the scene at hand. Photographic printing houses in England and France were founded within a few years after photography was perfected; they supplied in book form photographs of monuments, streets, ruins, cityscapes. These pictures showed what one could see by going there and looking. The nature of this kind of record is unassuming and as unmarked by 'esthetic' concerns as possible. Early descriptions of the Daguerreotype include happy accounts of verifiable details that could be counted: windows and bricks and details hardly visible to the eye, sought out with magnifying glasses.

These details tend to disappear when painted. It is curious that the principal market for paintings by Canaletto was England; his works were remarkably "photographic" in appearance, and in truth were made with the assistance of the *camera obscura.* The English appetite for photographs proved enormous; the whole society desired verisimilitude in imagery. The appearances of things were terribly important. The machine created images for a society, accurate pictures of its own surroundings. When photography was invented there were some three thousand painters of miniatures in England. Ten years later almost all these had disappeared, having become obsolete. Many had become photographers.

The documentary subject that was the most important, by sheer number, was the human face. The cityscape came next.

In the beginning it was felt photography could take over the work of providing likenesses. And so it did. The many painters of miniatures working in England before 1839 disappeared, to be replaced by the Daguerreotypist and Calotypist. Many early photographers were in fact miniaturists who learned the new process in order to service the market.

The portrait was so important that though one had to sit motionless facing intense light for three minutes at the beginning of the Daguerreotype era, and even five or six seconds at the end, thousands of pictures were made each year. When the albumen print was invented, one European factory used the whites of 60,000 eggs a day in the manufacture of photographic paper, primarily for portraits.

The photographs that have survived this period may not be the best. They are simply pictures that have survived. They survived because they pleased someone. We may or may not agree with that person's taste. So many pictures were made then, as so many are made now, it is difficult to say why certain images become important when two or three billion are made annually. What process of selection permits some images to rise in this sea of pictures and survive while all others disappear?

At a glance, the survival of photographs seems arbitrary. It is not all that arbitrary, on further study. The process of selection has a structure.

Survival is in part a caste- and tradition-ridden process. If an image looks like what it ought to look like, someone will honor it. In a time when photographs are supposed to resemble paintings, painterly photographs will be made and survive; the taste of the times will salvage the print. If the person selecting is connected with a gallery or a publication, the image will have a larger audience than if the person is solitary, with no public connections.

Once an image is published other photographers will copy it. The gallery director, the editor, the curator—each bears responsibility for modifying the stream of images; they in turn are affected by the community, its desires, delights, boredom, and fads. Today it is social consciousness, tomorrow it may again be the natural landscape, or perhaps strict investigation of intellectual relationships and forms, as in the collage images made by Moholy-Nagy in the 1920's.

Aloof from these drifts of style, the documentary photograph has been the enduring cornerstone of photography. Simply because the camera does it so well and yet because it is difficult to do documentary work with more than pedestrian results. The documentary image-maker alert to the life of his time and capable of capturing his perception in a photograph will probably never be totally ignored.

Part of this enthusiasm is because of the myth that the photograph doesn't lie. Nowadays everyone seems to know that the photograph does lie, but still we respond as though we didn't know. We pretend that the photograph is true. We also respond to the involuntary associations the photographic gestalt can create; these associations exist in the way metaphor exists in poetry.

In discussing the photograph as document and as metaphor, Minor White has said that any photograph can function as a metaphor for someone, someplace. The metaphoric possibilities of a photograph are controlled by the viewer, no matter what the photographer's intention.

The metaphor exists in the mind of the viewer, or in the mind of the photographer. The photographer usually needs to title a picture in order to impose a metaphor on the viewer.

Specific examples may help. Photographs of the nude by Edward Weston may create a sensation of participating in loving; the nude by Leslie Krims, a sense of participating in obscure perversion. In neither of these are formal values much considered. What is of importance first is the direct communication of evocative relationships. This in turn may be a clear evocation of the person behind the camera. Such sensation is powerful and direct. It is well discussed (in terms of poetry) by Yvor Winters who wrote that poetry is a bridge between two minds and that we can more truly speak of possession of a soul by art than by any magic. Replace poetry with photography; the photograph can carry powerful evocative meanings directly from one person's vision into another's innermost life.

The photograph permits us to know both the persons in front of the camera and the artist behind it. This discovery is often an intellectual process; many of the pictures presented or discussed here had little effect on me when I began teaching; through study and analysis their meanings unfolded, and they have become clear.

Scientific photographs without emotional content become emotive or esthetic images when experienced by a person capable of responding. Such images find themselves being the triggers of emotional or esthetic experiences. Color photomicroscopy in the 1960's produced this effect, partly because of the similarity to images being produced concurrently by nonrepresentational painters. Drug experiments as described in *The Doors of Perception* by Huxley can also invest neutral images with emotional values.

The risk in this, if it is a risk, is in the viewer projecting back onto the photographer meanings which were not intended. This is a risk any artist takes when he releases his vision into the world. In fact, there has been much work done in the past few years by painters and sculptors working with increasingly spare images, images which hopefully do *not* lend themselves to emotional projective action, which limit the viewer to physical systemic responses not susceptible to verbal paraphrase.

Photographic subjects are repeatedly investigated. The naked body, for example, can be seen as an erotic subject, as a study for a drawing, or as a psychological investigation. The landscape can be seen in many different ways. Each generation reveals its own image.

In the long history of art there is a concern with illusion and also with the meaning of light seen in the image. Light, in the art of the late middle ages, was the presence of God. Wylie Sypher has described this *sundelicht* as the presence of God; there were no shadows in late medieval art because shadow indicates the absence of Him. With the rise of humanism in the Italian Rennaisance, this changes—shadows appear, but not as cast by principals in the picture-dramas. Cross lighting avoids shading people central to the image.

This changes with increasing secularization of art following the Reformation. The tendency to deal with light illusionistically is reinforced by edicts from the Council of Trent, ordering the artist to present actions of the saints with versimilitude as much as possible. The petitioner, praying before an image of the saint, should mimetically participate in the passion. The "photographic" realism which was a directed result of this edict (combined with the access to the tool which encouraged this kind of plasticity, that is, oil paint) became the standard for art directed to approved purposes.

Etienne Gilson has noted in *Painting and Reality* that our inner tension between belief in illusion and awareness of the material of the print at the same time is a major continuing esthetic concern of art, one which seemingly is inexhaustible. It has entertained us for at least two thousand years. Our eyes become interested both in the two-dimensional surface and in the illusion of a reality beyond, created by that two-dimensional surface. This trick of art is a principle of painting; it was carried naturally and unthinkingly into photography.

As church strictures fell away and the middle class arose, the market for commonplace representational art increased. The print came to flower with the Renaissance; etching enlarged the field of engraved plate and block. The increased tonal range brought to etching by aquatint, and the invention of the lithographic process enlarged the illusionistic tonal range available to printmakers. Prints increased in demand as the sheer numbers of people increased and the middle class with the means to purchase them multiplied.

In the prehistory of photography, which *is* the history of art before the 19th century, the need for representational art was political and emotional, and its creation was assisted for nearly three hundred years by various optical devices. The *camera obscura*, or darkened room, was the principal invention. It used a lens set in one wall to cast a real image on another interior wall. Part of the reason for these rooms was not related to art at all, but to entertainment. There is a psychological pleasure in observing the world *in an abstraction*. It is the difference between watching an action directly and watching it abstracted, removed from direct eye-contact. One feels differently about actions witnessed in a mirror, for example, than the same reality seen on turning away from the mirror and watching it directly.

Trivial or unimportant scenes take on a kind of importance when removed from direct observation and seen in projection, through a lens or in a mirror. In Bertolucci's film *Before the Revolution* a young couple enter a building which has a periscopic lens that projects a panorama of the countryside onto a long table. The black-and-white film changes and shows them watching the *camera obscura* image *in color*. This is a photographer's joke and the photographer's magic: the world is more real and colorful seen through the *camera*.

12

Looking not at the original subject, but at an image of it, infuses that subject with a magic; it seems more colorful and important, and also safe. The legend of the Medusa reflects this knowledge.

The *camera obscura* became a tool for assisting the draftsman to an accurate rendering. The machine was made smaller, the *camera* shrinking to a mere collapsible frame covered with a dark cloth. The frame could be placed on a table over a piece of drawing paper, the draftsman huddled under the cloth, tracing out the image.

The paintings of Vermeer seem to have come from the *camera obscura*, even to certain characteristic lens distortions. The paintings of Canaletto were also dependent on this tool.

Other optical-mechanical assistances have been used. Dürer has recorded himself using a drawing-frame with an eyepiece, for speedy and accurate rendering of landscapes. Holbein used a similar device to speed the production of court portraits. And in the 18th century the simple silhouette known to art since Egyptian times was mechanized by Chretien and called the *physionotrace*. His was a mechanized silhouette making machine, with facility to fill in the details of the profile. And Dr. Wollaston developed the *camera lucida*, which was no camera at all (there being no room attached) but simply a double prism with eyepiece, compensating lens, and a supporting rod. It permitted the artist to superimpose a *virtual* image over a real image. If one kept very still and did not move the eye, the two images could be kept in alignment while the virtual image from the subject was traced. There was no real projection of an image in the *camera lucida* as with the *camera obscura* only a superimposition of both subjects reflected by the prism on the retina of the eye, while the image was being drawn on the paper below the prism.

None of these tools changed the fact that the touch of the artist controlled the illusionistic rendering. Nor the fact that drawing is a linear statement, and the camera image is tonal.

In the history of art it is important to know when technical means become available to the artist. J. A. D. Ingres was able to make the kind of drawing he did at least in part because he mastered the newly invented graphite pencil. The paintings of the Italian Rennaisance have their characteristic color, roundness or flatness, plasticity or linearity, depending on whether the artist worked with oils or with frescoe. The tempera paintings of Flanders, the

deep-etched line of Rembrandt, the aquatints by Goya, the supple lithographs by Daumier are each results of technical tools made available to a master.

At the end of the 18th century an agrarian culture was replaced by an industrial culture which was in turn base for our own technological culture. The industrial revolution made new tools: steam, roads, rails, chemicals, metals, papers in quantities not known before. The fever of that time affected even American Presidents; we find Jefferson designing a trick mechanical doorway. It is the temper of the time: people made tools to make machines which made better tools.

The painter, the printmaker, the photographer is dependent on his tools. They will modify his vision, because the tools make certain kinds of images possible. Or, certain kinds of imagery become impossible because the tools no longer exist, or knowledge of how to use them is not available. When new tools are invented they make art images possible which simply were not before. The history of art is also the history of techniques. Unfortunately, the history of photography is topheavy in technical innovation, and often less than exciting in terms of the resulting images. This is not to attack the great images we have, but simply a caution—there must be a weighing of the esthetic results. The Impressionists could not have painted the marvelous *plein aire* landscapes without the collapsible metal-foil tubes for oil colors, but neither did they advertise the painting as being marvelous because painted with tube colors. Technique was subservient to art.

In photography technical innovation may be the step from the simple silhouette to the physionotrace; from the first Daguerrotype requiring a six minute exposure to the same process a year later with only a few seconds exposure; from Anthony's street pictures to Muybridge's richly detailed photographs of tumbling acrobats or Marey's untextured and schematic studies of fencing thrusts. Each new mastery offered a new image; each process deleted from commercially available equipment limits the repertoire.
But all mechanical image making devices tend to produce a kind of slippery, polished performance. The physionotrace etchings and contemporary studio portraits both have a mechanical slickness that conceals the gritty contour of the sitter's personality.

The photograph has the ability to create a momentary sense of

14

belief, or as is said in the theater, suspension of disbelief. Verisimilitude, veracity, and belief are all supported by the crisp, sharply focussed, elegantly printed photograph. This momentary but intense illusion is the principal power the image has, regardless of how it is used. Robinson in the 1860's and 1870's used it to make sentimental Victorian metaphors, Hartfield in the 1930's made bitter attacks on the Nazi political deities; Uelsman today makes cloudy symbolic investigations into his own loves and dreams, all use photographic means. This photographic imagery demands a different kind of scrutiny from the historian than does a direct documentary record of a single event. Montage photography has been devalued for being untrue to reality, but to compare it to a documentary photograph is to fail to observe the grammar school requirement that we not add apples to oranges. The photographic image is the latent image, an instantaneous invisible impression which can be made visible. The nature of the latent image defines the boundary between the art of photography and the other arts. All other image making methods provide opportunity for the hand to modify the image as it becomes visible.

Photography was born in a culture that wished to see reality as though in a mirror. The actuality of the illusion was of importance. Hauser has noted that the early romantic movement created an art which because it was moralizing in tone contained the germ of the most immoral art that has ever existed, namely the incitement to indulge in wish-fantasies in which decency is only a means to an end and the inducement to occupy oneself with more illusions instead of striving for solutions to the real problems of life. The works of the last century which want to appear moral in most cases merely moralize.

In understanding and evaluating any of these photographs, a problem for the student is that he rarely encounters the original prints. There are large collections available for study in Chicago, Rochester, and New York. The collections at the *Art Institute*, the *Eastman House Museum*, and the *Museum of Modern Art* are complimentary. The *Eastman House* collection is also concerned with the technical history. There is also the newly relocated but not yet functional *Gernsheim* collection, now at the University of Texas, at Austin. Collections are also available at the *National Archive*, the *Library of Congress*, and the *National Gallery* in Washington, D.C. The Library of Congress collection was intended for copyright purposes, and so was legal in intention, but many of the prints have been reclassified and separated as examples of rare

prints. The Library's collection of O'Sullivan prints, for example, were once considered merely to be documents of land surveyed by the Powell expedition. In recent years Jerry Maddox has saved these and many other fine prints from casual mishandling in open files. Other collections exist at a few colleges in the country, and in some art galleries, e.g., The Kansas City Art Museum, Ryerson Institute in Toronto, and Rochester Institute of Technology. Most museums still have doors completely closed to photography and to photographic prints.

Even the silver print may be suspect, however. There are prints for sale in galleries which have been made by Brett Weston, from his father's negatives. These prints bear little resemblance to the prints made by Edward Weston. True, the prints are made from the original negatives, but the paper and the processing is different, and these prints are not similar to the originals, though they are closer to the originals than reproductions found in books. The market for photography has increased lately and there is more and more manufacture of facsimile editions of this sort. George Tice has reprinted many of the Frederick Evans negatives for the Witkin Gallery, to satisfy desires to collect such objects.

But prints should be sought out and examined. Only through direct encounters with the print can the student realize the difference between the illusionistic subject matter of the print and the statement of the print itself. The size of the image, the texture and color of the paper and the tones of the print all modify meaning in the photographic statement. A student most often sees only photoreproductions from books and magazines, or slide copies of prints. The slides themselves are often made from books, and are two full generations removed from the original.

Some images which were not made to be seen primarily as prints in the first place seem to survive mechanical reproduction. The work of Walker Evans is an example. Duplicate prints of his FSA photographs can be ordered from the National Archive. These are competently made prints, and since his initial statement was the subject in front of the camera seen in a direct documentary fashion and printed on a commercial paper which has not changed much, little seems to be lost. The value of the print as object will change with the intention of the photographer, his period, the materials with which he worked and with our own attitudes toward and uses of his prints.

16

The photographic reference books available offer only a portion of the photographic spectrum. This is the result of economics and an inevitable dictatorship of taste. The history of photography as seen in books offers a repetition of the same images, to a degree. This happens partly because few images have survived from certain times, partly because some collections are hard to obtain, and partly because there are difficulties in reproducing certain kinds of photographs. And also each author has his own definition of photography. For example, Gernsheim minimizes the work of certain photographers and certain countries; Pollock and Taft are excited by the verbal or social implications of the photographs they use; Newhall shows little patience for work done since 1940. Each of the histories available here are dependent on English and American collections. Little is known about German, Italian, French, or other European photographers unless they found a way to exhibit here, as the Italian Guido Rey did in *Camera Work*.

Reproduction of photographs has been controlled by a few individuals who become to a degree tastemakers for the next younger generation of photographers. The editors of *Camera*, *Aperture*, and *Popular Photography*, and of the various *annuals*, by and large, determine what young photographers will see. The curators of the Museum of Modern Art, the Eastman House, and owners of the few commercial galleries offering photography also determine what will be seen. Their exhibits become current standards and are, of course, reflections of their own tastes and training.

These conditions are imposed by economics and by practicality. Regular publishers have found photo books bad risks. There have been recent signs of change in this area: with the establishment of independent galleries and book distributors; and the increase of college classes in photography which have created new audiences. Several new publishers have started promoting the work of photographers whom they admire. *Lustrum Press* is an example. And some books which have been unavailable are being reprinted. *Da Capo Press* has made available Weston's *My Camera on Point Lobos*, among other books of importance which were long out of print. But new distribution sources were necessary for both prints and books; without a means of enlarging and educating the audience there was no market for books other than illustration.

A chronological survey of principal genres in the history of photography will cause some photographers to be mentioned often, and

others hardly at all.

It is presumed that most of the pictures referred to in this text can be discovered through a little research. The reproductions in the portfolio are designed to be touchstones, illustrating or supporting esthetic traditions. The esthetic history of photography can be understood only by intensive study and by looking analytically at all photographs and comparing them with paintings, films, prints and other contemporary arts.

There are various structures possible for a history. Photographs can be classified by technical methods (wet-plate, small camera), by chronology of subject or by kinds of subject (photographs as art, as scientific or technical documentation), or by historic sequences of photographers. The basic structure of this text is first to survey the initial technical inventions and then to make comment on the three principal genres: the *natural landscape*, the *cityscape* and the *social landscape*, each surveyed chronologically. The first genre is the world of nature, from macroscopic detail to pictorial studies of Yosemite. The cityscape includes the buildings and machines of our environment. The social landscape includes portraiture, the naked body, war and other interactions of the person and the environment. These genres are certainly broad enough, yet difficulties arise when a picture fits into more than one category. As long as the categories are not taken too seriously and the purpose of this structure is remembered, there should be no problem. The form is used to provide a method for cataloguing the artifacts of photographic history. When the method becomes unwieldy, it is time to see if some other way of talking about the picture cannot be found.

Chronological examination of a genre reveals how it changes as the society changes. This assumes that taste changes as the society changes, and that for the most part we have images that survived because someone desired them and preserved them. If this is true, the photograph esthetically echoes the time in which it was made. We cannot limit our definition of what is photographic when we do this, that is to say a certain image is or is not photographic. If it was made as a photograph, called a photograph and used as a photograph, it is a photograph. This permits us to examine Robinson, Uelsman, Winograd or Warhol's prints all as variations of the photograph.

18

TECHNIQUES AND ESTHETICS

In Paris, a man who understood the spirit of light and was also a consummate draftsman responded to his changing society by creating a successful entertainment. As the center of life had shifted from the farm to the city, the city found itself with many more middle-class citizens; they in turn found more leisure time and need for entertainment. Their need was answered by J. L. M. Daguerre. He created a theatre of light and illusion—the precursor of the movie spectacle of our own day—and called it the *Diorama*. Many illusionistic images were painted on scrims or removable curtains; lighting them carefully before and behind in controlled sequences, he created illusions of actual events happening before one's eyes.

In Daguerre's work there is no concern with *sundelicht*, where light is the light of God—light is simply God's sunlight—it modulates form, casts real and complex shadows and shades and is the stuff of illusion. Light has moved from theology to entertainment. He understood that if he controlled light he could create convincing illusions, belief in the physicalness of things.

In 1822 he tried to capture the tonal renderings he had seen in the *camera obscura*. In 1826 he heard about similar work being done by another Frenchman, Nicéphore Niépce. He wrote to Niépce, suggesting they confer. Niépce was disturbed; he had no way of knowing how this stranger had learned about his efforts. Daguerre had been told by a gossiping deliveryboy. Niépce did not reply. A

19

year later Daguerre arranged a meeting. They returned to their own lives and not until three years later did they sign a contract to participate, to investigate methods of capturing the *camera* image. Four years later Niépce died; his son, Isidore continued the contract with Daguerre.

The entire history of their correspondence and the details of their work is clearly described in Beaumont Newhall's book *Latent Image*.

At this moment in time, between 1829 and 1839, three names become important in photography: J. L. M. Daguerre, William Henry Fox Talbot, and Nicéphore Niépce. Each explorer moved slowly through his own experiments, suffered failures, repeated others work without knowing; each had successes and failures and sought to discover how to fix the tantalizing *camera* image.

One could make an analogy between them and explorers seeking a continent. They know the place exists, it has been sighted and none was successful. Now each has the means to success. Each makes a different landing and claims the whole. But two have claimed a promontory, and the third died just as the new land was becoming clear.

There was a successful investigation made by a fourth, by Hippolyte Bayard, who invented a photographic process which used the bleaching effect of light, and produced a positive paper image directly. In effect, his process was stillborn. Though he made a number of pictures, and presented them in exhibits, the process was never popular and had no essential effect on photographic esthetics.

The land in this story is glimpsed in the camera obscura; it is captured not through brute force but with subtle processes. In one case the latent image has to be discovered first, in the other case a negative bridge between the old world of line and this new one of photographic tone must be invented.

A German chemist, J. Schultz, discovered a century before that silver salts darkened in sunlight. Among others, Thomas Wedgewood made images on silver-sensitized surfaces with the *camera obscura*. These, and other experimenters, are the early explorers. But they could not retain the image. It was formed by light itself, light also darkened the exposed surface. They found no way to stop the action of light, it continued to darken the print. The image also took too long to make. The light needed minutes or hours of exposure to

change the silver chemicals by its action alone.

Niépce came from a family of inventors. Newhall notes that in about 1800 they developed a working internal combustion engine designed for a boat—and made it work. In attempts to capture the *camera obscura* image, Niépce knew that means were available, light could change a solid substance. Asphaltum hardens in the light. Niepce used asphaltum known as *Bitumen of Judea* as a *resist.*

He coated a sheet of metal with asphaltum. At first, exposures used an etching as the image; the etching had been made transparent with wax. Where light came through the paper, the asphaltum hardened. Where light was blocked by the ink lines the asphaltum remained soft and soluble. After exposure the plate was washed with a solvent. Unhardened, unexposed lines washed away, exposing the metal. The plate was etched in acid. After etching it was inked, wiped and printed to produce a print that was literally a photographic copy of the original etching. Niépce called this process *heliography.*

He attempted to use a similar process directly in the *camera obscura.* The exposure took all day, and because the sun moved from one side of the subject to the other (a farm structure seen out of the window where he lived and worked, at Le Gras), there was poor modulation of shape. But in 1829 a permanent image was achieved.

At the beginning of photography two basic processes are used. One uses silver salts that change color in the light, the other uses organic compounds which change hardness or solubility in the light. Except for the kind of metal (for silver has been sometimes replaced by iron, lead, platinum or palladium) these basic processes still exist today.

Daguerre experimented with silver. Like the other workers before him he let the light itself do all the work. Like others before him, his first concern was keeping the image, not allowing it to darken. Without this control, all else was useless. His second concern was to shorten exposure times to useful, practical lengths.

A solution to his first problem was to remove or neutralize unused silver salts as soon as the exposure was complete. The solution to the second problem was solved by an accident. The result of chance was observed, analyzed, and reconstructed. Daguerre had partially exposed a plate. He was interrupted. The exposed plate was stored in a cabinet. When the cabinet was opened again, an image existed on the plate! By experimenting, he discovered that fumes from mercury

were the operative agent. This known, his problem became one of standardizing the operation to make a repeatable and predictable process.

A paraphrase of Daguerre's discovery makes it seem trivial, fore-ordained. The hundreds of partial and complete failures are ignored; the thousands of francs spent on expensive, rare and eventually useless materials and chemicals are not ours and remain uncounted. Once the outline of that photographic continent, a new world of the latent image was discovered, the process seems self-evident. But before discovery such a state was unthinkable.

During their experiments Daguerre and Niépce exchanged information by mail. They established a code of numbers for the chemicals and substances they used. Their letters bristled with numbers, they wished to hide from curiosity until the work was complete. Perhaps they wished to be able to prove primacy in case of publication but more likely they were guarding the commercial implications of their discovery. Daguerre was a hardworking and successful entepreneur. He was an artist-entertainer, and his Diorama was a popular entertainment in Paris, and in London.

Niépce and Daguerre signed a contract in 1829 to engage in parallel research in what we call photography. They had met in 1825 and worked separately for four years before taking this step.

That was the last time they met. After this meeting everything was done by mail. Four years later, in 1833, Niépce died. His work was continued by Isidore. But Daguerre complained that Isidore did little work, while Daguerre slaved over a new Diorama production and made photographs. By 1835, Daguerre had the basic system of his photographic process complete. The discovery was still unnamed. Niépce's process had been called heliography, but was not finished; Daguerre's work was. In 1837 Daguerre proposed that the two processes be sold by subscription, to be offered the next spring. Isidore refused because the publication would bear only Daguerre's name. Daguerre said they could sell the Niépce process as partners, and he would sell his own process himself—and name it after himself. Before a subscription sale was actually offered, however, Daguerre realized that such an idea was foolish: once one person knew of the process he no longer had a singular commodity, and the whole thing would be lost.

He saw a friend in the government, a member of the House of

Deputies and of the Academy of Sciences. Francois Arago agreed to offer the entire Daguerre *opus* to the people of France—Diorama and Daguerreotype. The announcement of this offer was made in January. In May, the Diorama burned, destroying Daguerre's only income. Arago pushed a bill in the Chamber of Deputies for a pension and it was accepted. On August 7, 1839, the King signed the bill, awarding Daguerre 6,000 *francs* and Isadore 4,000 *francs* as annual pensions for life. Isadore agreed to publish Nicéphore's invention. Daguerre agreed to a public demonstration showing how his marvelous precise images were made.

On August 19, 1839 not Daguerre but Arago made the presentation. He was less than successful. The newspapers attacked him and Daguerre. Daguerre responded by inviting the press to his studio for a private demonstration on September 1. With this small group he was a winning personality. The demonstration was a success; the process was shown with clarity and simplicity. The newspaper writers described it clearly, and enthusiastically. But when he attempted to demonstrate to a larger group he did not come across well.

Daguerre's process was to coat a copper plate with silver, and then make the silver photosensitive with iodine fumes. Silver iodide was formed. After this light-sensitive silver compound was exposed in the camera it was developed over heated mercury; the fumes of the metal bonded to the silver surface in proportion the the amount of exposure. A change of surface was produced by the interaction of metals. When development was complete, the image was prevented from darkening further. The simplest way was to remove the unused silver iodide. An efficient chemical method was suggested by the English chemist, Sir John Herschel, who first offered his suggestion to Talbot. The idea was to wash the plate with hyposulfite of soda. At first, Talbot did nothing with the suggestion but did pass it on to a French friend. It was then offered to Daguerre and was being used by him when he made his process public.

Sir John Herschel is one of the first heroes of photography. He named *photography*. He named the *snapshot*. He invented a camera-microscope as well as an enlarger. And he offered hypo to photography—the simplest solution that has yet been discovered to fix the silver image and make it permanent. Herschel suggested using film to copy precious documents and so "invented" microfilm.

The images by Daguerre and Talbot were examples of *physical*

techniques and esthetics

development. This kind of development was later replaced by *chemical reduction* which is the process we now casually refer to as development. In the first processes, metal was either supplied to the photographic image from the mercury developing fumes or from a developing solution containing silver; in either case the metal clung to the latent image and made it visible.

Reduction development, using pyrogallic acid, hydroquinone, and other reducing agents was later used to change the silver salts themselves, breaking the chemical bonds between the silver and halide (chloride, bromide). This permits the latent silver image in the emulsion to become the visible image we see, and eliminates the use of metal in the developer.

In both processes, the end result is effectively the same: a little light changes the physical nature of the emulsion. An invisible image is formed and then chemically reinforced and made visible. This is the magic of latent image development; it replaced the brute force processes where light itself did all the work.

The analogy of the world of the latent image as a continent can be carried further. Two basically different kinds of image were discovered, like two polar areas. Daguerre discovered one, the unique camera image; each picture was an original document. William Henry Fox Talbot, working at the same time in England sought another pole. His was a *negative* image. What was bright in the original object before the camera was dark in his picture. What was dark in the original, was light in the picture. (This was also true of the Daguerreotype but by choosing the correct angle of view the image is made to look right, that is, *positive*).

Talbot was apparently not dismayed by his reversed image. He waxed the paper on which this backward thing appeared to make it translucent, and then used it as a new subject to rephotograph. Everything turned around: dark became light, light dark—and the result resembled the original vision. The path seems trivial once it is found. The idea of the negative as a matrix from which can come a number of subsequent positive prints is now a cliché of our technology and culture. But not in the beginning, when the experimenter was trying to seize and retain the transient vision from the *camera obscura*.

At first Talbot did not discover development. It was not until 1841 that he discovered that there was a latent image; here too success was

by accidental discovery. His discovery was not unlike Daguerre's discovery of development: an image partly made but not exposed long enough to be visible, the paper put aside; the fully developed image discovered later in the day; a successful reconstruction of the accident. His new process was different enough from the earlier *Talbotype* to need a new name. He called it the *Calotype.*

These primary processes bore the following similarities:
> they both used silver salts;
> they both used Hyposulfite of Soda to fix the image, by removing unwanted silver;
> they both utilized the latent image, made visible through physical development;
> they both used processes which, once known, could be accomplished by any technically competent person.

This last item is of some importance. Unlike painting, drawing, or sculpture which requires special hand-and-eye training and are largely dependent on native talent, a person could make excellent representational images with photographic methods merely by following mechanical rules.

The first processes differed in that one produced a single and unique image for each exposure and the other produced a matrix image from which innumerable copies could be made. The Daguerreotype was a brilliant, sharp, direct positive and was non-reproducible (except by rephotographing); the Talbotype (later Calotype) was a soft, fuzzy, tonally simple image that could easily be reproduced.

The first market for photography was in protraits. The emotional need for documentary pictures of people was profound. Even the cutpaper silhouette was honored. Lewis and Clark had an artist with them who made black cut-paper silhouettes for the explorers on their journey west. He folded paper twice, and cut four copies at once: one for the explorers' journal, one for the subject and two for the Library of Congress. This was considered the best and most economical means to record the people of this new land.

A careful study of a good silhouette from that time shows the spirit of the person often survived this extreme abstraction and simplification. As with any picture, what can be taken from the image depends on what experience the viewer has of the world, what references he can bring to pictorial hints that will flesh out the abstraction of silhouette or print.

techniques and esthetics 25

The Daguerretype immediately lent itself to making miniature portraits. These pleased their subjects because they were mirror images, reversed from left to right. The subject saw himself not the way other people did, but the way we see ourselves in a mirror. The photograph therefore had a feeling of rightness for the model. The format of the typical Daguerreotype, the vertical oval image, was also the format made popular by thousands of miniaturist painters in the decades preceding photography.

Undoubtedly the crisp detail increased the sense of veracity from these metal images. That the renderings were often too sharp, detailed and unkind was also noted by critics; the paper negative of the Talbot process provided an alternative.

Different *genres* or types of photographic imagery appear in the first years of photographic history. These possibilities are found in Daguerreotypes made in the first five years: the portrait as document of the person, as anthropological study, as environmental study, as a record of an "important person".

The genres of photography can be defined by subject matter and simplified into three broad categories These are the human form and face; buildings, and ruins men have made and left, and the natural, pastoral landscape. More schematically, these can be called the *Social Landscape*, the *Cityscape* and the *Natural Landscape*.

The Cityscape in America reveals the growing towns, the photographic records checkered with small lozenge and pyramidal shapes of balloon frame buildings; these photographs accidentally remind one of the structure of paint in late Cezanne paintings. Daguerreotypes from the same time in England are straightforward studies of churhes and abbey ruins; the French photograph locomotives, machinery and the glories of the later Imperial Court.

English portraits reflected the styles offered by Reynolds and Gainsborough in the generations preceding photography. French camera portraits on the whole seem more casual and experimental than English photographs and occasionally one finds environmental, almost "candid" glimpses of French life. The American portrait was, by and large, direct, spare and harsh.

Other genres were carried over from painting and etching. The *nature morte*, or still life, was the subject of the first Daguerreotype. The *memento mori* or reminder of mortality appeared early: the

26

image with skull and hour-glass has been used in art for five hundred years. The tourist's record photograph appears—done competently by Blanquart-Evrard, professionally by Maxime DuCamp, and with finesse by Francis Frith. In America, Babbitt photographs the great Niagra Falls; Fontayne and Porter accomplish on the Cincinnati, Ohio river front what Frith did in the Near East, i.e. make accurate beautiful documents.

The materials available affected the esthetic product. The surviving images from early photography can be divided into the following groups:
 —Daguerreotypes
 —early Talbotypes (with paper texture from the negative)
 —Calotypes (made on glass/albumen plates, with pre-waxed paper, or other modifications of Talbot's basic process), yielding an image with fine detail, subtle tone and a number of grey steps between the black and white values of the print.

For example, the original D. O. Hill and Robert Adamson portrait prints are reddish-brown, with large simple masses, and a very few tones. The differ sharply from the Daguerreotype portraits, whose image quality we now associate with the photographic print in general. But the recording of the instantaneous event, which later became one of photography's most important possibilities, could not yet be achieved; exposures with the best materials were several seconds. Yet even this was often short enough to create pictures with a sense of spontaneous and unposed action.

From the beginning, the photograph was used as a tool by artists. Delacroix owned Daguerreotypes made for him from which he drew the figure. Later this practice was to be "abused," to the point that some Victorian painters painted directly over large prints. This posed ethical problems and led to general hostility for photography by many artists and critics. A general attitude arose of denial that photography could be an art or even ethically be used to assist the draftsman or painter. This was changed only in the last few years; photography publicly reenters the tool box of major artists in the 1960's.

The original Talbotype had coarse detail and tonally limited because of the nature of the emulsion and the way it was coated on the surface of the paper. Modifications by Blanquart-Evrard, who double coated the paper, allowing the emulsion to penetrate deeply into the fibers, achieved a smoother tonal scale. It also increased the

sensitivity of the emulsion, and permitted much shorter exposures than Talbot's original process.

Talbot's early photographs show he understood the limits of his medium. He discovered those limits and worked companionably with them. The textures of the print and its inability to render certain kinds of detail became esthetically useful.

The Pencil of Nature, Talbot's first book of photographs, was not equalled by anything Daguerre produced. Daguerre turned his back on photography after his invention was published. Talbot made pictures of things as they are, documents which are also pleasing. Talbot worked and struggled with the art for years.

In Talbot's photographs one finds bold simple mass and straightforward records of light. His subjects lent themselves to the medium, and were not distorted or marred by simplications of tone. He was not able to make casual records as Blanquart-Evrard was able to do with his negatives. Talbot sought subjects that would survive the medium. He saw and recorded them with directness and simplicity.

There has been argument for 150 years as to whether photography is or is not an art. It has been argued that photography is not an art because it is mechanical, because the machine interposes between vision and artifact. The photographer may argue that in any art some sort of machine stands between the artist's vision and the work. All arts require tools; this medium has a more complicated and yet flexible tool than other arts. The critics have a good stand, because of the vast numbers of photographs that are bad in and of themselves. They exist in part because the camera is too facile a tool, producing images without much physical, psychological or spiritual effort. The images are often moderately satisfying, to an undisciplined and undemanding eye that satisfaction is sufficient.

David Octavious Hill and Robert Adamson worked within a tradition of portrait making. Hill was an Academician; he copied academic work of his time. But these traditions worked well with the medium. His Calotypes are also records of characteristic poses that survive being translated from academic painting.

Hill and Adamson used the original Calotyope with all its supposed faults intact. They are almost unique in having preferred the early Calotype for portraiture. In fact, Talbot underwrote the efforts of

an English portrait house which offered both Daguerreotype and Calotype portaits; there were few takers, and only the Daguerreotype part of the business survived. Perhaps there was too much of the "print" in the picture. Later, however, when the Hill and Adamson images were rediscovered, Stieglitz was to hold them up to an uncritical and sentimental age as comparative standards or *touchstones* as Mathew Arnold might have called them, from which true quality could be determined.

In the early 1840's when Hill and Adamson were working with the original crude Calotype, Blanquart-Evrard m dified the process. He has been called the "Gutenberg of photography" because he made the photographic negative-positive printing process efficient. His procedure allowed him to make great numbers of prints rapidly and economically, and to produce prints that have lasted.

In a paper submitted to the French Academy of Sciences in 1847 he described modifications of Talbot's process. One change was in the manner of sensitizing the paper negative. Instead of coating the surface, he allowed the emulsion to penetrate the paper fibers deeply. And he emulsified the paper twice. The picture then had more intermediate tones than the original Calotype. His process increased sensitivity; his negatives were four times faster than Talbot's. However, the Blanquart-Evrard negative was in effect a semi-wet process.If the damp paper negative was not used the day it was made it lost sensitivity.

Talbot was angry that Blanquart-Evrard had not mentioned Talbot's work when announcing the improved process. He accused the Frenchman of piracy. A committee examined the problem and decided that Talbot was right, but also that the new process was definitely superior. It was such an improvement that the paper print began to take hold in France. In 1850 the Frenchman began making negatives coated with egg albumen this permitted him to return to a dry print process.

In 1851 Blanquart-Evrard opened a printing house at Lille. He hired forty girls to make prints; they also worked on his farm when there was insufficient printing work.

Blanquart-Evrard had paper made using gelatin as a sizing, and using chlorine, iodine, and bromine as sensitizers for the silver. The paper was coated with silver halides, dried, and exposed immediately. The latent images were developed in a gallic acid solution, rather than

being printed-out, this is, images were not produced solely by the action of light.

In 1851 he was producing 200 to 300 prints a day from a negative; the price was correspondingly low, as little as 5 *centimes* for small prints. The print exposures ranged from 2 to 20 seconds.

The prints were fixed in two hypo baths, washed thoroughly, and then preserved and toned in gold chloride solution. He produced the first photographically illustrated French publication. The negatives were made by Maxime Du Camp; the subject was the Near East; the book was entitled *Egypte, Nubie, Palestine et Syrie*. The choice of subject was dictated by French imperial interest in north-east Africa. A supplemental text was written by the novelist, Gustave Flaubert. The work was well done; after 120 years the prints are still handsome.

Aside from economical and practical problems, it would seem logical to have replaced the grainy, dense paper negative with a glass support far earlier than it actually was accomplished. Buth the high cost of glass, and its fragility did slow its introduction. And there was a greater problem in finding an emulsion that would adhere to glass and be sensitive, producing negatives with short exposures competitive with the improved Daguerreotype and Calotype.

In 1847 a cousin of Nicéphore Niépce, Abel Niépce de Saint-Victor discovered that egg albumen worked well. The albumen was permeated with potassium iodide, and the plate coated. After drying, the emulsion was flooded with silver nitrate. After exposure the plate was developed in gallic acid. The emulsion was very slow. Exposures were about twenty times that needed for the Calotype.

The albumen emulsion was quickly adopted for the paper print. Blanquart-Evrard announced his process to the Academy of Sciences in 1850. The smooth surface that the egg emulsion gave to the paper revealed more detail; the image on paper became truly competitive with the Daguerreotype. This sizing changed the color of the silver image but toning baths were invented to restore a desirable warm-brown color. By 1862 the albumen paper image was most popular and a single firm in London used a half a million eggs a year; in the 1890's when amateur photography had blossomed a Dresden manufacturing plant used 60,000 eggs a day. The yolks were wasted.

The albumen negative had a short life. It was replaced in 1851 by the

collodion negative. But it had shown the way: find a medium which would cling to glass, remain clear, and not desensitize the silver.

The photographic process came to maturity with the development of the glass negative and the paper print with a glossy surface. The image produced had a full yet delicate tonal range, with many gradations of tones from white to black, and with great resolution of detail.

A useful comparison may be made between the prints made by Hill and Adamson using the early Calotype process—a coarse paper negative and a characteristic harsh tonal—scale with the contemporary Daguerreotype, and that again with early prints by Blanquart-Evrard. The Blanquart-Evrard print approximates the Daguerreotype, and has what we feel today is a full photographic tonal scale.

The early paper print was harsh and limited. But the limitations were soon overcome. The albumen-glass negative, the waxed negative of Le Gray, and then the collodion negative invented by Frederick Scott Archer permitted the paper image to become lustrous, fully detailed, and truly competitive with the Daguerreotype. Abel Niépce de Saint-Victor perfected his glass-albumen negative, it was an insensitive semi-wet process, and was not used for portraiture so much as for architectural documentation. In that same year Archer began experiments which culminated in his 1850 paper on the collodion process. Once this became public, there was no limitation to photographic uses; the paper print began to supplant the Daguerreotype.

Talbot attempted to incorporate the wet-plate into his patent; he did succeed for a time, forcing a photographer named Thomas Sims to close his studio (since he refused to invest in a license from Talbot). But in 1855 Talbot lost a court action against a photographer named Leroche. The trial discouraged Talbot; he did not attempt to renew his patent on the Calotype process. In 1855 his photographic process became public, unlimited by patent and license agreements.

Photography was taught to soldiers in Woolrich in 1856, Gernsheim notes, and introduced into the curriculum at Kings College, London, that same year. Queen Victoria and Albert had a darkroom installed at Windsor. Five years later there were "two dozen photographic societies in England," according to Gernsheim. One of these was chaired by the Duke of Windsor.

Sir John Herschel in a paper presented to the Royal Academy in 1840 named the camera-made image the "negative" and the print made from the image the "positive." At that time he also noted that a silver negative, seen in a certain light, could look positive. In 1852 this effect was patented by James Cutting who bleached the dark silver collodion negative image a light color, and then backed the plate with black paper or velvet. This created a direct positive. It was in effect a step backward, toward the Daguerreotype: each image was unique and the glass support was frail. But it was popular. The process was adapted to being made on black lacquered iron sheets. These were called ferrotypes or tintypes in America, and melainotypes in Europe. They were introduced in 1853.

Eleven years after photography was made public the entire perimeter of this new medium was revealed: the latent image, the development of the latent image in both the negative and the print, the printing-out of the image by the direct action of light, the means to fix the image and make it permanent, toning and coloring the print, retouching, the direct-positive, the negative/positive print process, and the textureless transparent negative. What remained was the recording of color, and the means to capture motion.

The use of printing-out paper instead of developing-out paper continued until the middle of the 20th century, in spite of Blanquart-Evrard's inventions, partly because of economy and partly because of the image itself. Economy was achieved because expensive developing chemicals were not needed. Light itself did the work, the print needed only to be fixed and toned. But the printing-out paper also had a very long tonal scale because of the self-masking contrast controls inherent in the process. As soon as exposure began to darken the paper the image being formed shielded the rest of the emulsion from the light. Because of this, shadow areas could hardly get enough exposure to make them print dead black, yet exposures could be made long enough to print densely exposed highlight areas correctly. In a developing-out paper print, the exposure made is only sufficient to produce a latent image; differential control of shadow and highlight densities must be by manipulation of the developing solution that makes the latent image visible, or in the choice of paper itself, for the contrast is controlled by the manufacturer of the paper.

Other possible photosensitive printmaking processes had been discovered. Iron salts are sensitive to light and were used to make the *ferrocyanotype.* This survived as the *blueprint;* it was used a little in

the 1850's and again during the 1890's for continuous tone photographic prints. Iron chemistries reappeared in photography as platinum prints in the last decade of the century. The effects of light hardening organic compounds described by Poitevin, and which was also the basis of Niépce's Heliography, were reinvestigated and made useful by Klic, who perfected the photogravure process. The gum-bichromate print, the carbon print, and later the carbro-color print are all extensions of the same relationship between light, chromates, and hardening of organic solids.

The grainless glass negative and the albumen print killed the Daguerreotype, it was no longer competitive. The Daguerreotype was too small, it was a left-to-right reversal of reality, it was both positive and negative and had to be held in a special way to see it clearly; it was non-reproducible, it was terribly frail, heavy and bulky. It simply was not a competitor.

Many of the surviving Daguerreotypes have esthetic value to us. They often elicit a sensation of encounter with a real person rather than a mask. Almost painful detail, the sense of characteristic expressions, all caused by the long exposures which denied the sitter a chance to assume uncharacteristic expressions, assist this sensation of innate integrity to which we respond.

The albumen print succeeded in displacing the Daguerreotype partly because the image floats above the texture of the paper, in the Calotype the image was integral with the paper fibers. Fine detail is resolved better in the albumen print, the tonal range is greater because the emulsion is smooth. The best black the silver image can produce is controlled in part by the amount of silver in the emulsion and in part by the smoothness of the print's surface. The albumen print approximated the polished mirror surface of the Daguerreotype.

The presence or absence of surface texture, of a sense of the materiality of the print itself are elements in two attitudes towards photographic print. These are established in the first days of photography and continue today. One is concerned with the apparent reality existing on just the other side of the magic window of the photograph; the other is also concerned with illusion but is as much involved with the nature of the print, the shapes, colors, and textures in the rectangle of the print itself.

The power of the photographic illusion was such that Roger Fenton

was commissioned to photograph the war in the Crimea specifically to help save the Queen's government in Britain, his faultless record of British officers, boats and encampments relieved the pressure on the government, accused of mishandling that war. To our eyes his photographs are static *tableaus*. To an age unhardened by the immediacy of photographic reportage his pictures were unique discoveries of what war looked like. The brutal side of reality which Fenton avoided was available in art, in the illustrative etchings, *The Disasters of War*. Emotionally powerful, they do not have the automatic sense of verisimilitude the photograph had and yet has today. Now that we have seen Goya's visions ourselves in full photographic color through Ron Haeberle's My Lai pictures, the originals have new power, we realize how documentary they are.

The materials of art have always influenced the image. Fenton, for example, could not make photographs of actual battle events because they moved. The early collodion process did not permit him. The glass plate had to be buffed, washed and degreased, then coated with collodion. One poured a pool of the thick liquid onto the plate and tilted it back and forth until the surface was evenly covered. When the ether, the solvent, had evaporated, the plate was dipped into a silver halide sensitizer, the picture was exposed immediately. After the exposure the plate had to be returned to the darkroom and developed. Sensitization, exposure, and development had to take place before the plate dried from the sensitizing, or it lost most of its sensitivity! From 1850 until the production of the dry plate in the 1870's, the photographer had to perform this complex photographic dance whenever he wanted to make a picture.

Because of this the collodion process is also referred to as the *wet plate* process, because the emulsion was much more sensitive wet than dry; it had to be exposed and developed while damp.

Aside from the physical problems of making the negatives, early photographers took frightening chemical risks. Mercury poisoning, ether poisoning, or poisoning from cyanides were all common risks. Sodium cyanide was used well into this century as an alternative to hypo as a fixing agent since it also dissolves silver halides. In spite of these risks and difficulties there was an enormous multiplication of the number of photographers and the number of photographs. In 1873, for example, the Dresden Albumenizing Company used 60,000 eggs a day making albumen paper for photographers. The individual photographer sensitized this coated paper just before using it for prints.

34

The homemade products which were essential to photography during the early years gradually were replaced by standarized machine-made goods. In 1885, J. B. Obernetter, of Munich, began manufacturing a gelatin based printing-out-paper, and "Aristotype" paper (which was quite similar) was introduced by a firm in Dusseldorf in 1886. The gelatine dry plate had been introduced in London in 1873 by John Burgess. His plate was not fully prepared; the photograper purchased emulsion from him and coated his glass plate. A gelatin support had been suggested as early as 1850, by the French chemist A. Poitevin. A working form of gelatin emulsion was developed by Dr. Leach Maddox, who published his results in 1868.

The introduction of the dry gelatine support for emulsion was almost concurrent with the development of successful dry collodion emulsions. Many different methods had been tried to make the wet plate retain its sensitivy as the emusion dried. Most methods seem to have depended on some mechanical procedure for keeping The emulsion damp! The solution that finally worked was a change of the basic chemistry—to using silver with a bromide sensitizer, plus using a new developer, based on an alkaline chemistry. The wet plate had depended on silver with iodine or chloride and pyrogallic acid as the developing agent. The discovery and use of what we call *hydroquinone* changed this, permitting the dry plate to become competitive with the wet plate. Yet there was no immediate takeover by the dry processes. This was partly because of habit, and partly because the new processes simply did not have the quality of the wet plate, either in dependability or speed. Records indicate, for example, that in 1877 at the Edinburgh Photographic Society exhibition about one-eighth of the pictures were from dry negatives and the rest were from wet plates.

The wet plate era came to an end early in the 1880's, and the dry plate changed the nature of photography. It allowed those unable or unwilling to cope with the physical requirements of the wet plate process to investigate photography. There are photographs by Emile Zola, for example. The painter Edgar Degas liked photography enough to make pictures as well as to literally draw upon new ideas coming from this medium.

Before the dry plate was invented one either had to set up a dark tent to make photographs in the field, or wear what approximated a collapsed umbrella—a framework supporting a dark tent which covered one's head and tied shut about the waist. The plates were sensitized and processed in this stifling enclosure!

For several reasons the dry plate did not sweep the wet plate from the field. It was less sensitive than the wet plate. It was also irregular in quality. The dry plate was difficult to ship and was erratic, depending on how it had been stored, on how its emulsion had changed with age. During the time of transition some manufacturers acquired excellent reputations, but many failed to make a dependable product, and disappeared from the market.

Photographic emulsion changes with age. Heat and humidity together are deleterious. A photographer had no way to know how old the plates were, or how they had been shipped and stored.

Of the many manufacturers who tried producing dry plates during the 1870's and 1880's only a few survived into this century. One of the best known names was created by George Eastman, who coined the word KODAK so that his company name would be pronounced the same in all principal languages. Eastman had experimented with dry emulsions, and was a successful manufacturer of dry plates. In an attempt to expand the market, and to introduce an even more useful product he experimented with flexible emulsions. At first the idea was to use the new gelatine based dry emulsion on a paper support. Before developing the negative the emulsion was warmed, permitting a substrata of soft gelatin to melt, and the undeveloped negative was stripped off the paper and transferred to a glass support. This method worked, but the image was often torn.

Many inventors participated in refining the photographic process. Only a detailed technical history could discuss them fully; errors abound in the literature, and a survey of the technical literature indicates there is favoritism, depending on whose text is being read. Ultimately, skipping unkindly over many modifications and small perfections, one comes on John Carbutt, who in 1888 persuaded the Celluloid Manufacturing Company of Newark, New Jersey to make 10 mill sheets of their clear plastic. He coated this thin transparent stock with a workable dry gelatine emulsion, and introduced *Carbutt's Flexible Negative Films.*

The Reverend Hannibal Goodwin applied for a patent in 1887 for making emulsion support of a nitrocellulose and camphor base. There were expensive delays, and the patent was not awarded until 1898. In the meantime, a similar product was manufactured by George Eastman. A lawsuit followed; in 1914 the owners of Goodwin's patent, the firm of Anthony and Scovil, were awarded five million dollars as settlement for Eastman's infringement of their

patent rights. It was a modest enough settlement; Eastman had raised his company from being a small producer of dry plates to a nearly monopolistic position in photography through introducing a complete photographic system dependent on a flexible dry negative film. The Eastman system permitted anyone to make photographs.

An investigation of the literature of photographic history reveals that almost everything which came to fruition in George Eastman's successful system had been offered before, or tried commercially somewhere else. In 1875, Leon Warneke had offered a roll-film camera, some thirteen years before the Kodak was marketed. And the Blair *Kammeret* was very popular and more compact than the Kodak camera; its design was in fact later used by the Kodak Company.

In August, 1888, George Eastman created the entire Kodak system. The original advertising showed the three basic operations which were all one needed to do to make pictures pull the string, press the shutter, turn the crank. These sequential operations cocked the shutter, made the exposure, and advanced the film to the next frame on the roll. When the entire roll of 100 exposures was finished, the camera complete with film was mailed back to Eastman's Kodak company offices. There the film was developed and printed, the camera reloaded; the prints, negatives and camera packed and returned. In 1895 this process was simplified further: Eastman produced a camera using film that could be loaded into the camera in daylight, since the film was protected by opaque paper leader. The daylight loading system was invented by Parker Cody of the Blair Camera Company, in 1894. The Kodak camera for which this daylight loading film was produced was nicknamed after its inventor, Frank A. Brownell, and was called the *Brownie.*.

Eastman's Kodak system of photography changed the whole medium and in effect produced contemporary photography, in which the photographer can be free of the burdens of chemical manipulation if he desires.

The pictures made by No. 1 and No. 2 Kodak cameras were circular because the simple meniscus lenses used made a picture that was sharp only in the center. The unsharp edges were masked off, in the camera and in the print Because the first Kodaks had no aiming device, other than a small arrowhead stamped on top the camera body, composition was no longer a major consideration for the photographer. The implications are important. Because the

photographer could not compose the picture carefully he had to become more interested in the events of the moment. The new camera had in fact been designed to respond to the momentary event, rather than to a pictorial intention.

The Kodak was aimed like a weapon, and the shutter clicked. The work was done! Everything else was superfluous. The possibilities of this have been fully understood by only a few photographers, exemplified by Gary Winogrand. Henri Cartier-Bresson, for instance speaks of finding the decisive moment in which pictorial elements will come together in a composition. Winogrand shears the time between first seeking the picture and the moment of the shutter release, approaching human reaction time as a limit: the change is of degree, of intensity.

The *tondeau*, the circular picture, has had brief recurrences in art; it was used frequently in the Baroque. It imposes difficult compositional problems on the artist, and most of the circular image photographs we have from the early Kodak days have value not because of planning but because of accidental events caught and recorded by the camera. The Coburn portrait of Stieglitz, done in 1913 with a circular format Kodak is ironic; Stieglitz disliked the Kodak system because of the motto, *you push the button, we do the rest.* The implication was that nothing mattered in the photograph except the instant of exposure, that craft was not involved. And also the picture was made when that camera was already obsolete, and so was being used self-consciously, to make art of an anti-art machine.

The images from the Kodak period often have a delightful innocence that more self-conscious photography loses. They are not unlike children's drawings, except that the camera produces the same quality of rendering for both amateur and professional. The photographer becomes anonymous, anyone can make pictures. As of 1888 photographers can no longer be defined as trained chemists.

Through the decade of the 1890's the technical burdens which the photographer had borne were one by one eliminated. It became possible for anyone with the money to purchase a simple camera to make photographs. Technical knowledge was no longer essential to photography.

The photograph became anonymous to a degree before unknown. The snapshot, another term coined by Herschel, became daily reality. The snapshot became the comtemporary image. The

significance of this to photography and to art was not recognized or accepted; some of the implications of it are difficult problems today for anyone raised in a climate of traditional, romantic esthetics. An essential part of photography since that time has been the ability of the camera to seize a fraction of a second. Whatever happens in that instant when the shutter winks is on the film. There is little opportunity for forethought or afterthought without being manipulatory. Ultimately, perhaps, this esthetic expresses itself in the work of a photographer like Gary Winogrand who lets an instantaneous event be comprehended and recorded with the participation of his camera. In a public lecture he was asked by a critic "how long did you spend on that picture?" Winogrand answered "about a five-hundredth of a second." The hostility of the critic was perhaps based on esthetic traditions that physical work and forethought are necessary parts of the art object. This theory is fundamental to the large photographic construction made by Rejlander a hundred years ago, and to work of Henry Peach Robinson, but has not been considered necessary to painting, for example, since the 1940's. At the least one would think that the esthetic explorations made by the Abstract Expressionists in painting could be accepted as battles won. But apparently this is not true.

After answering the initial social, and economic demands for photodocumentation, photographers in turn felt they must compete with painters. Many early photographers had been painters who had moved into photography. This kind of lateral movement continues into our time, though sometimes from disciplines other than painting. Wright Morris, for example, who began by working in photography began creating text to accompany the pictures and then moved into writing fiction. Ben Shahn began work as a photographer and then left that for illustration and painting.

But the photographer of the 1870's who felt himself to be an artist had to fight economic and esthetic battles to establish himself as a legitimate artist, and to establish his medium as a tool of the artist. On both fronts he had to be competitive to survive. The art of England was illusionistic and sentimental, pictorial and moralistic. In Arnold Hauser's *Social History of Art* one finds an excellent background for understanding these social and esthetic conditions. Photography followed the drift of the times.

One of the reasons for the struggle was the steadily cheapening product. After Talbot's patents lapsed there was no reason anyone

with capital could not become a photographer. In ten years there complaints that all the buildings with skylights on certain streets of London were occupied by photographers. When the ferrotype and ambrotype became available, the number of second, third and fourth rate photographers multiplied. The photograph slipped in a dozen years from being startling to being commonplace, hardly worth keeping after leaving the beach or park where dingy tintypes were sold.

The dedicated photographer often wished to separate his art from this tawdry craft. He could do so through excelling in craft and by making photographs which obviously looked like art.

Oscar Gustave Rejlander is the first major name in this awkward struggle. English Academic art of the 1850's was exhausted. The work in the English Academy was dependent on ideas dull a half century before. Exhaustion was felt by many artists and critics. Gernsheim quotes from a contemporary journal where an Academician wrote that he hoped photography would open the world of art to new landscapes, new Madonnas, new concepts... that all the old concepts were trival and worn out. His enthusiasm and hopefulness about the new land of photography was immediately denied by the photographers themselves. Photographers who had been minor painters and had changed to photography continued the worst of painting's traditions. Rejlander and his successor, Henry Peach Robinson simply resurrected Greuze.

Rejlander was born in Sweden in 1813 and had lived in Rome where he had copied old masters. After marrying an English girl, he moved to London. He learned photography in 1853 as an aid to portrait painting and was so successful in this new craft that in 1855 he opened a photograpic studio. Two years later he exhibited a large allegorical composition entitled *Hope in Repentance*, which was later renamed *Two Ways of Life*.

Two Ways of Life is what the French call a big machine. When it was shown at the Manchester Art Treasures Exhibition in 1857, Rejlander hoped it would rescue photographic art from the attack of critics who disputed its legitimacy because of the mechanicalness of the medium.

The first print was purchased by Queen Victoria. It is a very large print for the time, about 16 x 31 inches; in fact the print had to be assembled from two sheets of photographic paper. Rejlander made

several versions of the print. Made on printing-out paper, it was possible to expose each negative, examine the effect under a dim light and then darken edges and change the effect of overlapping areas. The image was assembled from about thirty negatives.

The successor to Rejlander was Henry Peach Robinson. He wrote *Pictorial Effect in Photography*, first published in 1869 and now recently reprinted. He described in detail how he assembled photographs into composite prints that closely resemble the paintings of Reynolds, Veronese, or the images found in the *Liber Studiorum* by the late Turner.

In terms of the history of photographic esthetics, the point of Robinson and Rejlander's pictures is that many separate photographs were used and assembled to make a single print. The parallel between this and the traditional painter's assembled image is obvious: sketches and studies are made in the field, then brought together in a finished painting.

Robinson perfected techniques used by Rejlander to produce more subtle and carefully assembled images. Rejlander's print had taken ten weeks to assemble. Robinson produced one to four finished prints each year, for many years. They were very popular. Prince Albert placed a standing order for a print of each new picture. The machinery required for the production of his photographs was large. Stage sets were built. Wagonloads of flowers were required. The purpose of each image was to illustrate a popular emotional theme. *Fading Away* the first of the series, was calculated to excite "painful emotions."

In recent years the reaction to Robinson has been to deny that his work is photographic. To deny image assembly is photographic is to truncate the limits of the medium. A contemporary photographer who utilizes similar tools of montage (considering the technical changes in the printing methods used) is Jerry N. Uelsman. He once jovially proposed that the motto of contemporary photographers might be "Robinson and Rejlander live!" Uelsman's thesis is that the image can be manipulated after the original negatives are finished without denying any fundamental properties of the medium. This is valid if the photograph is seen as a print medium.

THE PORTRAIT

The history of the portrait in photography begins with the first picture of a human face. The first coherent body of work we have is the group of portraits by Hill and Adamson. They borrowed much from painting, but they also brought to the work an awareness of the characteristic gesture.

Only in the last few years of art have we seen the artist and technician practice again the interdependence which brought their work such strength; there is a renewed acceptance of that relationship. Hill and Adamson are not really different from Oldenburg/*Gemini*, or Donald Judd and the technician, each modifying the other's concept have again become important. There are also parallels in the works accomplished by the artist-printmaker teams like Rauschenberg and *Gemini* in etching and lithography. The work done between 1843 and 1848 done by Hill and Adamson working together is unique; when Hill returned to photography some years later his results were lackluster. In the early pictures something essential about the person is revealed in the portrait; he is not isolated and abstracted, as in the typical American portrait, nor is he in a fully textured environment, as in many of the French Daguerreotypes. There is abstraction, a simplification of detail, not unlike the work of a painter working from sketchbooks. They generally avoided the minaturist format which Daguerreotypists had immediately fallen into.

The Hill and Adamson negatives have been reprinted since their own time by other printing processes. Each of these has given the images other meanings. The prints made for *Camera Work* from which this book's illustrations were made, make their pictures resemble contemporary prints. They are very handsome; they are not Hill and Adamson's pictures, but something new and different.

In responding to any photograph one has to remember what was possible and what was desired at the time the work was done. For example, there were traditions and conventions in portraiture. English portraiture was strong and created definite styles of pose and placement of figure in the rectangle. Hilton Kramer once said that "in English painting one can study the portraits by Reynolds and the paintings by Constable and Turner and then forget about England for a hundred years." The history of art generally does just this. History turns to France. Unfortunately, the majority of photographs derive from English esthetic traditions of illusionistic reality, apparent verisimilitude, and moral sancity.

Hill was an academician, and honored the weight of authority, yet in spite of convention he and his assistant produced, in the first days of photography, a body of images which have a sense of encounter, of authentic presences, simply of life.

Hill and Adamson also made genre scenes. Their landscapes do not always reveal a figure set there for scale, though this was usual. The records made by DuCamp, for example, almost inevitably have a figure, oftentimes almost comical in its intrusion. Their straightforward photographs of working folk are echoed later in the work done by Paul Strand in the Hebrides, in Italy and elsewhere. His photographs were of a class of people, made deliberately selfconscious and photographed with care.

Hill and Adamson required that their subjects find positions which they could hold motionless for long exposures. Gestures were unsuitable; muscles will not hold still, will move; the image will be smeared and obliterate details or even limbs. Poses where the muscles are at rest and the bones directly support the massive weight of the body were acceptable. Facial muscles must be relaxed. Muscular tension im the face causes movement that obliterates its image. Characteristic and revealing images were the result of these very problems.

Hill and Adamson took over a number of genres from painting; these

genres still exist in photography. Examples are the frontal encounter with members of a working-class group of the documentation of a particular village which have as their successors photographs by Paul Strand. The genre picture of two young girls in a sentimental encounter, for example, preceded Hill and Adamson in painting, and was repeated later by Lewis Carrol, Julia Margaret Cameron, O. G. Rejlander, and H. P. Robinson, among others. The environmental protrait, where the subject exists not in the neutral space of the photographic studio, but has a real environment, comes from English painting, and is successfully restated for the camera by Hill and Adamson. It is never relinquished and survives to this day, in work by Steichen, Arnold Newman, and Duane Michals, for example.

In spite of severe technical problems they created gestural poses which survive and interest us though the subject is long dead. There is one portrait that is similar to the famous portrait of J. Pierpont Morgan made 60 years later by Edward Steichen: the face and hand glowing with light floating in dark textured space. In both images the sense of the power of the personality is vivid. It is interesting that their work had been newly rediscovered just before Steichen's portrait was made, having been unpublished for half a century.

In the portrait of Lady Mary Ruthven they achieved a record of the personality without showing the person at all This is akin to the Steiglitz photographs of Georgia O'Keefe, showing only a hand, or hand and breast; or to a photograph made by Victor Hugo's friend, A. Vacquerie, in the 1850's, which shows only his hand. In none of these pictures is the face seen, yet the personality is richly suggested. The wit of Hill and Adamson in making the portrait a photograph of the woman's costume is of importance. The costume is the sole part of the gestalt we present the world which can be changed immediately. It takes great effort and time to change our face (though this certainly can be and is done through stress). But the external gestalt can be changed quickly by changing costume; this change is traditionally associated with the feminine.

When Hill died his work was neglected. The pictures were in effect lost to the public, and recovered by the Scotsman Craig Annan, etcher, in 1900. The work had no importance in public portraiture during five decades of Victorian photography.

Technical processes affect the image, and have affected photographic portraiture. After the initial period of technical

discovery ended about 1850, there are three decades in which the problems of the photographer were straightforward and dependable. If he was a businessman, the problem was steadily increasing competition and price cutting. If he were an amatuer, an artist, it was convincing a critical audience that this medium was truly an art despite its facility and cheapness. After the wet plate process became standard (with the ferrotype being the cheap competing photograph for a time), technical exploration takes second place and it is useful to study chronologically the major genres of photography. The portrait was the first, the most important use of the medium. Hill and Adamson, and then Julia Margaret Cameron in England provide early standards of quality for this investigation.

In terms of mere numbers, of the amount of money spent on photography, the portrait is the most important photograph. In a history of photography, most of the portraits we have to examine were made by professional photographers, working for a living. A few were made by amateurs. The commercial photographer, however, has to make a certain kind of image for a competitive market, otherwise it will not sell. Styles of portraits change, and the styles of a given time tend to be pervasive. Studying the portrait within the limits of the style of the time will reveal what individual differences there are to be discovered. The amateur photographers of a time will often not be limited by the same stylistic mannerisms that mark the professional's work.

The first important name after Hill is Julia Margaret Cameron. Born in 1815, she was self taught and did not begin photography until she was 48. She felt she found her purpose in life when she found photography; with it she could create beauty. She was in a financial and social strata which permitted her a number of English artists as neighbors and friends. Tennyson, Herschel, Longfellow, Rossetti, G. F. Watts, and others were at hand. Not dependent on photography for a living, she was not burdened with conventional technique. She was happy to make a picture that looked like the person looked to her eyes; she did not try to make pictures that looked like other people's photographs. She did things that were nearly impossible in her day, and in fact even increased her own difficulties. Some of the wet plates she used were 12 x 16 inches. To fill the picture frame, showing only the face of the sitter, she purchased a 30 inch lens, a veritable canon.

This camera and lens would have overwhelmed a lesser person. The combination of film and lens was very slow. Her exposure often ran

four minutes, partly because she ignored contemporary rules of photographic lighting (which were calculated to make exposures as short as possible). She modulated the light in her greenhouse, using curtains and drapes to control the quality. These decreased the total amount of light and increased the exposure times. She disdained neck-rests and head braces. Her subjects often moved; their movement somehow seems integral to her picture.

Her portraits were examined later by Roger Fry. who felt they would outlast their famous sitters. He seems to have been right. The photographs evoke a sense of power even without knowing the names of the sitters, though that knowledge should not be disdained.

She also illustrated a number of books; these usually presented sentimental ideas common to Victorian society. Her photographs of precious children are like the images by Hill and Adamson, by Lewis Carroll and others. One wonders about the need for this kind of picture. A little girl, or two, are shown in innocent repose. Often there is a flower basket; the scene is idyllic. The female child is an untouchable innocent creature; there is a sense of evanescence, as though all this will momentarily vanish. Reading Mayhew's *London Labour and the London Poor*, one sees another side of this Victorian cliche: thousands of child workers and child prostitutes, an inordinately high infant death rate from industrial concentration, puerperal fever, malnutrition and unemployment. The Victorian genre of the sentimental child image subtly relates to this other, unpublicized reality.

Commercial photographers rarely make images with such a vigorous sense of person. Yet two contemporaries of Cameron did make fine portraits which still have meaning. In Paris were Nadar and Carjat. Nadar is a pseudonym; the man's full name was Gaspard Felix Tournachon. He was born in 1820, and began to work as a lithographer. He created the *Pantheon Nadar*, showing important people of his time. To assist him in this he learned photography, and drifted into portraiture. He used the mode of the Daguerreotype, though working with paper prints. The images have a tonal clarity and simplicity like the metal photograph. The subject is seen in a synthetic studio space; there is no attempt to deceive us.

Nadar photographed a number of important men. The lighting is standardized; a high side light is used, almost always from the subject's left, though occasionally reversed. The light modulates the features of the sitter, but is not itself the subject, as sometimes it is in

46

Mrs. Cameron's photographs.

It is difficult to say whether his pictures have interest because of the strength of personality of the subjects, or because of the interaction of the photographer and his subject.

The pictures we have from the 1860's are really fairly few in number. No one knows how many good amateur photographs were made. The pictures available in collections exist partly because of the personalities involved, partly because they have survived the destruction of time. For example, examining anonymous tintypes of the time one sometimes finds beauty, humor, and social information. The anonymous picture stands on its own, without specific social or political associations. These always change the meaning of a photograph. Partly because the subject is unknown, the anonymous snapshot is fascinating.

In fact, there is another historical anonymous genre. This is the albumen print mounted on a small embossed card, called the *carte-de-visite*. It was made with a camera having a number of lenses. The shutters were arranged so that they could be released singly or all at once. A number of small pictures were produced side-by side on a standard large plate. The plate was processed, printed, and the separate images cut apart and mounted.

It is doubtful that anyone with taste actually used these as visiting cards, in the sense that Victorians left their cards. The idea of doing that had been proposed several years before the French photographer A. Disderi patented a special camera in 1854. This instrument, which had a battery of lenses, was created in response to the steady cheapening in price (and quality) of the photograph. It permitted Disderi to make a number of pictures while coating only a single plate, and print them all at once. He had this camera working several years before Napoleon III, enroute to Italy, discovered his shop and had his picture made. Everyone in Paris then had to have his picture made by Disderi. Appointments were booked weeks in advance. It has been estimated that Disderi photographed 200 people a day. These little prints were made to give away, exchange, and to advertise.

The invention made him wealthy. In 1861, three years after Napoleon was photographed Disderi earned about 48,000 pounds sterling. But by 1865 the fad had passed; the clients dwindled; his patents expired; he was unwise with his money and died penniless, a

street photographer in Nice.

The carte-de-visite became a standard image. Styles of props changed each decade. It was used by actors, acrobats, dancers, anyone who needed an image to remind people of their appearance or talents. Lincoln had his photograph made, as did other politicians. The Kinsey Institute has carte-de-visite prints of prostitutes demonstrating their specialties. Because of the production line quality the tiny pictures were stylistically anonymous. The carte-de-visite, paralleling the tintype, became the common denominator of photography: mechanical, documentary, trivial at first glance.

The photographic portrait becomes, through these few examples, a portmanteau. One can easily cram into it all the photographic styles discussed, and more without crowding. The word includes a camera penetration of the personality and transference of it to the print, as done by Cameron and Hill and Adamson; it also includes the slick portraits by Nader or Carjat and even the tiny prints by Disderi. The photograph of itself produces feeling of veracity, of the reality of the person.

The person seen in the photographic portrait becomes most clear when one examines either the work of a sensitive or a very mechanical photographer. An artist encourages some sort of spiritual interaction which permits the camera to record both the sitter's and the artist's personalities. A completely mechanical photographer, working as a picture-making machine also often transcribes some essential part of the personality, because the sitter himself controls the image. Only when everyone involved is self-conscious and trying to make art is the anonymous plastic mask achieved which is characteristic of most studio portraits. This kind of picture is the mainstay of professional photography. The *Professional Photographer* magazine, Nov., 1971, estimated that this business earns at least one billion dollars a year in America. There is no need to include examples of these photographs. They are at hand in shop windows in every town.

The idea of portrait can be extended to include group photographs. Some photographs hover on the borderline between one category and another. The work of John Thompson, who photographed street people of London in the 1870's and 1880's is both portraiture and social documentation. His people are alive and exciting. But he probably should be examined with Lewis Hine, Jacob Riis, the FSA

48

photographers of the thirties, and down through time to Robert Frank of the *The Americans*, and Danny Lyon of *The Bike Riders.*

After looking at the photographs available, one needs to define the word portrait. One possible meaning is to reveal the person, another is to show the person in his environment. A third is to document the external physical person, and another meaning—that has become most important in the last forty years—is to translate psychological knowledge of the subject into the photograph. Other interpretations are possible.

Some pictures are both portraits and records of people who are examples of workers in special classes, or trades. Photographs by Thompson, in England, and Riis, in America are of this sort. A second look reveals that Thompson is less concerned with a didactic picture than is either Riis, or Lewis Hine, his successor in social documentation. And Atget, though he recorded street people, sees them in an aloof and spiritually distant way so that they become part of the cityscape, and hardly exist as portraiture.

Parallel to portraiture is the social landscape, exemplified at the beginning by Thompson, Jacob Riis and Lewis Hine. This genre deals with the person as a social phenomenon. Sometimes the same pictures exist in both categories, depending on how they are seen. Thompson is more alert to the individual than Riis, whose images echo his trained social and intellectual consciousness. Thompson's pictures are artful, sometimes painfully witty.

Contemporary with Thompson is William Henry Jackson, a commercial photographer in western America. He worked from 1870, and lived until the early 1940's. He photographed and sketched the American west, beginning with wet plate cameras, using glass plates up to 20 x 24 inches. His autobiography, *Time Exposure*, recently brought back into print, describes vividly the early life of a photographer on the American frontier.

Considered as a portrait photographer, he is primarily important as an ethnographic documentarian, making direct and honest records of Indian chiefs, Army officers and scouts. *The Colorado State Historical Society*, in Denver, Colorado, has most of his negatives and prints.

An American photographer whose work overlaps Jackson yet who is very different, is Adam Clark Vroman. His work is illustrated in a

recent monograph, *Photographer of the Southwest*. His images include landscapes also photographed by Muybridge, Watkins and Adams. His portraits have formal strength, and are closer to the subject than those made by Jackson's camera. Vroman seems to have been a better technician than Jackson even allowing for twenty years improvements in materials. Jackson's images always seem to have a slightly slapdash quality. Vroman is documentarian but is also formally conscious in a way Jackson is not.

The next period of photographic history, which will be treated in passing at this point is often referred as pictorial photography. The photographer was usually concerned more with making a handsome picture than with photographic verisimilitude. The initial period of pictorial photography had a sound philoscophical base.

It began in the 1880's in England, with the work of the group called *The Linked Ring*, supported by a number of photographers concerned with the decreasing critical value given to their art. The medium was devalued because of commercial cheapening of the product, and poor taste exhibited by most photographers. There had been increasing numbers of complaints that the photographic exhibitors had merely been showing technical developments and pictures were dull copies of current art. A move toward better quality was spurred by this secessionist group, separating themselves from the older camera salons. In America a similar group was formed a few years later under the leadership of Alfred Stieglitz, following the watershed showing of photographs at the Pennsylvania Academy of Arts, in 1901.

The pictorial photographers made photographs as art. After 1902 their images were published in the American journal of the movement, *Camera Work*. The history and nature of this publication will be discussed later.

Portraits associated with pictorial photography are variable in quality. They range from portraits by Frederick Evans, which are luminous records of the subject, to the gum prints by the Frenchman Robert DeMachey, who used the person only as a starting point for a print.

Frederick Evans' portrait of Aubrey Beardsley, 1895, is as clear, unequivocal and direct as Evans' architectural photographs; it also offers us the sense of the person much as Beardsley reveals himself in his own drawings—elegant severe, slightly perverse. Evans worked

only with the platinum process because it produced a tactile silver-gray image, very much part of the paper that supports it, yet having clear articulation of the shadow tones. The silver emulsion on the contrary produces an image that floats somewhere near the surface of the paper, but is not integral with it. This is an esthetic problem, or possibility, of the photograph, depending on how one views it. Dr. Aaron Scharf noted that photography has been disadvantaged in comparative evaluation of its prints with prints made by other methods because the silver image seems to be unattached to the paper, and becomes esthetically disturbing.

Evans' work is a clear example of the interaction of technical methods and visual needs. The platinum print image supported the artist's statement; when the process became unavailable, he ceased to make prints.

Another technical process that flowered at this same time was the gum bichromate print. It was invented in 1839 by Poitevin, knowing from others a bichromate became insoluble on exposure to light, and that it would sensitize natural colloids like gum arabic so they too became insoluble upon exposure. The process lay dormant until Robert DeMachey revived it in the late 1890's. He used the process to make a colored print. Gum arabic was the medium for a colored pigment; the gum was sensitized with bichromate, painted onto paper, dried and exposed in contact to a negative. After exposing the paper it was developed by floating it on a pool of water. As the water penetrated the gum layer it dissolved the unhardened gum where light had not penetrated. The image is a permanent layer of pigment adhered to the paper by the sticky gum. The image is quite tender when wet, and can easily be manipulated, by brushing for example. Or an image can be dried and the paper resensitized, using the same color or changing to another. Gum process was used with platinum to reinforce the soft shadows of the platinum print. Steichen, C. White and others often used the processes together. Published contemporary work with the gum process has been done by Scott Hyde, Betty Hahn, and Bea Nettles, among others.

The image is permanent and tends to be granular and coarse. It was not popular except in pictorial photography because it did not affirm the "silver mirror" idea of the photograph which began with the Daguerreotype, and has been reinforced by the use of glossy albumen paper, and then with a gelatin emulsion "gaslight" developing-out paper, a fore runner of our contemporary paper, which is also quite glossy.

DeMachey made romantic cityscapes, and genre scenes, and cele-
brations of female beauty, using colored gum pigments. His por-
traits are ideal and tend to anonymity, because of the medium.

The Philadelphia Photographic Society announced, in 1898, an
exhibition limited to "such pictures produced by photography as
may give distinct evidence of individual artistic feeling and
execution." The show was judged by a jury of painters and
photographers. The need for such a statement of excellence was real.
Photographic societies in England and America had deteriorated,
becoming uncritical social clubs in which members' photographs
were almost never rejected as long as they were technically
competent.

The reputation of serious photography had suffered. By 1890
museums turned their backs on photography. The Philadelphia
exhibit was a breakthrough; the show was hung at the Pennsylvania
Academy of Fine Arts. The photographers shown included several
young artists whose images have survived. One was Clarence H.
White, at that time working as a bookkeeper in Newark, Ohio. He
had a job which kept him busy six days a week; in spite of this he had
produced many carefully planned images which were fresh and
lovely. From Milwaukee came the work of Eduard J. Steichen. From
Boston, photographs by Alvin Langdon Coburn. All of them made
soft focus romantic images, but each discovered an individual style.

In 1900 these men were brought together under the leadership of F.
Holland Day. He assembled a show for London; the exhibit was
called *The New American School.* Day, Steichen and Coburn
arranged the exhibit in the Royal Photographic Society building;
Stieglitz was not hung in that show.

The lines between different kinds of photography and different
esthetics of photography were clearly drawn at the time. Pictorial
photography included the photographers trying to work as artists,
yet excluded the tradition of the pure documentarian—so much so
that even Frederic Evans was attacked for making cold, rigid prints.

In 1902 in New York, Alfred Stieglitz assembled the first exhibit
that can be described as a contemporary, photographic exhibit. This
is an exhibit in which the taste of a single man dominates and which
focuses attention on his idea of photographic esthetics. This show
was *An Exhibition of American Pictorial Photography, Arranged by
the Photo-Secession,* at the National Arts Club of New York.

52

The reaction to this show was puzzlement. What was the Photo-Secession? The public was puzzled about the photographers shown, and the absence of popular photographers who had not been shown. Stieglitz used the facilities of the Camera Club which promoted the exhibit, and then imposed his own rules on them. This aspect of a *coup* upset and alienated many members. Eventually he was formally ejected from the New York Camera Club. Stieglitz drew away from the organization which had been his means to an audience; he founded a new organization, obedient to his own taste.

Gertrude Kasebier was one of the photographers initially included in his inner circle. She worked commercially and also photographed women, as individuals and as types, in a romantic and yet intimate fashion. She shows gentle strength, with an understanding of the feminine spirit. One of her photographs of a young engaged woman, illustrated in the Portfolio of this text, reflects a minor genre of Nineteenth century English Painting sometimes referred to as "pitcher" portraits, in which a small pitcher was used (consciously or otherwise) as a symbolic equivalent of the vulva. Her women are sensual, innocent and yet alert to their femaleness.

Clarence H. White moved from Newark to New York with the encouragement of Stieglitz. He became a commercial photographer and a teacher, establishing the *Clarence White School.* His school was continued by Clarence White, Jr., after his father died. Clarence White's portraits, published under the pictorial banner, are idealized and abstracted, though they are of course records of particular people. The person becomes gentle and somewhat archetypal, vaguely symbolic. Jerry Uelsman, a contemporary photographer, described his own pictures as being "obviously symbolic, though not symbolically obvious" and a similar reaction is felt to White's pictures.

White photographed real people, but they are seen as private myths. He created costumes for the ladies, designing dresses which would photograph well yet not date the picture as being of the fashion of a certain year.

He was technically innovative and made many photographs using strong backlighting or strong windowlighting, yet retaining a rich sense of surfaces and materials through all the shadowed areas of the picture. When he came to New York he found that this hadn't been thought possible! He used platinum overprinted with gum to provide

rich image densities, and was willing to use iron salts or colored pigment with gum to produce colored images if he thought the result was suitable.

His photographs of figures-in-landscape made in Ohio are accurate records of the atmospheric mood of that countryside, though this is difficult to know unless one has seen the country; but if not known the images seem romantic and contrived period pieces. The pictures are records of the spirit of the area; when abstracted from their origins and seen in a New York or urban ga''ery they undoubtedly seem more poetic and dreamlike. They are that, but are also records of the light and ambience of real places. They were also emotionally compatible with the manipulated image of his time; he achieved by straight photography what other photographers, working in other atmospheric lighting, had to use manipulation to achieve.

Alvin Langdon Coburn photographed a number of important men of his time. He lived a long, productive life during which he worked in a number of photographic styles. Born in 1882 in Boston, he died in 1969; he left behind a pleasing autobigraphy as well as a body of pictorial photographs and portraits. Many of his portraits were printed in gravure by himself and published in two books, entitled *Men of Mark*, and *More Men of Mark*. His work was both straight and manipulated: whatever tools he felt necessary were used to capture the sense of the person in the photograph. Examine his portrait of Ezra Pound, in the Portfolio, in which the image is overprinted several times: increasing size creates a prismatic effect, reflecting the poet's own verse.

The documentarian photographers continued working concurrently with the rise of the pictorial photographers. Lewis Hine, for example, made a large number of portraits after 1900 while producing his social documentation; his pictures influenced legislation on child labor and immigration. Trained as a sociologist, he used the camera at first to support his sociological research work, but later became fully a professional. In the 1930's, he turned to documentation of work as an affirmation of the society, rather than as revelation of ills of the society.

His work raises problems for the student or art historian responding to the photograph as a fine print. Hine's prints are not especially pretty. The reproductions in books are misleading. The ink itself provides a visual richness not found in his prints. His prints are usually greenish-brown contact proofs; the negatives were often

54

flawed with light streaks from bad film holders. By "fine print" standards, the prints are not well made. *The thing in front of the camera* was his concern, not the print as an artifact. The print was made to be used, to be reproduced, to be sold by the Hine Photo Company of New York. The person in the picture was first a social event, second an individual. Many of the photographs provide a painful sense of discovery, an individual seen almost in spite of the camera—his photographs of mill girls, coal pickers, and factory workers become true portraits.

He worked in a very self-conscious manner, posing his immigrants as neo-Rennaisance models. Several of the mother-and-child pictures are copies from Leonardo, *St. Anne of the Rocks* rediscovered at Ellis Island. This sentimental quality undoubtedly helped his work as a lobbyist. He worked with 4 x 5 or 5 x 7 inch cameras, and used magnesium flash powder when artificial light was needed. His blunt images remind one of anonymous tintypes except when the subject is a *madonna*, posed selfconsciously, camera conscious and shy.

This kind of photography still exists today and is of continuing interest. Most recently it is exemplified in Bruce Davidson's *East 100th Street*, also made with the 4 x 5 camera. Open flash offered Davidson controlled artificial lighting for the dingy rooms in Spanish Harlem, just as flash powder lighted tenement rooms for Hine sixty years before.

The important result for either Hine or Davidson is the thing in front of the camera, not the print; the thing is a human in a state of pain, reflecting no virtue on society. It is of course a particular person, but that person seen as a symbol.

The esthetic problem is that the images are often beautiful when the actions recorded are not. The problem does not occur so much when one examines Hine's prints in a sociological or legal context but does when these prints are seen in a context of art. A similar problem arises in the work of many contemporary photographers, for example Eugene Smith, who photographed Pittsburgh and made the ugliness and dirt of the city strong and beautiful. It is a recurring problem. Attempting to define the relationships between the polemic, documentary and sensual elements in the art of photography has to be done by each viewer.

The invention that changed photographic imagery as much as the perfection of the dry plate, and daylight loading roll film, was the

minature camera. The *Leica, Contax* and then the *Ermanox* freed photographers from the burden of carrying large obvious cameras and explosive artificial light.

The Leica story is fascinating, beginning with Dr. Oskar Barnack's invention of the tough little machine using standard 35mm movie film. This tiny camera made excellent pictures with standard size film. There had been little cameras before, called *detective* cameras made into the handles of canes, hidden in hats, in shoe boxes. The Leica was not by intention a secret camera, though its small size and comfortable balance permitted it to be a swift silent participant of an agile vision.

The Ermanox was introduced in 1928. It used cut film rather than rolls, and was advertised as being able to photograph *what you can see.* This was not quite true, but its f-2 lens was capable of exposing usable film in very low light levels. Dr. Erich Salomon used this camera to photograph public personalities as they have never before been seen—in candid conversation, with revealing gesture.

Dr. Salomon captured the natural gestures of public persons, politicians and diplomats. His honesty and insight is exciting and was undoubtedly much more exciting when the pictures were first published, because it had never been seen before. He was not necessarily kind. It is possible to select gestures, to chose, finding ones which direct our response to the personality. Once film and cameras are swift enough to allow gesture to be photographed, the photographer becomes a judge of the subject. Dr. Salomon was making both portraits and political judgements. The people he photographed were men with power, busy remodeling Europe in the 1930's. The conclusion to his judgments came in a concentration camp in Germany, in 1944.

The miniature camera and high speed lenses permitted recording human gesture, captured in an instant of time under dim light, without supplemental lights. This possibility was unknown before. The gesture had been analyzed before, by Muybridge and others, but only by using special equipment, lighting and processing. Now, many photographers immediately adapted these new tools to their work. In the 1930's, the portraits by Brassai, and by Henri Cartier-Bresson are outstanding.

Brassai made portraits of cafe people in their own environment, capturing a brutal and honest sense of the person in a particular

56

society. This kind of photography is very popular today. The pleasure it brings may be due to the fact we are witnessing reality, but are safely removed from risk of contact with those strangers.

Brassai's portrait method does not change with time. This is often true in photography. A man finds a vision, a working relationship between himself, his camera and the world, and lives and works within that mode. It is as though he found an endless vein of precious ore and mined it without exhausting it. Other photographers change frequently, using one style after another, finding one subject after another.

Once the miniature camera appears, the bystander becomes a hapless subject for the photograph. This is not the same as in Thompson's or Hine's day; the bystander then had to be a conscious participant, due to the nature of the equipment and film, especially when indoor pictures were made.

Cartier-Bresson used the Leica camera to produce pictures that record what he chooses to call the *decisive moment*. Such a moment is for him an instant of revelation: relationships between people, spaces and gesture are suddenly graphically clear and humanly meaningful. There is almost always in his photographs a sense that he discovered a matrix of order in the chaotic surface of reality. His subjects often seem like ballet; the pauses in their motion are much more than transitory, and take on a sense of weight and import.

In this century, the photographic portrait takes several directions. The formal, anonymous commercial and amateur picture continues in the Daguerreotype and tintype tradition. The small camera permits a record of gesture which was impossible before. The photographic portrait discovered by Cameron is restated and enlarged.

The master academician of our century is Edward Steichen; the master of the photographic portrait, seeking to reveal spiritual personality through the camera is Alfred Stieglitz.

The life and work of Stieglitz is thoroughly documented, yet strangely unclear. It is not easy to discover what were the critical relationships in his life, partly because of the unwillingness of his survivors to discuss him. His photographs are in collections at the *International Museum of Photography at Eastman House*, the *Museum of Modern Art* and the *National Archive;* numbers of prints

are held by a few private collectors. The best sources of information are *America and Alfred Stieglitz*, his own magazine, *Camera Work*, (recently republished in a fascimile edition) and remembrances by Seligman, *Conversations With Stieglitz*.

Stieglitz was born in 1864, and died in 1946. In the last year of his life he was photographed by Cartier-Bresson, Ansel Adams and Weegee; all photographers reveal a weakened man, frail with age. In *Naked City* Weegee relates a self-pitying monologue in which Stieglitz says everyone has abandoned him. This was certainly true in the sense that his dominance of the *avante-garde* was lost, and he seemingly was left behind. The images and ideas which he developed in the 1920's are now coming into their own.

Sent to Europe to study engineering, he fell in love with photography, learned photochemistry, and returned to the United States where he invested in a photoengraving business. After joining the New York Camera Club he became secretary, and also editor of the journal, *Camera Notes*. With the platform of this publication as his base, he imposed a benevolent dictatorship of taste. He defined what photography might, and ought to be. In 1902, he organized the Photo-Secessionist exhibition, and founded *Camera Work*. He published the magazine for 15 years. Concurrently, he managed a succession of small galleries. The galleries were forums for his disciples and centers for his teaching work for the rest of his life. Until the late 1930's he continued to photograph. Many of his strongest photographs were portraits, and many of these were of his second wife, Georgia O'Keefe, whom he married in 1924.

The body of his photographic work, fragmentary as it is in published form, is impressive, and has taken on new meaning in photography in the past decade.

His portraits date from 1887. The pictures are direct, pure, straight; as documentary as Hine, yet as mannered as Cameron. Only for a short time, during the early 1900's do his pictures ever depart from the crisp, technically brilliant print. His images are often limpid; seemingly the camera does not obtrude on our perception; we feel a direct encounter with the person.

The portraits he made of women are unique. "Stieglitz's prints of the body, face, and hands of women are among the truly great achievements of art, because he has made of them the symbol of man's physical closeness to the world itself... Steiglitz's photographs

of women are the image of a total immersion in life," notes Howard Clurman in *America and Alfred Stieglitz*.

He made many photographs of one woman, Georgia O'Keefe. Clurman noted that "one of the distinctions of Stieglitz's work lies in his ability to make each photograph a complete thing in itself and at the same time part of a process toward something beyond." The separate pictures are each part of a portrait, although each stands alone.

He was an excellent technician but was willing to use accidental results so long as they supported his intention. Several of his prints were on palladium paper, which solarized easily. The reversal of tone in the deep black areas produces a sense of floating, of weightlessness which was esthetically useful. Reproduction of Stieglitz's work is misleading, whether it be a slide, book or magazine illustration. The scale is usually wrong, and one misses the tactile values. One is divorced from the esthetic experience of the print; the reproduction provides catalogue information, not the entire experience.

The portraits are technically pure and sharply focussed, excepting a few pictures made just after the turn of the century. The apparent ease of his accomplishment disturbed his contemporaries; according to legend they accused him of hypnotizing his subjects, so naturally revealed were the ladies, artists and friends seen in his prints.

The entire cumulative portrait of Georgia O'Keefe, begun when she was a young woman and continued for more than twenty years, is not yet public. It is possible to see some of the pictures by examing various books published on his work. He reveals the person through recording the parts; he is not hesitant to show her as unbeautiful, or unpretty. Sometimes he approaches contrivance, but as a means of illustrating her: see the pictures of her hands on a cow skull, a central prop in her own paintings. It is difficult to avoid projecting emotions into many of the pictures. O'Keefe is seen often as a fierce, taloned creature, more aloof and ungentle as the years pass. Such interpretation must be done with care, but the older their relationship the stronger she seems to become.

The image quality varies in reproduction. One has to remember that not all the originals were silver prints. Platinum or palladium prints look flat and murky in halftone reproduction, because the originals do not usually have a long tonal range. The beauty of the platinum print is intrinsic to the materials. Only the silver prints seem

contemporary and read well in books or magazine reproductions.

Many of the pictures in his extensive portrait are unpublished and are still unavailable, contained in private estates.

While he supported and helped establish the manipulatory pictorialist photographers, Stieglitz's personal work remained technically pure. He also seems never to have used the face and body of a person merely as a means to a pleasing image, as many of the pictorialists did. Yet in editing *Camera Work* he published work he disagreed with, when he felt it was the best of a kind.

A useful experience is to look comparatively at the work of Stieglitz and of Steichen. Steichen was born in 1879. He is a generation younger than Stieglitz, and his first pictures appear a decade later than Stieglitz's. He was a co-worker in founding the first gallery associated with Stieglitz, *291*, or *The Little Galleries of the Photo-Secession.* The rooms in fact were Steichen's own apartment, offered for use when he went to France. One may see Steichen's work during the years 1900-1920 as published by Stieglitz in *Camera Work.*

Steichen's photographs span several genre other than portraiture. Many of the portraits are available in reproduction; examine his *A Life in Photography*. He was always alert to the use of the picture. Stieglitz seems to have photographed most for his own personal vision, Steichen for an audience. Steichen often used the personality of his sitter lighted in a technically masterful manner, but used it to achieve a pictorial statement. The story is after the First World War, when he began magazine illustration, he set himself to photograph a white cup and saucer on a black background and worked at this until he realized the materials could not resolve that tonal range. In the attempt he discovered what the materials truly could do.

The portraits begin early. By 1901, when he is 22, he is making pictures of famous personalities: George Frederick Watts, F. Holland Day, and others. His images seem built up on the groundglass as a painter would build up an image with pigments; one is aware of the studied richness of a contour, the tastefulness of a texture.

He went to France just after the Photo-Secession show, and increased his reputation by photographing Rodin and his sculpture. The photographer became the interpreter of the artist, presenting his

60

image to a public. This special relationship exists today, for example, in David Douglas Duncan photographing Picasso. Quality, materials, intensity may vary, but the fundamental relationship is the same in that the photographer is using his association with the famous, and also his understanding of the artist and his work to advance himself. This is parallel to the carte-de-visite photographs, and it can degenerate into something like the photographs Ron Gallela makes of Mrs. Onassis: publishable because the subject is notorious, and is difficult to photograph. Steichen worked with Rodin, as Duncan works with Picasso, rather than against him as the *papparezzi* work against personalities of our day.

Steichen used all available photo materials: gum and platinum, separately and in combination, *Autochrome* color, and of course silver print papers (see *frontispiece:* an advertisement for Kodak, from *Camera Work.*)

From the first pictures one is aware of his deliberate architecture of light. Bright and dark areas in the print are used as shapes to mold the print's surface; often they have no integral relationship to the illusionistic subject. Patterns of light and dark are repetitive. A major form which reappears in a vertical bar of light, extending most of the height of the print, usually near the right edge of the print. Occasionally the bar of light becomes somewhat diagonal, leaning slightly to the left, to create motion in the frame.

He had great sensitivity to formal possibilities. His photographs of Isadora and Therese Duncan are delightful discoveries of gesture, rendered two-dimensional. On examining his images, there is the sense of a thoughtful artist creating a formal structure, building it into a finished print. It is to his credit that his idea is almost always visual rather than verbal, so that while his pictures always refer a viewer to a covert schematic, the schema is not verbal, it is visual, formally and intellectually sound.

During the period after the first World War, and until it ceased publishing in 1936, Steichen worked for *Vanity Fair.* His pictures set a standard for portraiture of public people, much as Richard Avedon's portraits were to do during the 1950's and as Baron DeMeyer had done in the 1910's and 1920's. The sensation is rarely one of looking at the person hidden behind the personality, behind the theatricality of the picture-making. He produced excellent masks; they convince us of their authenticity as masks; they are performances, antithetical to an intercourse with the soul of the

the portrait 61

sitter, to an understanding of the private person.

Steichen is closer to David than to nineteenth century romantic; he is less concerned with trompe l'oeil illusionism than he is with formal structure. His limitation is that he always refers his photographic image back to French painting, at least until the First World War, then his style changed. As a photographer concerned with military documentation, he changed the way he used the camera, but not his gestalt. He no longer manipulated the surface of the image, stopped using gum pigments, but he never ceased to manipulate light. The structure of light in the portraits done in the early thirties for *Vanity Fair* has arbitrary light and dark forms similar to those found in his heavily manipulated gum prints of the 1900's.

Stieglitz's views on contemporary photographers is easily seen on examing *Camera Work*, preceeding the Strand issues. In his magazine, Stieglitz had steadily turned his back on photography. Out of the more than five hundred plates presented in fifteen years only the early and the very last issues are fully photographic.The middle years of the magazine almost exclusively contain reproductions of drawings, paintings and photographs as sculpture, except for recapitulations of important photo work done much earlier by Cameron, and Hill and Adamson.

The last year that Stieglitz published *Camera Work* was 1917; it was a double issue devoted to the photographs of Paul Strand, 27 years old. Stieglitz found in Strand what Stieglitz thought a photographer ought to be. Strand's work had purity, formal strength, and intensity of direct observation.

Strand is not a portrait maker as was Steichen was or even as Stieglitz. He is closer to John Thompson or to Atget: a documentarian, formal and self-conscious. And yet his pictures are dramatic. The people are often posed in what should be stiff tableaus, but these become documents of their essential masks. The *Mexico* portfolio uses the Indians as heartlessly as though they were statues from the Spanish Baroque—as sculptural objects place in his concept of Mexican time. He used the subject; he imposed ideas in much the same way a photographer may use eroded rock forms carved by the ocean as shapes on which he can impose his own emotional and intellectual sensibilities.

The pictures change little over fifty years of his work. He is always a pristine printmaker, usually working with a 5 x 7 inch camera,

printing from this a 5 x 6 inch format. His books are mostly out of print, excepting the new *Aperture* monograph; each book studied a particular place, New England, the Hebrides, Spain, etc. He stayed in each place until he knew the inhabitants and they knew him and he could photograph with their cooperation. The resulting pictures are a record of mutual consciousness.

In his pictures one looks at the person through a magic window of the print and the person looks back out. This minimizes the sensation of the person being merely used in a composition, even though he is placed always in a most careful arrangement.

A contemporary of both Stieglitz and Strand was August Sander. Born in 1876, his earliest available photograph is dated 1896; it differs not at all from the last photographs he made in the late 1930's. This early picture is of an aged German farm couple standing side by side in a doorway. The marks of the land are on them, their life and their work. He photographed people as they were, as they revealed the imprint of their culture—in dress, pose, stance, coloration, affectations. His pictures are accurate ethnographic or anthropologic records; the natives are not bare-breasted Balinese, but doughty Bavarian farm women, dour professors, limp students or dull troopers. His photographs reveal the effect of membership in a particular class on the person. It is difficult to find any other photographer who has used his camera so surgically, with such coolness, without becoming involved, without commenting but allowing the subject to reveal himself.

The only work in America that comes close to this will be discussed under the heading of the *Social Landscape*, photographs of the interaction between the person and the environment. American class portraits have always been rather sentimental; they do not have Sander's detachment, his freedom from romanticism.

In Stieglitz's own work one finds the first major examples of the psychological portrait in this century done deliberately and successfully. Most portraiture is of another sort, the public portrait which is made to display a mask suitable for a public person, to reinforce an ideal of the person.

Most of the photographers from the period before World War II whose work is in print were excellent technicians. Steichen is an example; he became *the* magazine portraitist in 1923, following the ten year lead of Baron A. DeMeyer who was first seen in *Camera*

Work; before the war DeMeyer photographed for *Vogue,* and produced excellent cosmetic interpretations of public figures.

Edward Weston made many handsome soft-focus portraits becore he discovered for himself the beauty of the crisp, revealing sharp focus 8 x 10 inch contact print, about 1920. After that his portraits are an integral part of his whole body of creative work and cannot be separated. Weston was born in 1886; he was a mature artist when he made a commitment to clear focus photography.

The Daybooks of Edward Weston clearly describe his explorations, in which the portrait, the nude, and the landscape all take their rightful place. Any object equalled an opportunity for him to photograph. The large camera he used imposed a steadiness on the subject which reminds us of the quiet found in Daguerreotypes. His portraits from the 1920's were often made with a reflex camera, and captured the expression of a gesture without losing the large negative image quality; they are close to the work by Cameron, but brighter and not subdued.

Weston commented that "time, and a quiet heart" were the essentials for making photographs; a subject for photography was never lacking, almost anything at hand would do. A Guggenheim Foundation Fellowship, the first granted for photography, afforded him two years in which he could work without financial pressures. A number of photographs from that time were published in *California and the West,* and there are available two *NET* films on his life and photography which illustrate effectively the integrity of his vision. Technical attributes of his portraits have some significance. After a certain date he refused to retouch negatives. He imposed a purity of photographic record on the sitter.

Photography became technically uniform in the 1930's, except for a few holdouts like William Mortensen, whose work can be seen in the book *Madonnas and Monsters.* Gum printing was no longer acceptable, platinum no longer available. The enlarged print became standard, usually made from a 4 x 5 inch negative, though more and more frequently from a 35mm negative. Enlarged prints imposed more severe technical requirements on the photographer. The print began to look standardized. The number of films and papers decreased in variety.

Portraits published from this time are mostly of persons of

importance. The people in the picture make pictures important even when we have no direct knowledge of them any more. The painter-turned-photographer Man Ray photographed newly important artists, writers and poets in Paris, doing this work in order to live. He also produced symbolic and experimental portraiture. His portrait of the erotic novelist Henry Miller is a useful example: the writer is framed by a clinging nude female disguised by a painted mask, a rose stem and leaves. The portrait becomes a witty icon related to Miller's work and life, and also to his major work-in-progress at the time, *The Rosy Crucifixion* trilogy, published here as *Sexus*, *Nexus*, and *Plexus*. His portrait of the popular model Kiki is another example; her nude back was painted on the photograph with two 'f' holes from a violin. The shapes have reference to the artists for whom she worked, whose images involved guitar or violin shapes, and to the erotic joke of an instrument which one plays.

Man Ray was one of the first DaDa artists, and was also an important technical innovator in photography. His rediscovery of the cameraless image, made directly by the light itself acting on photographic paper—originally called *photogenic drawing* by Talbot, and named the *Rayogram* by Man Ray—was seen by Moholy-Nagy in Paris, and then used by him as a printmaking and photo-teaching tool at the Bauhaus. Moholy-Nagy called these prints *photograms*.

Man Ray often observed his own mistakes in handling the photographic materials, and then used the results of the mistakes to produce new photographic images. Solarized portraits came from such a happy accident. He describes his accidental discoveries with candor in *Self Portrait*. He observed and analyzed, then used the effects when needed.

One of the few photographers of the 1930's to make pictures of famous people that were closer to Stieglitz's psychological portait than to the manipulatory image, exemplified by Steichen, was the English photographer Bill Brandt. His work arouses our response to the personality as a force and also to the person as a public mask. Harsh tone and a brutal vision in Brandt's images sometimes seems to be affectation, and yet in his portrait of the Sitwells it all seems terribly appropriate. He is humorless, all in all, and drawn to the social crocodiles of the period just before the war; he reveals them in their jungle. He could be gentle, with all his candor, as in *Parlour Maids*. (See Portfolio).

the portrait 65

To see the differences between his kind of photograph of public people and a more familiar kind of portraiture, Brandt may be compared with contemporary commercial artists, Eisenstaedt, Halsman, Avedon, and Yousuf Karsh.

Eisenstaedt could well be called the public portraitist. A *Life* staff photographer from its beginning, he has the ability to produce a seemingly effortless image capturing what a personality ought to look like. His pictures of Bertrand Russell and of Jacob Epstein are cases in point—one the witty elder man of philosophy, the other the mad painter ravishing a canvas. His photographs are made for publication in large circulation magazines; the picture has to make an instantaneous impact, and be superior to the competition of news and advertisements. Seen outside this context they are somehow overstated and blatant; but again, this is not the way they were meant to be seen.

Theatricality appears also in the work of Phillipe Halsman and Richard Avedon. The same subject, for example Oppenheimer, or Russell, was often photographed by all of these men. Their pictures can be usefully compared. Halsman and Avedon are masterful technicians, using light and theatrical direction to create an ambience, a sense of unremitting contact with the personality. Their people all seem larger than life, super-real.

Compare Avedon's portrait of Ezra Pound, incarcerated at St. Elizabeth's, with the portrait of the young poet made by Alvin Langdon Coburn about forty years earlier. Coburn's mulitiple exposure is true to the poetry of the man; Avedon's picture is true to the liberal's political image of the self-tortured, ambivalent relic of a political nightmare.

Many of the portraits done by Avedon, Halsman and Eisenstaedt are in essence caricatures. We have the sense of knowing the personality at first glance. Some characteristic has been abstracted and enlarged; the viewer cannot miss. This is probably essential when the photographs are intended for magazine reproduction. In *Observations* Avedon achieved a set of pictures that are as formal as Steichen's.

Finally, one must examine the polished and marvelous work of Karsh, of Ottawa. He has sympathetically and gently photographed the world's great. Sandburg, Churchhill, Prince Phillip, Pope Paul, and Krushchev are all benign, slightly glossy, round, alert and

inmaculate. Karsh is the Norman Rockwell of photography—never offending always pleasing. This is serious praise, but can be read as damnation, if something else is desired. He has held up to professionals of portraiture a very high set of standards. In a country which spends about one billion dollars a year on studio portraiture, the higher the standards, the better.

Compare Karsh's photographs of Oppenheimer or Russell with those of Halsman. Karsh looks at Oppenheimer as a physicist in the theatre of his equations at Princeton; Halsman sees Oppenheimer as a tragic figure, on his way to immolation. Both images are true to the time in which they were made and are equally glossy. Many examples of popular portraiture that could be chosen. The *Professional Photographer* magazine can be examined for contemporary portrait studies.

In terms of this history a major change in portraiture appears with the work of Minor White. Born in 1908, he comes to photography from poetry, unlike most earlier artists who came from painting, chemistry or commercial photography.

White completed college before the second World War, learned photography and worked for the WPA photographing the "iron front" buildings of Portland, Oregon. His work is represented in many issues of *Aperture*, and in his book, *Mirrors, Messages, Manifestations*. His portraiture matured after the Second World War, when he had to face the fact that he was forty, many people in his life had died, and he had chosen to photograph his way through life.

Experiments made teaching at the California School of Fine Arts, and later in experimental classes at RIT, and MIT, as well as dozens of private workshops enabled him to work out a method of psychological portraiture which is occasionally embarrassingly naked and often painful both to observe or to participate in. His methods produced photographs that move us emotionally in spite of having a predictable viscous tonal range. The work he has done is only partly reflected in his monograph; the printed page often violates the experience of the silver print. But the print and printed page are different mediums and it is difficult to compare them.

His portrait *sequences* are complicated picture stories; the story is not linear but is an unfolding psychological onion, presented layer by layer. As each layer is opened it is compared to the others. This

may sound fanciful, precious, and difficult. Sometimes it is all three yet the photography is memorable. The sequences offer new visual and perceptual experiences.

This work of White is an extension of the portrait idea initiated by Stieglitz, but interpreted in White's own way—consciously assembled, dependent on contemporary psychological research and experimentation with himself, friends and students. The result is a number of synergetic images brought together. Stieglitz first did this in his show of 1921, in the group entitled *A Demonstration of Portraiture:* White expanded this idea by also using photographs of things other than the person, shapes that direct our eyes, modifying gestalts that create meaning through evocative associations. The sequence is a major addition to the genre of the psychological portrait.

At least two people exist in the sequence-portrait, White and the subject. This is true of all portraiture, both the photographer and the subject are mirrored. The difference here is that though these photographs are self conscious, they often seem to have come into being by themselves. There is no repetitive formal gestalt, as in Steichen's work; no stylistic lighting, as with Karsh or Halsman; no covert erotic reminders as in Stieglitz's photographs.

The photographer always reveals himself in the picture, just as a painter reveals himself in the paints; in both arts there is an intimate relationship between the gesture and the result. One of the difficult jobs in teaching either art is to enable a student to discover gestures which are inimitable, not borrowed, not abstracted from other artists.

Essentially, White says since you will always be looking at the photographer as well as the photograph and the subject, he will assume responsibility for the whole. The photograph then becomes the entire relationship: the individual images seen in their order, plus the connectives. The connectives in this visual syntax are very important. Work done by Bell Laboratory in speech communication indicates that the most important sounds, those which carry most of what is called *information* are not primary vocations but the transitory, or connective slurs. In White's sequences, the images evoked by interactions of two adjacent, sequential pictures are equivalent these slurring sounds, and are virtual images created by the viewer that carry the ultimate meaning of the sequence.

He works consciously, assembling a sequence out of a reservoir of images, rearranging them many times. The gestalts suggested to him by a print are discovered and verbalized to discover what the image suggests as well as what it illusionistically represents. The possible associations are enumerated and the relationships between prints are eventually fixed, after many trials. In doing this he has been accused of being a manipulatory psychologist; he responds with a smile; because the photographic image never has only a single meaning, the photographer might as well discover what other meanings it might have, and assume responsibility for those meanings.

the portrait

THE CITYSCAPE

The *social landscape* is the most inclusive photographic subject. Rather than fully cover this category which includes the nude, urban and social conditions, photographs of war, and leave the cityscape and the natural landscape squeezed together at the end of the text, it seems wise to investigate these other subjects and then return to photographic records of man and his environment.

It was in the nature of things that the first photographs were not of people but buildings; buildings would stand still for the hours needed to make exposures in early days of photography. But even after this mechanical reason for photographing buildings passed, when films became more sensitive and permitted short exposures the photographers of the time continued to photograph architectural subjects.

Buildings were and are important subjects in themselves. Pride of ownership, of living in a certain city, of a sense of history, the belated English rediscovery of their own ruins, and the parallel rediscovery of Gothic monuments in France, the international excitement about Egyptian ruins and culture—all encouraged early documentary photography of the cityscape. This desire for images of architecture has few parallels in the history of art. Guardi and Canaletto come to mind, but architectural painting had mostly been the *concetto* of Baroque art, or the *model architecture* of the Renaissance, excuses for fantastic stage sets for mythic and religious

action. The image of a building seen for its own sake is almost nonexistent before the invention of photography, excepting where the *camera obscura* had been on hand to assist the artist rendering exact shade and shadow, rigorously seen and not idealized.

An illusionistic rendering of a building complex requires accurate transcription of the sunlight and shadows on those structures. Shadows before the *tenebrists* had been mere modeling, used to suggest mass and roundness. Even Flemish painters, with their proto-photographic accuracy, reflected light and careful modeling of the rounded surface, sidestepped problems of direct sunlight and its delineation. Caravaggio and his followers used brilliant internal light seen within the frame of the picture, and radial shadows, yet freely violated actuality of light and shade to achieve suitable dramatic relationships and curiously unshadowed faces of all the principals in the painting.

In paintings made before the *camera obscura* there is a shaded side and a light side, but no sunlight and shadow on real polyhedral geometric solids. As has been noted, there is a psychological change in the culture in which photography was itself formed, in that the previously unknown cult of the ruin came into being. This is the time of the specialized artist in England painting only English ruins, sometimes painting the same church many times over, for sale to a middle class desiring documentary records of a romantic landscape. In 1839, Talbot photographed his ancestral home, Lacock Abbey, with his positive-negative process; it was not the first time he had photographed the manor. His early *matchbox* cameras had been used to photograph the leaded windows, suitable subjects for the very long experimental exposures.

Talbot always made very straightforward record photographs. Looking at his pictures one has very little sense of the scene having been organized, composed or arranged to make a pretty picture. Even though he was helped by a painter named Colleen, in a pictorial sense his pictures are often almost incoherent; the subject before the camera was of prime importance, so he photographed it straight on. He almost always chopped off parts of a building arbitrarily—steeples and pediments suffered at his camera. One has the sense of him placing the camera where most of what is important is in the picture, and then making the exposure. Talbot's pictures approximate the snapshot; one does not feel the esthetic arrangement controlling his decision, only the need to make an accurate record.

When he put people into the picture it did become pictorial. Most of his pictures are honest, unassuming documents of the buildings and life around him. He evidently found excitement in being able to make a documentary image, simply because it had never before been possible without both talent and tedious specialized labor.

The Calotypists Hill and Adamson also made a few cityscape photographs, as well as portraits, photographing Scottish ruins, and a burial ground near Edinburgh, with the castle seen high on a hill behind the tombs. Their prints are painterly in composition and massing, partly because of the limited tonal scale of the Calotype and partly because of Hill's training.

They used frequent "near-far" relationships—near (and pictorially large) foreground objects graphically contrasted with far (and pictorially small) background subjects. This method of composing tends to crush space and produce a graphically rich image. This same sort of relationship was also used by the photographers making stereographic images in the 1850's and later—to make the spatial effect of the photograph more exciting.

Some charming anonymous street scenes of American and European cities survive from the early days of photography. These are both documentary records of the buildings used in daily commerce and life, and rich sociological documents of life in that day. They recreate an awareness of rhythms of life from their times in a way no verbal description can match.

Photographic documentation was used both commercially and artistically. In Paris, for example, the camera was put to use at once to discover and to document the hidden beauties of France's rediscovered Gothic architecture. The French had earlier turned their back on Gothic design, to the point that Notre Dame nearly did not survive the Napoleonic Empire. With the rise of the romantic attitude in art and literature, expressed by Hugo, Gothic intensity had renewed virtue.

The beginning of archeology is closely linked to this rediscovery of indigenous ruins. French imperialism had recently acquired the archeological treasures of Egypt and the ancient north-African cities. The camera was available to record and to show what was there, and present the show to the rest of the world. The ancient *tympani* sculptures, hidden capital figurines, *putti*, gargoyles and even the variations in flutings and arches all became available to an

72

interested public through the medium of photography. Pictures offered information; the original subjects had been hidden for years by dirt, darkness, having been boarded up, or hidden in transept or choir from the lay eye.

Both Daguerreotypes and Calotypes were used. The negative-positive process quickly became important, because copies could be made. Charles Negre, Henry LeSecq, and Blanquart-Evrard all made documentary photographs of the city's buildings in Paris. They were concerned with showing what was there. Negre also brought a degree of wit and casualness to his images which made them seem almost contemporary to our eyes.

The photograph permitted one to see things that could not be seen otherwise, because of physical location, light, or special problems of access to the subject. The photograph permitted one to see without having to go there oneself. This was the beginning of Andre Malraux called the "museum without walls" in *The Voices of Silence*. He gives photography credit for destroying the walls of the gallery and creating a museum without walls, a portable museum.

When the photographic document was invented, one no longer had to travel about in order to be visually literate. One could see all art through the photograph. Malraux warns us that this changes things. In a book of photographs of art the ambience of the original object is destroyed. A Scythian brooch, small enough to fit into the hand, is equal to a caryatid from the Erectheum when seen in photographs of the same size, reproduced on the same page. The documentary photograph dislocates art, tears it from its context and changes its meaning. The reality of photographic illusion becomes deception. The photograph creates a museum without walls; it also imposes severe analytical responsibilities on the viewer. He must learn to read through the illusion of the reproduced print to recreate the correct ambience for the original object, if he truly wishes to understand it.

Even when we know the name of the photographer the documentary photograph is often curiously anonymous— the Negre, LeSecq, Blanquart-Evrard and Marville photographs of statuary and ruins are nearly interchangeable, being of a period of photo-documentary discovery. This is true for each such period. And, this is only right if the purpose of the documentary photograph is to reveal what is intrinsic to the object, not to impose personal esthetic interpretation onto the subject. These are photographs in which the photographer ceases to be present—becomes, as it were, transparent. The object in

front of the camera is important, not the mannerism of the photographer. An esthetic judgement of such a photograph is often not relevant. One may well have an esthetic reaction, as with the photograph by LeSecq shown in the Portfolio, but that is in a way secondary; the meaning of the documentary photograph is in the catalogue it presents.

The documentary impulse was hardly ever pure and quickly became modified by pictorial considerations. One can compare Hill and Adamson's photograph of the castle at Edinburgh with photographs of the same battlement made by Kieth, in 1851, and by the photographer Burns, in 1867. One photograph is vertical, the latter two horizontal but both the later photographs are made from similar *station points*. Hill and Adamson's photograph is pictorially speaking more than merely documentary; Kieth's picture is about the same as work by contemporary French documentarians; Burns was more cognizant of light, composition and tonality.

The pictures we have available from the Near East are similar in this pictorial growth. Maxime DuCamp's photographs are documents and show little sense of pictorial possibilities. He includes a human figure to illustrate scale, often placed in an ungainly way. The English photographer Francis Frith, photographing for his own printing company, revisited the same sites and often placed his camera in very nearly the same places as DuCamp (see the example in the Portfolio). His pictures have a pictorial warmth and grace which changes our response to the ancient sculpture and bas-reliefs. James Robertson in turn photographed similar sites, as did others. Robertson's and Beato's photographs of Greece are so handsome that our response is probably more esthetic than educational.

In the history of the documentary photograph a strong pictorial sense is what the movie version of Mary Poppins called a little bit of sugar that makes the medicine go down. A subject made esthetically pleasing in the photograph often distracts the viewer from seeing the larger meanings of the original documentary subject, or encourages him to see it through rosy glasses.

A photograph becomes an esthetic object because we say it is, because we have a response to the prettiness of the picture, to the way the shapes work within the frame of the print. Defining a picture this way becomes a definition of one's own taste.

The photographic document was worth money; publishing houses

were established early in the history of the medium, dedicated to printing photographs and marketing them. Blanquart-Evrard's firm outside Paris was one, and in English history there were three important print publishers. The first was Talbot's, at Reading, where the illustrations for *The Pencil of Nature* and his other picture books were prepared. Francis Frith, and George Washington Wilson also published prints. One catalogue for Frith's firm had over 600 pages of titles. In America a photographer named Anthony published prints, as did Muybridge, in San Francisco, and others in most major cities. All of them published single images and stereographic pairs. William Henry Jackson also did this sort of work, though not on so vast a scale as Frith, or Anthony, and later, in our century, so did Lewis Hine. There are still many firms selling "stock" photographs, agencies which purchase photographs of places which will have a market in advertising or calendar photography, or in educational publishing.

Wilson's photographs differ from earlier work; he made pictures which capture the sense of the movement of the time. These must be seen in the context of the times, otherwise his achievement can be too easily ignored. He had a continuing contest with Anthony, his Atlantic competitor, each trying to make more nearly instantaneous pictures of street events than the other. The delineation of moving objects seen by the camera was considered to be a dubious possibility at the beginning of photography, yet it was less than twenty years until both Wilson and Anthony made street scenes (see Portfolio) in which pedestrians seem to be caught in the flick of an eye and the cityscape appears *natural* not empty, posed and artificial.

The achievement of these near-snapshots and the visual depth created by the stereographic camera and viewer completed the achievement of the documentary picture. Lacking only color, the three-dimensional and accurate record of exotic places, Egyptian tomb or Paris street, was complete and believable. All this was achieved before our Civil War. Many photographers made and sold stereographic pairs, and marketed them through direct-mail catalogues, well into the 1920's. They were the standard for documentary fidelity for eighty years. The stereograph still exists, using small color transparencies mounted on circular discs, and has also found renewed life in the publishing of educational texts, where complex realities are made clear through three-dimensional illustrations.

The stereograph image is made by two cameras photographing simultaneously; the lenses are about three inches apart. They see slightly different views of reality, just as our eyes do. When these two photographs are printed and mounted so the left eye sees one picture and the right eye the other, the images merge in the viewer's mind to produce a sensation of three-dimensional space. The original viewers were bulky machines; these were replaced before the Civil War by the light frame supporting a pair of lenses and a handle at one end and the paired photographs at the other, invented by the jurist Oliver Wendell Holmes (see Portfolio). He gave away his invention, making no attempt to patent or profit from it.

The stereograph was a major entertainment that survived until just before the Second World War. It enabled a rancher in Wyoming to see the ruins of the Parthenon, or simply revisit in fantasy the big city of St. Louis without having to leave his ranch. Before movies, the stereoscope enabled one to feel he had been there and seen the places shown. This is no small achievement for any medium.

Stereographic compositions were selected to reveal deep space. Pictures that mean little seen in a two-dimensional print become startling spatial events seen through the stereo viewer. The canyons of the American west and the canyons of the great city streets become alive. The edge between documentation and titillation is thin. Many documentary stereographs were marred by striving for effect; the real spatial relationships of the subject were exaggerated to produce sensation.

The photograph in the stereoscopic image is dependent on its illusionistic effect, and physical illusion is the basis of its appeal. Half a stereo pair is often dull, sometimes even unintelligible. Many times the only purpose of the photographer was to create a sensation of vertiginous depth, which is lost forever in the truncated single image. Our intrusions on the western wilderness are well documented. Panoramic pictures survive, showing in depth the great speed of new civic building, the power brought to bear against the earth itself, all revealed in documentary photographs of the great train trestles and embankments thrown up to support the railroads in the 1880's.

In documentary photography of the west the first name one encounters is that of Timothy O'Sullivan. He came to fame in the Civil War, photographing for Brady. Afterward he traveled in the

west on various expeditions with Wesley and Powell. It is interesting to compare O'Sullivans's photograph of the ruins at *Canyon de Chelly* with the photograph of the same ruins made sixty years later by Ansel Adams. O'Sullivan shows the entire dwelling and includes the valley floor, all in one clear document. Adams focuses in, eliminating the valley floor and by so doing allows the rock-city to float in space, dramatizing it with light and exaggerating space to produce a poetic and self-conscious photograph, more interpretation that documentation. The photographs of O'Sullivan were made with wet-plates. The exhaustive labor involved and the limitations of the process must be remembered when a judgement of his, or any other work of the time is made.

Among others, Andrew Russell photographed the American railroad crossing the country, and his pictures can be classified as either landscape or cityscape. They hover on the borderline and make confusion of any system of classification. His pictures are very straightforward, made to show what the rails were doing. We can read these pictures in different ways, and they are difficult to examine without projecting new meaning into them. It is only when one digests the facts of the pictures and accepts them as they are that one realizes their esthetic and associational richness.

There was an emotional need to document the new towns in the west as they arose along the railway and beside the gold-filled streams. Later, the same towns became suitable for photographers seeking nostalgic and pictorial subjects.

William Henry Jackson produced excellent documentary photographs of the new cities rising in the West, from Nebraska to California. Many of the scenes he photographed in Colorado, for example, can still be visited. The place Jackson photographed can be compared with the town, mountain or vista as it now exists. Often there is change—Mt. Holy Cross has faded—the rhythm of life and death in the gold-mining towns was swift, but occasionally a subject survives, seemingly unchanged, as for example the town of Central City, Colorado.

In photography there has always been interest in *counting things*, in studying a print to discover just what the camera saw, to marvel at *minutiae*. Delight in what is recorded is part of the photographic esthetic from first photograph made until today. The documentary photograph, purely stated, tends to become a bit dry unless the viewer is interested in the things being catalogued. The work of some

photographers as documentarians and as formally aware artists gives special pleasure. In England, Frederick Evans was such a man, though preceded at a lower level by Frith and Wilson. Evans was a purist, doing work between 1885 and 1915, producing pictures accurate as to substance and spirit which are also lovely to behold. The esthetic impulse was so strong in him that although his images seem pure, revelatory of the nature of the subject, one also sees them as *fine prints;* sometimes they are seen as fine prints first and as documents of a part of the cityscape second.

Evans owned a bookstore, and then retired to devote all his time to photography. He made portraits as well as photographing English churches and buildings. He was both very popular and severely criticised by photographers of his time; some critics felt his work was too severe, too plain, close to standard commercial work because his clear sharp prints were made only on platinum paper. When platinotype was no longer made he ceased to make photographs. Only the platinum paper yielded the long-scale shadows he desired to see. He was also an excellent critic, with a rather dry style, and he wrote frequently for *Camera Work.*

His review of the London Salon of 1906 (in Vol. XVII of *Camera Work*) is an example of his firm impartiality. The exhibit had been mounted by Alvin Langdon Coburn, who had attempted to make a new environment for the photographs. The gallery had distracting wallpaper; Coburn covered this with brown paper, an unsatisfactory solution either as background for the prints or as a surface in itself, wrote Evans. The paper was bland, and it was wrinkled. Yet Coburn's attempt was both right and necessary Evans' writing was direct and spare, like his photographs.

In *Camera Work,* Frederick Evans outlined a "dream" about photography, predating Dorothea Lange' *Project One* by sixty years. He wrote in Vol.V, 1904, "I lately dreamt that I had the overseeing of a huge National Photographic Record of current life, buildings, people, types, etc., as a Department of History-making for Posterity. I had such autocratic authority that I was able to deal at will with persons, or buildings.... I had the right to call on any person, public or private, to sit for his portrait, either as a celebrity or as a type of current life. My small army of workers were as enthusiastic as myself, and adequately trained; and my only sorrow was that I could not live to witness the satisfaction of posterity over this veritable history-making.

"It is not the current but the past that delights and charms us most; we have the present, like the poor, always and too much with us; it is only the exceptionally enthusiastic student who sees in it what will have the like interest and value for posterity that the past has now for us.... But it is all an empty dream, and one that will end in this mere adumbration of it." However something not too far from this was later achieved by Roy Stryker, working under the sponsorship of Standard Oil, from the beginning of the Second World War well into the 1960's. The Standard Oil project comprises more than 80,000 negatives, now stored and being catalogued at the University of Louisville Archives, Kentucky.

Evans's photographs of English churches were as faithful to the substance and spirit of the building and to its light as he could make them. His desire to make faithful transcriptions imposed technical problems which were solved in part by the use of platinum printing. The platinum print makes an essentially *straight-line* reproduction of the negative. Platinum and gravure alike share this ability to reproduce linearly without distortion the darker tones of the negative. The non-linear character of the silver process exaggerates separation of print tones in the middle part of the grey scale while crushing shadow values at the same time, deforming both high and low tones.

The platinum print reproduces shadows much as we see them; what is seen in the negative will reproduce in the print. The platinum and the gravure processes both translate density for density whatever is on the matrix image. Using the platinum process enabled Evans to make prints which had fully detailed highlights and shadows which become darker and darker yet do not merge in blackness. His images appear gentle, and somewhat soft when compared to contemporary prints. When platinum paper was withdrawn from the market, due to the rising costs of platinum salts, he stopped photographing.

Concurrent with Evans, though younger, the Boston photographer Alvin Langdon Coburn also photographed the cityscape, but was not concerned with Evans need for documentary accuracy, untouched by personal interpretation. He made straightforward photographs, and he manipulated freely at the same time, fragmenting and distorting the image through the use of mirrors or aspheric optics, or through the ultimately simple device of pointing the camera sharply *up*, or *down*. As manipulation goes this seems to be little enough, but photographers had carried over habits of Renaissance perspective, used in rendering model architecture: vertical lines found in

buildings must remain parallel. Even in the vast conceits of interior architectural fantasies engraved by Piranesi, verticals remain parallel. A camera does not know that these lines should remain parallel. If a camera is pointed down from a height, the vertical building lines converge down; if pointed up, the lines converge upward. Talbot once prepared to photograph a building by pointing the camera upward and was sharply reprimanded by his friend and adviser Coleen; he leveled the camera. Coburn on the other hand, found the times had changed. His photograph of octopoidal sidewalk patterns in Central Park, overlayed by the transparent shadow of the tower building from which he photographed, startled his audience: by pointing the camera vertically downward a new reality had been created. Likewise, a tall building seen looking down on it, all its paired windows becoming eyes, became a thousand-eyed monster. He achieved a new vision, dependent on the camera's intrinsic geometry, independent of painters' conventional ways of seeing. This is not to say that no one had photographed from high or low vantage points before. But Coburn is important because he had an audience, and achieved publication of intentional work made as a master photographer. He was aware of the implications of the image; not only what he saw before the camera, but how it might appear as a print, as a new reality with new associations. The associations suggested by the print were not merely the reality of the subject before the camera, but were transformations arising from the photographer's vision and manifested by the camera.

Once a new way to see is published, it is easy to copy. Anyone could now become aware of the new meanings things take on when photographed from unusual angles, or isolated and seen out of context. There exist earlier photographs, for example one made by the amateur photographer Emile Zola, looking down through the arch of the Eiffel Tower toward a restaurant building; it is similar to some of Coburn's pictures.

The cityscape first appears as a pure documentary record. It is only when economic pressures are taken off the photographer, when there are photographers enough and to spare and materials are simplified that photographs begin to appear as self-conscious artistic statements, rather than as mere documentation. As long as photographers are working for a living, and have to survive from sales made directly to a middle-class audience, all photography of the cityscape is essentially documentary.

At the turn of the century, Evans, Coburn and other pictorialists

introduced a new cityscape. This was the photographic document deliberately and consciously colored by pictorial, emotional or sociological meaning.

After the War, Eduard J. became Edward Steichen. He stopped manipulating the surface of the print but he never stopped manipulating the subject by manipulating the light used to make the picture. The structure of light in almost all his cityscapes is repetitious.

A Steichen photograph is usually divided into three vertical bands alternating light and dark. The earliest such picture still available is the double-coated gum print of the *Flatiron Building* seen at dusk. The original image is blue and green. It is soft, the tonal range limited, ranging from pale grey-green to a soft blue-black. There is a luminous quality to the darkness; details are obscured, yet do not seem hidden, as they would appear in a silver print with a corresponding lack of exact detail.

The building is a vertical shaft of dark, flanked by light. This pattern or *gestalt* appears many times in Steichen's pictures, for example in *George Washington Bridge*, 1931. The composition of this picture is similar to his portrait of *Isadora Duncan;* she stands in a vertical shaft of light formed by the columns of the Parthenon. His photographs of New York at night are uniformly dramatic, indeed theatrical. These images can be best seen in his autobiography *A Life in Photography*. The night views of the city seem like settings for a Clifford Odets play. Steichen's photograph is always a virtuoso performance; it seems terribly simple, often belying his profound mastery of craft.

His work stands at the edge, between virtuosity for its own sake and technical brilliance used as a tool. One can see this in Steichen's work when it is compared to the photographs by Stieglitz, in this case to Stieglitz's cityscapes. For Stieglitz the city view was a way to rediscover and to describe his relationship to American society and to reveal his commentary on it.

The earliest Stieglitz photographs of the city date from European study years. The photograph of laundry, hanging outside a building in Venice (in *Alfred Stieglitz: Photographer*) is a technical and perceptual tour-de-force, with formal strength while remaining a perception of instantaneous events (in the water ripples) and avoiding any feeling of having been forced into a composition.

The momentary or instantaneous event in the cityscape was photographed early by Stieglitz. *The Terminal*, from 1892, shows the machine, animal, man and cityscape in complex interaction. The photograph was a triumph in its day both because of the esthetic quality of the image itself and because it was a technical triumph—the small hand camera being used to make a masterpiece of art photography, defying the critics. In 1892 he also made *The Hand of Man*, one of the earliest ambivalent cityscapes characteristic of the man's work. The photograph shows a locomotive with a plume of smoke, amid a field of converging bright rails. The train has been a subject for art since the train was invented (for example, see Monet). It was too exciting to avoid painting. Looked at in the context of his other city photographs, this image is ambivalent: at the center of the picture is blackness, out of which comes power. This is an impression which he creates over and over in pictures made during the next thirty years. Examine his photographs made from the windows of the galleries, from *291*, or from *An American Place*. As time passed, darkness rose; the city became untextured black space rising into and overwhelming the print. That this response is not imposed on his pictures is affirmed by transcripts of his conversations, and by his own writings. His photographs of the city appear to be documentary at first glance; with study one discovers they are private poems. Raw light and shadow become the stuff of personal exposition, and yet these survive in and of themselves. The *subject* is important in Stieglitz's photographs and is clearly delineated; his *state of mind* is also important and can be read through the image, if one desires. This reading of his state of mind is not necessary to an appreciation of the photograph, and is not imposed on the viewer, but is made available; an accurate and masterful rendering of the cityscape before the camera is also always offered.

These pictures come to a quiet climax in the photograph *White Porch with Grape Vine*, 1934. The implications of this picture are profound. A photograph of a fragment of a building becomes a keystone of contemporary photographic esthetics. It is discussed in the chapter entitled *Photography as Art*.

It is exciting to look at the photographs made during the same years by the French photographer Atget, and compare his pictures to those made by Steichen and Stieglitz. All worked concurrently. Atget photographed for about twenty years, during the first two decades of the century. His photographs were sold to artists, and some were commissioned by the French government, who asked him to document the brothels of Paris. Most of his prints and negatives

82

that survive were saved by the American photographer Berenice Abbott, who was studing photography in Paris under Man Ray. She purchased all negatives she could locate, and since then has spent much of her life publishing his work and printing his negatives. In the late 1960's she sold her collection of prints and negatives to the Museum of Modern Art.

The value and meaning assigned to his photographs has changed during the past forty years, since they were first published by Abbott in the early 1930's. His pictures pleased DaDa and Surreal painters, concerned with the irrational and the accidental vision. It is now apparent that they imposed on Atget, and molded him into their own image. Visual happenings (see Portfolio) that delighted the Surrealists do occur in his photographs: fragmentary men appear, carts seemingly trundle down streets by themselves, hats float by without heads.

But these are technical byproducts, accidents arising from his *idea fixe*, the need to photographically document the physical objects of Paris with what amounted to manic intensity.

When one examines the pictures themselves and does not attempt to equate them with art movements which postdate him, his pictures fit logically into the esthetic of photography as document, colored and shaped by his vision and equipment. Atget photographed with a slow lens and film long after more efficient materials and optics were available. The printing paper and chemistry he used produced prints with a curious soft red color; it makes individual objects seen in the prints become parts of a luminous catalogue. The images are so purely of the genre of documentary photography that they have survived repeated attempts to herd them into one school of esthetics or another. A cautionary note for the student: none of the reproductions, including prints made by Miss Abbott during the 1950's, approximate the tactile and color statements achieved by the photographer. The book reproductions are uniformly harsh, flat and grey all at the same time; they deny the tactile beauty of the original prints and force one to respond only to the photographic document. They isolate us from the whole photograph. One suspects that he liked his work the way it was, or he would have found a way to change the camera, film, lens or paper and produce something else. His art exists in the interaction of these, and he produced more than a catalogue of detail, though it is brilliantly that as well.

Concurrent with the later work of Stieglitz and Steichen in photographs of the city is the work of Ansel Adams. He is younger, born in this century, and his work has none of the ambivalence toward the straight photograph which was characteristic of the vivid success and ultimate failure of the pictorialist, and of the Photo-Secessionist. Like Strand, there is a sameness in Adams' work; photographs from his youth and maturity are strongly similar. The image is pure, crisp, and evanescent. Adams in fact speaks of making the image *float*, using affirmatively what Scharf has described as the principal esthetic failure of the photographic silver print, making it into a virtue for him. During technical critiques with students Adams describes in detail the methods he uses to make the image recede until it seemingly exists just behind the paper, rather than be heavily bonded to the surface, as it is with gum, gravure or platinum prints. This is possible with the silver-gelatin emulsion, and most effective when the surface of the print is very glossy and the print is meticulous. His brilliance is difficult to match, but he makes it seem fore-ordained. Adams has been a master of the silver print for fifty years. Aside from his own photography, he has established a canon of work with silver emulsions called the *Zone System.* This system has eliminated many of the tedious failures which used to be inevitable in the photographic working methods inherited from the casual days of pictorialism.

His position in documentary photography is ambivalent. At first glance his pictures are pristine records of the subject before the camera; on closer examination they are reworkings of the subject to achieve a personal image to reveal what Adams feels ought to be seen. There is in his work a sense of dramatic heightening, not unlike that heard in late Romantic music, early Schoenberg or late Rachmaninoff. His world is super-clear, enlarged, brilliant, with detailed surfaces. Since the invention of wide-screen movies, we are less moved by this kind of image in photography; before that, Adams' vision was unchallanged.

What begins to be clear is that it is very nearly impossible to make emotionally uncolored, undramatized documents. Personality, and craftsmanship, all functions of the photographer, modify meanings. The effect of these is to intrude upon the subject, to heighten our awareness of it, or to distort it. Distortion beyond a degree changes the image to another category, regardless of the photographer's expressed intention. A picture which is supposedly a document may be in fact a pictorial essay.

Adams' work appears almost as reaction to the pictorialist images, prominent when he was a youth. The discipline and craft he carried from music into both cityscape and landscape photography is exactly in opposition to the idea expressed by A.H. Hinton in *Camera Work*, (Vol. V, 1904) who wrote that "the maximum definition procurable with f/64 is not necessarily inimical to pictorial effect, provided there be that degree of softness which deprives each minute factor of irritating insistance... that has something to do with the unpleasantness of the old-time sharply focused photograph made upon a slow landscape-plate and a small lens aperture." Adams brings into congruence the "minute factor of insistance" *and* the surface brilliance of the contemporary glossy silver print, which is his answer to the richly manipulated gum prints created by the pictorialists in the generation preceding his photographic maturity.

Paul Strand has done excellent work in the cityscape genre. Most of his photographs were unavailable for years, but now have been republished by Aperture. The photographs Stieglitz published in *Camera Work* before the last, double issue devoted solely to Strand's pictures, included several cityscapes by the young Strand; in *New York* the buildings are seen as graphic shapes buffeted by the rocky landscape. The picture is characteristically Strand: he finds a place to stand where the shapes of the earth itself oppose the buildings and provide textural and spiritual references for them It was in relation to this that Weston noted in his Daybooks that when he saw Strand's work there seemed to be too much of Stieglitz in it.

The 1930's suddenly revealed a different kind of picture, in a development parallel to what happened in portraiture—less pretentious photography, more humble and affirmative, concerned with recording what was at hand. This was a choice not to seek dramatic and romantic compositions in the chiaroscuro of urban lighting, but on the contrary to reveal fragments of everyday urban reality. This change was a major esthetic decision. It was in part a by-product of economics. Like other artists, photographers had no way to make a living in the 1930's; some of the best of them were hired by Roy Stryker, working for the Farm Security Administration.

The FSA photographers were assigned to rural life, for the most part, but in fact recorded all facets of daily American life. Stryker boldly extended the limits of his mandate. Out of the assignment he gave his photographers came many photographs that are of value, and can be

easily obtained by an interested student; they are part of open U. S. Government files, and may be purchased as duplicate prints from the National Archive, or from the Library of Congress. Some of the delightful photographs from that time were shown by the Pasadena Museum, and published in the catalog of their exhibit *Just Before the War*. Of the many photographers who worked during those years for the FSA the man who typifies the photographer of the American cityscape is Walker Evans.

He is of the same generation as Adams, but he treated the world seen through his camera much differently. As a print-maker, Evans' vision tends to be grey and flat, underplayed, definitely formalized. His pictures are not so much like Stieglitz's "well considered" snapshots as they are a curious mixture of grittiness and formality, as though a small camera image were crossed with platinum or gravure printing.

His work lies both in what is called social landscape and the cityscape. Both aspects are well represented in the Museum of Modern Art *Walker Evans, American Photographs*, which has replaced an older monograph with a similar name. The streets and buildings shown in *American Photographs* are poignant and many of the subjects still exist, and are almost unchanged when one gets away from the Eastern urban seaboard. All that is notably changed is the lines of identical cars; they no longer park diagonally. Evans offers a clear view of what the American city looked like in 1935. In Appalachia and the rural south his towns have survived with so little change that it can be a shock to find oneself driving through a photograph by Walker Evans! He offers an accurate taste of a place; and he occasionally displays humour, as in the photograph of two gothic clapboard houses with eye-shaped porches, echoing a large billboard displaying Carol Lombard, replete with a black eye.

His pictures are of exact moments in time, not idealized summations. There is honesty and unpretentiousness in his photographs from the 1930's. This fails to appear in the portfolios of his work published after the War in *Fortune* magazine.

His earlier work was passionate. If the thing was *there* it was important enough to be seen for itself. One problem with this kind of photography as Frederick Evans noted is that a young photographer rarely knows what is important of his time; an older photographer often does not have the physical energy needed. Evans had both the perception and the energy, before the War. His documentary photographs of the moment reveal a special spirit of

perception; the photographer created a sense of inevitability about his choice. Few photographs have this quality.

Pictures made "just before the war" now have ambivalent qualities because they are both nostalgic and are also being sought as prints by collectors. The magic window onto another time is of importance; so is the rising market value of the prints themselves, which increase in value as their age of record draws further away.

Discussion of the photograph as art has blossomed angrily several times—in the first days of photography, in the 1860's, at the turn of the century, and most recently in the last decade. The photograph has been adjudged to be art at least twice: in 1862 there was a trial in Paris and this was the issue. If the photograph was art, it was protected by copyright; if it were not, it had no protection under the law. The French court determined that photography was art. The leader of the opposition witnesses was J.A.D. Ingres, an artist who worked in what we might call a "photographic" style, though his drawings were linear rather than tonal, and photography is essentially more tonal than linear, as his contemporary Ruskin noted.

Another attempt to prove the medium is an art medium was made by Dr. Peter Henry Emerson, who in 1889 published a thesis entitled *Naturalistic Photography*, supporting art photography's claim. He renounced his position three years later. Like Rejlander before him he felt that art was in essence manipulation of the medium. New research in photographic sensitometry by Hurter and Driffeld convinced him that suitable manipulation was not possible in photography. If this were true, then photography was not art, and he must recant.

The banner of art was picked up by members of *The Linked Ring*, a group of London photographers seceding from camera club parochialism. Later, their idea was adapted by the *Photo-Secessionists;* the efforts in turn culminated in the Albright Gallery Exhibition at Buffalo, New York, in 1910. This was an exhibit of photography *as art*. A prophetic article in *Camera Work* described the Albright exhibit, it's success, and then prophesied that the battle was won, the army would leave the field, and the war would be lost. This is what happened. Photography slipped again into formalized rituals, this time of pictorialism, where it remained until rescued by the photographers of the F:64 group in San Francisco.

There was no further public consideration of photography as art until the 1930's, and another hiatus existed until the late 1950's. During this time the faith was kept by a select few, turning toward the new collections of photographic art, first at the Museum of Modern Art in New York City, and then in the 1950's at the George Eastman House Museum in Rochester, New York. But even the Rochester museum was not, in 1948 when it was founded, so much concerned with the present status as art as it was with the technical history of this unique medium of human expression.

As late as the mid-1960's *Time* referred to photography as mere genre art, and implied there was no reason to reconsider its judgement.

It is obvious that two photographers using the same materials, in the same time and place, will achieve different visual statements. The photographs by either could be esthetically important. This conclusion is subjectively clouded by the fact that there are so many photographers. Sheer numbers almost defeat critical judgement, and exhaust the processes of critical evaluation. Stieglitz accurately summarized this in an early issue of *Camera Work* when he wrote that there are many photographers, but few *original* photographers. He wrote in relation to Paul Strand, whom he called the first original photographer he had seen in ten years, the first photographer whose work did not immediately remind him of other work in similar genres.

A contemporary version of this thought is found in the phrase A.D. Coleman used when he wrote in *The Village Voice* that young photographers speak in dialect and the most popular dialect just now is *Robert Frank*. In the 1930's there were many photographers making photographs of the American cityscape, and Walker Evans, for example, was only one of them. But on examination his work appears to be to that time what Frank's is to our time—a touchstone, a reference to which we can relate other workers in the genre.

When anyone can speak the language, to continue this analogy, when everyone can handle the materials with equal facility, the esthetic problem then becomes how is the language spoken, and what is said with it? This is what happens when one attempts to classify or judge the documentary photograph. Immediately one has to face the esthetic limits of art in our time. Before this century, art was only that which was hand-made. Since then a definition has been offered which includes more contemporary work; it suggests that a work of

88

art is either a manipulation of raw materials, an arrangement of objects, or the choice and selection of an object, a placing of it into an art environment. The work of art is the result of any one of these three acts: selection, manipulation, arrangement.

Photography certainly exists within these limits. This definition of contemporary esthetics has been reaffirmed so many times there should no longer be any question about its validity.

The photography of the cityscape by Paul Strand is probably typified by his famous photograph of the *White Fence*. It is one of the more important photographs of the century. From an art-historian's point of view it is important because it shows the combination of straight photography, the unmanipulated image, with a formalistic concern for the print-object that comes from an awareness of the avant-garde of his day, which is to say at the end of the First World War. The tight relationship between the picture plane and the print surface is fundamental to contemporary print-making esthetics. Dating from 1916, the photograph is a calculated and formal structure; the diamond patterns in the door of the barn exactly extend the lines of the picket fence point; the pattern of square blocks along the lower edge of the print are a foundation for the image, yet the slope of the upper line of the fence makes a vigorous diagonal downward from left to right. This image is a self-conscious formalization of the subject; the fence and the barn are used as a means to create the tense organization of the print, and are seen for themselves hardly at all. The subject of this photograph is really Strand's perception; it is no wonder that Stieglitz was excited by his work, for this was also the subject of Stieglitz's own photographs—the organization and perceptions of his own mind, projected outward onto malleable surfaces, drawn by the light itself.

Strand's photographs are only nominally documentary. He imposes structure on all subjects that come before his camera, rarely merely accepting what is found. He never photographs to discover what is there so much as using the camera to assist and reveal what he has perceived is there.

Strand and Walker Evans can be compared. Evans was concerned with making a photograph immediately relevant to its own time. Strand appears to use the subject, to make an image aimed at a classical, detached, aristocratic (in the sense used by Arnold Hauser) audience. Strand's concern for the permanence of his work reflects

this concern. He remarked to Professor Coke once that he wished he had printed everything in either gravure or platinum, those being the only permanent photographic processes.

It is somehow startling to realize that at the same time Strand, Evans, Stieglitz and Steichen were working in this country Lazlo Moholy-Nagy was making images in Germany which offered a radically different esthetic. He intruded printmaking techniques and esthetics quite far into the world of photography. Moholy-Nagy taught design, painting, film and photography at the Bauhaus from 1923-1928. Art in the Bauhaus from 1919-1928 was a means of vision for the craftsman. Art and purpose were not divorced. Contemporary vision expressed by Klee and Albers in painting, by theorists like Doesburg in architecture, by Gropius and Breur in design were used freely in the whole school. The Bauhaus was moved from Weimar to Dessau to Berlin, and ultimately left Germany altogether. After a lapse of nine years, Moholy-Nagy transplanted what was left of the original ideas to Chicago. There were immediate financial problems; the school was moribund for a time, and then found new life as the *Institute of Design*, a part of *Illinois Institute of Technology*.

Work from the Bauhaus is well described in many books. One of the best is *Bauhaus*, a detailed history of the school; another, more concerned with the spirit, is *The Thinking Eye*, notes and work by Paul Klee, who spent many years teaching at the Bauhaus; and there is the book by Moholy-Nagy himself, *The New Vision*. His early book *Painting, Photography, Film* has recently been reprinted and is again available for study.

An exhibit in 1969 at the Museum of Modern Art entitled *New in the Twenties*, demonstrated the flux of ideas still available from the decade. Some of these ideas have not yet been fully developed. For example, the assemblages of Moholy-Nagy combine photographs as anonymous images. Found objects are used to flesh out didactic collages. This idea found renewed life in the 1960's in paintings and prints made by Larry Rivers and Robert Rauschenberg, among others.

Photography by Moholy-Nagy and the pictorialists is similar in that both depended on manipulation; however his work is an esthetically logical extension of ideas about fracturing and reassembling space, made available during the First World War, and of even earlier painterly solutions involving pulling the picture plane up to the

surface of the print. This *flatness* of the image that essentially dates from Cezanne, was extended by Monet and Matisse, fractured and reassembled by Picasso, was now made a photographic picture possibility. Camera optics make it difficult to make a straight photograph in which flatness is essential to the esthetic effect. Circular objects, seen by the camera, produce images which the eye inevitably interprets as circular shapes seen in perspective—not as elliptical, or parabolic curves. When circular elements exist in the photographic subject the image momentarily becomes three-dimensional, even when the lighting of the subject reinforces the two-dimensional image. Moholy-Nagy was concerned with the presentation of a tension between illusion and the fabrication of an organized surface through the direct use of the camera, as well as through manipulation. He was not concerned with representationalism *per se* because that was old: illusion had been brought to a marvelous state in Victorian art, and of course through photography itself. The intellectual recreation of reality, making something that is literally something new, excited Moholy-Nagy and still stirs interest. Photographic tools functioned here at the service of an analytical personality, creating a "new vision".

His cityscapes are new pictures in the genre. His soft-focus photograph of water rushing over curbstones into a gutter can be viewed as simply being out-of-focus, a bad photograph. It can be rejected on technical grounds before it is seen as *a careful structure of light and shape*. The *subject* is trivial, the treatment is all. His photographs of architecture are literal and also transformations of the building into a new, two-dimensional event. A building becomes a pattern of lozenges (see Portfolio); a boatyard seen from above becomes a synthetic-cubist collage, photographed. He transfers the ultimate problem of seeing to the viewer, who must decide if the photograph is a trivial snapshot or an image in a new style. His pictures require visual literacy; he refused to bow to previous definitions of *photograph*. His photographs include all— photograms, straight prints and manipulated prints. He exaggerated scale relationships and alternated flatness with spatial rendering, by discovering textures that are ambiguous when seen in the print. He made images that simultaneously seem to be macroscopic and yet are actually naturalistic cityscapes.

The unthinking grandchild of his photography is the *pattern picture*, in which only the pattern is seen, not the spatial ambiguity modifying meaning of both the original object and one's relationship to it on seeing the print.

Moholy-Nagy's photographs are meant to produce a sense of shock in the viewer, creating new relationships between himself and reality. Why should one see things the way one has always seen them? He neutralizes up and down; his image violates *in* and *out*. Through the use of tone and point-of-view he achieves the sort of effect Coburn sought in his photographs seen from either high or low viewpoints, but had rendered more conventionally. Three-dimensional forms become pattern, yet hover between pattern and illusion. Form becomes object—it is never diluted to simply being pattern. The photographs are document of the industrial cityscape as they are records of his intellectual discoveries of new realities.

Charles Sheeler was both painter and photographer. He is treated ambiguously in some art histories and obituaries failed to mention photography when he died in 1964. But that has happened to Ben Shahn as well—Shahn having been a photographer of the social landscape before he became known as an illustrator, in the 1930's. Sheeler could be described as being a photographer in the way Robert Graves described himself as a novelist. Graves wrote that he made novels to pay for his poetry, as a friend bred dogs to pay for his pet cats! Sheeler made photographs to support his painting; he worked as a commercial photographer for forty years.

At a glance, his photographs and painting are similar. He consistently used the camera to make images like his paintings—documentary, yet poetic, records of the light. He chose a time of light and point of view for a photograph that isolated an essence of the subject, permitting it to be seen. This ability to edit, to isolate his personal vision from the chaotic plasticity of reality produced an image with a surface cohesion typical of his analytical paintings.

The paintings purify and simplify relationships. Van Deren Coke noted that his painting of a steam locomotive's driving wheels is a tidy version of the photograph from which the painting was made. The accidental, photographic elements have been eliminated in the painting. His concern for the pure geometry of the object, delineated by the light, exists from his earliest photographs.

He often found forms that pleased him in architecture— both in early American houses and in contemporary industrial architecture. He often used the staircase as a light modulator. Unlike Frederick Evans, one feels a sense of the shapes being removed from context and being replaced by flatness. This does not change in his work over

Comparing his pure cityscape photographs with those by Steichen reinforces Steichen's theatricality, his illusionistic deep space, with light modeling plane after plane—or Stieglitz's darkening of the city. Sheeler used the same cityscape, in the same years, to make classical, cool, ordered compositions. Sheeler always admired American architecture and translated it into exciting two-dimensional forms. he returned frequently to the same subject, for example the massive monolith of the RCA building. His pictures of mill stacks become decorative rather than being naked transcriptions of power, as they were in Weston's ARMCO plant photographs, made in Ohio contemporaneously with Sheeler's pictures. Weston admired Sheeler's clarity of vision and pristine photography.

The Ford Motor Company *River Rouge* photographs typify his method of work. He stayed at the factory for six weeks, then exposed about two dozen plates. Not all of these were even printed, apparently. Then he made paintings from the photographs. These few plates summarized the complexity and power of the enormous new factory. His superb summation was published as a major portfolio in the new financial magazine, *Fortune.*

His work was a summation of *possibilities*, a method of working once suggested by Frederick Evans, who said a wise photographer would spend four days to a week in a cathedral, studying light and forms before he ever took up a camera. Evans admitted he could not work that way himself, though he espoused the idea. Sheeler had the discipline and the River Rouge photographs are the essence of this experience. There are parallels between his work and contemporary new American painting. See his photograph *Ship's Funnel* and the painting by Demuth entitled *Little Egypt*, of a grain elevator. The works are dated 1925 and 1926 respectively. This is not to suggest a direct influence, but the interactions of a time, a similarity of visual experience that appears often— for example, when one sees Aaron Siskind's photographs of rocks in the Maine landscape and the paintings by his contemporary Abstract Expressionist acquaintances.

Abstraction of formal patterns from the texture of reality is most clearly seen in Sheeler's pictures of Chartres, made in 1929, especially when these pictures are compared with church documentation made in the last century by LeSecq, or even later, by

Evans. Architecture is reseen as *print*. As with Moholy-Nagy, Sheeler's architectural photography relates more to an intellectual experience than to documentation; it imposes a discipline on the viewer, who now has to overlook his normal responses, forswear an illusionistic statement: one has to see the image for what the image itself is rather than impose illustrative concepts onto it.

His photographs from just before the War reveal our national love of the big machine, a transient mood that has dwindled in our time. The photographs of huge dams, generators, lathes and hydraulic presses do not seem to be important now. They are fit material only for annual reports, and advertising. Similar subjects were treated more romantically by Margaret Bourke-White. We now take these machines for granted. They were also ennobled by Lewis Hine, in the same years.

Sheeler, Walker Evans and Moholy-Nagy all worked concurrently, documenting the spirit of life around them during the same years Edward Weston was living in California and in Mexico. On a trip to New York, in 1922, Weston made powerful and direct photographs of the ARMCO plant in Ohio. Charis Weston said they were the turning point for Edward Weston, in his change from pictorialist soft-focus photography to a new image dependent on extreme sharpness and an accuracy of tonal response, a recording of the surface as well as the spirit of his subject.

In the photographs of the city made during the New York visits (sometimes seen as environment for a portrait) he always seems to see the city for what it is, not imposing a special superstructure of meaning onto it. His photographs of Los Angeles seem almost like snapshots. The formal substructure of the images become more recognizable when the picture is inverted, and seen as it appeared on the ground-glass, without the immediacy of identification with the story-elements in it.

But it is another kind of photograph which Weston makes his own, whether the subject be the eroded coastland of the Pacific, vegetables, or the city itself; it is in the *significant detail* that a new imagery appears. It is an image new in the 1930's, characteristic of the 1940's and then a cliche of the past twenty years. It is the discovery of the abandoned cityscape seen as microcosm. The textures and shapes of the fragment of the city are used as a means to a sensual experience. Growing from the traditional documentary image, these prints are needle-sharp, photographic transcriptions of

94

texture, macroscopic, larger than life. The significant detail is a way of seeing characteristic of the time and place. The group that affirmed it has been known as *F:64.* It was never chartered, as were the Photo-Secessionists, and the closest it came to having a public journal was frequent articles in *U.S. Camera*, a magazine published then in Los Angeles. Each issue had an excellent gravure insert, and also offered editorial space to Adams, Weston and others of the group. *Camera Craft*, a west coast magazine, also supported this new esthetic movement in photography, and published a long dialogue of letters between Weston and William Mortensen, the last of the great manipulators of the pictorial tradition. And F:64 differed from the Photo-Secessionists in that Weston, the spiritual leader, never dictated as Stieglitz had with his New York group. Photographers turned to Weston for advice and counsel until his death in January of 1958, but there is little sign of his having encouraged the emasculative and destructive cult that centered about Stieglitz's galleries, as described by Clurman in *America and Alfred Stieglitz*, and definitely echoed in Seligman, *Conversations with Stieglitz.*

F:64 included Imogene Cunningham, Willard Van Dyke, and others, as well as Weston and Adams. The name derives from the smallest aperture available on most large cameras, an opening which tends to make all parts of the picture equally sharp, producing an appearance of overall crispness. This was in contradiction to the moribund pictorialist esthetics which had lost creative power years before but still dominated the backwaters of art that were photography in the 1930's.

Clear, crisp representation of the world was the hallmark of the group. Yet even their photographs of weathered wood are not one-to-one translations; the tools of photography were used to make the tones of the subject fill the scale of the print. A sense of super-realism often resulted.

The images from the group form a community of vision. Adams has described riding in a car with Weston when, at the same time, both saw a weathered barn with rusty nail patterns. Adams said "Edward got there first, because I was driving." Not that they would have made the *same* picture, but they were responsive to the same visual raw material of the photograph; out of the landscape at large they were triggered to action by a significant detail of the cityscape.

This community of vision is now nearly moribund in its own right,

having dominated the vision of the coast photographers for forty years. Margary Mann once wrote that she was sure she had seen at least three hundred white doorknobs on abandoned white churches, an image made famous by Edward Weston, and at least as many shattered windows in abandoned buildings. The inheritors of Weston have embraced the abandoned western cityscape; the treatment is super-real, brilliant, and dependent on the ambiguity of the photographic illusion. This hegemony of west coast photographers was shattered in the 1960's, mostly by the San Francisco State College students; the cracks were perhaps first created by student work from the old California School of Fine Arts, now known as the San Francisco Art Institute.

Weston's photographs have a consistency found in a few photographers; this is not a repetitive gestalt, as with Steichen, but a spiritual clarity, a non-didactic steadiness of attention focused on the spirit of the subject, and a subsequent affirmation of this response by the viewer. Charis Wilson Weston wrote that when Edward photographed the cows always meandered into place in time for the exposure; this sense of *rightness* in his pictures, of an unforced ·relationship between the photographer, the subject, and the composition is experienced with great regularity on viewing his photographs.

At the same time Weston was photographing ruins in California, and Evans was recording the eastern cityscape, Bill Brandt in England photographed manorhouses and estates. Like his portraits, these photographs are not gentle, not unbiased. He was isolated, photographing outside traditional esthetics of photography in England. The pictures in *The English at Home* are scarifying. He develops a visual surgery: harsh and brutal tones reveal what he believes is the structure of the society. It is rarely pretty; he shows us where crocodiles lurk.

The esthetically anonymous document from the early days of photography still exists in our time and is economically important. The picture postcard is an example, showing clearly and without comment a building, a town, or a landscape. The color travel magazine illustration is another example. And there are business firms with just the same intent as Frith, Washington, Muybridge or Jackson who sold photographs and stereograph sets in the 1800's. These pictures accentuate the participatory illusionism of the photograph. The color slide approaches the cinema, and permits the private fantasy in which the person *enters the picture* and through a

slight imaginative effort places himself momentarily in the cityscape of the slide.

A logical but rare extension of this sort of storytelling is found in the work by Wright Morris. His early books from the 1940's, were created through the assistence of two Guggenheim Foundation grants. *The Inhabitants* and *The Homeplace* are long out of print, but *God's Country and My People* has recently been reprinted. The earlier books were collections of pictures, each presented with a facing page of text; each page is a complete little story. Sometimes the word story is explained by the picture, sometimes it is parallel to the photograph and speaks to a similar mood but not about the identical subject.

God's Country and My People offers photographs and a continuous inner voice monologue, in which the photographs become dreamlike illustrations, appropriate but not exact replicas of the text. Morris left photography in the 1950's and turned wholly to writing fiction.

His photographs document the isolated life of the railroad towns but they also evoke other realities; they are very nearly snapshots, but are also definitely planned, organized, and controlled. They are emotional statements, complete in themselves and yet reinforced by the text. The meaning is the picture plus the words, a synergetic relationship in which the result is more than either part. Morris is not the only photographer to document the bleak, desolate, drying life of the plains and mountains—western Nebraska, Colorado, and southern Wyoming. And even he was unable to make the photograph alone evoke the wild loneliness those states engender. There is no other body of photographs of that part of our society. The young creative photographers who lived then in those states were trying to remake Weston's landscapes; the photographers from the east did not know the area existed; there was no way a photographer with any taste could make a living there; that part of the country has never otherwise been interpretively photographed. The days of its growth are recorded by Jackson, and by the postcard makers. Morris succeeded in linking the picture and the word, but his success was critical and not financial; in the late 1950's the photograph was abandoned for the novel—a direct result is *Ceremony at Lone Tree.*

Edward Weston's second son, Brett Weston, is a photographer who has continued working in a mode closely identified with his father. He works carefully, allowing his camera to record without manipulation or apparent distortion. Brett has gone beyond his

father as a printmaker, in the sense that he has worked with an 11 x 14 inch camera, making even larger contact prints than Edward did.

In his photographs, Brett pulls the pictorial subject up to the picture plane, squashing realistic space. This flattening of the picture plane began during the last century, and is most apparent in late Monet and Cezanne paintings. Imagistic space was rendered with more and more shallowness: the horizon crept upward until it disappeared above the edge of the canvas. Visual space and the picture frame coincide; illusionistic depth is weakened even when the original subject is quite deep in actual near and far object relationships.

In Brett Weston's photography the illusionistic recession of objects in space is often negated by choice of angle of view, lens length, placement of tonalities in the negative and the print, and print contrast. What is left is flat pattern, a two-dimensional translation of the cityscape. In his photographs patterns of light and dark moving across the print are the subject of the print—not that he abandons the illusion of the magic window, but that though tension is created between illusion and pattern, pattern dominates.

This concern for surface space over illusion was part of the American scene during the thirties and forties; it found support in the art that developed during the war, a concern for gestalt possibilities of the painting-object, or the print-object in photography. Increasing flattening of visual space became especially important to photographers on the east coast after the war when investigations in painting now called the *New York School* were happening. Photography reflects this esthetic ambiance.

At the end of the Second World War, Aaron Siskind began making new photographs—images without people—that offended critics grown to maturity on a diet of *Photo League* social consciousness. His new pictures were no longer concerned directly with the political human subject or with storytelling. They were dimensionally flat, and almost "subjectless" by current standards. They were fragments of the cityscapes, calligraphic accidents discovered by the photographer and intensified or underlined in the photographing. They were very close to what was happening in painting done by his friends though by no means a copy of those paintings.

He was a good friend of the New York painters. Critics of the 1950's accused him of copying, of finding objects that looked like paintings, especially those by Franz Kline. It is inevitable that new

vision possibilities were exchanged; just as Adams and Weston and the F: 64 group reinforced their own crystalline vision of the world seen by the camera. Siskind found support among the painters for his new vision of the cityscape revealed through provocative fragments. His photographs are documents of gestures, of interactions between unknown people and their enviroment. These gestural remnants are taken out of context, translated into the silver print, and so become *new things*. Rotation of position, change of scale, exaggeration of tonal range, and isolation from the original site all change calligraphic accidents into personal statements by Siskind.

The change of tonality, of geometry, of color to monochrome; the act of abstraction, and the esthetic act of judgement are all part of his photography. Siskind isolated himself from the evocative nature of the illusionistic subject; one cannot become involved in the story told in the picture, but must investigate the shapes, and one's own relationships to these shapes, somewhat as illusion but more as *gestalt*.

The strength of Siskind's creative act is reinforced upon comparing his photographs with the work of contemporary Abstract Expressionists. They are superficially similar. The differences exist in the rhythm, color, scale and tone. He worked in a time of discovery of a new vision and carried the fruits into his tradition-ridden medium.

Art Sinsabaugh produced a number of photographs of the cityscape and of the landscape which utilize, and depend upon, the characteristics of a special camera, invented for making photographs of large banquets. The format of the banquet camera is squat and wide, yielding a print about 8 x 20 inches. Sinsabaugh wittily adapted this format to photographs of the midwest, where the horizontal visual rhythms are langorous and vertical events are well separated. His photographs are difficult to reproduce because of the format, but are well represented in the Jargon Press book *Mid American Landscapes*, with poems by Sherwood Anderson.

Sinsabaugh captures the rhythm and detail of the midwest: tiny articulations of buildings, trees, poles and furrows modulating endless gentle undulations of the Indiana and Illinois horizon. This special large format negative, contact printed and cropped to an even more extreme aspect—the final prints being often three or even two inches high—achieves a delicate balance between magical transcription of detail, photography's mainstay, and an allegretto

delineation of space. Immaculate printmaking is also a part of his offering.

The work of Harry Callahan is important in a search to discover the photography of the cityscape. The published photographs by Callahan mislead; certain images are used repetitiously—photographs of his wife, early pictures from Chicago, anonymous faces against the blackness of the city facades. These pictures are part of the social landscape.

But Callahan has made a number of pictures of the city which penetrate the spirit of Chicago, visual and tactile realities of the Chicago street seen and felt by a pedestrian. The buildings are photographed with a camera tilted upward to include most of the building; the curb and sidewalk become a graphic foundation on which is built a trapezoidal pediment, tilting, unstable, ephemeral, uneasy, and yet obviously accurate and correct. It is a third solution to the problem initiated both by Coburn and Moholy-Nagy. Coburn looked up, or down, to discover graphic or associational equivalents—the image of a tall building is seen as a creature with a thousand eyes; the patterns of a sidewalk become an octopus. Moholy-Nagy looked up or down and transformed solid architectural mass into the flat dominoes characteristic of 1920 graphics. Callahan points his camera up, creates the illusion of place, and lets the buildings fall, suspended, caught in time, in the web of the photographic instant. The viewer participates in three visions at once: the pedestrian street scene seen through the magic window, the mimetic sensation of vertigo created by precise photographic rendering and subtle tonal scale, and in the classical balanced graphic structure of the image. These photographs are as ordered as Cezanne's *Bathers*. Few of these photographs have been reproduced; it is easy to make an erroneous summation of a man's work on the basis of popular restatements of certain photographs, seen over and over.

There are many other photographers who have treated the cityscape. Some of them will be discussed under *social landscape*, the interaction of the individual with the environment.

An attempt to examine the work of any photographer without seeking out the man, and a collection of his work is burdened with difficulties. Photographs change in reproduction. Recently there have been attempts to restore to the photographic image seen in reproduction some more of the rich tonal range which is in the

original. The reproductions found in many books are subtle distortions, to the point of being lies. For example, the photographs of Aaron Siskind. The original prints are not harsh and simple black and whites as revealed in the book *Aaron Siskind: Photographer.* Siskind's original prints are luminous rather gentle prints which work in different ways depending on the light: in a brightly lighted room they are full scale images, with many shadings between black and grey. As the light level falls and twilight comes on, the prints become more simple and graphic, closer to the book.

If the original print has unmodulated black areas and a simple tonal scale then the photograph has only one kind of statement, it becomes a monotonic song. This is unfortunately how major prints often appear *when seen in reproduction;* the reproduction then becomes a standard for many young photographers who have had no experience with the fine original print *per se.* A beginning photographer may attempt to print to the standards found in reproductions and not realize he is looking at an abstraction of the master print. This has come about in part because of the degrading of standards for reproduction concurrent with the second World War; examine the photographic annuals printed before 1940, or the gravure insert in each *U.S. Camera* before the War; the prints are beautiful, and have a sense of light though the pictures themselves may be insipid. Care was lavished on the photoreproduction. Poor silver print materials, economic pressures and wartime shortcuts encouraged harsh and ugly printing during the War; these habits were carried on afterward.

A change for the better began to be seen in the 1960's. But most of the visual resources for young photographers during the 1950's were grey-black, harsh, ugly reproductions found in magazines. Few fine photo books were published during that time, though many thousands of books using photographs as illustrations were made in the same period.

The increasing popularity of photography after the War also encouraged a loosening of standards. Before the War, one learned photography by apprenticeship, and if attracted to fine printing sooner or later approached a master photographer, to discover through participating in his work what were good print standards. After the war photography flourished, yet print traditions faltered.

Photoreproduction is rarely more than an approximation of the photography; it is almost always a translation into a new medium.

Davidson's *East 100th Street* is about as close to the original prints as is now possible. The engravers worked directly from his negatives, not from prints; he supplied finished prints to use as engraving standards. The engravers recapitulated his local printmaking manipulations in making the halftone plates. This is an expensive and rare procedure. *Camera Work* was prepared the same way; Stieglitz's photogravure plates were exposed from original negatives, not from copy prints. In his case the quality of prints used in *Camera Work* apparently often exceeded the originals in tactile beauty and tonal range. His prints were translations from the originals. Today, original prints are almost never used when an anthology is prepared. The etchings are made from copy prints of mediocre quality.

Most reproductions are notable distortions of the original prints; even in the *Aperture Monographs*, see the Weston and the White books, the reproductions are brittle compared to the original prints. Reproduction changes the image. The resultant harshness and simplification of scale is inevitably copied unwittingly by young photographers because there are not enough prints in circulation.

THE NATURAL LANDSCAPE

It is difficult to realize how short a time the landscape has existed as a subject in its own right, and how much this is due to the effect of photography. This does not become clear unless the landscape paintings are catalogued, their dates noted. The landscape comes into its own with the invention of photography. Helen Gardner's early edition of *Art Through the Ages* honors this relationship, and explains that it was due to the new science of photography that landscape painting came into existence. The painter of the early 1800's became concerned less with his idea of what was in the landscape and more with the literal rendering of the surfaces of things. Before that time the landscape was only a vehicle or an armature, a means for supporting political, religious or mythic story.

In English painting Turner and Constable exemplified a new concern for the surface actualities of things. Though they date from the late prehistory of photography, their late work is concurrent with efforts to invent practical photographic systems, efforts that culminated in Talbot's invention.

Their work apparently influenced young French painters who pursued the realistic and impressionistic possibilities of painting, so fresh after the years of fabricated studio landscape! All this culminated in paintings by Monet, of whom legend affirms Cezanne said he was only an *eye* but what an eye! This comment is attributed to other painters at various times during the century, yet is

essentially true and underlines the uneasy and ambiguous relationship painting had with the documentation of surfaces, sought until that pursuit was deflected, in 1907.

Landscape before photography was a framework assembled to fit fancy, politics or religion. It was abstracted in the field, assembled in the studio. Part of the reason landscape painting changed was technical: the collapsible soft metal tube was invented which permitted the painter to carry oils with him into the field and paint in *plein aire*. Part of the reason for the change in meaning of the landscape was cultural, as has been noted by Hauser (see Frontispiece statement).

Daguerre's early landscape paintings reflect the practical needs of the artist-entertainer; and they reveal vividly the reàson he tried to solve the problems of photography—so that he could accomplish a naturalistic image by a less tedious process.

One needs only to compare Turner, or Daguerre with Claude Lorain, or Poussin; the latter painters' finished landscapes bear little resemblance to any special place in the real world. Certainly fragments were used, but they were abstracted from daily reality and reassembled in studios to make the visual structures to support their religious, mythic or coloristic inventions. Rembrandt etchings allow the real world to enter the picture, but he is nearly isolate in art.

By the time photography was invented the French world of painting had split into three camps: *Academics* concerned with political and illustrative problems; *the men of 1830*— the name which preceded the more geographically exact *Barbizon painters*— the group who painted in the forest of Fontainbleu, near the village of Barbizon and who were concerned with illusionistic reality, with things as they seem; and the *independents*, typified by Courbet.

As time passed the Academics took photography's lesson to heart; at the start, the latter groups showed immediate evidence for photographic concerns, either in terms of discovering how best to capture the surfaces of things revealed by the light, or to do this but also enhance them and make them super-real as Courbet desired, producing a sensation of the thing seen larger-than-life.

One of the Barbizon group was Corot, a friend of photographers, and the first to work with the *cliche verre*, or drawing on glass. It is of interest to examine his paintings which predate photography; they

104

exhibit great interest in accurate modeling of architectural mass revealed by light and seen with photographic accuracy. Compare these with later landscapes, whose texture is changed because he observed the characteristic smearing of light into dark boundaries caused by photographic *halation.* The linear nature of his paintings dwindles, and tonal sensitivity increased, becoming steadily more subtle throughout his long working life.

The Victorian painters reacted to the competition by becoming more and more photographic, attempting to equal and surpass photographic accuracy and immediacy. The English invention of water color painting just preceeded photography and was concurrent with this new interest in the evanescent. The immediacy and gestural response to a given moment of light permitted by watercolor flourished in the period of photographic gestation. David Cox published a *Treatise of Landscape Painting and Effect in Water-colours* in 1813; it was in print or reprinted over a hundred years later. And William Dyce, whose paintings are extremely photographic in accuracy of tone and spatial perspective was the man who introduced what came to be known as the Pre-Raphaelite Brotherhood to their ideas of intense surface realism. William Holman·Hunt, for example, produced images in which the massive texture of the surface seems almost impossible to achieve without the camera, yet was wholly painted. There were Victorian painters who narrowly avoided scorn by making large photographic prints and merely painting over them; the whole relationship between the photographed image and the painted image came to be held in such disrepute that painters became discreet about their sources. Van Deren Coke has shown that even Cezanne used the photograph as a handy abstraction of the *motif* from which to work, unimpeded by weather; and William Powell Frith had drawn and painted from photographs in the late 1850's, though he was reluctant to make that admission.

The Victorian attitude toward photography and the landscape was ambivalent and a bit mendacious. Aaron Scharf has documented in *Art and Photography* the tendency of Victorian painters to hide the photographic sources of their paintings. But the entire Pre-Raphaelite Brotherhood, Millais, Brown, Dyce and others did use photographs as sources, either as sketches from which the finished image was fabricated or as a literal transcription from which the image was transferred by grid.

Ruskin, the principal critic of the era, was most ambiguous. He

disliked the mechanicalness of the photograph, and yet attempted to emulate its tonal rendering. Baudelaire inveighed against the mere copying of the surface of things, as photography was used in his time to reinforce the worst inanities of the Salon. At the heart of the problem was the discrepancy between recording surface and the perception of spiritual meaning, a dichotomy which finds statements ranging in time from Michelangelo, who wrote that he wished to show the idea which hides itself behind so-called reality, that he sought the bridge which leads from the visible to the invisible, to Baudelaire, pleading that imagination be the Queen of the Faculties. Gauguin urged that the artist work around the eye, and look to the mysterious center of thought; Paul Klee said he wished to make the invisible visible. All these phrases are anti-photographic, as photography was practised by Victorians.

The landscape was considered a suitable subject by Talbot, but was apparently of secondary importance to him; arrangements of shapes selected from dwellings and architecture predominated in his pictures. He tended to photograph a *thing* rather than an ensemble, aiming his camera as though he were pointing out an object of significance rather than seeing a subject tree as a graceful element of the entire landscape.

Early landscape photographs are mostly from after the invention of the wet plate. Partly this is because of the slow speed of the calotype materials, which rendered shrubbery as a blur unless the air were absolutely still. Also, there is a suspicion that photography waited until the landscape painting genre was established as a respectable subject; photographers have consistently lagged a generation in esthetic groundbreaking. Photography has not often guided esthetics; it has been a leader but had to wait for other artists to affirm its vision and return to its efforts with an imprimature before it was honored.

It is in the American landscape, just after the Civil War, that the first body of new landscape photography exists. Perhaps this is because of the fantastic nature of the American landscape, which allowed a straight image to be made which was not dull, because the subject itself was not dull, almost regardless of how it was treated.

Landscape painters investigated the American landscape in a way different from Europe; the early Hudson River school painters did mythologize the landscape, investing it with a sense of hovering presences and made it spiritually akin to the German romantic

landscapes. But as the same painters moved west and away from the urban centers, their vision changed. Thomas Cole, for instance, whose academic fantasies grew into photographic transcriptions of the spiritual essence of the American west. Frederick Church and Albert Bierstadt both made paintings from the west which are unlike the French landscape painters in that they are not in the *avant-garde* of imagistic techniques, are very nearly photographic in substance and at the same time surpass the mere recording of surfaces so decried by Baudelaire. The need to match the photographic record perhaps prompted them to produce landscape visions which surpassed mere recording and allowed spiritual truths of the new west to appear through their extremely accurate, tonally photographic renderings.

The early photographic landscapes are formally structured; the fact that the emulsions used were themselves colorblind helped this graphic sensibility. The emulsions were sensitive only to blue light. The skies were always over-exposed, and usually printed as a featureless white. Different solutions for this were tried. Photographers would make separate exposures of interesting clouds and print them into pictures as needed. Others trimmed the photograph, rounding off the top of the print to eliminate dull white corners and create an arbitrary zenith. The better photographers planned the composition of the picture and made use of this white sky space; in photographs by Muybridge, Bierstadt, Vroman and O'Sullivan the white sky is often articulated into graphically interesting space by massive rocks and trees of the western landscape.

Gustave LeGray published seascapes in the early 1860's which did have fully textured skies, and Muybridge sometimes achieved cloudscapes in the high mountains, above timberline. However the subject was essentially monochromatic, where an adequate exposure for green trees and yellow earth would automatically overexpose the sky.

The first major photographer of the American west seems to have been Timothy O'Sullivan. He was trained before the Civil War, and photographed during that war; afterwards he traveled with the Powell expeditions throughout the south-west, and then went to Panama. The hardships of those expeditions are well described in a monograph published by the Museum of Modern Art, *Timothy O'Sullivan, Frontier Photographer.* Since this work was done for a government survey, the prints can also be seen or referred to in the

Library of Congress and the National Archive.

One becomes conscious, on examining O'Sullivan's photographs, of physical scale: he found ways to provide a human reference so that the immense formations of the Utah and Arizona deserts are impressive, and of inhuman scale. He is rarely as obvious as Maxime DuCamp, though sometimes he had to be blunt. Sometimes these references are indirect, as when he included the expedition tents at the bottom of a vast canyon view.

The photographs are usually structured about a central vertical line; his compositions tend to be latterally symmetrical. He was not rigid or doctrinaire about this; it simply happened frequently. His pictures are usually handsome shapes on the page while still being extremely faithful to the spirit of the subject. Occasionally the photographic materials themselves distort the subject: moving water is rendered as a smooth plastic surface because the wet-plates were not fast enough to freeze the action.

The response to his and other's pictures where water was recorded as a smooth blur and skies were all white has changed with time. When orthochromatic films became available, and skies could be recorded in grey tones resembling the original, these pictures seemed old-fashioned. When films became faster and it was possible to stop the water motion and present the shape of every drop, the artificial surface of the rivers in O'Sullivan's desert scenes was ridiculous. Now these effects are being viewed for themselves: the strong graphic possibilities of the white sky can produce an optical sensation of detaching itself from the rest of the picture. An intellectualization of time created by a lengthy exposure of the sluggish flow of water over stones is being used by Wynn Bullock and Paul Caponigro as an esthetic or philosophical statement.

Wynn Bullock records time and motion. Caponigro deliberately uses long exposures, destroying the tactile surface of the water, making it a streak of light modulating the surface of his photographic landscape. Such uses are like double exposures, ethically sound manipulations firmly in the tradition of the straight print.

The *near/far* relationships in O'Sullivan's photographs are important. He fixes space for the viewer, juxtaposing near and vertical stone walls against vastly far horizons. The spaces between these buttresses and sands do not recede, but hang suspended. There is no atmospheric distance in the western desert landscape, no

108

Italianate *sfumato*: the air of the southwest was too pure. Absence of atmospheric perspective alone is sufficient to declare these landscapes unique and separate them from the photographs and paintings of Europe. When space cannot be defined by increasing unsharpness and fading tone, then compositional and graphic means have to be found to make clear the traverse, otherwise the image immediately fractures into abstraction.

All the photographers who worked in the desert of the west fell back on this technique. The visual problem was most easily solved by discovering a near, foreground object which could be utilized in the photograph to provide scale for a diminished background vista. The translation from a three-dimensional actuality to a two-dimensional equivalent always involves mechanical manipulations; one of these was to place a scaleable foreground object against the intellectualized immensity of the background.

An effect of photography on contemporary painting was the formal restructuring of the landscape disappeared. The acceptance of the landscape as it exists came into prominence; then the significant detail began to appear—Alexander Wyant's painting of *Winona Falls*, for instance, or Church's painting of a watery fragment of the great *Niagra Falls*, in which a small part stands for the whole event and no real scale references are given, or suggested.

In America, artists attempted to encounter the landscape, not transform it. Yet their work was more than mere documentation of the actuality of it; theirs was an attempt to retain the magic. As artists moved away from the east, dramatization became less and the sense of actuality more important. The sense of the spirit of the place becomes important, exemplified by Church's drawing *The Heart of the Andes*— which shows only a meadow and the foot of a mountain rising beyond the limits of the image, not recorded, but felt. This simultaneous concern for accuracy of spirit and surface was in the taste of the time; it is reflected not only in the work of painters but photographers of the time.

In 1870 Albert Bierstadt painted and photographed in Yosemite. The same valleys and cliffs were also photographed by Edweard Muybridge (Muggeridge), Adam Clark Vroman, Watkins, and then some sixty years later by Ansel Adams. The earlier photographs are similar, in that the photographer stood in awe and delight, and permitted the camera to record the beauty of middle-distance scenes as carefully as he could.

the natural landscape 109

It is interesting to compare Watkins' and Adams' photographs of *Vernal Falls;* Watkins stood further away than Adams; the nature of his materials also changed the image. Watkins' film was colorblind and slow. Adams had panchromatic film, able to record the sky as a dark grey. Watkins solved the white sky problem by rounding off the picture. The falls are a white smear. Adams could have stopped the motion of the water, but chose not to; he chose the psychological effect of a medium-slow exposure, the semi-sharpness being an optical equivalent, creating the sensation of water falling through time and space. Watkins made a middle-distance picture, an *establishing shot* in cinematic terms; Adams closed up the distance, eliminated all boundary areas, and made the picture melodramatic; he imposes his personal vision on the place. Watkins picture is documentary, Adams is personal, and interpretational.

Muybridge's 1870 photographs from Yosemite are some of the most beautiful made in the valley. His life and accomplishments have been maligned in several texts; fortunately there is a corrected biography and bibliography available in *Film Comment*, 1969. Though he is best known for his studies of human and animal motion, the Yosemite photographs show the immense sensitivity and technical accomplishment he attained before he began experimental motion study photography for Leland Stanford.

William Henry Jackson in the 1880's photographed in the same Colorado-Wyoming-Utah wilderness areas that O'Sullivan had photographed. He also made pictures in the Yellowstone area of Wyoming—his pictures were documentation for a plea that Congress establish Yellowstone as the first National Park. The legislation was carried by the photographic documents that convinced the Congress the physical marvels of the place were not Jim Bridger's lies.

Jackson's photographs are rather naive and direct; they are essentially handsome snapshots, or tourist pictures. He tended to point the camera like a gun; because of this one is less aware of the cameraman than of the subject matter. He does not make the landscape more than it is; he understates it; it is all the more significant for the absence of personality in the pictures.

Jackson's images in the Rocky Mountains are not often pictorially exciting, but that is due in part to the natural scene itself: most of the mountain vistas he photographed are not oriented for pictorial or dramatic lighting. However, his pictures, like Adams' photographs of Yosemite, are often the dominant image of the place. They yield a

110

sense of having been there, and are difficult to surpass.

Adam Clark Vroman is adequately illustrated in *Photographer of the Southwest.* He was more sensuous than his contemporaries who photographed the southwest, and he came on the scene about a decade later, with better films and printing materials. Jackson is straightforward; Watkins is pedestrian; Vroman smooth and confident; Adams, coming last onto the same valleys and waterfalls is self-conscious, and an overwhelming performer. Adams is to landscape as Berlioz was to the orchestra—he redefines it and strips bare the the possibilites of the "big performance."

Many other photographers photographed and worked in the landscape genre during the years before the end of the century, and sadly their names are only names. Some of their pictures found in museums or books or private collections are very handsome. Each photograph encountered must be valued for what it offers of itself, though there is always another scale of value, which in gallery and museum terms is dependent on the *oeuvre* of the photographer, his fame, his history.

Just as Claude Lorrain modified possibilities of vision in terms of color, so that English gentlemen purchased yellow tinted monocles called *Claude glasses* so they might see the world through his eyes— every major artist modifies the vision of those that follow him. The world was not seen as Edward Weston saw it until his pictures were published; for years his vision dominated nude and landscape photography in the Bay Area. The technically brilliant visions of photography of Ansel Adams were possible for others after Adams codified them into the *Zone System.* Once codified, his ideas of craftsmanship enter esthetics; they dominate the practice and vision of many photographers.

A private vision, forcefully expressed and well reproduced has the power to transform our experiencing of the world. This was described by Yvor Winters, who wrote about the magical effect of poetry, in both literal and theological terms. In poetry one mind acts directly upon another, without regard for "natural" law, and allows one man literally to take possession of another for a time, perhaps to change him. Poetry and photography are not different in this, that a work of art is a means of possessing another's soul. Once a work of art is known, is experienced, the world of one's vision is no longer the same.

the natural landscape 111

Photography in America grew in importance parallel to the westward expansion; but photography was essentially documentary. O'Sullivan photographed war, then the west; Muybridge photographed the western scene, and then animals and people in motion. In England there was a different path. The documentarian image had early importance. The print factories of Frith and Wilson thrived, though Talbot's photographic factory at Reading did not. Portrait studios multiplied and then grew cheap. Photography fell out of favor; it was merely a cheap way to a likeness. Rejlander attempted to restore art to the medium with his one major assemblage, and with his imitative pictures derived from Italian painting; Robinson followed, and produced many composite prints. Both argued art equaled tedious work, careful assemblage. But because or in spite of their work the annual camera club exhibitions declined in strength and importance. They became mere shows of technical processes, and moralistic or anecdotal pictures. In 1886 a physician named Peter Henry Emerson spoke to The Camera Club in London on *Photography, a Pictorial Art.* He based his lecture on his understanding of scientific principles, the physical optics of human sight. He held the task of the artist was the imitation of the effect of nature in the eye. He argued the photograph surpassed the woodcut or charcoal drawing because it was more accurate; it was second to painting only because it lacked color, and the ability to reproduce exact tonal relationships.

The tonal failures of the photograph were because of the colorblind nature of the films; this was soon to be corrected, in orthochromatic film. He did not know that Ives in Philadelphia had already made color prints, or that Ducos DuHauron and others had essayed them with some success.

Emerson expanded his ideas into a pamphlet, *Naturalistic Photography.* Photography was an art form if the camera was used the way the eye is used. He was interpreted to mean that since the eye sees sharply only in the center of the field of vision and is everywhere else unsharp—becoming unsharp at the periphery—this is the way the photograph must appear. Followers, especially George Davison, did photograph like that, but curiously he did not! Emerson's own photographs are carefully focused straightforward platinum prints.

At the time Emerson published, two young photochemists named Hurter and Driffeld were doing experimental work which was to undermine Emerson's enthusiasm. They standardized exposing and

112

developing photographic emulsions in order to evaluate latent sensitivity and the response to any exposure and development for any given film. Their work was to clarify the photographer's relation to his materials. Before, it was generally assumed the photographer could manipulate tones seen in the print and the negative through changes of development. They revealed that the process is straightforward: once the negative is exposed development will only proportionately increase or decrease overall density, but cannot cause certain other effects, specifically inverting tonal rendering of one area with respect to another.

To Emerson, this was the end. As a Victorian, it was essential that an art be accompanied by manipulation. If manipulation were not possible, the artist could not accept the medium; the medium was not capable of producing art. Emerson recanted and published a black-bordered booklet, *The Death of Naturalistic Photography*. If the medium were mechanical, art was impossible.

Emerson himself photographed mostly in the Norfolk Broads, a softly lighted rural landscape. He printed in platinum; the images are visually crisp and tonally soft. They are definitely reminiscent of French landscape and genre scenes of the preceeding generation. There are echoes of English landscape by Millais, and of the French—Courbet and Millet, specifically the *Angelus*, and the *Reapers*. His landscapes are a framework for working people, carefully posed to reveal the nature of their work; perhaps his photographs ought to be examined under the Social Landscape. However, his concern was more with the landscape than for gestures or styles of the people themselves.

The composition of his images shows an increasingly high horizon; this parallels the late Impressionist and post-Impressionist paintings; the picture plane is tipped up, it approaches the image plane, crushing the visual space. An increasing ambiguity results. Deep perspectival space is suggested by the shapes of foreground objects—boats and fish traps—but effectively denied by the angle of view and by the smooth, even tones. The overall grey crispness of his image also affirms this flatness.

Emerson stands a bit above the sentimentality of Victorian painting, never falling into the excesses typical of Hunt, or John Brett. He also is a reminder that the major esthetic traditions in photography rise from English art and are not overthrown until late in the 1920's. Photography, because of the illusionistic nature of the image, is

always linked to genre art and has never fully succeeded in breaking away. This failure is a burden both the photographers and to their critics.

Clarence White's pictures of the landscape, like Emerson's, are on the border between genres. The landscape is used as a setting for a story. Children wrestling naked in the woods, and elegant ladies seen in mist are technically accurate to southern Ohio landscape, and are also personal tales. White's work is also characteristic of the Photo-Secession photographers in that very few produced pure landscapes; most involved the subject with other meanings. For all the argument about pictorialism, they were concerned with contemplative meaning in the image, with a verbally paraphraseable content separable from the graphics of the picture. The subject in itself, as seen through the camera, was rarely the true purpose of the picture.

Alvin Langdon Coburn, the Boston photographer, George Davison, the Englishman, and Edward Steichen, from Milwaukee, are the principal landscape photographers closely identified with the Photo-Secession and its English predecessor, The Linked Ring. Coburn appeared later than the others, and is totally different than the documentarians; his pictures of the Grand Canyon depart radically from O'Sullivan or Jackson's documents of the west. They documented; he being a pictorialist, interpreted, making his visions graphic and artful. Documentation versus interpretation: the earlier photographers photographed because it was there, because it was itself; the later photographers made pictures of it for pictorial possibilities, for the graphic and illustrative suggestions inherent in the landscape. Examine Coburn's Grand Canyon image in Portfolio.

White's photographs from the Newark, Ohio area and Coburn's pictures from the Colorado river are contemporary, and for esthetic comparison were made within a year of the time Picasso painted the *Demoiselles d'Avignon*.

Steichen's gum prints of the landscape are very much like Impressionist paintings of the preceding generation. They are moods: misty, unsharp, usually concerned with color. In one issue of *Camera Work* the editor remarked on the complexities of printing to Steichen's specifications a two-color, blue-and-yellow, landscape showing trees and sheep. Steichen's vision of the *Garden of the Gods* is a heroic transformation, the stones mutated into Wagnerian props. He abstracted, transformed the rocks into a mythic backdrop,

114

exaggerated and dramatized through special photographic tools—gum and platinum—and produced a photograph like unto late German romantic landscapes. These photographs are a far cry from the dry accuracy of the documentarians. Steichen's constant involvement with rebuilding surfaces into new realities of light is explicit in his landscapes.

Steichen is the epitome of the photographer imposing his personality on the subject; he photographs landscapes, cityscapes and people all in the same way, remaking them with light.

Studying Steichen's landscape work chronologically, there is increasing technical purity—he abjured manipulation after the First World War—but little change in his manipulation of light. He created a superb, controlled dramatization of the subject through the use of light. His first great pictures were pictorial landscapes: the subject became the raw material for a mood; he continued this manipulation for mood until the end of his work.

Steichen made significant details of the landscape during the 1920's. The plant form fragments which he isolated from a larger context take on architectural beauty. *Planzenform* photographs were also beautifully created by Imogene Cunningham and Albert Renger-Patzsch during the same decade. The images in each case are characteristic of the artist; Steichen's are dramatic and theatrical, Cunningham's sensuous, sinuous. and feminine, and Renger-Patzsch, in *Die Welt ist Schoon*, is reminiscent of Weston.

In the *Aperture* monograph *Edward Weston: Photographer*, his photograph of a cloud is presented above a photograph of the female nude, creating an equivalence between the two subjects. The placement of the images implies an equivalence of sensual gestalt which may or may not be true. It is true that the shape of the cloud and of the nude are similar, but the juxtaposition may be an editorial imposition. When an editor puts more than one image on a printed page, or arranges any group of photographs in a sequence, he assigns meanings to those images which may not have been intended.

After Weston gave up soft-focus photography in the early 1920's, he never returned to the diffused image. His life, as revealed in the *Daybooks*, shows clear knowledge of the implications of his pictures. As he photographed significant details, important fragments of nature, the photograph became with time more and

the natural landscape 115

more a record of what the subject was and also an evocative trigger for a healthy imagination.

This ambiguous relationship between Weston, his camera and the image was both affirmed and denied by him. He spoke with hostility about people looking at his photographs and finding sexual subjects, yet was delighted when Diego Riviera found his photograph of cypress roots "like flames." He was aware of this ambiguity but chose to reject this knowledge. Looking through his photographs from 1926 onward, one finds a period of freedom and great strength of vision between 1934 and 1940. The years that followed were constructive, although many of the wartime satirical photographs from that time have not been published (or are too personal to be popular). Van Deren Coke once remarked that Weston's photographs were the only large body of photographic work which "didn't weary one." There is a re-experiencing of the original subject in every print, with a continuing freshness; a spiritual lovingness between Weston and the world leavens the photographs.

Starting about the time of his first Guggenheim fellowship awarded in 1939, ambiguity in Weston's work becomes more marked. The subject is always the thing in front of the camera, but it is also the shapes on the page; the meaning of the print almost always can be ambiguous. As he came close to a limpid record of the thing before the camera he also more and more frequently created evocations of events drawn from his own life, or available from our imaginations. There is sensuality, for example, in the desert photographs: dry deathly hostile, the sand as seen in his prints transforms itself into momentary visions of female contours, supple and loving.

These images are not meant to vibrate from one visual reality to another: they exist simultaneously. The landscape illustration for this text is an example. It is clearly a photograph of eroded rock forms, from the Pacific coastline. Yet when it was seen by an uneducated, middleaged garage mechanic in New Mexico it was described as "being a strange picture...a picture of a full womb." The photographer Nile Root once described the quality that identified Weston's pictures as "there's always a wave." Not that there was literally a wave seen in the photograph, but the sense of unfolding, something coming into life. With Adams, Weston's contemporary, by way of contrast, there is a contrary sense of the moment being frozen, stilled, not quickened. Even when Adams' photographs show bursting surf there is a sense of the moment being heartlessly seized: in Weston's pictures the subjective sensation is of *opening*. These

116

terms pass beyond the intellectual: they are subjective and emotional responses.

The middle 1930's produced many pictures in which the viewer never loses sight of what the subject is; the shapes of the object are seen clearly. Weston was a superb technician, but the technique was always subservient to the purpose; one never feels a picture was made as a virtuoso exercise. The print always seems appropriate to the psychological statement, rather than being an end in itself. Technique is handmaiden to the statement, rather than an armature to be clothed in a pictorial cover.

After the War the significant detail from nature became more important in his work. The heart of this is documented by Minor White; he described Weston saying you "have to find the moment in which Nature reveals herself." This revelation was often expressed during the 1944-1948 period as an almost macroscopic picture; the detail was isolated from the larger landscape.

In response to this new genre, the abstracted detail—for example ice patterns seen in macrocosmic, scale-destroying perspective—all similar later work will be judged against these first standards in the medium. There will also arise a natural query, a question of "how does this photograph effect me?" Do the shapes have a sense of life, or are they shapes seen *in the manner of* the founder of the genre? This kind of judgment may seem severe, but is inevitable.

A comparative examination of Weston's and Adams' photographs made on the Monterey coast, south of San Francisco reveals an iciness in Adams' photographs, compared with Weston. It is impossible to say whether this is because of the technical brilliance, or because of Adams' innate vision. To relate him to painting, David comes to mind.

Most photographers are trained from youth as photographers, or as painters who turn to photography, like Steichen, Robinson, and Rejlander, or they are trained in distant disciplines and bring with them new ways of thinking. The last group have produced many advances in photographic esthetics and techniques, perhaps because they are not burdened with automatic responses to old problems.

A contemporary who makes use of some intellectualized implications of the photograph is Wynn Bullock. He came to photography late in life, in his forties. He brought a mature way of

viewing the world to a camera, and found it a tool adapted to externalizing his vision.

He was trained as a musician. His landscapes have a featheriness and lightness which is difficult to achieve with the silver process and does not exist in other west coast photographer's prints. Adams and Weston both have a weightiness in their transcriptions of forests and rocks. Bullock sees these as ephemeral; he somehow manages to make them appear in a state of transformation, moving through time. He controls the print so there is a sensation of weightlessness, penetrating light, and windblown surface even when photographing water that Weston saw as a surging amniotic fluid, and Adams as a steely, impenetrable mass. Bullock is technically innovative; he patented the line effect in pseudo-solarization. He perfected it for commercial use in making direct line drawings from small parts through photographic and non-manual methods. He is a masterful printer.

Another inheritor of Weston and White is Paul Caponigro. An important comparison can be made between his photograph of a rock wall from the 1960's and Paul Strand's photograph of a rock wall from the 1920's. His rock is prismatic, light plays over the entire surface. Strand's wall is a spare, heavy vision, the camera focused selectively until only this image remains. In Strand's picture there is the feeling that nothing could be removed without violating the entire image; Caponigro is more relaxed, gentle and inclusive. His later photographs, done in Ireland and Brittany during a Guggenheim Fellowship year in which he photographed the eoliths and dolmens are substantially unchanged from his work of the 1950's.

There is a logical growth from the pictorial movement through Weston and Adams to Caponigro. Caponigro is selected for this text as typifying many young photographers dealing with the landscape. Another is George Tice, from New Jersey; he makes handsome pictures not unlike Weston's pre-war photographs.

Going back to the end of the First World War, other possibilities become apparent. Paul Strand, for example; one has a feeling of him wrestling with the landscape until nothing was left except what is essential. One cannot remove anything from Strand's pictures without weakening them, breaking the tension between the graphic and the illusionistic. This is also true with Weston, but Weston has a relaxed and effortless air of elegant irreducible minimum, while

118

Strand has hewn away the fat from his pictures, and his hard work is part of the resulting picture.

There are surface similarities between Strand's photographs of rocks and photographs by later artists, for example Minor White. The differences in meaning between these photographs are profound. Strand has torn his graphics from the rock; Minor White works responsively, using the rocks as participants in dialogues between himself and his soul; the rock becomes the chorus, speaking things no one else will say.

Once the idea of the significant detail in landscape photography was discovered, and the abstracted shape selected from the whole landscape elevated to importance, the spirit of landscape photography was forever changed. Once photographers realized they did not need to record the entire shape, to see the object as part of the environment, but could find a new intimate visual universe, the idea has been investigated again and again.

When looking at any photograph one is always aware of the illusion, of the thing in front of the camera being presented with deceptive correctness. One accepts that he sees the thing in itself for a moment. But one is also seeing a print, its surface and colors. One also sees the shapes that exist in the print more or less as independent gestalts, that is as other visual possibilities. These alternative shapes became more and more important to photographers after 1920. An accidental event in all photographs, the evocative gestalt becomes a controlled expressive tool for some photographers.

Beginning in the early 1920's a new area of the landscape was defined by the vision of Alfred Stieglitz; one cannot now make a photograph of clouds without being compared to Stieglitz. His reasons for photographing clouds were partly intellectual and partly egotistical. He had been accused of "hypnotizing" his models to make them reveal themselves for the camera. He chose to photograph clouds, a subject incapable of being controlled by the photographer, available to anyone. He wrote that he hoped to make pictures which when shown to a composer would seem like music. He desired to make pictures that would both be a record of the event and also be evocative of other clear and distinct feelings, though perhaps feelings difficult to paraphrase. He used simple camera techniques, in reaction to the manipulatory methods of the majority of the Photo-Secessionists; he was hostile to the continuing and

the natural landscape 119

undiscriminating manipulation they practised automatically.He called his photographs of clouds *equivalents*. He felt these images evoked equivalent experiences, not created by the object and its obvious image, but dependent on the translation of the image rhythms of the print. Most of these photographs are not dramatic, as prints. The originals are 4 x 5 inch contact prints made on silver-chloride paper. They were usually placed in the center of the mount so that they could be experienced from any direction. They were really meant to be viewed as *chamber* photographs, not gallery prints.

These photographs are of great importance in the history of photography. Each is an act of faith, of trust between the photographer and the viewer. They are nearly subjectless photographs; the clouds themselves are light modulators, but the print requires the viewer to invest it with meaning (or to refuse to make that investment). In effect these images become a kind of *needle's eye gate* through which only the faithful may pass. If one demands the photograph be documentary and record a public event which has a definite consensual meaning, these photographs are empty. If one admits the photograph can reveal a state of inner being, that the photographer can find a physical analogue to his thought at which he may point the camera and produce a matrix that will trigger contemplation, then these photographs are the source of a new esthetic in photography. Most photographs are documentary in the way most sentences are declarative; some declarative sentences become poetry, and evoke more than they describe, as these photographs evoke more than they describe.

They came into being near the end of a long life in photography, and are the fruit of all his seeing and teaching, and of his critical work expressed through *Camera Work*, and his sequence of galleries. In the early 1930's he added many other objects to the *equivalent* genre: poplar trees, grasses and outbuildings, and finally the *White Porch with Grape Vine*, at Lake George, New York.

In his later pictures the naturalistic subject is almost bypassed; it is the sweep, rhythm, texture and above all spirit which is the subject of these pictures, rather than the documentation of the object. It is the burden of the viewer to determine meaning.

This work was seminal, and is now influencing many young photographers. Immediately after his death in 1946, Stieglitz was

apparently forgotten. The new important influences in American photography seemed to come from Chicago, where the *New Bauhaus* had been founded, had foundered, and was again reborn in the *Institute of Design*, in the Illinois Institute of Technology. One of the teachers there was Harry Callahan. His landscapes are witty, and graphic. Callahan was one of the first post-war photographers to reuse multiple exposure, disregarded since the pictorialist days. His work is always *unmanipulated*, in the sense that the image is not changed after the film has been developed. But, the effects of chance operations and multiple exposures in camera were accepted as being legitimate modes in straight photography.

This attitude of uneasiness about manipulating during printing, and yet accepting the optical manipulations possible in the camera was restated by Ralph Eugene Meatyard, commenting on recent work by Jerry N. Uelsman, when he said "it ought to be done in the camera!" Many photographers have defined the purity of the medium in terms of the latent image. This has been central to photographic esthetics; it is the boundary between two conceptions of photographic art since the invention of the medium. One school argues that whatever can be done before the latent image is developed is acceptable; the other that the latent image is only a starting place for the print, that whatever is needful to make the print effective is acceptable.

Manipulators have either been honored for their freedom, or derided for their permissivity. Within these terms, Callahan is classical, using multiple and chance exposures as well as straight photography. He is a masterful printer, able to control large black areas in the silver prints without allowing the prints to become leaden or dull.

The man who took up the principal ideas of Stieglitz, and made them his own, is Minor White. Born in 1908, he came to maturity before the Second World War, worked for a short time for the W.P.A. before the War, and turned to teaching photography afterward. He instructed with Ansel Adams for a time; they developed a new and experimental program of teaching photography at the *California School of Fine Arts.* In 1951, he accepted a suggestion made at the first Conference on Photography sponsored by the Aspen Institute; from this conference came a mandate for the journal of creative photography called *Aperture;* White became editor and publisher.

His own work to some degree recapitulated the ideas of Adams, in terms of responsible control of the medium, and of Weston, in terms of encouraging and allowing a rapport to exist with the photographic

subject, so that "nature can reveal herself." But his thinking enlarged upon the ideas gained from Stieglitz, and centered on the terms *equivalency*, and *responsibility*. He felt the photographer was responsible to his audience, not only to titillate with new images, but to treat the audience tutorially. This didactic inheritance was reinforced by his early associations with Zen, developed when he lived in San Francisco, and with the severe disciplines directed toward self-learning and social responsibility, learned from the followers of G.I. Gurdjieff. He encountered these ideas in Rochester, having been introduced to them by Walter Chappell, and later investigated them more thoroughly when he moved his work to Boston. He now teaches photography at Massachusetts Institute of Technology, and continues to supervise the editing of Aperture.

Several relationships are possible between the photographer, the photograph and an audience. How much is the photographer's function to allow the subject to reveal itself? How much of photographing is imposing personal esthetic standards onto the subject? What is the relationship between the photographer and his potential audience? Is the photographer a tutor, or is he merely offering his vision publicly as a work of art, a sensual entertainment? Adams, for example, has always imposed his personal esthetic on the subject, which is a dramatic heightening of reality. On the other hand, he has consistently refused to encourage any psychological investigations. White has delved into the psychological, and also the religious aspects of the image, and assumed a critical stance akin to Tolstoy's in that he feels his art should create a certain kind of response in the mind of the observer. The recent large monograph, *Mirrors, Messages, Manifestations*, summarizes his work from the 1930's through the late 1960's. The print in the Portfolio is more recent than the monograph. The monograph begins with the documentary photographs made before the War; it effectively ends with the complex and sensuous sequences which have occupied his non-teaching time for the past twenty years.

He uses the landscape as a means to an image. His image is expected to evoke in the viewer's mind an experience, or experiences, which can relate to White's initial experience in the face of the subject, and to the conscious statements he wishes to make. Certain gestalts appear frequently. The photographs are often almost subjectless, in the same sense the Stieglitz' cloud photographs are subjectless: the surface textures and tonalities of rocks and water are isolated, tonally manipulated and presented so that one has an ambivalent response. One sees rock, water, bark, and one also sees abstract

122

shapes. Through the evocations of shape, and through the associations carried by the illusionistic objects seen in the photograph, one is encouraged to sense meanings other than the original subject itself revealed.

The pictures were created to be seen contemplatively; great attention and concentration is expected. This is not unlike what Stieglitz expected to be brought to the cloud photographs. The photographs seen in galleries are different experiences than those same silver prints seen in the home, or images seen in books. This is to a degree true of all pictures, but the meanings of these are perhaps more sharply modified by changes of environment.

The photographic image in his sequences usually suggests the original subject, and simultaneously offers other gestalts. The landscape subjects are vehicles for his vision. He is as far from O'Sullivan when he photographs the arid Utah sandrock cliffs as Cezanne's landscapes are from Muybridge's views of Yosemite. Partly because of a need to use the raw materials of the world, to refer to them as a composer refers to a tonal mode, he never abandons the accurate record of surface, though he abstracts so thoroughly that occasionally the eye of the viewer becomes lost, and cannot identify the original substance. He frequently makes what appear to be macroscopic photographs of large pieces of the world. A man-sized slab of rock may not seem to be a macroscopic object, yet in the scale of its original environment, photographic isolation and tonal abstraction produce an effect like a macroscopic photograph, distorting the scale and creating new meaning. The rock photographs by Caponigro (see Portfolio) and by Strand can be compared to White's. All three men produce very different images from similar raw materials: the prints reflect the men behind the camera; the images become art because of this, that is they become a publication of private vision that enables us to re-experience another's inner state.

White has worked in areas other than the landscape, and those pictures are discussed in appropriate chapters. His influences on contemporary photography through *Aperture* will also be outlined later in the text.

Frederick Sommer is a photographer who is unfortunately little known in this country until quite late in his life, partly because of the unease his pictures created in the past when the limits of what was thought to be tasteful were more narrow. He is of the same

generation as White and Adams. He is a superb printmaker. Since the 1930's he has lived and worked in Arizona. For a time he was a companion of Max Ernst; they shared a concern for an image which hovers on the boundary of what can be seen and what can only be imagined. Sommer himself described this as "photography is not the moment of truth but truth before the fact." His photographs bring the dark edge of imagination into the light without making one aware of the machinery of his doing this magic. Unlike his contemporary, the photographer Clarence John Laughlin, who lives and works in New Orleans and also photographs ruins and rotted things, Sommer observes without becoming sentimental.

Sommer has said of his own work that he "walks about the world searching for something we carry within ourselves. Art is not about nature. Art is about art. You cannot carry nature with you, you carry nature as image, which is art." His photographs of the Arizona landscape are accurate documents, and yet are also fantastic. In an *Aperture* monograph Sommer was called a *phantast*, one who creates a new world out of the commonplace through the selective camera eye coupled with the inner eye of the subconscious. Working with the camera rather than using manipulation of the image surface, Sommer changes reality and invests it with something demonic. There is in his pictures a sensation of the subject revealed, yet still concealed—in all transformed, in the process of becoming something else. This is of course the esthetic of the *surreal*, the art that blossomed in the decades before the Second World War, and that has never since been absent from American art.

THE SOCIAL LANDSCAPE

The social landscape is amorphous and difficult to limit. It laps over into all other genres, yet defines photographs which cannot really be accounted for otherwise. It describes the interaction of the person with others and with the environment. It includes a kind of portraiture: the social class record photographs made by Hill and Adamson in the 1840's, the street photographs made by Thompson in the 1880's, the village peasants photographed by Strand in the 1930's, the class records made by Sander in the first half of this century, and the slum children seen by Danny Lyons in the 1950's—or his prison portraits made in the late 1960's. These are all seen both as portraits and also as archetypes, exemplars of their class.

The social landscape has changed as new materials and cameras became available. Charles Nègre, for example, made photographs that look like gestural snapshots—but he made them early in the 1850's (see Portfolio photograph of Arles), at a time when film required lengthy exposures. To a critic, the image then becomes a *tour-de-force*, achieving the sense of a casual record only through a careful working out between the photographer and his subjects of the technical problems. In *Image*, Beaumont Newhall presented a list of approximate exposures for photographic emulsions, from 1839 through 1880. He corrected all the exposures to a common aperture of f/16, so that they can easily be compared:

```
1839  . . exposures were 2400 seconds.
1854  . . . . . . . . . . 120 seconds.
1856  . . . . . . . . . . . 30 seconds.
1880  . . . . . . . . . . . 5 seconds.
```

Continuing with information from other sources, the exposures for later dates were:
```
1910  . . . . . . . 1/10th of a second.
1930  . . . . . . . 1/25th of a second.
1960  . . . . . . 1/250th of a second.
```

The problems faced by early photographers who attempted to photograph actual daily life were severe. Some of the best examples we have from early photograph were not made by known professionals, but were made by anonymous photographers whose prints have survived and are valued simply because they delight us.

War is a major part of the social landscape genre. There is some dispute as to the first war photographer; in terms of an esthetic history, what is important is the images we have. Photographs by Roger Fenton, made during the Crimean War, in 1855, and those by James Robertson, from the same war and the Sepoy Rebellion, taken a few months later, are the earliest photographs easily available (see Portfolio). Fenton was requested by the Crown to photograph the war in such a way as to support Her Majesty's government. The actualities of death and destruction are carefully avoided.

Only in the *Valley of the 600*, where the ground itself is seemingly paved with quieted canon balls is the nature of that dreadful and foolish battle evident. Robertson, after photographing in the Crimea as well, went on to India, where he photographed the Sepoy Rebellion, and the aftermath, producing documents of the ruins that are eloquent in their record of the fury of bombardment. Even photographs from later wars rarely produce such a sense of the energies that tear bodies and rend buildings.

Fenton worked and traveled through the Crimea in a large van that had been first used by a winemaker, in London. He replaced the glass sides with wood, and fitted the body with sinks and storage for wet-plate processing. In the Crimea, he complained, pictures should only be made in the spring and the fall of the year; in the summer the solutions in the van were so hot they burned his hands. Most of his photographs were merely portraits of the officers and men; since the

military had to supply horses to transport his heavy wagon he found these sentimental pictures paved his way. None of Fenton's pictures show actual death; Gernsheim hypothesizes that such images would have been unacceptable to the English mind. Evidence indicates Fenton specifically avoided such scenes as being potentially embarrassing to the government. His portraits are straightforward and academic, copying official military portraits of the generations preceeding.

Trained as a painter, Fenton was in his mid-thirties when be began photographing. The images show compositional habits resulting from this training.

A general response to such photographs is often that one is unclear about the subject: is it the person before the camera, or the meaning and import of that person in the society of the time, or the relationship between the person, environment in which he is discovered, and the times—or all these? Rarely is an image separable from illustration, from political or social commentary. These reactions change for each generation examining a print.

Because of the nature of the genre, social landscape photographs rarely have special pictorial or graphic beauty. In fact, those that do seem suspect; the suggestion is that self-conscious framing of the picture must have made the photographer editorially selective. Thus pictures which are notable lie on a tenuous boundary between dry document and pictorial elegance. This mode is marked by centrally placed figures: the camera is pointed like a gun and the shutter pulled. The implication is that nothing matters but the action; the picture is apparently the result of a kind of pictorial thoughtlessness.

The *carte-de-visite* became an important record of the social landscape. In its anonymity it recorded the times, which is another way of defining the social landscape as a genre. The dress, stance, and attitude of men and women shown in those limpid multiple prints tell one much about the society.

In America, the Civil War became the first major historical subject for photographs of the genre; in the ten years between Balaklava and Bull Run war changed and photography grew more facile. There was no fundamental change in the chemistry of the wet-plate, but there were dozens of tiny modifications of the technology that cumulatively speeded up the process of making a photograph. Yet when the Civil War started a newspaper writer noted that though we could now undoubtedly see photographs of war dead it was doubtful

that actual battle scenes would be recorded, because the gunsmoke would ruin the plates. This was not strictly true, and Civil War photographers took risks and hoisted cameras under fire, moving their traveling darkroom vans and tents well within range of rifle and shell.

Mathew Brady has a great reputation in the photographic literature. Born in 1823, he was a successful photographer in Washington, and organized a corps of photographers to record the war and to provide illustrations for the press, when the War began. The magazines and newspapers of the day could not use the photographs directly; they made engravings from prints, exposing the negatives directly onto photo-sensitized wood, then cutting around the image. These photographic engravings provided facsimiles of the photograph, more faithful to the reality of the event than anything previously available. *Harper's Weekly* used photographic wood engraving as well as drawings made in the field by their staff artist, Winslow Homer, to illustrate the progress of the war.

Brady made pictures at the Battle of Bull Run. His equipment was damaged, and he was lost for a time on the field of battle. He struggled into Washington three days later. His eyesight was already failing him at the time, and it is doubtful whether he himself did in fact make any battlefield photographs after that engagement. His hired corps of photographs was large, and even the mid-war loss of Gardner and others who left to form their own photographic company did not seem to slow his production. After the war, Brady lost everything. He had depended on continued public interest in the conflict, and published an expensive photograph history illustrated with original silver prints. It went unsold. He did finally manage to convince Congress to buy prints; the plate from which they were made went into storage and were recovered more or less by chance a few years ago. It is impossible to say anything about the photographs ascribed to Brady, except that they were made by one of his staff. To attempt a textual analysis is useless in these circumstances. In the 1950's, Ansel Adams made prints from a number of plates formerly ascribed to Brady in the literature, and noted that each one of them had the initials of the photographer scratched in the corner. Hardly any were marked MB, and most of the plates offered in reproduction over Brady's name actually bore the initials *TOs, or AG* for Timothy O'Sullivan and Alexander Gardner.

As a businessman, Brady insisted on publishing and copyrighting all the photographs made by his photographers under his own name. In

1863, Alexander Gardner rebelled, having requested public credit and also more money, and having been denied both. He left Brady's business and began his own. Later, he published a *Photographic Sketchbook of the Civil War*, illustrated with 100 original prints.

Most of the photographs of the Civil War resemble the photographs made earlier in the Crimea: vistas, portraits, groups of men and officers at rest. Most of the photographs made were duplicated: the photographer would often carry three cameras, a half-plate, a whole-plate, and a stereographic camera. This duplication was necessary as a precaution against technical failures and plate breakage, and also to supply different markets. Many of the prints reproduced from that time are actually halves of stereo pairs; sometimes the composition of these pictures is nearly meaningless unless that is understood. The photographer would place his camera in such a way as to record deep spatial relationships, not necessarily to create handsome graphics in a two-dimensional flat print.

In much social landscape photography it is not the quality of the print, or the graphics of the photograph that is important, but the actions before the lens give the picture value. These photographs often are dull, pedestrian or ugly, and it is only through emotive projection that value is given to them. One has to become mimetically involved in the event, snatched from time and preserved by the lens, to find value. It is only through intellectual association that we invest these pictures with interest and value.

Often value is given to photographs because they are part of an *oeuvre* of a particular photographer, and not because they are especially good. Because they were made by a certain man they become a collectible item. Anonymous photographs often have more actual interest or excitement, especially in the area of social history. And often photographs are not valued because the nature of the scene recorded transcends what the public will accept. The Civil War is the first war in which the actuality of death, and decay, appears. Gardner and O'Sullivan both made masterful photographs of dead snipers, discovered in their rocky fortresses, both weapon and life stilled. These were acceptable. *Where General Reynolds Fell, The Field at Gettysburg*, shown in the Portfolio, was marginal. What was not acceptable at the time and still have not been much shown in spite of our cultural education in the macabre following the Second World War, are the photographs of crews clearing battlegrounds after the War. The Library of Congress has hundreds of photographs of

crews clearing remnants and bones; these have an intensity unmatched by other photographs. They remain unused. This is not surprising, considering Alain Resnais' *Night and Fog*, utilizing German and Allied documentary footage of Dachau, Auschwitz and Belsen still cause illness when shown in American theatres.

Timothy O'Sullivan was trained in photography by Mathew Brady, and worked for him during the war, and made some of the best pictures of the day. He survived the war and went in to the desert country with Powell, in his expedition down the Grand Canyon.

After the Civil War, the American west caught up everyone. The great expansion rapidly filled out the undefined boundaries of the states; it was only fifteen years after the Civil War until the Battle of Wounded Knee, in which the American Indian lost his last freedoms. The principal weapon used against him was probably the railroad; it cut the ecological cord that had nourished him and it transported both white men and their hard goods through the plains and the mountains. Alexander Gardner documented the growth of the rails. A photographer named Hart worked for the Central Pacific, photographing the progress of the trains through the western deserts, making what we might call public-relation photographs of new tracks being established in the desert. Photographs appear that document ways of life, as well as ways of death. Later, William Henry Jackson was hired to photograph on the right-of-way of the Union Pacific, documenting it in its environment, as Hart and Gardner had done with other railroads.

In the exploration of the west J.K. Hiller learned photography in the field. He was not a photographer when Powell's group started west, but was taught by doing. He produced some portraits with a directness and gestural immediacy, rare in his day. There are many photographs of the Indians to be found, not in histories of photography but in U.S. Government ethnographic bulletins.

The best known photographer who succeeded O'Sullivan in photographing the west was William Henry Jackson. Born in 1843, by the time the Civil War was over he was already working as a photographer near Omaha, Nebraska. He began making portraits, and used a small horse-drawn van as a portable darkroom. He became interested in the west; an unfortunate love affair seems to have propelled him into travel. He was a competent sketch artist as well as a photographer. He traveled and sketched along the emigration trails in 1868. Then he was hired to photograph for Hayden, who was

leading a government expedition to map the wilderness areas, and to validate stories about the Wyoming wilderness—unbelievably described by Jim Bridger and John Colter, men who tended to exaggerate. These early mountain men had described the area we call Yellowstone, but which had already taken on the name *Colter's Hell*, accurate by Colter's descriptions, but simply unbelievable in light of the rest of the known countryside.

The landscape photographs made by Jackson have a vigorous, somewhat slapdash quality, and they often reveal the daredevil youth who made them. His portraits of the Indians are lively, and more revealing that the dry ethnographic documentary photographs which are contemporary. Jackson's accomplishment can be discovered best by looking at his photographs of Indians, and then examining ethnological photographs, and discovering the liveliness he revealed with his camera.

He photographed throughout the west from 1868 until after the turn of the century. Contemporary with his first, most fruitful period of work, before he settled into commercial photography in Denver, was the photography of the English photographer John Thompson, working in and around London (see Portfolio). Thompson's photographs can be seen either as portraits or as part of the social landscape. They are much more pictorial than Jackson's, and he made quite handsome prints, something Jackson did not do until he finished his early period of work. But then Thompson was working in civilized surroundings, and Jackson almost always was struggling with portable darkrooms, dirty water, dust, high altitude, and truculent pack animals that carried his plates and cameras. Thompson's pictures record people in a seemingly spontaneous way; the pictures breathe. He also draws upon the English academic painting of his time, and echoes of Millais often appear in his photographs of people at work.

The same subjects seen by O'Sullivan, and then Jackson, were re-photographed by Adam Clark Vroman at the turn of the century, a generation later. Vroman had dry plates, and was able to achieve images whose technical quality was equivalent to or surpassed Thompson's London pictures. His landscape from Yosemite stand beside those made by Muybridge or Adams; they are not as elegant, because of the tonal abstraction the materials imposed on the earlier photographer as were Muybridge's pictures, nor are they as severely disciplined as the prints created later by Adams. Vroman's photographs are stylistically a return to the Daguerreotype; they have a

crispness, a vigorous frontality, and a clarity and directness (see the Hopi Snake Priest in th Portfolio). His pictures are pictorially handsome, and in fact are competitive with the work associated with west-coast photographers a generation later.

Newspapers began to make use of photographs. At first the negatives were merely used to make images on wood blocks, which were then engraved. In the 1880's, halftone reproduction of photographs began. Other kinds of photographic reproduction had been available before; the *Woodburytype* dates from before the Civil War, but it was unsuitable for high-speed reproduction, or for printing type and image together. The hand engraved copy of the photograph survived for years after the halftone was invented. Examples of etchings made from photographs can be found in Mayhew's *London Labour and the London Poor*, which is illustrated from Daguerreotypes made by Beard.

It was in 1886 that the first example of an important new use of photography came into existence. Nadar, in Paris, used dry plates to photograph the 100th birthday of the French scientist Marie Eugene Chevruel. The aged man was interviewed by the photographer's son, Paul, and the father photographed as the interview proceeded. *Le Journal* reproduced 21 photographs, each with the words the scientist had spoken at the instant the photograph was being made. Paul Nadar had written that he wished to add "to the camera a phonograph." The elder Nadar had been innovative all his life, had first photographed in the catacombs of Paris, using electric light; had first photographed from a balloon; had established aerial communications, using balloons and photographic reproductions of images, during the siege of Paris; and now he initiated a new use for the photograph, one which is not yet exhausted. In our time the photo-interview has been taken over by film and by television, but the gestural record coupled to the word has been a unique photographic possibility since its invention.

It is with the invention of the Kodak system of photography that the anonymous photograph became dominant in the social landscape. The anonymous snapshot, an autonomic record of events made by whoever happens to be on hand became a phenomenon which changed photography. No longer could one apply esthetic judgements carried over from painting or printmaking; the photograph truly became a genre art in the most narrow sense, and was at the same time ubiquituous and irreplaceable in a general social context. The event itself controlled the photograph; the photographer be-

132

came secondary; the print that resulted must stand or fall on its associative values, and the illusion offered by the little white-edged photographic print commands the public imagination. This dominance remained unchange until 1948, when Dr. E. Land produced the Polaroid system. The social landscape becomes identified with the snapshot. It is a term which Herschel borrowed from hunting: one fires without consciously aiming, without conscious thought. The term has taken on other meanings, even being redefined by Stieglitz, who called many a calculated photograph a "snapshot, made with consideration," which implied pictorial forethought that in the purest sense is alien to the snapshot.

The social landscape reflects our continuing interest in the real everyday items of life, an interest which is apparently far more intense and in general more constant that interest in formal or theoretical problems of art. Books which tell us clearly and believably what happened seem always to have a large market, these may be personal reminiscenses, as in *Papillon,* or carefully wrought histories, as Barbara Tuchman has done in writing *The Guns of August,* and *The Proud Tower*—books that outline in evocative detail the events of traumatic times. In photography, this kind of formal investigation rarely involves formal esthetic investigation; in fact, the genre is notable for repetitive compositions dependent on a simple central placement of the subject, and a frontal pose. The earliest photographs by Jacob Riis and the most recent photographs by Danny Lyons, *Conversations With the Dead* are in this way similar. There is little formal imagination apparent in the social landscape; indeed such imagination seems inimical. Our involvement is intellectual and emotional. Through association, extrapolating out of personal knowledge of the human condition, we give the image power over our hearts. If there is insufficient experience, the viewer cannot properly understand the photograph; since social landscape photographs are often pictorially weak, they may be dull taken on any level. There are other problems in evaluating these images: for one who has not witnessed the drug scene Larry Clark's *Tulsa,* delineating amphetamine worship, is shocking but not subject to accurate judgement. An alternative possibility may be found in Edmund Carpenter and Ken Heyman's book *They Became What They Beheld,* which is an attempt to transmit photographically some involvement in social scenes that depends not on our knowledge of them, but our awareness of our own inner responses. The possibility of such gestalt interactions—with visual records as well as with physical realities, is an area in which practical research has been done in photography by Professor Minor White. He worked for several

years with classes at Rochester Institute of Technology, and then through private workshops as well as graduate workshops at Massachusetts Institute of Technology, seeking to define the associational possibilities of the photograph.

Early work was reported in *Aperture*, in 1957. Since then he has been working on attempts to transcribe his ideas into written form, so they might be used by any student of photography, without a dependence on him. A special language has grown up around these experiments, and like all technically precise jargons, is easily abused by being used with partial understanding. Other sources than the writings in *Aperture*, for leads in investigating these ideas are to be found to Perls, Hefferline and Goodman's *Gestalt Therapy*, which is written in terms of verbal problems, but which can be rephrased in terms of photographic possibilities, merely by substituting *photoograph* for *sentence*, in the problems given in the text.

Such studies and exercises relate to understanding the social landscape photograph in that they help clarify what it is we are examining, responding to and perhaps evaluating: the photograph as print; the photograph as technical solution; the photographer's understanding of an instant; a record of the photographer's spiritual perception (or callowness); or, our own personal identification with the actions captured in the moment of photographic exposure, unwittingly involving our inner, secret life. The social landscape picture can easily be considered to be romantic in the sense of Hauser's comment on art of the last century (see p. vii), or it can be a call to action, a didactic entreaty. However, the social landscape is almost always illustration, in the sense that it requires a verbal/social interpretation of meaning be imposed on the image.

The social landscape may become a lecture on the society's ills. Its values are not formal, pictorial and esthetic, but are social and polemic. If the picture is also handsome, that is a dividend (or a distraction). One must examine social landscape pictures while understanding the mechanical limits of the medium as of the time the photograph was made, the social and economic nature of life at the time of the picture, and the risks taken as well as the accomplishment achieved by the photographer who made the picture.

The best social landscape pictures often have a rough and unfinished quality which equates with the event itself: a sense of flux, of life passing by, as compared to the pictorial polish put on the image when the photographer has time to arrange or control the subject.

134

Consequently, the amateur or anonymous photographer in this genre often gives us exciting, unique images, differing from those made by professionals, who have a habit of structuring things in a "pleasing" way.

This is true even when the social landscape statement is edited by a professional: the *Family of Man* exhibit, so important to the public's new acceptance of photography in the mid-1950's, is primarily a pictorial restructuring of social landscape images—selected by Steichen, assisted by Wayne Miller—with an eye to their architectural and illustrative interaction. In fact, many of the pictures were violated in the exhibit by being treated as design elements, and were enlarged and hung to control traffic in an overall statement that was fundamentally verbal, and Victorian in tone.

The social landscape as a call-to-action begins with the work of Jacob Riis, who in 1890 published *How the Other Half Lives,* a book of photographs and stenographic details of life in immigrant poor families in New York. His work has been reprinted, edited by Francesco Cordasco, in a book entitled *Jacob Riis Revisited.* Riis's work was continued by Lewis Hine, a sociologist who came to New York from Milwaukee to do advanced study and found himself photographing the plight of child laborers and garmet and cottage-industry employees (see Portfolio), first in the New York area, and then in mills and fields through all the United States. The work of Lewis Hine changed in the middle of his career. He began as a critic, crying out the sorrows of the helpless worker. His photographs of children are careful, correct records of the child and the machine to which he is locked, or the child and the field in which he labors. Once he had done all he could to change the unhealthy relationships common when he began, he turned to an affirmation of work as a creative social experience. In the late 1920's and early 1930's he photographed the building of the new skyscrapers in central Manhattan, and in the assembly of the great industrial machines of the 1930's, the foundations of our technological society. His later pictures are often pictorial, but the focus is always on the man in concert with his work—not man being destroyed or marred by work.

His early pictures often were made by deception; he was not permitted to photograph openly in the mills and he concealed his camera in a box he carried under his arm. The photographs assisted Roosevelt's legislation aimed at curbing child labor. After these photographs were published he became a professional, working in

New York, making stock photographs.

In spite of the fact that his photographs are not especially pretty as prints there has been a renewed interest in his work in the galleries. Part of this is due to current interest in social landscape photography and part is due to nostalgia, and an increasing market for photographic prints from collections that have definite limits. The same conditions apply to photographs as to any other collectible item: rarity increases its value.

In any mode, photographers occasionally surface, like rare fish. We have no idea they exist until they are found and published. Such a man is E.J. Bellocq, who photographed in New Orleans at the same time Hine was making sentimental portraits of immigrant mothers at Ellis Island. Bellocq was a commercial photographer; he also photographed prostitutes at Storyville—the red-light district across the Mississippi from New Orleans. His plates were discovered and printed by Lee Friedlander, in himself one of the more important contemporary photographers working at documenting the nature of American life in his own time, seeing it in a personal, expressive way. *Storyville Portraits*, published by the Museum of Modern Art, shows women who lived as prostitutes; some were candid and others concealed as much as they could. The range of possible disclosure is great, from a lady who wears a complete body stocking and smiles gaily into the camera to another who permits the photographer to make a cold anthropological photograph—then scrapes away the emulsion of the face, leaving a desolate blackness in the print. The book is unexcelled as a social document; perhaps there are more revealing social/sexual documents in private collections, but none have been published. It is only in the last ten years the social climate has eased so that these physically explicit pictures could be published. There seems to be internal evidence there was a mutual decision as to how each girl would be photographed. One plays with a cat, another is prim, a third reclines gleefully on a *chaise*, clad only in black knee socks, smile and carnival mask. The accidents of time have marred the plates, fragmenting the emulsion until some images resemble Pompeiian mosaics, sentimentally isolating us from the original subject, investing the pictures with rare charm. The girls were selling their services but chose to retain themselves, to be discreet or anonymous before the camera. This unwillingness to be fully naked before the camera is renewed evidence of the emotional power of the photograph.

At the same time Bellocq was photographing in New Orleans, a more

public record was being made in San Francisco by Arnold Genthe. His *Chinatown* is our first major example of photography of the mysterious, the *outre* within our own culture. He also made excellent documentary photographs during the great 1906 earthquake in San Francisco (see Portfolio).

Also contemporary with these was a very young man named Jacques Henri Lartigue, who was photographing in France. His work began when he was about ten years old and was interrupted by the First World War. It is the time described with loving attention in *The Banquet Years*. The *Photographs of Jacque Henri Lartigue* is designed to look like an antique family album. His pictures *are* snapshots, private family records, but the individual pictures are transported beyond the trivial by the delightful personal vision the young boy had, and by the often incredible graphic, and social, relationships he captured. He had assistance from an emotionally and financially wealthy and supportive family, and used this help wisely and wittily. Some of the pictures he made were possible only because it would have been difficult to take such a small boy with the big camera seriously. Many of his pictures are subtly different because of his angle of vision—the large reflex camera he used was never more than thirty inches from the ground. His psychological point of view was startling; not until the photographs of Gary Winogrand appear do the complex visual interactions and emotional implications of the instant achieve such brilliant rendering. Lartigue was a joyful participant, not a selfconscious professional observer of the society, who judged it as well as recorded it in action. As a contrast, Paul Strand is one of the most deliberate and selfconscious photographers in the history of the medium. In the *Mexico* portfolio the subject is always seen as shapes on the page; everything unessential is hewn away; all that remains is the evidence of the artist's thought and his studied observations. A comparison between Strand's portfolio, from the 1930's, and the documentation by August Sander (from the late 1890's through the 1930's) strikingly reveals how the same photographic tools reveal the human, yet produce different esthetic effects. Sander is elegant and eloquent, using a repetitive frontal and deliberately selfconscious method of posing the subject to reveal the effect of class or profession on the individual. He combined anthropological record with a discrete tastefulness which has not yet been surpassed. In the 1930's, as a byproduct of the Depression, the social landscape came into its own in America. A number of major photographers appeared. Dorothea Lange came from portraiture; initially, she assisted her sociologist husband with her photographic skills. Once having left the con-

ventions of studio photography, she never returned. Until her death in 1965 she lovingly photographed people at work, or suffering physically, emotionally and spiritually from lack of work. At the time of her death she had a dream: to create an American documentary record, to record our daily life, as a means of teaching ourselves about ourselves. This was to be done each few years, so that changes would be clear and the implications of our own life be understood. It is an idea similar to the FSA project of the 1930's, to the Standard Oil photographic record, and perhaps to the *Documerica* project just now beginning; yet her passionate love of people would have made it something other than any of these, had she been able to begin making her dream a reality. As noted earlier, this idea is not unlike a similar dream expressed by Frederick Evans. Hers was based on a more compassionate nature, and was concerned (as evidenced in her own work) with the intimate, telling detail from life, more than with a record of principal buildings, and archetypal personalities.

In Lange's photographs there is evidence of a duality of purpose; she both looks directly at the action and yet she always tries to give it a pictorial structure. Sometimes this is effective and sometimes the resultant prettiness obtrudes on the emotion she is attempting to transmit. One is almost always aware of the handsome picture, of a vantage point having been sought from which the exposure was made.

Certain images repeatedly appear in this kind of photography: in the 1930's Lange photographed an empty asphalt road in the southwest, which was reseen in the 1950's by Robert Frank, and is echoed in the 1960's in the paintings by Alan D'Archangelo. In all cases there is only the road, going straight away so that the picture becomes a simple form, a child's perspective brought to live by the texture and tonality of illusion in the photographic process. Loneliness within the society is a part of the meaning of the photographs. Henri Cartier-Bresson was trained as a painter, and turned to photography in his early twenties. Born in 1908, he came to maturity just as the camera he has used all his life became generally available. He has always photographed with the Leica, has never been involved with a stand camera. He came to popular notice when his first large book, *The Decisive Moment,* presented his esthetic theory of photography. The photographer observes the actions of the world; the camera is permitted to be at the right place in space at a critical instant in time through the discipline and training of the photo-

138

grapher. The moment of the photograph is then the decisive moment; it is not unlike the moment of *elevation* in ballet, when the dancer seems to float, be suspended, promises never to fall to earth again. The difference is that the shutter is opened at this decisive instant, and the latent image made; the action in the world will continue, but the moment of levitation will always exist on the film, and in the print. What is important is the time relationship, the time from the moment the photographer becomes aware of the possibility of a photograph to the instant the photograph is achieve. Since the photograph is in fact the latent image (invisible but real, available to be developed at leisure), the time relationship is a function of the photographer's nervous system. This was new in the esthetics of photography, and as Venturi said of Matisse's vision, it is something that cannot be taught. Time had never been so important; the small camera with fast lenses permitted this responsiveness to time to control the meaning of the picture. It was apparent a generation earlier, with Stieglitz, and before that with G.W. Wilson and with Anthony, but Cartier-Bresson made it the core of all his work. It is the moment in the dance of life when both meaning and pictorial elements are in harmony.

In his photographs, the viewer is never uneasy; all parts of the picture seem controlled. This tradition is being flouted by many younger photographers. Much contemporary work is predicated on uncontrolled events, chance operations, accidental phenomenon. The irrational has become important; logic is violated to create situations hostile to interpretation. Some of this has arisen from a renewal of surrealism, and some from an acceptance of the irrational in the world; some from knowledge of the inner visual experiences available through the drug culture and some from a passivity new to our art and our culture.

Cartier-Bresson's photographs are not, however, a discovery of an event so much as a planned encounter—a lying- in-wait for a visual event to occur. This is not all that far removed from the view-camera image, but the difference is in time, the interval between the moment of intention and of accomplishment, being so much less in Cartier-Bresson's photography. He also presented photography with another esthetic problem: he ceased printing his own negatives before the Second World War. Being a prolific photographer, he felt routine darkroom processing and printing a waste of his time. All his negatives are developed by custom laboratories. This isolation of the photographer from the photographic printmaking process raised questions about the function of the photographer as artist. If the

latent image is the photographer's vision, and the rest be mechanical, then his position is valid. If the silver print, with all the manipulatory possibilities controlled by the photographer is the work of art, then his position is not correct. A similar problem was raised by Dorothea Lange late in life, when her terminal retrospective was prepared by a commercial laboratory, though the work was supervised by Pirkle Jones. In traditional printmaking, in lithography and in etching, this problem has traditionally been solved by both the printer and the artist signing the edition; and in fact Edward Weston's negatives are printed, under the terms of his will, by a son and marked "negative by *Edward Weston*, print by *Cole Weston.*"

The question raised here is *what is the photograph:* the vision, the action before the camera, or the print? This question is at the heart of the fantastically successful exhibit prepared by Steichen for the Museum of Modern Art, *The Family of Man.* Designed around a verbal/philosophical concept, photographs by many photographers were chosen to illustrate topic sentences; these were then printed and arranged to produce an architectural effect, designed by Paul Rudolph. The real work of art can be seen as the editorial selection and the architectural manipulation of space and of human responses. The pictures were manipulated to fit illustrative/spatial conditions. The size of the prints and their tonal scale were changed to be effective in this new matrix, regardless of the photographer's intentions. This has other ramifications—the changes of meaning created by editorial layout, size realtionships, the interactions of adjacent text and prints, and these problems appear again in the work of W. Eugene Smith.

Returning to the 1930's, the work of Walker Evans stands out. Gene Thornton, writing in *The New York Times*, remarks on the debt Evans owes to Stieglitz, in discovering the meaning of the pattern of things, as well as their obvious meaning as objects. His pictures of the city are bleak; his photographs of people tender and direct. And he was able to photograph rooms without people, yet evoke the warmth of the person just left. His visual register of intimate detail parallels the verbal catalogue found in Agee's portion of *Let Us Now Praise Famous Men*, in which Agee describes the persons of a share-cropper's house through a catalogue of their sparse belongings, spied out during the day while the owners are at work. The photographs by Evans in the book are a record of his participation. With Evans, judgement is affirmation. He commented in a talk made at Harvard that he had to photograph the families of *Let Us Now Praise Famous Men* twice—once in their Sunday best and again in the costume

140

which he felt was native to them, the way they are seen in the book. It was substantive trickery used to reveal his idea of their real strengths. Brassai photographed street people in Europe during the 1930's, and his pictures can be examined for the differences between them and the pictures by Lange and Evans. He is closer to Henry Miller than to Steinbeck, to make a literary comparison; his images are consistently witty, often mordant, and frequently painfully accurate and unflinching. The American photographers all display more sentimentality.

Margaret Bourke-White began photographing in the 1920's. Her early photographs are pictorialist, and romanticize the subjects, smoothing them over with a soft-focus elegance. In the 1930's her photographs of men and women at work are sometimes painfully similar to art produced under the doctrines of Soviet Realism. On examining her work at Eastman House, it is evident that she was a skilled technician whose vision was largely controlled by the pictorialist training of her youth. Delight in formal composition is always evident. She became famous for her work with *Life*, beginning with the first issue, in which she prepared a trend-setting picture story about the effect of building a dam in Montana on the life and economy of the small town near the site. This kind of picture story was not an American invention: it had been used for years in Berlin, and was produced there with greater freedom. But within the boundaries of the popular culture of America, her work is powerful. During the years before the War she photographed men at work in a newly hopeful society, accentuating the creative and seminal aspects of American culture. Her photograph *Daughters of Pocahantas*, made in 1937 in Muncie, Indiana, is both a delicate comment and precise documentation. The scene is patently ridiculous, yet tenderly seen and gently recorded. Bourke-White photographed as long as she could, until finally disable by Parkinson's disease. She opened the way for serious photojournalistic photography for women in this country, proving to editors and clients a woman was physically and technically capable of such work.

Manuel Alvarez Bravo is almost unknown in this country, has had almost no exposure here, outside of one or two frequently anthologized photographs and a recent small exhibition at the International Museum of Photography at Eastman House. But this is true of almost all photographers outside our borders: the American audience knows next to nothing about young Canadian photographers, though fortunately they are now being publicized through the efforts of *Image* a government-supported publication that has no

relationship to the magazine of the same name, published by Eastman House. Bravo typifies the photographer who manages to photograph his people and by doing so remains outside the mainstream of photographic esthetics.

Bravo photographs his people with a directness that reminds one of Bill Brandt. Where Brandt created harshness through development and printing controls, Bravo records harshness—in the light and the life of his people. His pictures, like their environment, are fragmented, become sharp-edged notations of light and dark, without the smooth, continuous tone, plasticity of the print found in more northern countries. In his images he is aloof, not involved, and unflinching in his recording of nakedness, death and unsentimental in his records of life in Mexico.Bravo began working in the 1930's, and was a friend of Weston's, in Mexico. Another photographer who made excellent photographs during the Depression, and then left photography, was Ben Shahn. He came to fame with the Sacco and Vanzetti trial, in the 1920's. He photographed the principals, and then drew them from his own photographs, drawing upon a use of the photograph dating to the pre-Raphaelite Brotherhood, and past them to Delacroix.

Many of the anonymous photographs made before the war are delightful. The Second World War was to this country in some ways similar to the First in Europe—a strip of fire across our history, changing the pattern of life in this culture. What happened before the war is somehow less difficult, more simple than life since 1945. Looking at photographs made "just before the war," it is difficult to decide what should be valued; each has a sentimental value given it by the viewer; each picture also has more or less documentary or graphic beauty, which is its own.

With the Second World War a new kind of photograph appears: the actual traumatic moment of war reproduced for the public at home as quickly as possible. Many of the First World War photographs match those of the Second for honesty and directness, but were not published until the war was safely over. During the Second World War there were many hundreds of photographers working for the military and the civilian press. Film documents of the moment came into their own. They had of themselves become important in the decade before the war. They had produced a curious quasi-documentary blossom, the *March of Time* series of films, a dramatized cinema- propaganda produced for the public education. But simple documentation was not possible until the time lapse between

142

the event and the presentation prohibited complex manipulatory editing.

A major photographer who appeared during the war was Walter Eugene Smith. He had worked for *Newsweek* for a short time, had been fired, and then worked for *Life.*Late in the war he was wounded by shell fragments, and recovered with terrible slowness. Part of the fascination Smith has for photographers is that he did recover, and then produced photographs that surpassed his war pictures, though they were much different.

Smith participated in the War; most photographers chose rather to observe. His war pictures now seem almost to have been staged, in part because he was a superb technician and because he used large format cameras; to our eyes the prints are too clear, the tonal scale too elegant. Our judgement is conditioned by twenty intervening years of gritty photographs, slightly blurred by slow shutter speeds and high-speed films of dubious tonal quality.

The Korean War brought to fame a young photographer named David Douglas Duncan; the Viet Nam war has produced other new photographers. Most of them have made excellent documents of moments which have emotive power—are calls to arms, to humanity, to participation, to...action. Few pictures of this sort survive the time of their taking, no matter how intense they may be: Robert Capa's significant photograph of a dying soldier of the Spanish Civil War is somehow still alive as an image: it is impossible to say whether the documents of dead children at My Lai, or the many photographs of Biafran, Nigerian, or other starving children will survive except as examples of the genre. Goya's *Disasters of War* survives because the passion, documentation, and formal brilliance are in balance; let any one of these draw slightly ahead and a work of art falls by the wayside, becoming propaganda, formalism, or merely sentiment.

Most photographs of the social landscape require the viewer to invest them with meaning; in the 1940's this became easy with the rise of the *picture story*. Editorial choice openly affected the meaning of the individual photograph: the synergetic interaction of a group of pictures became important, especially as they were linked (and changed) by text. Editorial authority at *Life*, and *Look* was great. It aroused hostility in photographers who felt their pictures were changed in intention and implication by the editors.

In the 1950's W. Eugene Smith became a photographers' Luther: his

thesis was that the photographer be the editor, control the fate of the picture, or at least have rights to co-editing responsibility. His employer, *Life*, refused to accede. In the middle of a lengthy assignment, photographing the rebuilding of the city of Pittsburgh, Smith left the magazine, breaking his contract. He was given a Guggenheim Fellowship to complete the work he had begun. But it was three years before he could find a publisher, the *Popular Photography Annual*, who could offer him space to present the pictures his way. He was aware, as were many other photographers, that placing two photographs side by side changed the meanings of both, and created new meanings by the relationship between them. Size, placement of the prints on the page, association with text, and sequencing from one page to the next all affect meaning. This montage effect had been outlined long before in cinema, in discussions by Eisenstein, Pudovkin and others about the effects of images appearing serially. It had been touched upon lightly in art criticism for many years: in the 1800's a comment often appears that a work was 'poorly hung' which meant sometimes that it was placed too low or too high, but more often that it was associated with unsuitable images, ones that modified meaning in an awkward way.

Smith felt editors often violated the meaning and intention of his photographs through acts of selection, arrangement and placement on the page, and by captions which controlled reader's interpretation. Often formal symmetry controlled the arrangement, rather than the rhythmic relationships between individual photographs.

After he left *Life*, his photographs steadily became darker, and the prints more contrasty. He utilized more dramatic lighting. His image structure changed, consisting of key highlight areas arranged against dark voids. This patterning of light and dark areas, with complex linear contours, replaced the traditional continuous-tone image characteristic of his early work, and of many others who worked for *Life* during the same years. It is possible that the smooth image had been imposed by the editors of the magazine, rather than having been native to his way of work, or it may be that the long-scale image was one photographers of the 1930's grew into quite naturally, and accepted until they found their own private visual syntax.

It is true that about the time Smith left the staff of *Life* there was a general restatement of photographic tonal standards. High contrast, simple tonal images, gritty, granular pictures became popular. As with most changes in photographic esthetics, these reflected changes

144

in the materials available. It was in the early 1950's that the Ilford Company, in England, succeeded in producing the first double--coated film emulsion, one that permitted an exposure index above 200.

The Ilford film placed a very high speed emulsion over a moderately fast emulsion, on the same film base; the silver in the upper emulsion acts as a trigger to photosensitive silver in the lower, creating an effect of latent image amplification. The American equivalents to the Ilford film were produced first by GAF Corporation, and called *Super Hypan;* then by Kodak, and called *Tri-X.*

All these films were more grainy than the earlier films. Before, the faster films had exposure indexes about 64, a speed that is now considered to be a slow film. Yet it was with these 'slow' films that Smith and many others produced astonishingly smooth, delicately rendered records of events occuring under difficult lighting.

After the Korean War, the image of war changes. As techniques available change, the image will change. The change which caused the most effect was the invention of the lightweight, self- blimping movie camera with electrically synchronized tape recording. Starting in the late 1950's, in Viet Nam, photographic documentation became principally cinematic—film processed, exposed and edited to reappear almost instantly in the home, through the new medium of color television. Only rarely do particular still pictures hold one's memory, and in most of these the event, rather than the photographer is of importance: the first Buddhist monk burning in self-immolation is an example.

The social landscape does have a lighter side! The photographs by Robert Doisneau, for example, of French daily life; or Andre Kertez' little book of photographs of people reading. But images of monsters predominate.

In the early 1950's photography of the social landscape was transformed overnight by the work of the Swiss photographer, Robert Frank, photographing during a Guggenheim Fellowship year. In 1956 he published in France a book of photographs, with no text excepting a line identifying the place each photograph was made, entitled *Les Americains.* Several months later the book found an American publisher. The initial critical reaction was hostile. The uniform response was that Frank was unfair, venting his prejudice. America simply was not that cold, lonely, cynical, harried, bored,

dirty, dying. The book was either deliberately selective, and biased, or truly what Frank felt was the America of the 1950's.

His images are relentless; no one can be cheered by them. He does not deny that they are personal, that they are his response to the events around him. But that is the point of the pictures; unlike the inherently polemic photographs of the Depression, supporting a hopeful stance about America (as seen in FSA images), or justified the leftist stance of the *Photo League* (as seen in the early work by Aaron Siskind), his are personal intensive responses to the moment. They were subjective photographs; it can be argued that they are a record of the moment just as are the coins tossed in a consultation of the *I Ching*. The popular, affirmative and cheerful view of America was certainly well enough represented. At the same time that Frank's book appeared Emil Schultheis, editor of *DU*, published a large, elegant, pictorial record, *America*, which offered everything Frank failed to show: the vast fields, New York sunsets and Bay area bridges.

The perfect and pretty pictorial record failed perhaps because it was out of time; Frank's images succeeded perhaps because their grittiness was opportune. *The Americans* was also a new kind of picture book, intense, personal and independent of titles or supplemental text (though the American edition had an essay by Jack Kerouac, a leader of the *Beat* poets, probably inserted to please the publisher, but if so certainly with the cooperation of the photographer.). Frank turned to film after *The Americans*, and Kerouac and Frank worked together on Frank's first film, *Pull My Daisy*, in which Frank attempted to parody some scenes from *The Americans*, and also saw America as a curious mixture of Chaplinesque parody and stoned humour. The film has a scene with a 'bishop' and his mother evoking the prison chaplain in *Modern Times*, laced with irrational pseudo--religious speeches from Ginsberg's early poetry.

The picture book without words had been tried before, but only as a series of art images, each of which were independent, collated for convenience and portability. Frank's book is a complete visual essay, demolishing all arguments against the thesis it presents, which is that the human and esthetic qualities of America are unrelievedly perverse, ugly, dull, hopeless: the white child held by a black nurse is prim, all the women are self-indulgent, pouty or numbed into ugliness. The central icon is the juke box; the principal cosmetic is urban dirt.

146

Frank did not publish his book here first; there was no market for it until it was published in Europe. It became an underground success. Much earlier, a similar underground success had been the fate of Walker Evans and James Agee's *Let Us Now Praise Famous Men*, written and photographed in 1936, published in 1939, and almost immediately remaindered. Only a few hundred copies were sold. These were so influential that in 1960 the book was reprinted. Since then it has been printed in paperback and remains in print. The book opens with a portfolio of photographs without words—each a bell stroke to count hours in the lives Walker Evans shows, and Agee verbally evokes. It is actually two books: one pictures, one poetry, harnessed to a common revelation, linked by mutual trust in each other's vision.

In the 1950's it was commonly held that picture books were bad publishing investments, expensive to print and hard to sell; there was no way for a young photographer to question the editorial choice—to show that a pictorial, pretty interpretation of the world no longer had the market- place it knew before the Second World War.

Frank left still photography for years, and made movies; he said that he wanted to make as many pictures as possible and the cinema camera did this best. After *Pull My Daisy* he made *Sins of Jesus*, and *Me and My Brother*. Distribution difficulties prevented these films from being seen, except by students attending film conferences where Frank has shown his personal prints.

The films continued the personal investigation begun in *The Americans*. He turned first toward a society seen *in camera*; Frank worked his way by trial and error through an investigation of his own intimate life and through the mechanics of making a film. He combined his personal esthetic and the methods of *cinema-verite*, utilizing technology new in the late 1950's to establish a film image as seemingly casual and gritty as the 35mm prints he made before discovering the movie camera.

He verbally deplores self-conscious composition and the posturing with the camera characteristic of most pictorial work, and argues that the event itself should direct one's attention. However his cinema technique draws one sharply to the event of the picture itself, and becomes embarassingly romantic and frequently vulgar in the assumption that the particiaption of the movie camera will make a private event into a universal statement.

Many young photographers have been attracted to the stylistic manner of Frank's work. The social landscape is now a mixture, of Frank and the political consciousness of the 1930's, restated in the permissive language of the 1960's. A successor to the political pictures from the left made by Aaron Siskind before the Second World War and published as *Most Crowded Block*, in 1937, *Portrait of a Tenement*, and *Dead End: The Bowery*, is the work of Benedict Fernandez. His pictures were presented in a complicated audio-visual exhibit of slides and tape recordings at Eastman House, entitled *Conscience: The Ultimate Weapon*. After this, Fernandez attempted to establish training centers for young photographers in New York, to encourage radical political action by image makers—an extension of ideas common in the *Photo League* during the 1930's.

But Frank's pictures are not political; they do not argue against an establishment or propose an alternative structure. They shear away veneers; they expose that which is hidden only because it is ignored. Frank is like a small boy watching the Emperor pass by in his new clothes. The difference is that Frank is a grown man with an awareness of what he says, and with a strong sense of taste. His followers in the genre are successful in they have a rich understanding of their world, but merely dull and imitative if they do not.

Two young photographers who have produced books which emulate, or stand on the shoulders of, Robert Frank are Daniel Seymour and Larry Clark. Daniel Seymour's book, *A Loud Song* is a painful and occasionally embarrassing accumulation of photographs made by himself, his father, and friends. The different strengths and weaknesses of the images are played against meaning and their associations. Amateur, anonymous snapshots of his sister acquire interest in the context of the life he describes. He describes the book as a storyboard for a film; in fact he shows himself in one scene helping his mentor, Robert Frank, make a film. *Tulsa*, by Larry Clark, is closer to Frank's picture book. His image always relates to the needle, the paranoia and frenzy of amphetamine shooting. Words are used only to direct attention to sequential relationships that somehow could not be photographed: a man is shown, and *dead* is appended. These two books stand on the shoulders of Frank's accomplishment.

He first viewed a society through his inner eye, and made the possibility of a private vision and interpretation of society important; then Frank turned to his private world and made public a vision of that, intimate and unhampered by traditional standards of taste or

discretion; trivia assumes importance as daily actions become arche-typal, through the transforming power of the camera and print. Once this was accomplished, it was relatively easy for those who follow, peering into their own private lives, making them public. Ten years earlier Seymour's and Clark's books would have been socio-logical essays; now they become poetic documentary investigations of private landscapes. The social landscape has been moved, through time, from the vast world of war through the narrowing vista of economic and political problems to private relationships a man has with his sex, his drugs and his dreams.

There are many others at work in the genre. Each is defined by his political/social/esthetic relationship with the daily world: Fernan-dez, for example, commented that he moved (through the act of making the photographs used in *Conscience: The Ultimate Weapon)* from being an observer to becoming a passionate participator. Danny Lyons, on the other hand, began as a participant, a member of the motorcycle subculture which he so happily documented in the *Bike Riders.* Afterward he became a professional, documenting downtown New York lofts being destroyed, and the lives of convicts in Alabama prison farms being destroyed, in *Conversations With The Dead.*

Bruce Davidson has always worked as a professional. He has let his subjects be fully aware of what he is doing with the camera, and in fact has encouraged a dialogue around the camera. While making *East 100th Street,* he commented that "you can't hide behind the 4x5 camera on a tripod; you have to come out from behind and stand beside it, where people can see you." In *East 100th Street,* Davidson asked the people he was photographing to pose them-selves, and provided them with proof prints of his work. During two years, he gave more than 2,000 prints away. He photographed with a stand camera, and lit the rooms with electronic flash "so that I could photograph inside the room and outside the window at the same time. You can't do that with 35mm and have good quality prints." He deliberately lost the improvisatory possibilities ofthe small camera, and returned to the deliberate, intentional approach to portraiture used by Vroman and hundreds of other early eth-nographic documentarians. The reactions to Davidson's pictures have ranged from hostility to ennui—indicating the problem in-curred by photographers working with subjects much in the public eye—in this case the social-economic-emotional area known as Spanish Harlem.

the social landscape 149

As a genre, the social landscape is dependent on a projective investment by the viewer into the the scene recorded. Rarely, as with Frank, or earlier with Smith and Lange, does one find formal strength within the image, then it often seems imposed. This becomes evident on examining Danny Lyon's pictures: the search for pictorial advantage is an intrusion into our consiousness of the event being photographed. Admittedly this distinction is delicate: when is the photographer an artist, working in cooperation with the subject and the medium, and when is he a technician, using this particular tool to record and transmit information? The line between is rarely clear; it varies with each observer's degree of understanding both of the world and of the medium. Examining many of the photographs in the social landscape one finds it difficult to name the photographer without a credit line. The event itself controls the image, and dictates its value. The photograph becomes an instant replay; it permits us to objectify the event and its implications.

THE NUDE

The naked human figure is a principal subject of art. Its very naked-
ness has always been both a challenge and a delight to the artist.
There are two ways to respond to the erotic suggestions of the naked
figure; one is to deny the erotic, the other is to make art that affirms
it. Mere nakedness is not a necessity to produce erotic stimulus in
art. Gombirch noted in *Meditations on a Hobby Horse* that the con-
cealment of primary sexual characteristics could be erotic, if pro-
perly handled by the artist. The concealment of sex characteristics
may in fact be more erotic than revealing them. The polar responses
to the effect of the image of the naked figure are summarized by
James Joyce and by Sir Kenneth Clark. Joyce's hero in *Portrait of
the Artist as a Young Man*, argued that if art arouses erotic feelings, it
is bad art. Clark, in his book *The Nude*, argues that if representation
of the figure fails to arouse some erotic feeling it is bad art. Joyce
reflects the long puritanical Irish Catholic, and more properly Jesuit
history, whose name is synonymous with concealment.

Because the Victorian attitude toward sexuality was in effect to
deny its existence, the naked figure does not appear much in photo-
graphy as art until quite late. Not that the naked figure was not
photographed. Scharf and Coke both note that Delacroix purchased
a portfolio of Daguerreotypes of naked figures, men and women,
from which he drew and painted. Many French and English artist
used photographic props. Eugene Durieu supplied the majority of
Delacroix's pictures, and more than 100 plates exist in the *Durieu*

Portfolio at Eastman House. Nadar, cartoonist and master photographer, in his attempt to photograph everyone of contemporary importance, also photographed nudes, as evidenced by the picture entitled the *Original Musetta*, (from the Gernsheim collection) shown in the Portfolio in this text. His attitude is almost biographical: this is the figure which triggered passions. As with all images discussed in this category, this picture could also be considered in the social landscape—she is a figure in the social drama of the time. She is utterly exposed, yet the face is concealed. Were we not told who she is, she would simply be another handsome, plump, naked woman. There is little art or graciousness in the picture; it is nearly brutal, and so in our ungentle age finds new interest.

The naked figure used by photographers is a special kind of portrait, exemplified by the Nadar photograph *Christine Roux*, *the Original Musetta* seen in the Portfolio, and also by the E.J. Bellocq *Storyville Portraits*. The undressed figure was also used for pornographic, as well as being an erotic subject, and as a traditional subject for art. The pornographic uses of photography began within a year after photography was invented; a man in Paris was imprisoned for making dirty pictures. The intention in such pictures is not to call attention to the picture itself, but to encourage mimetic participation with the actions recorded. Pornography is probably the least ambiguous presentation of nakedness: the purpose and intent of the photographer is clear, and no extraneous terms need be brought to a judgement. Like all other forms of communication, art enters even into this, and one finds pictures such as those made by Bellocq which possibly originate as a personal pornography and become art.

Principally because of Victorian attitudes toward nakedness, the nude appears rarely in the early history of photography, except as an adjunct to the painter's workshop. The first important appearance is in 1856, when Oscar Gustave Rejlander presented *Two Ways of Life*, his large allegorical composite print, which clearly showed a number of nude women. The models were members of a troupe of actors, which meant by contemporary standards that they were already beyond judgement, and so were not being demeaned by being photographed without clothes. When this photograph was shown in Scotland the left half of the print, illustrating the way to obvious damnation (a way definitely linked to sex), was covered with a drape so that gentle tastes would not be offended.

Why, one wonders, should the response to the photograph of the

naked figure be so much different than the response to drawings or sculptural renderings of the body? Yet the standards for judgement were different until this last decade. The recent change has come about in part through a victory of ubiquituousness: photography is simply everywhere, all the time, and is no longer an elite medium because it is no longer isolated from general usage by complicated technical procedures. But more important is the change in the mood of the society, the increase of sexual/social permissivity. The general cultural response that the photograph is a "real" event still persists.

Rejlander published many photographs of the nude child, usually posed in imitation of a baroque cherub or *putto*. This presentation obviously struck a response from the Victorian audience, and was acceptable; similar images were made by Cameron and others. One must look to the society's response to children, and its ambivalent attitude toward their innocence, to appreciate these prints. To our eyes they are more or less awkward photographs of children holding angular draperies held by threads to simulate baroque billowings.

Cameron's use of nude children occurs in two periods: first, about 1865, as a series of romantic images which copy baroque cherubs; later, about 1869, in illustrations of Pre-Raphaelite art ideas.

The photograph of the nude was elevated to art before the end of the century. The change was partly a psychological problem, one of separating the reality of the illusion and consiousness of the abstraction of the photograph as a work of art. Before 1880, the only place the nude or nearly nude photograph existed other than in painter's workrooms, and pornography, was in advertisements for actors and dancers. The *carte-de-visite* advertizing prints so elegantly produced by Napoleon Sarony and competently made by others are often suggestive (see Portfolio). While not being exactly naked, these are adjunct to the genre. It must be remembered that to be an actor or entertainer was to be of the *demimonde*. Yet during the same years the naked figure was forbidden to photographic art it could be shown as ethnography; photographs of naked peoples from the 1850's and 1860's abound. The Portfolio shows a typical Daguerreotype of an unknown Indian girl from the 1850's. The newspaper descriptions prepared by Mayhew managed to include colonial ethnological reports, and the illustrations he used often showed nakedness, permissible because the subjects were foreign. the engravings were made from Daguerreotypes. Later, in the

the nude 153

pursuit of knowledge, Edweard Muybridge worked at the University of Pennsylvania. The reproduction of one plate from his work shown in the Portfolio depicts one of the many men and women he photographed wearing nothing more than skullcaps, gauze imitations of a lady's train, or nothing at all. He was photographing to discover how the human moved while performing commonplace actions. The results were published in 1887 in large folios. The folio on the human was entitled *Human Locomotion*, and another, entitled *Animal Locomotion* displayed animals—from elephants to birds. He toured Europe with his photographs, and with a machine that demonstrated the pictures *reassembled in time*. One could see the animals move! The machine that accomplished this he called the *Zoopraxiscope*, and it fascinated and enlightened both French and American artists.

Muybridge in this country, and Etienne Marey in the same years in France, both delineated the body's movements. The naked figure in Muybridge's pictures is removed from the erotic because of environment and presentation; the figures are seen against a metric grid, essential to differential analysis of motion. His presentation is dry; a dozen images differing by tiny fractions of a second in time are presented on the same page. The figure becomes part of a pattern. On the other hand, the startling aspect is that in the height of Victorian attitude toward the naked figure Muybridge published *Human Locomotion* which reveals in explicit detail the male and the female figure in motion. But he did not present this work as art, rather as science.

It is not until photographers declare their intention to be fully accepted as artists that photographs of the adult nude begin to appear. This happened in the last decade of the century. It began with The Linked Ring, in England, and appeared in America with the work of Steiglitz's friends in the Photo-Secession. If photography was to be an art form, one of the classical subjects of art is the nude. The photographs from the last ten years of the last century and the first ten years of this recapitulate every traditional pose of the nude, drawn from painting and sculpture.

The nude figures in photographic art from the end of the century are almost without exception anonymous, ideal, and not erotic. Certain precautions were observed and became traditions of the photographic nude, reflecting an ambiguousness toward the illusionistic reality of the photographic image: rarely was the face shown, and primary sexual characteristics were usually concealed. The fig

154

leaf was replaced by artful lighting, careful drapery or manipulation of the print surface. Erotic feeling, if any, is so diffuse that the conditions defined by Sir Kenneth Clark are rarely met, and the result is frequently bad art, no matter how artful the photograph. An unerotic photograph of the nude is only mechanical, it is divorced from the roots of our existence.

Even after Victoria died, and the new century was well under way, this attitude did not change. The famous scandal surrounding Nijinsky's dance of the Faun in 1912 is typical. Using Debussy's music, the dance ended with the dancer making a copulatory gesture into a piece of drapery dropped on stage by a departing nymph. The explicitness of the gesture enraged the audience. August Rodin wrote to a newspaper in support of the dancer's movements. He wrote that Nijinski had "restore freedom of instinct and human emotion to the dance." Rodin in turn was attacked in the press. And the attack was carried over to America, where Stieglitz had published Rodin's drawings of nude Javanese dancers. Half the subscribers to *Camera Work* canceled because of the (to the times) explicit sexuality of the drawings. Yet to our eyes they are quite innocent, because they are direct responses to the dancers; the fact the dancers are nude is an intellectualization about the relationship between the dancer and the society. But it was the intellectualization that was trigger to the response, not the work of art itself.

Pictorialist photography used the body as an art subject, yet used it discretely, prettily. Old legends were revived and set to photographs: grottoes reveal hidden nymphs, maidens lurk at the edge of misty waters. But these ideas were made fresh because of the very thing that limits the camera when it attempts to emulate the painting, its terrible honesty. These picture modes were carried on into the thirties. Long after the soft focus lenses were put aside and the gum printing process abandoned, the poses of pictorialist nudes remained—girls were photographed in dancing positions that originated in the murals of Pompeii and Egypt, postures taken from stone and paint that are merely quaint and awkward when seen in silver prints.

The major Photo-Secessionist photographers of the nude had an integrity that perhaps grew from the excitement of trying to make photographs that looked like art, to use the beauty of the female,

yet were photographs. Some of the best of these were made by Annie Brigman, who was less evocative of the erotic than a male photographer, and was most alert to the lithe grace of her elegant and curiously sexless females. This feminine but unerotic imagery reappears in the work of Ruth Bernhard, photographing from the 1940's, on to the present. At the turn of the century, Robert DeMachey used textured gum surface to montage the nude into seemingly painted surfaces. Clarence White revealed hesitation in his photographs at dealing with the nude, except when he and Steiglitz photographed together (see Portfolio) in an experimental partnership that lasted several weeks, during which they produced about 60 negatives. Steiglitz wrote in *Camera Work* that they were made as technical investigations of new plates; in any case the results are photographs of a nudity which is luminous, has gentle plasticity, is erotic, and at the same time is innocent as White's pastoral Ohio landscapes. Other photographers who appear in the pages of *Camera Work* merely remade figure paintings from 18th and 19th century European painting—the nude with a mirror and the reclining nude. Velasquez and Goya are revisited, but not Manet, whose *Olympia* revealed too much the photographic source of herself, and could not be redone without leaving the province of painting altogether. This was a risk the pictorialists were unwilling to take.

The postures and attitudes of the pictorialist movement survived long after the First World War. For example, in the 1930's the New York photographer Nicholas Murray photographed dancers in the nude, including Ted Shawn, and redid the attitudes captured by Steichen and others at the beginning of the century. But Murray used sharp clear lenses, and printed on brilliant papers, the result is neither fish nor fowl. In an attempt to create an abstraction of the too solid flesh he used what became a cliche of the 1930's, the oiled body, which made the flesh metallic and crisp. Murray's work is mentioned here as being best of a kind; photography magazines were frequently filled with weak copies until recently. Murray carried these images over into advertising photography. His nude photograph for Canon Towels, which was the first naturalistic color nude in American magazine advertising, is shown in the Portfolio.

In *Camera Work* the figure is idealized and individuality destroyed by manipulation. Photographic illusion was diminished and the surface of the print reinforced; the image is sensual, dreamy, non--specific. The poses and gestures of the figure are abstractions drawn from myth or Eastern art. A few *photographic* elements appear frequently, for example a glass ball, about a foot in diameter.

156

Clarence White, Jr., said he is not sure who first used the ball, but that everyone connected with Steiglitz's circle found it a delightful light modulator, a substance that could only be adequately recorded with the camera.

Pictorialism died with the First World War. Its habits lingered; a late performer was the photographer William Mortenson who in the 1930's and 40's published several books of manipulated gum prints, brilliant in technique but successively less intense. After the War the photograph began to be discovered to be a new way of seeing, and to be used by artists as a new way to print. This is of itself a kind of pictorialism, but must not be confused with the esthetic intent of the photographers a generation earlier. Steichen's nudes, for example, are part of the pictorialist movement, and have a sexual dryness characteristic of it. The change in the decade of the First World War is intense. Man Ray's manipulated photographs of nudes, made in Paris in the 1920's are both formalized and erotic: the body is seen as a female possiblity as well as a means to a print. Moholy--Nagy, working in Berlin at the same time, was more formal, perhaps cruel, certainly unsensual. Man Ray used the naked figure formally and intellectually, but always tempered this with sexual directness. He drew upon current happenings in painting in Paris, his portrait of Kiki published in *Self-Portrait* has very few tones: white, two or three flat greys and black (her hair). Shapes are flattened; one is reminded of Modigliani. Technical manipulation is simple, the fundamental photographic relationship between lighting and development had been creatively used. Man Ray used any technique possible to make a print exciting as an image. His pictures are rarely imitative, and he avoided the pictorialist burden of copying painters of the preceeding generation. He was an artist of his time, using photographic tools. He simplified tone through exposure--development controls, solarization, controlled fogging of the print, making photo-engraving plates and then printing from these, as well as painting onto the print. The spirit of his work is delight in experiment.

Moholy-Nagy photographed the nude in Germany during the 1920's. The Hungarian teacher brought to photographs of the nude a cool, formal attitude characteristic of the vision of the Bauhaus, where he was an instructor. He transformed plastic forms and textures of the body into shapes, fracturing them, and the complex three dimensional surfaces of the figure are violated. He achieved this through simple, purely photographic means, creating a new vision: lighting, tone control manipulation by development,

the nude 157

negative printing, and unusual point of view all prohibit the voluptuous response. The body seen by his camera is ambiguous, advancing and receding in space as functions of light and dark, often in a visual violation of our kinetic memory of the body's shapes and volumes. The erotic is minimized, is absent or perhaps even perverted in his cold vision, at least when compared with Man Ray, who also manipulated tones and shapes of the figure but retained its human warmth.

Edward Weston's work with the nude began in the 1910's when he came of age in a pictorialist time. His early nudes are langorous, draped figures seen through soft focus lenses, framed with Japanese pots and linear stalks of flowers. His imagery of this time is suggested strongly in the portrait made by Margretha Mather, who had been taught by him. He put aside this borrowed vision and began seeing the figure and photographing it as sensuous shape and volume early in the 1920's. One of his first photographs of that decade shows the new composite of graphics and sensuousness: the breast and shoulder are outlined with a crescent and triangle of light, crisp, yet erotic and sensual. The picture is one with contemporary concerns for geometry of form, and yet never leaves the photographic love of the human skin which is at the heart of all Weston's photographs of people. His nudes always are photographs of people, not merely pictures of erotic, generally handsome, idealized figures.

There is a specificity of response, amounting to a dialogue between the subject and himself, so the viewer is always aware of the *individual* before the camera. The classical photographic nude is not explicit: an idealized female is shown, rather than a particular, real person. This is true throughout pictorialism and dates back to Durieu, whose studio pictures Delacroix used. Weston's photographs violate the tradition. Even when the face is completely hidden, as in his famous photograph of a woman seated in a doorway, arms and legs curled about herself to conceal face and sex, the sense of a particular person exists in the hair, even in the textures of the body. The concealment does not seem coy, it is felt as a way of concentrating attention on the sensuous form of the real body. The picture becomes a portrait, so great is the sense of presence.

Many other pictures support this response: a naked black woman hunkered down in the shadows of the bushes seems specific and personal, revealed to us in her female frailness and strength; another, made during the Second World War, show a naked woman lying on a couch, face concealed in a gasmask. These violate all traditions of

gentleness and erotic fancy, yet reinforce our awareness of the particular person. These pictures heighten our awareness of the photographically rendered femaleness, and so produce a self-consciousness, as though we were caught peeping. His satiric nudes from the wartime make us aware of habits of response brought to the photograph. His pictures are formally brilliant, but also were responses to real events, not the sterile mustiness of a studio. Part of this feeling exists because of the completeness of his figures, all parts of the body are shown, nothing is hidden in a photograph from a time when much was hidden, all parts of the body are equally photographable. The last hangover of Victorianism disappears; there is no hint of prudery, shame, or concealment.

An arbitrary way of differentiation between art and pornography has been the presence of absence of pubic hair. Until 1970, Kodak color processing laboratories would often sequester color film showing genitals. In 1962, for example, Stan Brakhage, the film maker, had films of a childbirth withheld by Kodak because it showed the vulva, as the child was being delivered. He retrieved the film by having it declared *medical photography* by his family physician. Kodak did not change its attitude until about 1970.

Until the late 1960's photographs of the nude shown in magazines and books either were airbrushed, to conceal pubic hair, or the model was a professional figure model who shaved off body hair. These avoidances of hair supposedly removed the nude from any participation in erotic fantasy! In actuality, the unnatural concealments and avoidance methods used probably created exactly the fertile ground for erotic imagination which it had been the censor's avowed intention to avoid. Weston always ignored this legalistic quibble (see Portfolio), he photographed the body with love, as a subject that reflected both the light and the spirit of his life.

Stieglitz's photographs of the nude are of two kinds: one is a record of lovely women he had known, the other was a portion of his concept of portraiture, expressed photographically during the years 1915-1935. He made many photographs of the face and body of Georgia O'Keefe during their relationship—and always recorded her both as a strong woman, as elegant female, and also as frail, human sensuous participant. He makes us aware of both image and print through formal devices, small shapes appearing near the edge of the print that distract our eye from the central subject, returning attention of the boundary and surface of the photograph. With Stieglitz, the print is never all illusion.

the nude 159

By the beginning of the Second World War, the genre suffered an exhaustion of form. After you photograph the figure as pure, com plex form, folded upon itself; after you photograph frontal naked-ness, with no concealment; after you photographically transform the woman into cubist geometry—what do you do? One answer is to totally distort the figure, as was done by Andre Kertesz, who photo-graphed the model seen in carnival distorting mirrors, making images that evoke Henry Moore, or perhaps the line of Juan Miro.

Francis Brugiere literally painted the figure away, transforming the actual print surface into a neo-cubist drawing, allowing only bits and pieces of the photograph to remain. This reversed the collage idea initiated by Picasso, who had glued a bit of photographically copied chair caning onto a small drawing. Brugiere made several images suggesting cubist transformations, changing girls into cellos.

Such distortions and transformations have lately been reinvestigated. The Polish photographer Waclow Nowak, illustrated in *Creative Camera,* is an example.And optical distortions created by the use of new very wide angle lenses have recently been used to create new interpretations of the body. Charles Swedlund (see Portfolio) used a "fish-eye" lens to visually reinforce the roundness of his wife's preg-nancy. Jim Alinder used the special format made possible by the panoramic camera; the lens rotates slowly through a 140-degree arc during the exposure: it is possible to move the camera and selectively rearrange reality while this is happening. In all these pictures, the formal values dominate: shapes on the page determine ones re-sponse, and any illusionistic participation with the figure before the camera is difficult, if not impossible. The romantic response is essen-tially eliminated in distortion photography of the nude.

Other treatments of the figure, and other relationships are possible. Manuel Alvarez Bravo photographed a quiet female lying beside shards of broken glass; there is tension between the sharp glass and the frail flesh of breasts and arms. This picture depends on the associations brought to the image as illusion. In another photograph the model was wrapped with gauze above and below the loins, leaving the pubis exposed. She lies flat on her back; the gauze is seen as bandages, as though she were wounded; her nakedness becomes a terrible pun. He inverted the traditional relationships between the photographer and the viewer, between seeing and hiding. He de-mands that one look at the sex (framed by the white gauze) and not avoid it. Nakedness is reinforced, and Victorianism turned on its head. Bravo denies puritanism, he demands sensual possibilities and

160

alternatives to mere erotic response; in so doing he also draws one away from the safe position of judging the picture only on formal grounds, as pictorial picture-making. His images of the nude are in effect ethical events.

The formal photograph of the nude was carried to new purity by Bill Brandt, whose work was presented in *Perspective of Nudes*, published in 1961. It was met with uniform hostility. In 1971, the English magazine *Creative Camera* published an anthology of reviews that had greeted Brandt's book. The American reviewers not only were uniformly hostile, but several had assumed Brandt was making a photographic joke. None of them saw he had abandoned mimetic sensuality, inherent in all earlier photographs of the female body, and was extending his coldly passionate vision of our society into this mode. He used very wide angle lenses and tiny apertures to destroy normal near/far spatial relationships. He composed images that exaggerated space and made parts of the body into fantastic monumental objects. Some photographs are solemn dislocations of body parts: elbows become massive sculpture; an ear dominates a rocky landscape that is suddenly realized to be only pebbles; arms and cliffs have equal importance. All shapes have equal mass. Near and far, small and large are in a delicate and ponderous balance, destroying normal judgements, inhibiting any automatic responses.

The figure is seen as a prop in the theatre of personal fantasy, a use dating to the heyday of pictorialism, in the photographs made by Leslie Krims. He has the reputation of being the only photographer whose photographs have directly caused a kidnapping; they so angered a man in the south he intimidated a gallery director into removing two prints from an exhibit. Krims uses the figure in a chamber-theatre: he creates tableaus, and then photographs critical moments, creating pictures that are full of evocative tension, never fully rational or clear. Because it is a photograph, it has a sense of truth; his pictures are out of the unpleasant erotic fantasy of Heironomous Bosch, without benefit of religious comfort. The nude in Krims' photographs is anonymous; the naked person is merely an actor, used by Krims functioning as director and photographer.

The figure is used in a technically similar way by Duane Michals in a number of pictorial sequences, forexample *A Young Girl's Dream*, *Paradise Regained*, or *The Journey of the Spirit After Death*. One frame from this sequence is shown in the Portfolio. The people he photographs are means to illustrating ideas. In Michal's work the

image is almost always tender, gentle, and barely avoids becoming sentimental; it is almost opposite in tone to the violence expressed by Krims, in whose work there is every psychic and physical gore. Krims is out of the *Grand Guignol;* our accultured mind responds, and yet the events shown are unreal in daily-life terms. In Krims' photographs sexual beauty is violated, violence abstracted, moulded into a photographic pseduo-event that triggers within us a tolerable level of response, in distinction to the intolerable responses suggested by documentary photographs from atrocity scenes—be they Jew, Ibo, or Viet Nam.

Pictorial treatment of the figure has not always been concerned with idealization or with theatrics, and in the 1880's Thomas Eakins, the painter, produced a series of photographs analyzing human motion—much as Muybridge had done. Eakins' work was contemporary with Muybridge's, but was made for another reason. He wished to paint more accurate transcriptions of motion. His photographs are often beautiful in themselves. Rather than being separate plates (presented in an array, but each exposed at a different time), all the exposures were made sequentially on a single plate. The result, shown beside a Muybridge presentation in the Portfolio, is a shimmering record of the body's motion through time. The instant expands and is revealed. The complex patterns of the body's motions become esthetically important. Eakins also discovered anthropometrically correct, though seemingly ungainly postures in these photographs, and then used them in his paintings though they were untrue to centuries of idealized gesture drawing practised by Western artists.

Photography lagged painting by half a century in the treatment of the body as unpretty but real. The Manet *Olympia*, a *demimondaine* nakedly revealed, preceeded Photo-Secessionist confectionary nudes by forty years. We now have available, however, evidence that blunt photographic records of the nude were made concurrently to the pictorialist soft-focus gum prints—though these pictures, like Hill and Adamson's portraits, had to wait half a century to be published and to become effective. E.J. Bellocq, about whom little is known except that he was a commercial photographer in New Orleans from about 1895 until the Second World War, and that he made many photographs of prostitutes at Storyville, the red-light district across the river from New Orleans. Bellocq's photographs of prostitutes are often portraits, and sometimes nudes, and sometimes both. Like the Manet *Dejeuner sur l'herbe*, from 1863, these pictures

162

make the viewer self-conscious and uneasy. The women in the pictures are sometimes naked and sometimes not. Their nakedness is frequently ugly; the pictures are as blunt and documentary as medical or police photographs. Yet there is a sense of beauty created, perhaps because these are revelations of particular women, seen not merely because they have handsome bodies (many of them do not, in fact: breasts sag, buttocks are pendant, stomachs protrude in ways never recorded by Steichen or DeMachey) but because they are frail, timid, yet willing to be seen. Ultimately they are human, tender. These pictures are not of the same coin as Weston's photographs of candid nakedness; the relationship between the photographer and the subject is different; the pictures in each case arise from a different society. Weston worked in the freedom of a new bohemian culture; Bellocq and his models lived within the boundaries of a society that was in effect contemporary with that of Manet and Lautrec—the paid woman as companionable model. The photograph captures this fragility as easily as pencil or chalk, and with more ambiguity. It is the double-edged meaning, the tension between accurate record and unexpected revelation, that in photography surpasses other arts. Rarely have professionals accomplished it, no matter how great their craft. Is is found most often in the photographs by inspired amateurs, that is to say the lovers of photography; the world of the unexpected is revealed through the camera. Here, photography finds stature. Bellocq's photographs lie on the boundary between pornography and art, between the covert purposes of Storyville and the nature of human frailty. In many cases this ambiguity might not exist, even in these photographs, were it not for accidents that have happened to the original plates, formalizing them into print statements we can deal with more easily. Torn emulsions, cracks and feathering of the image caused by the gelatin being eaten away by mold, damage caused by handling, all make one conscious of the print itself and remove one from identification with the explicit sexual intention of the illusionistic image that was probably originally intended.

Bellocq and Weston both defy Victorian tradition, already dying before the First World War, though lingering on into the art of the 1950's. But once those traditions were shattered, by the War itself and the changes in society that followed, complete puritanism in photography was never regained. Since then many photographers have taken advantage of this freedom to work joyfully with the nude. An example is the photography of Wynn Bullock. During the 1950's and 1960's he made a number of pictures which depend on a tension between the tender, sensuous surface of the female body and

harsh, abandoned or threatening surroundings in which the figure is discovered. He places the figure in what should be unacceptable or shocking juxtapositions that are nevertheless gentle, and that somehow encapsulate or protect it, making one more than normally aware of the sensuousness of flesh. Sometimes there is a momentary implication of death: one of his most famous pictures is of a young naked girl lying face down in a dark glade, surrounded by growth. Yet she is very live, threatened and protected at the same time. Sensual, yet innocent. This is also true of the photographs of the nude by Jack Welpott, a photographer associated with the new work on the west coast both because of his teaching activities at San Francisco State and because of his leadership of the *Visual Dialogue Foundation*, a group of photographers in the Bay area who have gathered together to support new art photography.

On looking at Weston's photographs of the nude, one becomes aware that a specific person is perceived, almost as though one were in the presence of that person. Perhaps because of the remarkable honesty of his photographs, the photographers who followed him often produced a similar sense of dialogue between the photographer and the subject. No longer is the model merely a female object (though this has again become the mode, after a generation's lag), but the model is a co-respondent, and the people on both sides of the camera show mutual awareness.

The pleasant elements of the pictorialist tradition have not wholly disappeared. Ruth Bernhard, in San Francisco, is one of the few contemporary photographer to achieve a new image while holding to older attitudes about the figure. She continues to make images that are pretty and pictorial, and though she is willing to show the entire body she achieves a contemporary equivalent of the romantic image of the end of the century, obscuring sexuality. She photographs the body for its traditional beauty, and yet the figures are often cool and distant. Perhaps it is not possible, one might think, to combine the sexuality and the warmth and the beauty, yet it was done, by Weston and by Stieglitz. Bernhard is an elegant technician, working with simple tools and lighting and achieving a rich record that reveals the architecture of the bones, the luxuriousness of flesh, the luminous beauty of healthy bodies. Her women are lovely and untouched; her prints are lyrics to young female beauty.

Another kind of photograph of the nude appears late in the 1950's; an important example of this new vision is found in photographs made by Walter Chappell, photographing his wife and his children.

164

His pictures are like Stieglitz's photographs of O'Keefe, but differ both because the personalities of the artists differ and the times in which they lived are so unlike. Chappell rarely makes pretty pictures; they are often cold, hostile, unpleasant. The photograph is analogous to a chemical precipitate, it is a by-product of a relationship. The camera was allowed to participate in an extended dialogue. When a breathing place came, the images that resulted were examined by the artist, working now not as a participant but as an artist, selecting from the work done, choosing which to print. Little of Chappell's work has been published outside *Aperture*. in part because accidents destroyed many of his negatives while a volume of photographs was being prepared. The two photographs in the Portfolio represent work of the early 1960's.

Chappell allowed covert attitudes implicit in such an intimate dialogue to appear and to find expression. His intention was not to create beauty so much as to allow spiritual and emotional relationships between the photographic participants to become visible. Inevitably, many pictures arising from such a relationship are never used, not because they are "bad" but because they are incomplete, unrealized, and do not evoke any special state of awareness in the beholder. His photographs turn away from traditions of romantic, sensuous or idealistic involvement with the figure. He sometimes sees the body with hostility, usually with a brutal honesty, and always with the eye of an artist who has found a mature vision. Chappell worked with paint for several years before finding photography, having learned the craft while recuperating from tuberculosis.

Because photographs suggest as much as they record, Chappell and Gassan drafted a paper in 1955, in Denver, which was rewritten by Minor White and Chappell in Rochester, and published as *Some Methods for Experiencing Photographs*, in *Aperture*, Vol.5 No.4, 1957. Chappell, Gassan and White felt the need to learn if it were possible to classify and predict the kinds of response the photograph creates. They knew the photograph may suggest many possibilities to the mind's eye; Chappell had known Minor White earlier, in San Francisco, and through him learned of Stieglitz's use of the term *equivalent*. The paper that was written in Denver, and rewritten in Rochester was an attempt to bring intuitive perceptions and the idea of equivalency into a rational structure, and to encourage photographers to understand the evocative power of the photograph. The authors felt that if the photographer knew and understood how the image evoked secondary meanings, as well as

documented the light, creating an image of surface reality, then the photographer could make ethically motivated decisions about the total meaning of his photographs.

Chappell's own pictures are investigations of these ideas; the subject before the camera is seen for itself and it is also seen as a light modulator, making shapes and shadows whose meanings are sensed by the artist and captured for him by his camera. These patterns of light and dark are read by the eye as independent gestalts, which term Paul Klee defined as meaning not merely the form, but the spirit of the image. The paper published in *Aperture* implicitly argued that these meanings ought to be understood by the photographer before he releases his photograph; only through discovery of covert gestalt meanings can the photographer know what he is in fact communicating, and know what responsibilities he holds as a communicative agent, if not as an artist.

This sort of private relationship exposed in Chappell's photographs—the personal experiences made public through the use of the camera; the photograph becoming akin to an archeological artifact—has interested many other photographers. Robert Frank's film work turned to this kind of vision, though not specifically associated with the nude, though it does deal with emotional nakedness. A young photographer who has used this mode with strength is Emmet Gowin, who photographs his wife (naked and clothed) and his wife's family. His pictures are somewhat like snapshots, somewhat like Stieglitz's Lake George equivalents. And sometimes there is a momentary perverseness, as of children at play. One such picture (see Portfolio) shows his wife, standing behind an aged woman; the young woman opens her blouse to reveal herself, but is hidden from the sight of the older woman, literally behind her back. The old woman is blurred, as though turning away as the gesture was made. The photographic subject is both the beauty of the young woman and a little drama. The print itself is a relic of the event, a drama between the wife and the photographer. Gowin made a series of photographs of his wife's pregnancy which record both the sensual tenderness and female hostility of the time; the viewer sometimes becomes the focus of her energy, and sometimes is a voyeur, observing her in her female isolation.

The richness of the long-scale silver print, ignored by most photographers for some years after the War, is restored to primacy in Gowin's prints. He prints on contact-print paper, which has a chara-

166

teristically longer scale in the shadow areas than does projection-
-printing paper. His prints have a dreamlike tonal softness combined
with an optically crisp rendering of detail. He weds contemporary
optics to an older tradition of photographic tonal rendering to
achieve a sense of *presence* without harshness.

Chappell and Gowin illustrate the effects of changing esthetic and
social standards on the medium. The past decades have seen radical
changes. Weston could photograph models and mistresses; Chappell,
Gowin and others have found it possible recently to photograph
their wives' and their childrens' nakedness without censure, a condi-
tion improbable before the Second World War.

Photographers photograph the naked figure for many reasons: some
wish to make pretty pictures that relate to traditional images and
compositions found in painting; others wish to make private records,
of people they have loved or relationships they have had, or possible
relationships they have dreamed about. Before the Second World
War the presumption was that the image of the nude was associated
with affirmative feelings; most art supported this assumption. In
1969, Minor White announced an exhibit, to be presented at Massa-
chusetts Institute of Technology, entitled *Be-ing Without Clothes.*
His announced intention was to discover what photographers of our
day saw when they photographed the human unclothed—when both
the photographer and the subject were in a state of awareness, of
consciousness.

The photographs submitted to Professor White disturbed him be-
cause the naked figure was rarely seen as a beautiful object. The
esthetic and the psychological world of contemporary photo-
graphers, revealed in the submitted pictures, was rarely pretty,
gentle, or comfortable. There was a uniform sensation of harshness,
often an anti-erotic ugliness. Sir Kenneth Clark's assumptions that
good art of the naked figure is associated with erotic affirmation
were disregarded by the young artists of our day.

The exhibit was arranged for publication by *Aperture* as *Be-ing
Without Clothes.* It illustrates the mood of contemporary photog-
raphy of the nude, of photographers working in the universities, as
independent artists, and as photographers who were not concerned
with commercial, applied photography in the 1960's. Photographs
like the Sabbatier-effect transformations of the nude by Todd
Walker (see Portfolio), have no relationship to traditional salon

the nude 167

photographs; in some ways they are closer to the tonally bold and equally untender nudes that had appeared in *Harper's Bazaar*, and in *Vogue*, whose models were dry, brilliant professionals.

The selection of images was made by Minor White; it reflects his personal taste, choosing from the spectrum of the photographs offered; the book is uniform to a degree. This uniformity is to some extent created by the photo-reproduction process itself, but an earlier exhibit and monograph, entitled *Light*[7] had also demonstrated this uniformity to a degree that Ralph Eugene Meatyard commented "all the photographs look like Minor would have made them if Minor had had time." It is true there is a remarkable cohesiveness in both sets of pictures; the printed reproductions have a uniformity of surface, of ink and tone, that eliminates much of the individuality that might have been found in the original prints.

Nevertheless, the fact that there is this degree of uniformity of emotional tone is not fully the responsibility of White, as editor, choosing the prints. He has achieved in the book a consensus of contemporary attitudes toward the figure—not through words but through images.

These photographs reflect the new world of photographic art, the world reflected in Costenada's *The Teachings of Don Juan;* they are visions of the body unseen or unknown before the War, before Larry Rivers, before Rauschenberg's *Big Boy*, before Leslie Krims, before the general discovery by the society and by young artists of hallucinogenic agents. The body is cut apart, montaged, distorted through lenses or chemistry, and seen through bewildering varieties of private vision. Almost none of these visions have inherently what Costenada called a *public consensus.* There is no way to assure another of the truth of your private internal vision, unless one can forge an image powerful enough to convince, to educate others to belief in the fact that this is what you really see, this is what you feel. In the mass, these pictures do eventually create a base for a public consensus. The human body is no longer inviolate; our response to is is no longer automatic—be that sensual, tender, affectionate, honorable. The human body is a machine, a remnant of a relationship, a gestalt trigger found in an assembled *mandala.*

These attitudes are seen in the work of Roger Mertin, in a portfolio entitled *Plastic Love Dream,* (also published in slide-set form). The voluptuous body is covered, hidden and concealed by a sheet of transparent but mirror-like plastic, the principal material of our

168

century. The announcement of the exhibit at the Pasadena Museum was offered in clear, hard plastic sandwich boxes. The female figures in these pictures are never fully or clearly seen, never separated from the textures and shapes of a distorted environment that is fractured and reassembled by plastic light modulators, or by mirrors. The voluptuous figure is irrational: it beds down in wildness, is segmented by mirrors that rend it, juxtaposing fragments of sky and trees into the torso, obliterating limbs.

The photographs of the nude in our own time tend to anonymity, just as photographs printed in the first twenty-odd issues of *Camera Work* are often similar to the point of anonymity, in that they participated in an esthetic ambiance, a consensus of how the photograph should appear. In either time the apparent esthetic consensus is an admixture of the intentions of the photographer and the influences of the time, or in the case of publications like *Be-ing Without Clothes*, or *Camera Work*, of the editors— White in one case, Stieglitz in the other. Had the editor been a brilliant commercial photographer like Avedon, Penn, or Hiro, then one suspects different photographs would have been submitted in the first place, and an entirely different show would have appeared, one which would have revealed the body as an elegant participant in the suave world of the 1960's. The point is that beginning with F. Holland Day's selection of *New American Photography* for an exhibit in London, in 1900, the possibility of influencing a subsequent generation of young photographers through the editing of a major show has never been absent. This was maintained through Stieglitz's dominance of the avante-garde—beginning in 1902 and continuing into the 1930's—and sustained by Steichen's creation of a series of major exhibitions at the Museum of Modern Art: most notably the *Family of Man*, but evident earlier in his editorial choice of photographs for *Fighting Lady*, and continuing in other "theme" exhibits, especially in the *Sense of Abstraction*. Some of these exhibits summarize moods, others anticipate and encourage new vogues. Such a show was the Eastman House exhibit assembled in 1969 by Nathan Lyons, entitled *Vision and Expression;* the catalogue of the show illustrated the rise of a new manipulatory mode in art photography.

The contemporary scene permits a wide spectrum of possibilities in photographing the nude: straight photography, documentation, pictorialism, manipulated prints, photographs combined with other prints and with paintings, optical distortion by means of slow shutters or special anamorphic lenses or panoramic cameras, chem-

ical manipulation of the negative or the print, solarization, renewal of technically obsolete processes (including photogravure and blueprint), as well as non-negative sources for the print combining the photogram and cliche verre image with regular camera-made negatives. All these possibilities are now considered to be photographic, because they use photosensitive materials and are made by persons who consider themselves to be photographers. A contemporary definition of photography proposed by Jerry N. Uelsman is "using light sensitive materials to make an image."

The photographs made by most of the photographers in *Be-ing Without Clothes* raise questions of meaning and understanding. How much meaning ascribed to the photograph was intended by the photographer; how much is being projected on or into the photograph—first by the editor of the exhibit, in arrangement of images within the pages of the catalogue, and then by the viewer? The arguments which W. Eugene Smith raised against the editors of *Life* arise anew; the covert exhibitor in the book and the gallery exhibit is not the photographer but the person who editorially selects and sequences the photographs. Strong individual formal investigations by artists like Robert Heinicken, Charles Swedlund and others diminish in this group context; one tends to see the idea of the total statement more than any individual photographer's vision. Individual vision becomes merely a part, an element in a series.

PHOTOGRAPHY AS ART

When one looks at painting done between 1400 and 1900 there is an obvious consistency. During that very long period of time painters were concerned with capturing the sense of surfaces. Nature was what was available to a public consensus: the textures, illuminations, and masses of things taken as a whole fabric, seen by a normal eye were the subjects of art. This is not to deny or devalue experiments and developments. Raphael brought the artist into the scholar's estate by presenting himself equal to the philosophers in *The School of Athens*; Caravaggio announced a new dimension when he presented images of radial light; Rembrandt's etchings transformed this light into mystery, transformed simple theatrical centering and replaced central light with eccentric shadow; Goya added washes of tone, and the violence of direct record. Watteau derided seriousness, yet retained poignancy; Gericault attempted to reveal inner states through exact medical recording of maniacal features; Ingres' linear vision captured essential gesture, and competes with the best photography; Turner and then Monet looked at the light itself and transcribed it with exactness. All these and hundreds of other artists were involved with the way things look, caught the light, or modulated our feelings and perceptions through the nature of their surfaces. Art was the way things look.

The way things appear to be, the way they look, as presented in any art is modified by the way other artists have seen. When photography appeared, Ruskin immediately began to relearn *wash* and

tone techniques. He affected to despise photography because of its mechanical translation of light into tone, but he emulated it, pronouncing photographic tone as being correct, the right way to render solids.

Art became, in the Nineteenth century, the manual transcription of reality into a two dimensional shape. Photography was a possible tool in this translation, but could not be the only tool; the hand itself must be allowed in the process. The translation of vision is of itself not the whole purpose: man's hands, not a machine, or not wholly a machine must be the means. The Nineteenth century artist is not unlike the Amish farmer who will not allow an engine to draw the wagon, but will permit a gas engine to power a thresher, drawn by horses. Once the purity of a medium is marred, all other transgressions are of degree. Of course, these fine shadings of degree are the substance of most bitter arguments, in art, politics, and morals alike.

The general boundaries of most art mediums are outlined in the first generation of serious work. In photography this was also true. Talbot produced the first photography intended to be art. Though little other photography as art exists until forty years later, Talbot certainly qualifies by contemporary definitions; many of his photographs were not made as a commercial product, in the sense of being made directly for a client. They were photographs which pleased him, and then found a market after the fact. *The Pencil of Nature* is the first book of art photographs. Illustrated with silver prints, it showed how light itself unassisted by the artist's hand could be used to draw the world. Talbot started out to do just that when he found himself incapable of manually drawing the loveliness of the world accurately, even when using a conventional artist's crutches, the *camera lucida* or the *camera obscura*. Talbot called his process *photogenic drawing*, a term relevant to this investigation.

History repeats itself; in 1948, Dr. Edwin Land announced a new photographic process, the Polaroid- Land silver-diffusion process; it permitted a finished print in a few seconds. In his initial announcement of his invention he noted it would permit anyone who could not draw to become an artist. The same idea is at work, taken a step further: Talbot could not cope with mechanical problems of contour and tone, and discovered a way to fix the optical image; Land sought to free the seeing person from the relatively nominal chemical procedures required of the silver process.

172

Talbot's book recapitulated most principal genres of painting. *The Open Door*, from *The Pencil of Nature*, is one of the first memorable photographs in art. It is a simple, almost homely image, a drawing made by light. Certainly it relates to genre painting, but it is essentially photographic. It is neither a picture story, nor illustration; the subject is the door, a broom, shadow and light. Many of the other photographs in the book are less prepossessing. Buildings are truncated, presented with what appears to be a brute documentary intent. The Portfolio shows *Plate 22* from the book. Details of lace are also shown, recapitulations of Talbot's early experiments in photogenic drawing. Only now these have been printed *correctly*. The lace images present a tidy problem in deciding what is *positive* and what is *negative* in the photographic print.

The original lace was white. Using the lace itself as a template, and exposing paper laid under it would produce a white image on a dark ground. This is visually correct, it is how lace appears, yet it is technically a *negative*. Using that negative print and exposing through it to darken another piece of paper created what Talbot showed in *The Pencil of Nature*: a dark form on a light background. This is visually reversed from the tones of lace on a table, but now is technically correct, a *positive* print. Such a leaf negative is shown in the Portfolio. Both images are photographic. In these prints, the photographic art becomes a matter of tasteful selection, of isolation of part of the pattern from the whole cloth, and arrangement of this part within the border of the print. The camera need not be involved at all. Other pictures of his, for example ships at dock, are seen first as a pictorial/documentary record and are not all that much different from Danny Lyon's photographs of rows of motorcycles at a race. Scenes of dominant artifacts of a time, photographed from a point of view which transforms them into handsome patterns is basic art photography. Such pictures are both records of society and handsome, graphic images.

Certain images in art appear as modifiers of taste, touchstones against which we can measure subsequent images; they offer an evaluation by comparison. Edward Weston once remarked that a good photograph would stand comparison to Bach. Hill and Adamson's portraits, Cameron's portraits, Stieglitz's portraits in turn offer us references, each body of work redefining what is appropriate to, and possible for the medium.

Hill and Adamson's portraits, made concurrently with *The Pencil of Nature* were made from a painter's viewpoint, but that vision was

changed by the materials of the medium itself, in effect creating work which was an extension of earlier traditions and a forging of standards for a new medium, beginning a new tradition. The negatives were reprinted at the end of the century by J. Craig Annan, exhibited and then published in *Camera Work*, renewing their critical value. These standards were made newly available to photographers at the turn of the century, through Stieglitz's editorial awareness.

Hill and Adamson lent themselves to illustration; Victorian art almost might be defined as illustration. Most painting of the neo--Classic school in France was also concerned with illustrating—delineating specific political, moral and ethical situations—in effect a bourgoise renewal of the Council of Trent, nonreligious and specific. Hill and Adamson attempted to illustrate a number of romantic texts, using costumes and props. In many pictures the slowness of their films destroyed the illusionistic effects they intended.

Illustration is one of the pillars of art. It supported artists and pleased patrons for several hundred years; in illusionistic art it is the principal justification for the artist as a paid craftsman, from Giotto in 1400 through the political frescoes of Orozco in the 1940's. Illustration was modified into a more complex intellectual mode with *The School of Athens* which is an illustration of an intellectual conceit—bringing together humanistic heroes and the artist himself, and also displacing standard illustrative figures from theology—God, His saints and His prophets—by humanistic heroes. The philosophers were seen as though contemporary with Raphael, and as though Italian. Painting becomes cinema: specific real faces stand in for other real, but unobtainable faces. Rembrandt continued this, using old neighbors for saints, old Jews for illustrating early Christian myths. Perhaps the conscious awareness of the fine edge being trod came to a peak when Velasquez painted the *Ladies in Waiting* where the subject is only nominally the Princesses' women, and is actually the optical problems of illusion: where does the viewer stand? Can he be placed behind the canvas, and still be convinced he glimpses reality? Illustration requires illusion; illusion necessitates models; models impose themselves on the image, and it begins to be portraiture. If the artist overrides the personality of the model, the work becomes a celebration of the medium and the artist.

Hill and Adamson attempted to illustrate contemporary, romantic literature. Cameron also did this, illustrating Tennyson's *Idylls of the King*. Neither made these pictures as a means to a living; the

174

pictures fall into a class of photographs made not for money, a very small class until the end of the century. Others did make art pictures as well. Adolph Braun, for example, photographed elegant assemblages of grasses and flowers, reminiscent in their linear accuracy of Durer's engravings from nature.

The specific rallying point in photography was the large print assembled by Rejlander, echoing the idea of *The School of Athens*, entitled *The Two Ways of Life*. Using Raphael's composition, and Italian modes of dress and composition that certified the image as art, Rejlander created the masterful print as a work of art. It is a masterpiece, not matter how distasteful or gauche the illustration may be to current taste. It is Victorian. Rejlander also made many other images recapitulating art as he knew it: post-Renaissance images of Mary and Martha and Anne; Dutch scenes with serving maids, woolly dogs and brick walls. The esthetic environment of Victorian art makes it difficult to separate works of the period. Alfred Rankley's *Old School Fellows* (in which a weeping former companion, on his uppers, is being comforted and given money to tide him over); Alexander Wallace's *The Death of Chatterton* (the young poet dead by his own hand, photographically backlighted); Alexander Farmer's *An Anxious Hour* (a mother watches her ill child)—all these are contemporary within five years. All are of a photographic vision. They appeared in the late 1850's, just before Robinson's composite *Fading Away* was displayed, an image which shocked and disturbed Victorian critics. Robinson is as classic in structure and cool in intent as any of these mentioned, yet he was a disturbing image maker in his time, principally because of the real and continuing confusion about the illusion of reality implicity in the photographic image versus the directorial implications of illustration. Photographic illustration is *theatre*; actors, lighting, a script and a director are evident; the event is often predictable; ones esthetic response is always split, part being directed towards the event being described, and part toward the texture of the performance itself. The machinery of the performance is the cause of the major effort in the illustration. Photography tends to confuse critics because of the verisimilitude of the visual event in the photographic print. When well done, it is difficult to separate theatrical truth—photographed—from experimental truth captured in the instant of actuality seen by the camera. This is the razor's edge separating critics and participants in any discussion of esthetics in photography.

These photographs have little to do with the romantic idea of art

that had been developing since the beginning of the last century. The out-pouring of the soul, the song of the skylark is considered by many to be art. But art has a longer tradition, meaning the working out of visual problems with which to delight and to fool the eye by craftsmanship that reveals concept. The craftsmanship is of itself often the purpose of art, more than the song.

Also, as Gombrich and others have pointed out, most art comes from art, from reworking earlier themes, and is contemporary restatement of older visions. Robinson's photographs are revisions of genre pictures from Spanish, Dutch and English art.

Cameron made illustrations, as well as portraits. Functioning out of the pervasive Keatsian ambiance that truth is beauty and beauty is truth, believed by many of the Victorians, she made a number of illustrations of contemporary texts and Victorian precepts during the middle period of her work, about 1865-1869. Many of these showed idyllic children. The technical mannerisms that move us in her portraits seem affections imposed on children. The children are shown in the manner of Italian paintings. Pre-Raphaelite Brotherhood female figures frequently appear in her photographs. Her illustrations suggest the stage, much of the time. Yet her illustrations of the *Idylls of the King* in their very awkwardness somehow make the image momentarily believable, although one is never wholly convinced, and remains outside of the magic window, looking in on these moments of chamber drama.

This kind of staged picture—the photographer is designer, director, costumer and script-writer, and only terminally a photo-craftsman—has come again into favor, specifically in the works of Duane Michals and Leslie Krims. This kind of image-making is a revocation of the passive role accepted by the photographer for thirty years, the implications of which were that photographic art comes from a sensitive yet essentially passive selection of critical instants from world's the ballet. The photographer, like a *Noh* dancer dressed in black, assumes he has invisibility as he moves through the world; he never changes things, only observes them. Michals argued in an interview that photographers should think 90% of the time and only take pictures 10% rather than the reverse.

Returning to Cameron, one must look again at the portraits to realize her strength of vision. Compare her portrait of Carlyle with Whistler's portrait of the man, done in the same decade. She penetrates the surface of the Scottish historian, giving us a glimpse of his

energy, even of his thought; Whistler polishes, idealizes and diminishes him, transforming him into pattern—elegant, suave and safe.

In America in the 1870's the landscape became the principal subject for photographic art. Muybridge, Watkins, Jackson and others made photographs for sale in unnumbered editions, as handsome pictures. Muybridge published albumen prints of large format negatives, often 16 x 20 inches, and Jackson used plates as large as 20 x 24 inches in Colorado. Muybridge and many others also made stereo pairs of the landscape. These depended on a different esthetic than the large print; one's response is to an illusionistic deep space; graphic considerations are lessened. Formal considerations in the stereographic picture are minimized and replaced by a romantic participation in the sensual possibilities of the subject. One is encouraged to *walk in* to the landscape with the eyes, and for its time the stereograph was as startling a psychological experience as the large screen film is in our own time. The stereo image is being rediscovered today through holography, but has to date been limited by technical and financial problems. White-light holography permits full-color, illusionistic three dimensional images unlike any seen before.

The photographs sold by these men were both illustrations and art. They carry on primitive interpretations of art still common in our culture, which is a belief that art is documentation of what is there. One has the sense of being able to participate, to merge, as it were, with the landscape before the camera.

The search for accuracy is reflected in the studies of motion. Concurrent with the Muybridge motion analysis done in America and investigations of motion by Etienne Marey in France, the American painter Thomas Eakins also analytically photographed human motion. His studies were a means to verisimilitude in painting. He did not deny the existence of these photographs when he painted, as English painters had tried to do. We have portraits by Eakins done with the camera, and in paint; studies of a falling figure and subsequent paintings of divers. Both images have beauty—the photographs because they are straightforward, delicate and honest renderings; the paintings because they combine the search for realism and a formal awareness that is rare in Impressionism. Though formal consciousness is central to post-Impressionism it is usually accompanied by a loss of illusionistic reality.

It was in the 1840's that the first camera clubs appeared in London.

By the 1850's it was apparent from critical articles appearing in the press that the new photographic art was already dying, and yet the machinery of exhibitions had been established; they continued, more or less automatically. These photographic equivalents of the Salon presented luxuriously framed photographs—floor to ceiling, wall to wall, edge to edge. Hardly ever was a member of a club rejected, especially for taste. Photo copies of paintings were shown. It was suggested once that to purify the shows it be mandatory that the participant hang the negative beside the print, because there was evidence that people exchanged negatives. Not only were paintings photographed, but the majority of photographs were, in effect, copies of antique Italian painting. It was in reaction to this taste-lessness that H.P. Robinson, Emerson's follower George Davison, and others formed The Linked Ring in 1892. The Linked Ring was a secessionist group, divorcing itself from the esthetic mires of existing photographic societies. Like many dissident organizations, the reasons for its founding and subsequent efforts were not fully rational. Robinson was, after all, one of the best (or worst) of the pseudo-painters; Davison emulated Impressionism in his photo-graphs, even to using slit apertures so as to fully simulate the blurred vision characteristic of some Impressionist painters. Craig Annan was an etcher turned photographer. Their bonds were clearly closer to painting than to photography, as we know it. In fact when Frederick Evans was elected to this select circle in 1900 it was re-marked that Evans was one of the few *links* between their Salon and photography. By implication, one senses how far from photographic purity pre-Secessionist camera clubs must have been.

But The Linked Ring did become a rallying point for the pictorial movement in photography; it accepted F. Holland Day, Coburn and Steichen, Clarence White and other Americans into its halls. At the time Steichen was twenty-one and Coburn only eighteen.

In time The Linked Ring interacted synergetically with its American equivalent, the Photo-Secession, even to being accused of being an English branch when jurors selected an American dominated show, in 1908. Steichen exhibited 39 prints that year, including Auto-chrome color prints; Coburn showed 21, and Baron DeMeyer 28. Pictorial influences were great, so much so that one effect was almost to eliminate from the later shows the pure and chaste images by Frederick Evans, who had only one print shown in 1908. The Linked Ring was broken in 1910; a few of its members attempted to start anew. as the *London Salon;* Evans joined them and soon re-signed.

178

Photography as art flourished and found support in England in those eighteen years. But purposes and esthetics of the group were unclear except during a few moments when Steichen presented his impressionistic photographs of the Steeplechase, and Evans countered with the pithy comment that he did not wish to raise 'a monument to a moment.' This idea of the photograph being a record of the instant, which is a pillar of photographic esthetics, was confused with the pictorial effects of Impressionism, at the same time the other principal pillar of all photographic esthetics was maligned, which is the ability of the camera to record a sense of absolute detail. Predisposing attitudes on what the photograph ought to be seems to have prevented anyone of the time from discovering the possibilities of bringing these two together, as they were to be done later by Stieglitz, Strand, and Weston, each in his own way.

The Linked Ring was in its own right an offshoot of the renewed energy given to art photography by the young American, Peter Henry Emerson. His public discussions on the art of photography, and the simultaneous production of a large number of excellent photographs produced during the 1880's, excited many other young photographers into renewed activity in art photography. Emerson's *Life on the Norfolk Broads*, evocative of Millais, and perhaps Breughel, is also photographic art. His platinum prints have beauty and are still filled with a sense of life (see Portfolio).

An interesting contrast to Emerson is found in the photographs by Ducos DuHauron, a contemporary. He produced a number of photographs which are optical distortions, which do not translate reality into photometric perspective renderings, but warp it into new shapes (see Portfolio). DuHauron also invented a practical color photographic system. His distortions were ignored for the most part by later photographers, though Andre Kertesz made a series of pictures of the nude, just before the Second World War, using carnival mirrors to twist the figure into new shapes. Recently, other new pictures have been made, using fish-eye lenses or cameras with moving lenses. Charles Swedlund uses the sperical distortion of extreme wide-angle lenses (see Portfolio) to create photographs of the nude that greatly exaggerate the figure's natural convexities. Jim Alinder has used the moving lens of the *Panon* camera to shear the surface of reality and reassemble it into new relationships by moving the camera during the exposure, while the lens is rotating.

During the last twenty years of the last century, painters in France

used many effects of light, perspective and pristine rendering of detail naturally available to the medium of photography. Muybridge showed the world how a horse moves: Degas, Lautrec, Meissonier and others, including the American painter Frederick Remington, immediately began painting the horse in the new, technically correct postures. Eakins, Muybridge and Marey showed the world how men move. The Italian Futurists were to restate this knowledge in paint. The details of this interchange between photography and painting is thoroughly described in Scharf's *Art and Photography*, and Coke's *The Painter and the Photograph*. It is curious to note that as the painter moved toward accurate optical rendering (just before abandoning that altogether),the photographers moved closer to the appearance of paint. In the 1890's. Robert DeMachy revived the gum bichromate process, dating back to 1839, and skillfully made images that bridged the gap between the optical accuracy of the photograph and the manipulated surface of the painting. His effect was recreated by the introduction of the *bromoil process* at the end of the century. A gelatin print can be made more or less absorbent of oil, depending on exposure. The print is exposed, developed and tanned;printing ink is stippled on with a brush. The photographer controls the amount of ink, and the texture. The ink can be allowed to dry,or the fresh image transferred to a final paper support by pressure.

The photographic print became the starting point for a printmaking process. The result often resembled an aquatint, with the drawing having been accomplished by the light itself. The result was an image with the optical accuracy of the photograph, and with texture and soft detail not unlike post-Impressionist prints. Photographers had again confused the manner with the substance; of them all only Steichen seems to have had a strong sense of the architectural elements of the image that permitted an indistinct impressionism to make a lasting statement.

DeMachy echoed the style of Degas without pungency, in his photographs of ballet girls; and the style of Seurat, without structural tensions. Only in romantic images, where background gum dissolves into waves and swirls does the texture appear original and appropriate to the meaning of the photograph.

A short chronological summary of principal events in the flowering of photographic art that came to be called pictorialism, may help to

180

make clear the sequence of events:

1853—The Royal Photographic Society is formed.

1857—Rejlander shows *Two Ways of Life* at Manchester.

1869—Robinson publishes *Pictorial Effect in Photography*.

1887—Emerson awards Stieglitz first prize in the British Amateur Photographers competition, a year after Stieglitz began photographing. That same year, Emerson publishes *Pictures of East Anglian Life.* Emerson and Robinson entered into public hostility over definitions of photographic art.

1889—Emerson published *Naturalistic Photography* urging an impressionistic, rather than a linear and manipulated vision as practised by Robinson. This moved photography out of the Victorian, toward the French mode of vision.

1891—Emerson recants, publishing *The Death of Naturalistic Photography.* He had predicated his support of photography as art on the assumption that the photographer could manipulate tonal renderings in the print. Hurter and Driffeld taught him he was wrong, that one could not change the tonal scale (without manipulation) during printing. This discovery was to become the foundation on which the "straight" photographers built the doctrine that the real photograph is the pure, straight, unmanipulated photograph; this idea was carried to the extreme that not even local variations in exposure during printing were permitted.

1892—George Davison, H.P. Robinson, H.H. Cameron (J.M. Cameron's son), and others found *The Linked Ring.*
1893—The first photographic Salon presented by The Linked Ring, devoted to the complete emancipation of pictorial photography from the bondage of scientific or technical work. In Hamburk, Lichtwark founded the

International Exhibition of Amateur Photography; he showed 7,000 photographs in the city museum arguing that the exhibit in the museum would revive tradition-ridden mechanically dull portrait painting. The Photo-Club of France showed the first Exhibition of Photographic Art. It was juried by four painters, an engraver and a sculptor, the National Inspector of Fine Arts and two photographers.

1898—The Philadelphia Photographic Society Exhibition in the Pennsylvania Academy of Arts was juried by two painters, an illustrator and two photograpers. This show introduced Steichen, Clarence White and others who later became the central figures in the Photo-Secession.

1899—The Society of Amateur Photographers and the New York Camera Clubs consolidate because the are losing embers to the new fad of the bicycle clubs. The new group was called the Camera Club of New York. Stieglitz was elected Vice-President, and also made editor of *Camera Notes*, the Club's journal. That same year the Camera Club of the Capital Bicycle Club mounted the Wasington Salon and Photographic Print Exhibition. The director of the National Museum purchased 300 prints for the Museum. This exhibit depressed Stieglitz, who noted that only about 30 of the 480 entrants were refused. The fad of photography was waning. It was more important to the club to maintain membership than to offend members by refusing to exhibit their pictures.

1900—The New American School of photography exhibit in London was arranged by F. Holland Day, and showed almost everyone except Stieglitz. The exhibit was attacked by Emerson, who said the Americans were becoming pseudo-painters, and violating all tenets of pictorialism,

1901—Stieglitz was asked to assemble an exhibit. It appeared at the National Arts Club, February, 1902, Stieglitz was driven from the Camera Club because he had chosen to use his position there as a means to power; he

sued for re-admission, won, and then resigned. Under the name of the Photo-Secession he founded the journal of pictorial photography called *Camera Work*, which became his new platform from which to influence and advise.

1903-1918—*Camera Work* published, at first as the Photo--Secession pictorial journal.

Volumes 1-30 of *Camera Work* were essentially straightforward records of what was happening in pictorial photography, offered to the editor, or sought by him. The issues were illustrated by gravure prints made under the supervision of Stieglitz. The prints were hand--wiped, tipped in, glued on two and sometimes three different colored submounts. Some of the plates seem to have exceeded the original silver or gum prints in beauty. Most issues had seven to ten plates. A few had as many as fifteen. One issue offered color reproductions of Steichen's Autochrome plates. Another had color reproductions of Rodin's wash drawings of nude Javanese dancers. A third had color reproductions of Steichen's paintings. A fourth showed early John Marin watercolor abstractions of the Maine coast. Steichen's two-color gum prints, in russet and blue, or yellow and green, were reproduced with exactness.

After thirty issues on photography, Stieglitz in effect slapped his audience on the wrist with *Issue SN1*, which showed only Picasso, Matisse and other contemporary painting and sculpture. He had grown impatient with the dwindling interest and low intensity of pictorial photography. The artists illustrated had been shown in the *291* gallery. Issue 34-35, a combined issue, showed naked dancers drawn by Rodin; the reaction was that many of the subscribers cancelled. Volume 36 illustrates Stieglitz's own photographs, and drawings by Picasso. Volume 37 presented only D.O. Hill's portraits, holding up the sixty-year-old, recently rediscovered, portraits as examples to contemporary photography. Volume 39 presented Marin and Oroszco. Volume 40, Baron DeMeyer's portraits. Volume 41 showed Julia Margaret Cameron, and his own photographs again. Aside from Annie Brigman's nudes, in Volume 38, he had published almost no pictorial photography in two years. In Volume 42, and again in 43, he presented Steichen's photographs; Volume 46 offers only intellectual, abstract images, Marius DeZayas's caricatures. *SN2* is about Cezanne and other contemporary painters. The last two physical issues, Volume 48 and the combined Volumes 49-50 exhibit Paul Strand. The last volume shows only Strand. With that issue, *Camera Work* stops. He has 36 subscribers. After he closed the

magazine, his succession of galleries became the platforms from which he spoke to contemporary photographers and other artists.

Camera Work is both a journal of the times and a record of Stieglitz's own changing attitudes. The articles he published were witty, well written, and include a wide range of currently available critical thinking. S. Hartmann, for example, who had just published a major two-volume study of art history, and J.B. Kerfoot appear many times. Gertrude Stein appears here, the first place she was published anywhere. Others pass through the pages and disappear. There are both critics and boosters. Stieglitz published photographs he did not like, but which he felt were examples of a certain mature craftsmanship, for example the careful copies of Dutch genre paintings, made into photographs by Guido Rey; or the almost forgotten assembled and overpainted photographs evoking Baroque paintings, made by Herzog (see Portfolio).

It is not until the founding of *Aperture*, in 1951, that another such journal appears in this country—devoted only to creative photography, dominated solely by one person's taste and philosophy.

The life and work of Stieglitz was in effect a continual reinvestigation of photographic art, using whatever means were at hand. From 1886 until 1905 he made slide photographs in quantity, working with small cameras as well as view cameras, winning hundreds of prizes and being published frequently. With the increasing pressure of editorial work, and *291*, the gallery which became an adjunct to the magazine, he moved away from personal photography for a time, learning a new critical stance. He did not stop photographing, but the photographs were fewer; in retrospect the prints seem to be more solid for the absence of spare time in which to work. The *Steerage*, and the first of the O'Keefe prints date from this period. Pictorialism wanes. His own images become increasingly crisp, spare and unconcerned with story. The cessation of the magazine permitted him time to photograph; in the closing years of editorial work he had evidently come to a final understanding of what photography meant to him. The pictures from the 1920's are increasingly spare. They require the viewer to invest more psychic energy than any photography which had existed before had ever dared to ask. This coincides with the second period of his galleries. They were sales and exhibit spaces, but also were forums in which he could listen and lecture, prod and advise. The last period is the summation (and fading) from the middle 1930's. He is alone; O'Keefe had left; he no

184

longer made photographs; the culture that had supported and responded to him lost interest.

He supported the pictorialists because they were in the large doing the best photographic work available, but privately he practiced a different photographic art, combining the best of pictorialism and of straight photography. The actual subject often is an ambiance, the mood, the pattern of light and dark, and the effect these generate in the viewer—not the illusionistic transcript of surface reality.

Many of his best pictures he called "well considered snapshots." The picture was made in an instant, with a handheld camera, yet it is visually solid, and a well conceived image. Optically, he fractured illusionistic depth, pulling the eye's attention back to the picture plane, making it aware of the synthetic reality of the print. As time went on, starting about 1905, he increasingly used a gestalt relationship dependent on intellectualization of shapes in the print, to create new secondary meanings.

The literal event began to have a life of its own: a ferryboat pulling away from the pilings can be seen as the negative of the shape made by the pilings in the foreground; the pilings become people, the people become light (anonymous as the people of the boat are anonymous); one is momentarily uncertain of what is fixed and what is moving, what is static and what is in passage.

In all his photographs there is a sense of overall pattern, characteristic of the pictorialists in theory. On examining the hundreds of illustrations in *Camera Work* one becomes aware that pictorialist photographs are usually pleasing constructions that merely focus attention on a particular area of the print. Most photographs from the early issues have a *locus* about one-third the way over from the right, and one-third the way down from the top. Stieglitz violated rules that supported such pictorial image-making. His pictures involve the entire picture space; he makes our eyes move with the rhythms he perceives.

These visual rhythms can evoke other responses. Ocassionally he assists the viewer with a title, as in the photograph entitled *Dancing Trees*. The subject is trivial, being the bark of fruit trees seen against unfocussed background. He has taken an anonymous and insignificant subject, and by translating his perceptions of its joyful rhythms he offers us a way to participate.

photography as art 185

The cloud photographs do much the same thing. They are an anti-dote to pictorial excesses. It is interesting that, on the surface, similar terms could be used to describe Robinson's assembled prints and Stieglitz's cloud pictures: *they were made to evoke certain emotions in the viewer*.

The emotion in Robinson's work is explicit and narrative, the emotion in Stieglitz's photographs is non-narrative in the sense that music, in its pre-Strauss state, produces non-narrative emotional responses. After the First World War, it is evident that anything could be photographed by this man in such a way as to produce images that provoke emotions, tensions, new understandings in the viewer, and yet are not explicitly pictorial or narrative.

His work culminates, were one to choose a specific image as exem-plar, in the photograph *White Porch with Grape Vine*, made in 1934. In terms of the history of photography as art it is a touch-stone. The subject before the camera is the architecture of the porch, a bank of dark grape leaves, and the light itself. In effect, the building is anonymous; the structure of the picture is immaculate, every part being seen and felt and used. There is no sensation here of the instantaneous, but of a monumental timelessness. This print creates the sensation that nothing could be changed without having to start over again to rebuild the entire image. The tricks of Stieglitz's photo-graphy are here: *hooks* to catch the eye, irritating interruptions of the frame's contour that remind us the image is flat. But most obvious is the careful arrangement of parts; lines meet exactly, as though engraved. The parts of this picture are as carefully seen as the parts of the photograph, *White Fence*, by Strand. But composition is not all. The grape leaves at the base of the picture are as silent and ominous as the shadows in the late New York cityscapes. This picture has no specific subject for us except its evocations; a photo-graph that is an act of faith because it presumes a literate, responsive, audience able to read it. This picture stands for a body of photogra-phy, a personal art, one not dependent on repetitive gestalts to win easy recognition. His photographs open a new world to the imagina-tion; to any degree they satisfy the requirements of art—work created as a personal vision, not made for other purposes, and then discovered to have values as museum artifact.

Stieglitz avoided the hazards cited by Kenneth Clark, neither becoming sterile through discipline, nor vulgar in romanticism. There is sensuality and intensity of the romantic, and the analytical balance and structure of the classical esthetic. A similar balance,

though colder and less passionate, is found in the work of Paul Strand, whom Stieglitz encouraged and published in the last issues of *Camera Work*.

Strand's pictures are always strongly graphic. One is aware of graphics as much as of the subject. A comparison might be made between his photographic compositions and the Bach 'St. Anne' theme in the *Organ Mass* in that both works are aloof, spare, intellectualized, and yet passionate. Strand speaks of the need to know the subject thoroughly before photographing, and in his writings on his own pictures he discusses honesty between the photographer and the subject. "To him the object is all important," wrote Leo Hurwitz, quoted in *Paul Strand, A Retrospective Monograph, The Years 1915-1946*. The first pictures of the first volume, and the last pictures of the second volume, dated 1968, do not differ in this essential. There are differences in our responses to various subjects, depending on individual interests and taste. The structure of the pictures is affirmatively uniform. Some object is found to be a fit subject; a print is made as a product for the eye; the photographic vision is the sum, the interaction of these. His photographs reveal a personal calculus, placing him close to Frederick Evans' monumentality. Unlike Evans, he is willing to make a monument of a moment; indeed, the photographic moment is essential to Strand's vision. From the wall-eyed glance of the *Blind*, to a Rumanian steelworker's downcast gaze, the gestural moment, choreographed though it is, is essential to Strand's effect. Strand performs in photographic measures: optically correct, unmanipulated photographs honor the medium, and there is never doubt of the unique esthetic effect of a chaste use of the camera and film.

Once the reaction to pictorialism was firmly stated, in photographs by Stieglitz, Strand, Renger-Patzsch, Weston, and others, the need to produce only straight pictures seemingly disappeared again.

Pictorialism was scarcely gone when artists began using photographic methods to create new manipulated images. In the 1920's, in Paris and in Germany, young painters began experimenting with photography. Experimentation came in part from the original Dada movement, in itself an intellectual attempt to clear the art world of obsolte sentimental furniture. Other experimentation came from didactic experiments in teaching, at the Bauhaus. Some came from theater and from other types of illustration.

Francis Brugiere, working in France and in New York, created photographs in which the figure was painted over, in part, to imitate a

cubist painting. More important, he created photographic prints from non-camera negatives. These were renewals of the *cliche verre*, first used by Corot to make photographic prints from his drawings; the original technique had been to draw a stylus across fogged emulsion, then print the clear lines onto photo-sensitive paper. Brugiere used syrups, grease and other translucent materials on glass, creating patterns of differing densities. These accidental and gestural transcriptions were used as negatives. Variations in density of the syrups created grey patterns and shapes, unpredictable and unseeable before the print was made. The cameraless image dates from Wedgewood; it was used by Brugiere not merely to copy shadows of the world (as seen in Talbot's photogenic negative drawing of a leaf in the Portfolio), but to create images suggesting new possibilities, not unlike the stained-wall fantasies mentioned by Leonardo. The visions possible in his complex prints were given names like *The Ascent of Mt. Everest*, a suggestive title that leads the viewer into an interpretation of the image.

In the 1920's all barriers between media were broken. This breakdown affected the major artists of Paris; lasting work was produced and fresh vision possibilities were created by fracturing conventional limits. Earlier, Picasso had collaged a photographically copied piece of cane chairing, enlarging tactile surface possibilities by *collage*; the use of photographic illusion intellectualized the graphics of drawing illusion, but was then abandoned. Man Ray, in 1921, wrote to a patron in Bexley, Ohio, that he was preparing a set of prints which he would make without benefit of camera, letting the light draw itself. He commented that he had to keep his technique secret until his first Paris show because of professional thievery practiced by Paris artists. He had his exhibit; it was a success; the *Rayogram* soon appeared in Germany as the *photogram*.

Of course the direct drawing of light was not new; in fact it was the first method used by Talbot, literally photogenic drawing, copied from Wedgewood, Schultz and others. But the shadows of twigs and leaves and lace had not been deliberately used since then by other artists.

Lazlo Moholy-Nagy used the photogram as a teaching tool, to introduce his students to graphics and photo materials, as well as a creative way to make a unique print. Other non-representational photo image methods were developed. Brugiere used cut paper to make non-representational compositions; he photographed these and changed their meaning by changing the light. Such light modu-

188

lators later appeared at the *New Bauhaus*, in Chicago. Primacy is not the matter here: the times held these things in common. These techniques were "New In the Twenties" as Peter C. Bunnell described them for the Museum of Modern Art exhibit: assemblage of news print photographs linked by drawn lines (by Moholy-Nagy); drawn and painted upon prints (by Brugiere); Rayograms and painted-on photographs (by Man Ray); photograms and paper modulators (by Moholy-Nagy and Brugiere). Some of these reappear, as in recent work by Frederick Sommer who uses razor-cut paper to create forms which only the camera can see as images. He said, "You can stand right beside the camera and not see what the print will look like."

The photograph was no longer concerned with transcriptions of the surfaces of things; photographers had taken Paul Klee literally, making the invisible visible. This sort of image often excites us only because of the assumption of photographic esthetics, that the print is an image of reality. If that assumption is untrue, the response is different, and the print is formally judged as graphics. Many of the pictures from that time fail on this ground.

Sommer used a variation of the *cliche verre*, smoking glass over a spirit lamp and lifting off part of the carbon patterns with transparent adhesive tape. This is then used as a negative in an enlarger, as in *Paracelsus*, seen in the Portfolio. He also assembled small sculptures, and photographed them. Van Deren Coke once argued the sculptural assemblages themselves ought to be exhibited, to which Sommer replied that the photograph was its own reality; in the presence of the small constructions one felt something very different than when one viewed the photograph, and so the criticism was unsound, he said. The photogram Rayogram cut paper modulator, *cliche verre*, smoked-glass negative are all combinations of a gestural/intellectual art, photographic printmaking. There is no way of exactly predicting the results as a moving light illuminates photosensitive paper. Judgment becomes dependent on individual response to gesture, for there is little possible relationship to a narrative art. The gesture of the hand in this kind of print is, however, very like the selective motion of the eye, seeking an image structure from the surface chaos of the world. Photograms by Moholy-Nagy and his contemporary photographs made looking sharply *up* or *down* flatten space and transform solids into patterns; they reflect similar kinds of vision. In Man Ray's work there is a sensuous eclecticism, an amateur vitality that makes it work difficult to describe and catalogue. His work is full of puns, and gentle jokes; there is a published photogram showing the shadow of a gyroscope

with a contact print of movie film. The implication seems to be that which seems to stand still is actually moving; that which stands still will actually appear to move.

Man Ray made copy negatives of what he considered to be his best Rayograms and in 1924 published an edition of a dozen of them. The porfolio was priced at $150.00 and the edition was sold; Man Ray renewed the edition concept for photographic prints competing in the art market. Portfolios of photographs had been available earlier, of course, but marketing a photographic print set, of images without illustrational connotations, was new.

The struggle to establish photography as a medium of art has been argued each generation. It has depended on constant redefinition of the medium, and is susceptible to an attack based on the shoddiness of commercial and illustrative technicians who quite naturally produce the greater quantity of photographs, flooding the market. Each generation has had heroes in this struggle, photographers who have created photographs imbued with lasting qualities. Cameron, Hill and Stieglitz alone provide a foundation to which later work can be referenced. The Pennsylvania Academy of Arts exhibit, the Photo-Secession exhibit at the National Arts Club, the Buffalo Exhibition of the Photo-Secession in 1910, all seemed to promise cultural acceptance, and yet in 1930 Weston was reviewed by a *New York Times* critic, recapitulating a seemingly inevitable attitude separating the photographer and the "creative mind of the artist." This attitude was restated in a *Time* review in 1965, that 'photography is a genre art,' and in *Newsweek*, April 1972, quoting an anti-MOMA demonstrator saying, "but photography is not a fine art!"

Pictorialism died with the First World War, in both America and in England. The Linked Ring was broken about the same time the Albright Gallery showed the Photo-Secession retrospective in Buffalo. That exhibit was followed by prophetic note in *Camera Work*, written by Klingsor (an editorial pseudonym taken from Nordic mythology), suggesting that the battle was won and the army would disband; in effect the war would be lost. Klingsor was right. The trappings of pictorialism continued; photographic art in America was devalued, except for Strand, Sheeler, Weston, and Adams, who carried a crisp new vision forward.

The last protaganist of the gum print and manipulated image was the

190

photographer William Mortensen, whose marvelous and horrible combination prints were published from the early 1930's late into the 1940's. A vivid dialogue between Mortensen and Weston was published at length in the editorial columns of *Camera Craft*, a magazine published in Los Angeles. And, Mortensen is quoted in a letter to the editor of *U. S. Camera* in 1941, saying that after seeing a P.P.A. salon he was glad he hadn't been exhibited in such dull company. This dialogue in effect began with DeMachy, arguing the validity of the straight print with Frederick Evans. Evans doubted that any manipulation, even varying exposure over a part of the print, was valid; this intense purity of means and an unflinching espousal of his standards in the face of a manipulative pictorial majority, was part of the reason for his departure from The Linked Ring.

Pictorialism gave birth to Weston. His nudes and portraits made before 1920 are not unlike most of the soft, blurred, pictorial photographs of the time with compositional details derived from Japanese prints. (See the portrait his first mistress, student, and sometime partner in his photographic portrait business, Margarethe Mather, made of him in 1919, presented in the Portfolio.) But in 1922 he traveled through Ohio, on his way East, and photographed the ARMCO stacks, in clear hard focus. This was five years after he had been elected to the London Salon, a high honor among pictorialists. He was 36 years old when he turned his back on pictorialism; his new work was essentially unpublished in the United States until the 1930's. During those ten years he assembled a massive spiritual biography, photographs out of his daily life that were both pictorially sound and photographically pure.

His life is marked by a passionate sensuality which controlled and drove his work, filling it with an intensity it still retains. The best description of this life is found in his own *Daybooks*, edited by Nancy Newhall. After the ARMCO plant photographs he printed from the 8 x 10 inch negative almost exclusively. The prints were made on platinum paper until it became unavailable, though many silver prints were made during the early 1930's. Occasionally he used a 3¼ x 4¼ inch negative, later a 4 x 5 inch negative, exposed with a reflex camera, to make portraits which were responses to a moment too fleeting for the stand camera. He turned his back on pictorial compositions, and summarized his own images by saying, "composition is the strongest way of seeing."

Weston has been a romantic hero in the faith and commitment to his

own work, the revocation of an established leadership position in a competitive field to turn to a new way of seeing, and in his liasons with handsome women, several of whom were also artists. Yet all this would merely be romanticism if his work itself had not also been the product of his energy, and revealed a vision that had not existed before. Weston can also be seen as a selfish, egocentric, bullheaded photographer with four children, an estranged wife, an established business, in early middle-age—who threw it over to go to Mexico and make photographs. He created a new esthetic, a great reputation, and several thousand masterful photographs, plus a way of seeing the world which has been accepted and emulated by hundreds of young followers.

In Mexico he rediscovered that for him the thing itself was the subject of the photograph: composition, film and print materials, and light were merely the means of revealing his passionate love of the world. This struggle to translate the sensual stuff of the world into a photograph was plausible if one allows the photograph to evoke in the viewer a sense of participating in the vision. The act of photographing becomes a mystical experience, directed toward the nature or essence of the subject. Weston's photographs exhibit a humility in the presence of the subject found in almost no other photography. Where Stieglitz used the warp of appearances as a support for the fabric of his imagination, Weston honored the completeness of the world, sufficient to itself.

There are few mannerisms in Weston that can be borrowed; the technique is naked and simple. With the large view camera it was possible for him to visualize the image before the film was exposed. This can be understood to be a reaction to the pictorialist esthetic, where the negative was only a starting point for a print. For Weston, the negative was unalterable, a complete picture.

He was aware of equivalency, of metaphors within the image, but had reservations about the amount of reading into the image that was acceptable. In his visit with Stieglitz he was disturbed at the attention the older man gave to 'irrelevant detail' and admitted he often did not know what Stieglitz was talking about. Whether he would have felt the same later in life, we do not know. According to his *Daybooks*, he was delighted when a metaphor was expressed, as when cypress roots shimmered like fire for Diego Rivera, but uneasy when others found explicit symbolic sexual references. His attempts to deny the existence of sexual metaphors in his photographs of peppers was rebuffed; perhaps because intellectual responses in the

192

time he worked were marred by second and third-hand amateur recapitulations of Freudian theories of symbols and signs, relating to sex.

Weston the photographer made one see the world anew. His selective eye combined with his craftsmanship transformed reality into the print, realizing otherwise unseen vistas,hills, valleys, or worn rock beauty, which had not been discovered. Standing by the photographer in the presence of the subject a viewer would not have had the esthetic experience found in the presence in the photograph, because the act of photographing transforms reality into image. This differs from the esthetic effect of large documentary lanscapes by Muybridge, Bierstadt, Adams and others who deal most often with subjects which are in and of themselves esthetic events, natural performances eliciting a primary response. Weston's seascapes reveal this in another way: the choice, the selection of an instant out of an unbroken continuum, is the photographer's vision, and it is not simply a sensuous record of a natural event.

The photographs made after 1945 on Point Lobos reinforce a subtle change which had begun to appear in his prints as early as the desert photographs of the 1930's. They are not unlike the lateVan Gogh paintings in that the rhythms of the subject are reinforced, selectively represented so they take on their own life. It is in landscape photographs made on Point Lobos that appears the germ of the photographic mode later nourished by Minor White; the significant detail was restated as the equivalent, similar to the idea by Stieglitz. but not identical to it. The subject of the image is always seen for itself, and also for what other possibilities are evoked. Image becomes ambiguity. Trees are trees, but they suggest other shapes, perhaps can be seen as birds, or snakes. The image suggests poetic dualities; a dead bird flies, a rock offers a promise of birth. In Weston's later photographs there is almost always ambiguity; one is never positive that only the the thing before the lens is what was photographed, for there is always the sense of other presences.

The prints themselves change in the 1930's. Weston began with platinum and changed to silver-chloride contact papers before the War. The print materials he used approximated platinum, were warm-toned by contemporary standards, and had a pale yellow undercoating. According to Cole Weston, he used *Haloid* paper just before the War. After the War, harsher, more brilliant papers were on the market; he utilized them and to a degree adapted his vision to the

print papers being made. The pictures seem to have become slightly more graphic.

Ansel Adams is younger than Weston, but their lives overlap. He is a major influence in contemporary photography, through both his work and his teaching. His long association with straight photography has helped its maturation. Adams grew up loving Yosemite valley. The valley itself apparently had a therapeutic effect on him as a youth; he once remarked that living and working there in his teens gave him a sense of purpose at a difficult time in his life. Trained as a pianist, he brought a musician's control of tools to photography; a musician knows wrong notes will be heard, and that only frequent, regular, arduous practice and investigation of his technique will permit a correct performance—if not insure that performance becomes art.

In 1935 he published *Making A Photograph*, a clear and lucid book describing basic practices of straight photography; it made them seem simple. Since then, Adams' work has been divided between teaching and photographing; his name is known to many thousands of photographers through the *Basic Photo Series*, a set of five volumes. These helped establish Adams as a major teacher of silver photographic processes. The books came after long teaching experience, in colleges and in a number of Yosemite workshops. The summer workshops were organized in Yosemite Valley at the suggestion of Tom Maloney, then editor of *U. S. Camera*, and of Adams himself. The *Yosemite Photo Forum* first met in 1940. The teachers were Adams and Edward Weston. The workshops were discontinued during the Second World War. They began again in the 1950's, after Adams stopped working with the California School of Fine Arts, and continue through the present day; as the workshops have grown more popular, teaching duties have been delegated in part to assistants, many of whom have in turn made names for themselves in photography. Examples are Pirkle Jones, Gerry Sharpe, and Stephen Gersh. Adams' teaching is indicative of changes in the practice and nature of photography. The numbers of photographic students have risen steadily, at a rate greater than the total population, since the 1930's. Amateur photography was an enormous fad after the Kodak was invented, but direct involvement with total control of the chemistry of photography had decreased steadily into the 1930's, and then was frozen by the shortages of materials created by the War.

Few schools offered photography before the War, and then as a

194

technical discipline. It is true that Harvard offered photography before the turn of the century, but that was soon dropped. The devaluation of photographic art concurrent with the end of pictorialism brought an end to other programs as well. The *Clarence White School* survived the death of the founder and was continued by the son. The Rochester Institute of Technology offered a program scientific and technological in nature. There were several well known commercial trade schools. It is with the experimental progam at the California School of Fine Arts, in San Francisco, that a program of photographic arts was first offered in an accredited school; like many programs of the time, this was dependent on the G.I. Bill students who filled all the campuses in 1945. The program was taught first by Adams, and then by Adams and Minor White. Even here, the teacher was a student; White describes briefly (in *Mirrors, Messages, Manifestations*) spending his first afternoon at the school listening to Adams lecture on the Zone System, and how the "whole muddled business of exposure and development fell into place." Adams' brilliant codification of the silver process assisted understanding and controlling photographic techniques and yet encouraged personal vision, within the limits of straight photography.

To Adams, the transcription from the subject through the negative to the print is like the transcription a composer makes of the aural subject—first to a score, then to the instrumental performance. The manipulatory element is implicit in selection of a subject and choice of the process of reproduction; quality of light relates to mode; contrast relates to dynamics; overall tonal placement relates to timbre. The discipline of the Zone System is alien to the romantic, expressionist artist; the Zone System has never overwhelmed American photography, which is by and large romantic and expressionist, to the point of being mannered. The System has lent itself to the academic structure of teaching photography, and has become pervasive. The original text of the System, stated in Volume 2 and 3 of the *Basic Photo Series (The Negative, The Print)* has been explicated in the *Zone System Manual*, by Minor White, and the *Handbook for Contemporary Photography* by Arnold Gassan.

Adams' argument for virtuoso control—technical control producing a seemingly effortless product—was the *coup de grace* to pictorialism; it also became a key to teaching photography within the academic form of the university. This is a side effect of his primary intention, which was to prevent common errors and permit a degree

of accomplishment impossible to achieve were one working out of intuition, habit or custom alone. *Moonrise and Half Dome* shown in the Portfolio, is an example chosen by the photographer from a large number of powerful landscapes; sky, rock, moon and daylight all are balanced, moderated, controlled.

His personal vision is monumental. Beaumont Newhall, in an *NET* film on Adams, referred to an 8 x 10 inch negative as a 'big performance' and it is true that many of his photographs resemble music prepared for and played by a large orchestra. The silver process is apotheosized in his work.

Ansel Adams has sold photographs for forty years, both in the form of book reproductions and in silver prints. This fact indicates he has been in touch with the taste of his time; a large part of his income comes from the sale of photographs, in contrast to the situation encountered by most art photographers, who must earn their living by teaching and have very small sales of prints. On the face of it, Adams exists in the popular culture, but less through bowing to popular taste than by molding it with the vigor of his art. One reason for this response to his photographs is because of the subject before his camera; other reasons are the techniques used, and the graphics of his prints. He does not fall into popular relationships with subjects that all too easily produce sentimental photographs.

It may be useful to compare Adams' work with the photographs by Frederick Sommer. Working in Arizona, Sommer photographed subjects that frequently offended his viewers: dessicated coyotes, dead rabbits, dehydrated bats, a fragment of a human leg. The subjects themselves disturbed one critic so much that for years no Sommer photograph existed in a major American museum, yet the total *oeuvre* was clearly not concerned with decay and corruption but with tension between the denotation of the image, the connotation of the subject and the evocative power of the print itself. Though he is a powerful straight photographer, Sommer occasionally deliberately misfocuses. There is no way one can simplistically relate to an unfocused image of a beautiful woman; she is obliterated as a specific person through misfocus, and exists only as abstract shape and tone. Elements of the surreal esthetic are involved in this. The *cliche verre* images he creates by smoking glass, or using heavy oil on glass (see Portfolio) also become surreal, suggesting illusionistic possibilities while remaining light tracings of the actual substances used to make the 'negatives.'

196

Sommer's photography is an example in the ongoing critical confusion between the subject matter before the camera, and the work of art itself. Because of the apparent perversity of subject matter—dead animals, assemblages of dessicated bats—the lyrical beauty of the final object, the print, has sometimes remained unnoticed.

Aaron Siskind turned away from the social landscape after the Second World War. He produced a series of abstractions from nature, rocks photographed along the New England seacoast; these pictures earned him harsh comment from New York critics concerned only with documentation of political/social reality. In the 1950's he made a series of pictures entitled *The Pleasures and Terrors of Levitation*, made by photographing an athlete rebounding from a trampoline; he lighted the subject with electronic flash, and printed it so that there are no background tones. The result is postures that defy gravity. These photographic realities could not be perceived were one in the presence of the original subject. Images of this same sort (where the eye and the camera do not share a common vision, but the camera reveals a vision to the eye) have also been made by Barbara Morgan, photographing dance, and first of all by the inventor of the gas-tube electronic flash, Dr. G. Edgerton (see Portfolio). Other variant possiblities of camera-vision have been created by using slow shutter- speeds, or multiple exposures; in all cases the esthetic is dependent on the fact the camera reveals otherwise unseen and unknowable realities.

Siskind's photographs are graphic; the *Levitation* series are also evocations that awaken our kinesthetic sensibilities to the possibilities of motion and by so doing produce momentary mimetic excitement. high contrast printing reinforces the graphic image and heightens the nullificationof gravity, of logical up-down orientation.

In the middle 1950's a new pictorialism appeared in American photography. The old pictorialist mode was long dead. Weston and Adams had thoroughly defined a new landscape vision; photographers on the Eastern seaboard were using the social landscape as their principal mode; a third school of photographic work appeared in Chicago, centered about the Institute of Design. This new work was dependent on the work of Siskind, of Harry Callahan, and ultimately of Moholy-Nagy.

Harry Callahan taught at the Institute of Design, which had absorbed Moholy-Nagy's attempt to recreate the Bauhaus in America;

Callahan later moved to the Rhode Island School of Design. He has worked solely with straight photography, in the sense that anything that can happen to the latent image, in camera, is acceptable; this includes multiple exposure. Moholy-Nagy, who had headed the New Bauhaus, had been quite free with scissors and paste when working with photographs, and perhaps was more excited by accidental events that happened in the photographic process (distortion of tonalities, changes of shape caused by flare) than by pure photography. Callahan shared part of this enthusiasm while retaining a purity of print that allies him to straight photography. Callahan renewed the possibilities of in-camera multiple exposure, used in New York in the thirties and forties by Brugiere.

Multiple exposure techniques were carried further by Ray K. Metzger (see Portfolio), who also shortened the tonal range, simplifying the image and echoing continuous-tone inverted-camera double exposures made by Brugiere in the 1930's. Metzger is one of the first photographers of the new pictorialism to consciously plan interactions of two or more adjacent film frames as exposed in the camera; he assumed responsibility for the entire strip of film in the camera. The roll of film is a continuous emulsion, though it is usually treated as separate compartments. He pre-planned relationships between frames; the intervening frame lines became part of the image itself. Metzger extended image assemblage by enlarging a single image, fragmenting it, repeating it, and assembling a mosaic composite from the parts. The mural print shown in the Portfolio example is an emotionally cool disassociation of the photographer (and the viewer) from the illusionistic tactile image of the nude previously associated with photography.

Another possible image assembly technique is chance-operation: exposing a role of film, then rewinding the film in camera, and rephotographing on the same emulsion. The effect is to create semi--transparent overlapping images of people, textures, signs, shapes that modify one another in surprising ways. Perhaps this reflects the Dada disdain for genre art, but in fact probably comes from aware-ness of the exhaustion of major modes felt in the 1960's, and a search for new image possibilities—without concern for their effect other than as sensation. It is possible that some of this imagery comes from the knowledge of hallucinatory vision available through drugs, now a part of our cultural vision norms.

Chance operation in photography appeared early in the Chicago schools: Callahan used a small camera with wide-angle lens, held at

198

his side, and exposed more or less at random in downtown Chicago. The effect of the pictures was to create a new, strange reality seen from a low vantage point, greatly distorted by the lens itself, creating unpredictable relationships.

It is in the 1950's that the roots of a new pictorial mannerism appears, which now seems to be the major concern in the medium. It is an emotional struggle to define the limits of the medium in very personal terms, no matter what tone of voice must be used.

Almost all the art photographers following Weston have made their living by becoming teachers of photography: Minor White, Callahan, Siskind, and then Uelsman, Metzger, Welpott, Heinicken and others are all (fiscally speaking) primarily teachers working to support their art.

Photography entered the schools and changed the nature of photography. This happened after the Second World War. Photography was no longer taught by the apprenticeship system, except in commercial areas. Almost all the art photographers since 1950 have learned photography in schools and universities. In the early 1950's the esthetic attitude could be simply defined as 'East Coast' or 'West Coast.' East Coast schools used the small camera, focused on people in the city. West Coast schools used the large camera, produced 'fine prints,' focused on the landscape and tended to show pictures without people.

The East Coast photographers carried on, wittingly or not, the traditions of the Photo League and other groups of the 1930's who had hoped to modify social conditions by a use of the camera. The Chicago area brought forth a number of design-oriented photographers, drawn to the formalistic concerns of the New Bauhaus.

Minor White did not only work as a teacher in an established school. He had been given a commission in Aspen, in 1951, to create a new magazine, one to provide a new *Camera Work* to replace the publication/platform for art photography provided by Stieglitz. The committee included Barbara Morgan and Ansel Adams. The result of their work was *Aperture*, commissioned in 1951, and first published in 1952. In 1955, White moved from San Francisco to Rochester, taking *Aperture* with him; he joined the George Eastman House staff, and then began teaching a series of experimental classes at

Rochester Institute of Technology.

White's work is available in reproduction both in *Mirrors, Messages, Manifestations*, and in *Aperture*, in which the photographs are either his own or reflect his immediate concerns, his attitudes toward photography. Since the Second World War, White has been most concerned with the evocative power of the photograph. Not on the simplistic level of illustrative drawings in gestalt reference books—two shapes become a face, or a vase—but on the level of poetic metaphor, where things photographed remain what they are, and can also be seen for 'what else they are.' The original subject and a metaphoric subject almost always coexist in his photographs, and this duality is often the actual subject of the photograph.

Concurrent with investigation of alternative meanings, sought and discovered, was his search for an increased evocative power in a group of carefully arranged photographs, called *sequences*. One of his early major efforts in this mode was *Intimations of Disaster*. The original version was on three large masonite panels. The photographs were glued edge-to-edge. The arrangement was awkward: implicitly, the photographer required the viewer to look at each image separately, yet to relate the evocations available from each image to the next; the physical pattern of the whole object, seen as a set of panels, was not well stated. Later, other solutions were tried—slide sets, framed sequences, portfolios of separate prints seen one at a time, and printed reproductions. Each method has had virtues and faults. The historical importance of *Intimations of Disaster* is that for the most part the objects before the camera were trivial; they required the viewer to invest their images with emotional energy drawn from himself. The last image, for example, was of a wheel-barrow overloaded with long vines and weeds; the gestalt implications of the irregular radial lines evoked a metaphoric image of lines of light from an exploding rocket, or more sinister parallels to violence.

White has an importance in the history of changing photographic esthetics in part because of his control of exhibition and display facilities for almost twenty years. *Aperture* reflected his taste alone; at Eastman House he affected the choice and display of new photographs, and at M.I.T. he has expanded this work into a series of monographs, catalogues of exhibits that were assembled to illustrate particular ideas. These are historical extensions of the single-critic shows begun by Day and by Stieglitz (with the Photo-Secession) continued by Steichen (at the Museum of Modern Art) and are now the mode of contemporary museum photography.

200

White's work raises anew the question of how much was intended by the photographer, and how much is read into the picture by the viewer. This is an especially difficult problem for the photograph, which creates automatically a sense of believability; contemporary photographers are unclear as to whether the photographer is responsible for the content of the photograph, or whether he simply fabricates an exciting object, one which because it is part of the contemporary scene is therefore an acceptable social document. "Acceptable" or "unacceptable" are parts of an ethical, not an esthetic question, hinging on the effect the photograph may have on a viewer as a social creature, not on its effect on the viewer as an esthetically responsive witness. White is firmly committed to an ethical posture and believes in photography as a means to self--investigation even more than as a tool for making an esthetic object. His photographs become iconic, meant to be studied, puzzling out the possible meanings, and eventually must be understood by each individual by a balancing of the experience of the image with thinking about the possibilities the image suggests.

Minor White's photography cannot be separated from his work as a teacher, as an editor, and as a writer. There is a parallel between White in the 1950's and 1960's and Stieglitz in the second and third decade of the century.

White came to maturity during the depression, before the War; there was a period of about ten years after college before he found work as a photographer, documenting the Portland, Oregon, cityscape; it was another ten years, broken by the War, before he found himself in a position which permitted him to begin mature work as an artist. He found a photographic expression which was not imitative, did not wholly evoke other's work. Before the War his pictures were documentary and poetic, reaching for effect; after the War he created a psychological portraiture, and began to control the linkages between images. His early sequences, mounted prints bound in grey portfolios, are visual equivalents of expressionist poetry. It was only with the creation of *Aperture* that he directed his attention to an anonymous audience, one that would not be able to provide a direct response (implicit in the early photographs, circulated within a small circle). His work did not change markedly from that time until the late 1960's.

He mentions in *Mirrors, Messages, Manifestations* that when he went to San Francisco to teach, Adams met him at the train, and he went

to hear Ansel's lecture on the Zone System and suddenly gained insight into the tools of photography he had been using for fifteen years. The experience he described relates vividly to the Zen teaching experiences he admired. His poetry and this discipline combined to produce a new photography. His work has involved portraiture, as a method of seeking understanding of his own life and landscape photography in which the subject becomes poetry.

The founding of *Aperture* gave him an enlarged forum. It became a platform for propagating his maturing ideas about the intention of the photographer and the function of the photograph. Partly because of this esthetically narrow base, the magazine lost money for many years; the deficit was paid by a wealthy photographer who admired White's work. The subscription list was rarely more than 1800 until the middle 1960's, when the publication was reorganized and diversified by Michael Hoffman, a young workshop student. *Aperture* monographs began to appear, beginning with the do-or-die Weston monograph. That book sold well, and was followed shortly by the Strand *Mexico* portfolio, a gravure edition reissued from the original plates of the 1940 printing. Other successful books have followed, and though the magazine continues, it has taken a lesser role in the publishing firm.

First came the mandate from his fellow photographers, given to White in Aspen, to create a journal for creative photography that would do what *Camera Work* had done earlier in the century. The first few issues of the magazine were largely text, with a few illustrations. The writing came from fellow teachers and historians—Henry Holmes Smith, Beaumont Newhall, and Ralph Hattersley. In 1956, the ideas on "reading photographs" appear, and the already present concern for the metaphoric element of the photographic image dominates the illustrations and the editorial policy. Volume 7, No. 2, entitled, *The Way Through Camera Work* is the central issue of this period.

The issue is an assemblage of writings on and thoughts about Stieglitz, Zen, and early Gurdjieffian notes, combined with White's own prose-poetry, and illustrated with spare and evocative photographic images and keynoted by a calligraphic character (Ch'i) from the Chinese, relating to "The Breath of Heaven, the Spirit." The entire volume is an invocation to a commitment. It was at the same time that White wrote in a letter that he was no longer encouraging students to make "photographs for exhibitions, but toward inward investigation."

202

His private philosophical interests always directed the texture of the the magazine. From 1952 to 1956 *Aperture* was an eclectic journal, reflecting a spectrum of ideas on creative photography, and the then new problems of attempting to teach "creative" photography in colleges, places ill adapted to such investigations. The second period is from about 1956 to the middle 1960's, and is concerned with the investigation of meaning in the photographic image, specifically with attempting to determine the impact the photograph will have on the psyche, and the photographer's responsibility in that relationship. The poetic possibilities, the metaphorical implications, are fused to religious implications in both his photography and his teaching. Almost all the images published during these middle years are didactic; often, subject matter disappears or is peripheral (disappearance means that the subject is not identifiable without conscious intellectual analysis, saying to oneself "what would make that kind of texture, or shadow, or pattern?"), and the equivalents possible in the picture are the primary reason for the image having been selected. In his own work, this is perhaps most clearly shown in the sequence, *The Sound of One Hand Clapping*; the meaning of the phrase is dependent on a knowledge of a Zen *koan* of the same name.

By 1965, this personal function of *Aperture* had passed. During these years White said to a number of people that he would like to cease publishing *Aperture* in 1967, at which time the magazine would have had a life span identical to *Camera Work*; a definite metaphysical linkage was implied, and in fact there are parallels in their histories. First, they both recapitulated current trends, then they each turned away; an attempt was made by each at a new definition of photographic possibilities; lastly, there was a presentation of new talent, for example Meatyard, Caponigro and Chappell.

However, he did not cease publishing. *Aperture* changed; for a time it became a journal of young photography, then for three years was unfocused, its purpose unclear, except as an historical reservoir of imagery on which to base new understandings. One issue was a catalogue of early French photography; another catalogued highlights of a Chicago collection. In the last few issues attention is again being paid to coherent bodies of recent work; Caponigro, Nathan Lyons and others have been published in depth in recent volumes.

A comparison of *Camera Work* and *Aperture* offers some insights into the nature of the times, and the character of their respective

editors. *Camera Work* offered more reading and a large percentage of it was witty. The times apparently fostered literate responses to photography. White, on the other hand, found it difficult in his editing of the journal of mid-century to supply critical writing enough to fill even the thin issues of *Aperture*. Stieglitz had Shaw, Gertrude Stein, Hartman, Frederick Evans, and others who could talk well, write clearly and energetically discuss the problems of the day. Much of *Camera Work* is still readable. There is little of lasting literary value in *Aperture* and almost no wit or humour; nothing like the parody of the Rubyiat, singing the song of Kodak, that appeared in *Camera Work*. More important, there is none of the occasional devil's advocacy that Stieglitz permitted; he published both photographs and text with which he disagreed, but which was of itself best of a kind. In retrospect the later magazine is solemn and monotonic in its beauty.

Other publishing attempts were made in the 1950's and 1960's. Carl Chiarenza, in Boston, attempted to provide a broader platform in the sporadically published *Contemporary Photography*. The Carl Siembab gallery in Boston also attempted a journal of the art photography of the day. In the west, there was *San Francisco Camera*. As an historical, informational journal, George Eastman House offered *Image*, first as a simple documentary record of Museum holdings, then as an illustrated critical historical journal (edited for a time by Minor White, then by Lyons or Newhall). This version, with the same physical format as *Aperture* was discontinued. The magazine reappeared for three years in a large format; that was discontinued; then it appeared again in 1969 as a small booklet, again with a historical, resource-oriented editorial policy, edited by Tom Barrow .

In England, an effective magazine of photography and photographic history was published by Colin Osman and edited by Bill Jay, entitled *Creative Camera*. It was a rebuilt publication, having begun life as an English equivalent to one of the American photographic magazines appealing to camera gadgeteers. Jay left the magazine in 1969 and started his own short-lived publication entitled *Album*, which published thirteen issues of historical and contemporary pictures. In both *Creative Camera* and *Album* the rich eclectic history of the medium was recapitulated for young photographers who had never seen these historically important images, and who were barred from access to them because the original books in which they had appeared, or magazines, or prints themselves were in vaults or out of print. *Creative Camera* hired Scharf, Coke and Robert

204

Frank on occasion to write critical columns for the magazine.

At present there is in America no critical journal of photography. There are reviews in newspapers and some magazines which did not exist even a short time ago. Jacob Deschin's long-standing column in the *New York Times* was mostly a catalogue of events and equipment, though that was enough in a disinterested era. Recently, A.D. Coleman has supplied critical reviews for both the *Times* and *The Village Voice;* his reviews are balanced by those of Gene Thornton, also in the *Times* and by occasional references to photography by Hilton Kramer, who unlike most of the critics has never taken photography for granted. *New York* magazine published supportive comments by the well known critic, Barbara Rose; *Art Forum* has been reviewing photographic exhibitions since the middle 1960's, frequently using the writing talents of Margary Mann, among others, until painters rediscovered photography, in the late 1960's. The other art magazines have recently been forced into finding critics to write about photography, as photographic realism has become a new element in serious painting. The problem of a satisfactory inter--disciplinary terminology still exists.

There are a number of trade journals, for example *Professional Photographer*, a publication of the Professional Photographers of America; and *The Rangefinder*, a magazine published in the west, directed toward the professional portrait photographer. There are technical, engineering journals. And there are the popular magazines, directed toward the equipment-bound amateur—*Popular Photography*, *World Travel and Camera*, and the *Popular Photography Annuals* are all examples. But none of these truly view photography as an art, though the existence of art photography is useful to them; all of them lack discrimination of esthetic developments starting much after 1945. It must be noted that the introduction of photography into the university system has not to date produced a redundancy of critical talent, that is to say writers competent to observe and to analyze and write about photography as a contemporary art. Attempts were made by the *Society of Photographic Education* to begin a journal, but they were discarded because there was an obvious scarcity of well written articles, and historical studies, suitable for publication.

The history of *Aperture* paralled the growth of Minor White's photography, from the discovery of the poetic documentary, through the assemblage of sequences and turning the image away

from the original subject toward what the photographer, as poet, determines is the spirit of the subject. This work is recapitulated in the monograph, which is both a didactic autobiography and a body of photographs which can either be viewed for themselves, or related to the psychological investigations schematized in the biographical outline.

Several other photographers of the 1950's were concerned with "hidden faces," the possibilities of secondary images within the texture of the photograph. One was Clarence John Laughlin, who constantly responded to the double-image—the face in the stone, the fern that becomes a spider, an old doorknob that resembles the planet Mars. Perhaps this was in reaction to the metaphoric drought that seems to have been inherent in the strict documentary social landscape, the genre that dominated photography outside California during the preceding twenty years. Perhaps it was part of the romantic-mystical esthetic underground that has always been part of the American scene, exemplified by the painter Morris Graves. Dependent on allusion, treading the narrow edge of sentimentality and ultimately linking the image to verbal associaiations, the *phantast* photographers continue to make images, sometimes harking back to the rich heritage of Odilon Redon, sometimes to the sentimental possibilities of Mortenson. Part of the work of Laughlin came out of a need to revitalize the documentary accuracy of the photograph enhanced by the introduction of spirit possibilities. His work has been given to the Louisville University Archives by the photographer himself.

Young photographers have attempted to deal with the landscape in other ways. Paul Caponigro, for example, has created a contemplative photography of an unpeopled, timeless forest. The print in the Portfolio shows water and trees, seen for themselves and also transformed into mirrors and linear forms that float weightlessly. But on the whole the landscape genre has not drawn new talent lately, partly because it requires exceedingly fine technical discipline, and partly because in the search for personal statement it defies the manipulatory methods which have been the mode. The landscape does appear as a subject for abstraction.

A by-product of the university system has been to make the creation of a number of young photographers working in-the-manner-of a certain artist more evident than before the War. So many people are in photography than before the War, and that of course has an effect, but the consolidation of training into academically graded schools,

with the inevitable tendency to respond to what a teacher does in seeking approbation, has encouraged the development of stylistic camps. The Bay area has seen hundreds of young photographers photograph according to Margery Mann, "as though the penis had not been invented before 1965," producing endless quantities of male nakedness, tending to confuse subject with esthetic effect.

Ansel Adams, as teacher, has fostered a number of excellent photographers, all superb technicians, who apply the camera in a straightforward way. One is Gerry Sharpe, a documentarian of a high order, who was awarded a Guggenheim Fellowship in 1964, for photographing the Peace Corps activities in Africa. Pirkle Jones is another example of strongly teacher-influenced photographers, who worked with both Dorothea Lange and with Adams, and combines the best of each.

In the mid-1950's another kind of image appeared in art photography, photographs that superficially resemble the pictures made by White or by Siskind. The subject before the camera is often difficult to describe, or to paraphrase, but unlike White's pictures, the meaning is not easy to paraphrase, it does not lend itself to a verbal equivalent. Photography by Nathan Lyons, and later by a number of young photographers in the Rochester, New York area is quite dry, intellectual, and unconcerned with the esoteric or emotional content possibilities that concerned White.

Lyons brings to the camera a formally alert vision, trained by painting. He is important not only as a photographer, but also as a teacher, as a modifier of the attitudes of many young photographers working toward a definition of photography. He was the editor of *Image*, the Eastman House bulletin, and also was responsible for choosing and assembling photographs for the Eastman House traveling exhibits. He edited and assembled several books of photographic writings and prints, notably *Photographers on Photography*, and *Vision and Expression*. He resigned from Eastman House in 1969, and began a new school of photography, *The Visual Studies Workshop*, associated with SUNY at Buffalo, located in Rochester. The purpose of his school has been stated as an attempt to define contemporary photographic possibilities.

The sequence has been used by other photographers in art photography. Other sequence statements are possible, and are being investigated. For example, one of the few photographers who is not dependent on teaching for financial support, who works commercially to support his personal art, yet publishes enough of that to

make it pay is Duane Michals. He learned photography late in life; he was 35 when he went to Russia, and was urged to photograph while he was there. When he returned he found his pictures were marketable. Since then he has steadily sold portraits to large magazines. Beginning in 1969, he began making another set of pictures which tell a story print by print. They are terribly clear, unlike White's sequences which are equally obscure in a story sense. They are not quite pictures without words; each sequence story has a title that tells one where to begin. They vary in length from five to thirty-odd pictures, and illuminate Michal's gentle fantasies.

The pictures are meant to be seen one at a time; Michals mentioned that when early sequences were shown at the Museum of Modern Art they were matted all in one frame, which allowed the viewer to slide from the first to last without experiencing each intermediate step. Book presentation, where there is one picture per page, seems to have been the best form for his pictures; in fact Michals has refused to sell sets of prints to individuals, preferring the effect of the books, selling print sets only to museums.

A modification of the sequence form has been created by Leslie Krims. He published three sets of photographs which can be seen either as sequences, or as collections of closely related images. Three sets released in the spring of 1972 are entitled *The Little People of America, 1971*, *The Deerslayers*, and *The Incredible Case of the Stack O'Wheats Murders*. All are noted as being limited edition folios, but no information is offered as to the size of the editions. The small boxed sets of printed reproductions, each about five by six inches, offer a number of pictures centering on a particular subject. *Little People* are dwarfs and midgets; 23 photographs show them at play and at home. *Deerslayers* also offers 23 views, of hunters with dead deer tied to cars, photographed either by daylight or by flashlight. The *Stack O'Wheats Murders* is ten photographs, and the only set with implied sequencing, in that one image has the word *Wheats* written in "blood" on the floor beside a naked, "mutilated" female corpse. This image can be seen to be either the first or last image in the set, functioning either as title, or as terminal signature.

Krim's sets use responses developed to social landscape photography, and formalizes them, isolating the response from the original intention. He has printed the negatives on lithographic proof paper, which has an emulsion designed to produce only black-or--white tones; in a dilute developer it will produce a continuous-tone

208

image that has a peculiar granular harshness, and a definite chocolate- brown color. These prints remind one of the rotogravure detective-magazine illustrations of the 1940's. Duotone printing has captured the flavor of these prints. From the social landscape photographers of the 1960's he borrows the tradition of the "complete" 35mm image, presented with a small black frame. This originally was a by product, a desire to use the entire frame, and it resulted when the enlarger negative carriers were filed out to reveal the entire exposed area in the frame, and show a little clear film beyond. This small black line became a shibboleth of the 1960's, and an esthetic crutch. It implied that this was just the way the photograph was seen, that there was no cropping, no compositional second-thoughts. The black line also becomes a girdle, holding together all parts of the image; it solves for the photographer the problem of large blank areas in the picture frame. In Krims' photographs the subjects are all slightly sinister, staged and photographed with brilliance; he uses the mode of the social landscape to create a parody, a new pornography, not far from the *Barbarella* parody of the late 1960's, in *Evergreen* magazine.

For several years the most exciting young photographer was Jerry N. Uelsman. He revitalized the composite image, extending the technical and esthetic possibilities of the photomontage. Taught by Henry Holmes Smith, at the University of Indiana, Uelsman has himself been teaching at the University of Florida since completing graduate school. His happy and somewhat ironic motto has been stated as "Robinson and Rejlander live!" He brought an excitement and magic back to photography which it had lost. His images are psychologically evocative, yet they avoid the heaviness found in White's pictures, and of those who follow him; they are illustrative, but are not verbal. Sommer said that art is "images about images, not images about words," and Uelsman fits within this.

As of the time Uelsman appeared, in the early 1960's, the East Coast social landscape photograph had become repetitive and dull, the West Coast landscape predictable, and the Northeast photographers very serious. Uelsman appeared to be having fun with the world. Even were he not a superb craftsman,one would honor him for his joyfulness. He uses economical, technically simple methods to achieve sophisticated results. Prints are made by exposing them sequentially to different negatives, by exposing them through sandwiched negatives, and by exposing them through other prints used as negatives. Occasionally *cliche verre* techniques are used—for example, a lettuce leaf was used as a negative in the enlarger to create

a veinous pattern in a print.

He uses certain images over and over, achieving a personal iconology. The meaning of these icons is rarely simple to paraphrase; he has brought a richness of composite elements to each picture that defeat simplistic interpretation. The Portfolio illustrates his own choice of recent images.

With Uelsman, a cycle is completed. The photograph was adjudged as art in the last century because it was manipulated, by Rejlander and Robinson, becuase it simulated reality with apparent faithfulness and yet satisfied the Victorian ethos. In our time the sensation of faithful representation is cheerfully used by Uelsman to fabricate baroque visions. The dramatic aspects of Robinson's photography planning and assembling the image, reappear in Leslie Krim's chamber dramas. The sequence of illustrative action appears in Duane Michals little picture stories, as it appeared in Nadar's 100 years ago. The terrain of the medium has been circumscribed. The photographic art depends on the illusionistic possibilities of the camera and film to transcribe light, convincing us that the subject exists just below the surface of the print; the art depends also on the personal vision of these many workers; each see our world in a new way. By recording their vision with this facile tool they permit us also to witness it. The camera, used in documentary, surreal, or printmaking modes permits the private vision to become subject to, and part of, the public consensus.

RECENT WORK

Photography as art became more clearly separated from commercial practices after the Korean War. New technical developments facilitated this. The invention of the Polaroid-Land system of photography isolated the family photographer from involvement with technique; it also permitted the creation of a new kind of image, one not dependent on being judged by *fine print* standards. After 1925 and before 1950, photographs either were technically good, or were bad photographs. Standards of judgment were stated almost totally in terms of craft, at least in general-circulation magazines, in the isolated outposts of American art photography, and in the parochial, but seemingly deathless camera clubs. Camera clubs and magazines alike promoted sound technical performance, often over spiritual perception of the nature of the object before the camera, and before formal investigations.

The reasons for this flowering of photographic art are many. An affluent society was fundamental to the growth. Photography is expensive in terms of a definition based on optical crispness and the full-scale, full-substance silver print; it cannot be accomplished cheaply. The physical and financial surpluses of the 1950's, and the growing number of purchasers of new equipment who steadily depressed the absolute price of cameras of a given quality promoted the expanding medium. Also, the end of the Second World War saw the publication of a number of books of photographs by Weston, for example, *My Camera on Point Lobos*, and by Adams, on the

National Parks, plus the creation of *Aperture*, and the acceptance of photography into a number of college and university departments of art.

As long as photography was primarily a method to achieve a commercial object, the medium found difficulty in being accepted as art. This has parallels in terms of other materials and tools--welding, spray painting, resins, cast plastics, neon and fluorescent light--and also in terms of the current definition of what was an art object. The gallery definitions of art were overturned by painters of the New York School, though critical writings continued to proscribe photography and the airbrush until well into the 1960's.

Once the esthetic act was defined as a work of art, the art object was removed from an arena of judgment dependent either on representation or on polemic. Once the primary judgment shifted from story to gestalt, the groundwork was laid for an evaluation of photography as art. This does not devalue the previous accomplishments of photographers working within the strict limits of the medium achieving profound spiritual strength. Weston, Adams, Stieglitz and Strand forged monuments in a neutral age; Evans, Lange, Cartier-Bresson, Russell Lee and others saw into the spirit of their times and recorded that; they also created images that unforgettably hover on the edges of our sight. Man-Ray, Moholy-Nagy, Brugiere and Kertesz found new images that, though evocative of painting, have their heart in photography.

But the central arena of art had made its judgment, and it excluded photography, confining it to illustration or to decoration. As noted at the beginning of the text, this judgment was undoubtedly correct for the overwhelming mass of photographs. The world is filled with pictures. Craftsmanship in photography has always been confused with art, and is still a muddle in all professional photographic journals. Photography slipped into the art arena first as printmaking, and only secondarily as a unique relationship between the human eye and the world.

When photography was espoused by schools, it came into a structure of judgment that valued it as printmaking, as manipulation of shapes and tones and simulation of textures. Printmaking itself had been raised from a nearly moribund state, not unlike art photography, by the efforts of Lasansky and few other pioneers, who during the period after the War encouraged formal investigations that expanded the possibilities of the print medium relieving it from the tedium of

212

representation to which it had been confined.

This emancipation reflected the loss of commercial value of the illustrative print. Claes Oldenburg has said that his art is a discovery of the objects and processes which have lost their original life, which have now become unseen cultural monuments. This can be extended to processes; printmaking lost commercial value with the rise of photograpy, and became an art-process foremost. Photography lost prime value in the redundancy of the documentary publication inherent in television film, and became an art process. Film lost prime value with the shift to television and video tape processes, and became a medium in itself subject to art manipulations. Television itself is undergoing a similar devaluation with the redundancy of video systems now available.

The watershed years in this transition are the early 1950's when still photography was being supplanted by film and television. All photography before that (after the First World War) was judged by critical standards derived from commercial production; optical clarity accuracy of record, tonal sensitivity, illusionistic believability. After that time, these terms are no longer relevant to a degree. With the devaluation of the professional practice of photography there is an inevitable search for new esthetic standards. A byproduct of this is the mannerism and the new pictorialism in photography.

The photographs made after 1955 no longer respond to the same critical judgment as those made before that time. They refer themselves either to a critical standard which attempts to describe the spiritual accuracy of the photographic response to the event perceived, or there is a comparison of the photograph to other printmaking: to lithography, etching, engraving and relief, and also to assemblage and collage.

The effect of this turbulence is to dislocate critical judgment. The *fine print* continues to be made, but is no longer the *ne plus ultra* of photography. The *unique* print appears, which is the result of non--standard manipulatory variations of the silver print process: accidents that had been considered detrimental to fine print making are deliberately used, including solarization, image color changes caused by chemical fogging, dichroic effects, and even gestural painting with chemicals. Painters' methods are brought to photography; the print achieved is a kind of chemical painting.

The photograph has become a record of relationships the photo-

grapher has had with the materials, just as the painting became a record of the painter's dance in the arena of the canvas, with Abstract Expressionism. The standard of judgment no longer refers to a fine print; the fine print becomes anathema to many young photographers, a dull relic of photography's bondage to commercialism.

Concurrently, there are technical innovations that make conventional photography much easier to accomplish. For one thing, a competent print is often taken for granted, rather than being considered the product of a special discipline. Stabilized photo-printing machines appeared, producing excellent prints in less than thirty seconds. The Polaroid system was improved so that a usable negative is produced, one which, according to Ansel Adams, is capable of consistently producing a sharp illusionistic image 4x5 feet in size, if properly enlarged. The Polaroid color system made color prints available to all. Photographers found their customers in competition with themselves as more and more customers discovered that the Polaroid picture could be used directly, being effectively an exposure meter and proof print at the same time. Automatic processing machines and automated handling of color materials proved that most photographers need only to be able to see, need no longer be technicians. Hardly a portrait studio today processes its own prints; a typical central photo-finishing plant handles in excess of 20,000 rolls of color negative and transparency film each day printing many thousands of technically excellent prints for less than a quarter apiece, in terms of the actual costs of materials and chemicals.

The photographic print becomes ambivalent: it is both an object, and a record of a transaction. An ironic side effect of economic affluence is the object *per se* is no longer highly valued in our society. In a curious turnabout, collections of art objects and art prints increase at the same time. The number of print collectors increased rapidly during the 1960's. *Fortune* noted that the single best portfolio investment of the decade was not a stock but the Jasper Johns lithograph *Coathanger*, which has gained in value about 2,500% since it was published. As prints gained value, an unease about whether the print is an object or an event became more clearcut: a new market grew for the photograph, and the fine print object *as a limited edition item* assumed new importance. This in turn caused a renewed investigation of the photograph as print, that is as formal object. In 1969, this was reflected in a small but important exhibit at the Museum of Modern Art, assembled by Peter C. Bunnell. *The Photograph as Print* attempted to define for the moment what was

214

being felt but was not fully understood. The old standards were lost.

The major genres as noted in this text have continued, and are still viable. Social landscape has predominated, given new definition by Frank, and being renewed again by other variants of his vision. The natural landscape has fewer major practitioners. However, a new pictorialism is evident in the medium. The unclarity of the valuation of photography comes about in part because of the failure to understand what photography is, and in part because of unclearness about the photographer's intention.

For example, Lee Friedlander could be confused with many other photographers photographing the social landscape. He uses the 35mm camera, abstracts details from the complex visual environment of our civilization, and yet differs markedly from other photographers with similar approaches. The city and its people are the raw material for a surgical vision. Friedlander discovers things happening in our society not unlike those found by Gary Winogrand, but Friedlander works more slowly, organizing and deliberating. He maneuvers until he finds the right graphic relationships, and the resultant image is at the same time a 35mm snapshot and a careful, organized graphic essay, sometimes humorous, often a comment on loneliness. Friedlander uses electronic flash to control the light, deliberately violating the environmental light; there is much of the surreal in his work, and an equal quantity of the romantic. He approaches a tender sentimentality, though never falling into that simple relationship. Two books, *Self Portrait* and *Work from Two Houses* illustrate this. *Self Portrait* is a book of shadows, photographs of the contemporary scene containing the shadow, or faint mirrored image of the photographer; the pictures are an intellectual reminder that the image always equals the interaction of the photographer and subject, and the print is not simply a neutral, magic window. *Work from Two Houses* was produced with the painter Jim Dine; it combines Dine's etchings and Friedlander's photographs on each page, a somewhat forced, but interesting product of the inter--media experiments of the time.

There has been an increasing separation between the commercial/documentary photography and the photography of private psychological investigations and experiments. Almost none of the art photographers sell enough photography to make a living from this work. Yet it would accrue to our visual poverty if they were to cease photographing. Therefore, the intent of the photograph must be understood before it can be criticized. The photographer may be

working as a communicator, passing on information about the world, and his understanding of it, as Lee Friedlander does. Or he may be making a handsome object, one that is pleasingly composed and exciting to see, offering us a visual feast, as do many of the pictoralists. Or the photographer may be turning upside down the warning by George Sand, who wrote that *the life is nothing; the work is all.* Many young photographers have taken photography into their lives as a means of assisting a philosophy which might be paraphrased as *the life is the work.* In this context, the photograph is not so much a print object as a mirror for the investigation of the photographer's own psyche; the print assists him in judging the state and growth of that ephemeral organ.

Because commercial photography has had no use for these private investigations, they have found alternative outlets. Some of these have been the small galleries of photography, begun mostly on idealistic grounds, that last a few months and then disappear. Other outlets have been the vanity press, in which the photographer publishes himself, lacking the financial and organizational support of a large, established publisher. These publications have been encouraged by the recent creation of new distribution systems that bypassed the established commercial distribution, a system that would not accept input from one-shot publishers, because of the difficulties of finding a successful way to retail the books to appropriate markets.

Concurrently with this, the standards for judging the photograph as a print object have changed; the print has always been judged relative to the best commercial product: accurate rendering of detail; long tonal scale, brilliant blacks, clear, crisp whites are terms of judgment before 1955. This, of course, has not always been the case: these same terms were considered to be a mark of oppobrium during the pictorialist days, when the too crisp, too clear image was a fault. These times are upon us again, but now all image types live together at once. The long-scale image, and the gum print; the platinum and the gravure print; the silver print combined with acrylic painting, or vacuum-formed plastic all coexist.

The sources of this new pictorialism are several. One is the general absence of real knowledge of what a fine print looks like; few students have seen prints by Adams, or his apprentices. At the next level, an equally small number have seen and experienced fine prints by White, Callahan, Siskind, or their peers. The universities offering photography rarely have the money or the facilities to obtain or to

216

maintain collections of prints. Strangely enough there has also been a reluctance to amass such collections, implicit in an unwillingness on the part of *all* collectors to purchase photographic prints and provide archival storage. A second source of this new pictorialism is not ignorance of the limits of the medium, but a subtle hostility to the print as a precious object. This is mixed with young photographers' general hostility to any careful, disciplined craftsmanship, hostility directed toward 'traditional' or 'establishment' art.

A third cause of the devaluation of the accomplished silver print is the influence created by printmaking and painting, in which photographic verisimilitude has been played off against the gestural or manual possibilities of the painting or the print. These concerns were vigorously stated by the painters of the New York School during the 1940's and the 1950's, and then restated and made even more eclectic by Pop Art, and by the practitioners of Magic Realism in the last decade.

An interlocking relationship, affecting the purity of the print, is that of the photographer to the subject. For many years straight photographers carried with them a tradition that the photographer was an observer, not a manipulator; Weston commented to the effect that the best compsitions were in nature, no matter how carefully he arranged a pepper or a cabbage leaf. This unwillingness to manip ulate in any way appeared to become a sterile limitation. An understanding of the essences of things seems to require many years experience of the world, and does not come so easily as a more mannered statement.

Another problem is that definitions of art and the practice of artists have in themselves defined the relationship between the artist and the subject in a much different way than these have been used by photographers, especially in recent years. The photographer has for decades spoken of an accurate portrayal of the subject, and one finds references in Strand, Weston, Adams and White to an "honesty" toward the subject, exhibited by the photographer. This kind of relationship is often alien to the printmaker, who's concern is for the subject as a raw material, especially in recent art where the subject is used as a means to an art object. Photography, having been involved in a documentary relationship with the visual world, and always having been implicitly bound to sensitometric accuracy and transciption of radiant energy into precise visual equivalents, has not easily foresworn its concern for the original object before the camera.

photography as art: recent work 217

However, in the 1950's a new kind of photography, concerned more with theatre than with documentation of found objects and discovered relationships, came into existence. The transitional figure again seems to be Frank, followed by an army of variant possibilities: Friedlander, Winogrand, Geoff Winningham (author of *Friday Night at the Colisseum*), Danny Seymour and Larry Clark, to name a few. They are concerned themselves with the actual event, and the event seen as dramatic, theatrical, pseudo-event, in which the people before the camera are actors portraying emotions, purging our needs without our pain.

This theatricalness is in itself part of the general *mannerism* which marks the photography of the 1960's, and seems to be the principal taste of the 1970's. Kenneth Clark describes mannerism, saying it "employs the exciting elements of picture making irrespective of their truth or relevance," in *Landscape Into Art*; Peter and Linda Murray reinforce that definition by noting that mannerism implys flouting of the rules, which "pre-supposes an educated spectator, otherwise there is no point in breaking the rules," in *A Dictionary of Art and Artists*. This is another way of saying the work requires an intelligent spectator "who must go beyond the pleasure of the eyes".

A cascade of terms arise upon examining late photography: theatre, manipulation, crossing or destroying boundaries of mediums, social relevance, expressionist, polemic, unique prints and matrix objects. All these relate to important photographs and photographic ideas grown to prominence since 1960. There are others: sculptural assembly, multi-layer image, non-silver processes, to name technically oriented terms that also reflect the objects created in the past decade that must be treated in the history of photographic art, catalogued and noted. And there is one other term that has been pervasive in all art during the last ten years, which is *concept art*, where the product of the artist's effort is often not a physical object at all, but a more or less transient environmental change, or the object is explicitly a result of an esthetic concept being brought to bear on the materials, or situation photographed.

The mannerism mentioned has been fostered by the surge of students learning photography in schools. The schools themselves have been affected by the pressure of numbers. First, following the Second World War, the schools offered courses in art photography as a byproduct of liberal educational policy established inadvertently by the U.S. Congress, when it enacted the G.I. Bill–encouraging

returning servicemen to complete college educations. Once the schools and the programs existed, they encouraged the participation of new students, ones not funded by public funds. Many of these students desired professionally oriented programs of education, and received them; at R.I.T., for example, the study of photography has never drifted far from accurate sensitometry and elegant illusionistic renderings.

Many of the students did not seek professional discipline. They did desire to learn photographic materials and methods as means to producing personal art. There seemed to be little concern for the market value of this investment of time, money and labor. The photograph itself was apparently worth the work. The separation between commercial/documentary photography (whose standards had dominated all judgement of photographic imagery for thirty years) and this new area of esthetic/formal/ psychological investigation became steadily wider. The creation of *Aperture* and its continued existence, in and of itself, is evidence of this concern.

Universities have always been under some pressure to make public an evaluation of students, even those in nearly unmeasurable areas, for example the studio arts, musical composition, and photography. The problems of evaluation of art work, and the inevitable judgement implied, has led many hundreds of young photographers to seek other ways to learn photographic craft, and also to establish a social milieu in which their investigations are supported, and perhaps understood. Two alternative solutions to the university have been the intensive workshop, and the unaccredited school. Ansel Adams led the way with the Yosemite Workshops. He noted in his critique of the first Yosemite Photo Forum, as it was called, that although the program had been planned around a very practical and professional set of goals, in which greater understanding of specific trade problems would be attempted, the greatest student interest was in the possibilities of general pictorial vision, not in commercial applications of photography. When he restarted the work shops, in 1954, there was no hint of applied photography; the purpose of the nine days in Yosemite was clearly to bring photographers together so they could see one another's work, examine his, and learn a number of philosophical and practical solutions to general problems—through lecture and by immediate application of the lessons, using Polaroid materials—then return to their private lives, enriched, but not converted to professional photography.

photography as art: recent work 219

A number of unaccredited schools have come into being as a result of this desire to work for a time in a supportive photographic community. Examples are *The Center of the Eye*, in Aspen, Colorado; the *Photographic Studies Center*, Louisville, and a *Workshop* section of the Nathan Lyons *Visual Studies Workshop*, Rochester. These are all residential communities, for students who wish to learn methods and materials, and are relatively unconcerned about applications of the process to commerce.

Minor White continued Adams' approach, but added to it his own involvement in the psychological implications and communicative possibilities of the photograph. A number of workshops were formed by him in the 1950's and 1960's; some operated year after year, with a core of repeating students. Others were solitary events. When possible, the workshop was an armature on which he built enduring relationships that encouraged the workshop participants to treat photography both as an image- making and as a reflexive analytic tool. The life is the work; and a photograph is a way to self-knowledge. Carlos Costenada speaks of Don Juan as "a man of knowledge," in much the same way that Arjuna and Krishna speak of "the knower of the field" in the *Bhagavad Gita*; and the photographic mirror is used by White and many of his students as a means to a self survey, to knowledge of the inner life. The photographer's work can become the investigation of his own life.

The ideas disseminated by these workshops became widely known in the mid-1960's. Before the decade, critical references were to commercial standards; after the decade began, judgement could just as well be referenced to the sense of accuracy of the evocation of inner truth—or to the formal language, the concerns of printmakers at large.

If the photograph is not considered primarily as a communicative object, but as an art object, then it need not communicate anything other than the fact of its own existence. It is or is not a decorative object; it is or it is not an evocative object; it is or it is not relevant to current frontiers in expressive possibilities. When this happens, the action before the camera is no longer significant *per se*; the treatment of the action, and the manipulation of the materials of the process must move one to attention.

Recent photographic work is illustrated in the Portfolio. The photographs reproduced were selected from the work of about 200 photographers. They were each asked to submit photographs that

220

described their work. In many cases similar photographs were supplied by more than one photographer. The prints reproduced were chosen because they each successfully illustrate a mode of working. The editorial need to clarify contemporary trends controlled the final selection.

Henry Holmes Smith's *Mother and Son* is an example of the continuing involvement in the cameraless image. The "negative" was made with corn-syrup and water. The print was made both in black--and-white, and in a number of color variations using dye-transfer color matrix film and printing dyes. The shapes in the image refer us to similar shapes found in daily life, and to our memories of paintings. Another *cliche verre* image is shown in *Paracelsus*, by Frederick Sommer. A comparison of the two shows the rich range of associational possibilities that can be created by similar means.

Minor White's photograph, (plate 133 of the Portfolio), illustrates his continuing involvement with the methaphoric possibilities of the photograph. It has been deliberately juxtaposed (in the Portfolio) with Caponigro's landscape, Meatyard's landscape and Siskind's photograph of a significant detail, a burn pattern in wood. Caponigro's picture is an extension of landscape photography, with the magical possibilities of the illusionistic camera image creating new awareness.

Ralph Eugene Meatyard's photograph, plate 135, is an illustration of one of the principal inventions of photographic esthetics. Meatyard was a prolific worker; during the last three years of his life he was concerned with several visual concepts which he repeatedly investigated. One of these were images of "noise" as he called them, made by double exposing the film. "The camera was moved one or two degrees between exposures," is written on the back of the print. This produced two images, overlapping and out of register. The effect is intended to produce "an uneasy feeling at the base of the spine, just like chalk on a blackboard." At another time he described his work saying, "why should the photograph always be tied to illustration? I am making pictures that stand for themselves, and do what they do, not pictures that send you somewhere else to feel." The landscape shown is not meant to provide information about a particular place so much as to produce a physiological/psychological reaction.

Duane Michal's illustration of *The Journey of the Soul After Death*, and Leslie Krims' print from the *Stack O'Wheat Murders* are both examples of the photographer working as illustrator, in which the

photographer is not making an object so much as he is documenting a story. This is one of the first uses of photography, dating back to illustrations of the Lord's Prayer in 1843, and to Cameron, and other Victorian photographers, as well as to F. Holland Day's series, *The Seven Last Words*, with himself playing the part of Christ.

The camera illusion of reality, so easy to believe, is used to advantage in photographic assemblage by Uelsman, and by other young photographers. Bart Parker's photograph of *Gladys and Yvonne* shows another possibility. Photographic reality is discovered to be illusionistic in and of itself. His "snapshot" of persons in the photographer's life is two different states of reality, montaged together photomechanically, bringing the figures into a congruence of time which they did not in actuality have. They were photographed in different seasons; the photograph brings together, in time, different real events.

Meatyard's other major terminal effort was a large number of photographs which comprise a complex poetry of words and pictures. The origins of the *Lucy Belle Crater* series is to be found in a number of photographs he made during the 1960's, showing children and adults alike wearing grotesque halloween masks. The masks worn in those early photographs disguised and distorted the persons wearing them. The children became sinister, dwarfish creatures; the speckled light in which they were photographed was as alive and uneasy as the figures themselves.

Beginning in 1970, he found forms of speech created by Gertrude Stein had caught his interest; the repetitive rhythms found in *Three Lives*, and phrased more intensely in her later poetry, had possible photographic/verbal parallels in his own vision. He began illustrating *Lucy Belle Crater* (which was essentially complete and ready for publication when he died in May, 1972); the pictures are the "story" of an imaginary southern woman, and her relations. The persons used to act out the roles were friends and professional acquaintances. His method of working was to find a "set, like a little piece of theatrical background, and then figure out who should go in front of it."

The changing person in pictures always wore a translucent rubber mask of an "old man." Each person was photographed together with his wife, Madeline, who wore a halloween rubber mask of a hag's face. The photographs change our perception of reality. One comes to these with preconceptions about how one recognizes a person, or

222

the essence of personality, which by presumption is transmitted mostly through facial gestures. The mask conceals these indicators. Looking at a number of these pictures, one becomes aware that the person dominates the mask. The anonymous "old man" becomes a young male, a saturnine creature, a gentle philosopher, a virtuous pregnant woman. The two prints selected for reproduction here reveal this as well as any two pictures could. The person behind the mask transforms the mask; in the transformation a poetry develops, which completes, and illuminates, the titles of the pictures.

The titles echo the repetitive verbal rhythms of Stein's writing. All the photographs have almost identical titles. The first and last pictures of the set have the same title, *Lucy Belle Crater and Her Husband, Lucy Belle Crater*. In the first picture, Meatyard himself wears the rubber mask, and his wife the hag's mask. In the last picture they have exchanged clothes, and masks, and names. In between Lucy Belle Crater is seen with all her southern family relationships; each of them bears the name Lucy Belle Crater. With Meatyard's vision, as with Stein's poetry, the reader/viewer is required to look through the surface of words/photographs to discover understanding of the world hidden just beyond.

Mimi and Jessica and the Door, illustrates another use of in-camera double exposure, used here to create a new sense of space, an emotional statement created by the displacement of the relationship between figures and the door, by the change of size and apparent solidity of the image. Just as in plate 142, *Self-Portrait, 1969*, neither of the principals are fully seen; both are translucent, ephemeral, another photographic possibility achieved by splitting exposures, recording an emotional biographical discovery.

Barbara Crane's photograph from *People of the North Portal* could also be considered a "snapshot," and also be considered one of a series of concept-art photographs. The concept here was to establish a stance in front of the North exit from the Art Institute of Chicago, and to photograph persons leaving by this door, using a large view-camera. The subjects were recorded by the camera in moments of awkwardness, transformed by the doors themselves; the awkwardness changed them from balanced, self-guarded persons into graphically interesting assemblages of arms, legs, light and dark shapes. These pictures also evoke responses similar to those created by Eakin's jumping and diving figures. The photograph by Betty Hahn, *Processed by Kodak*, is a good example of contemporary photographic printmaking. The original is a large two-color gum

print. The reproduction provides the reader information, but not the tactile sensations of the original color and texture. The image deals in part with the anonymity of the photograph (reflected in the title), and also with the creation of handsome objects, a part of the new pictorialism.

Michael Stone was a central figure in the *Photograph as Sculpture* exhibit at the Museum of Modern Art. He is shown holding some of his photographic objects, providing them with a sense of scale and substance. The photographic objects themselves were originally derived from the television screen; the prints are encased in vacuum -formed plastic containers which suggest the television screen in itself, and also suggest super-market packaging—the implications of carry-out items, repeatable and anonymous. These photographs were actually hung on a simulated display rack, in the Modern Museum's exhibit.

Stone's work redefines the physical esthetic qualities of the photograph. It is implicit in the prints shown, but more clear in another set of prints he made, on canvas. The image itself is anonymous. Stone selected his subjects from the endless visual serial possibilities of the television screen. This act of selection, the parody of the print and the source, is an esthetic act of creation. These pictures are lively illustrations of Gombrich's thesis that art comes out of art. Encasing the photograph in a plastic container, he evoked both the source, and the nature of the image— anonymous, repetitive, endless suggestions of fantasy characteristic of the television screen. His photographs on canvas were sewn into covers for foam rubber pads, wrapped in clear plastic sheets, and bound into cushions. The photograph becomes an object that inverts the shibboleths of traditional photographic art objects: the print is not a rigid and frail precious object but it becomes a cushion that can be thrown, or sat on without damage; the glossy surface, which in the original silver print is frail and creates a sense of translucence, here becomes a plastic overcoat, a tough protective surface. The subject of the pillow pictures is also anonymous—sequential bits of road scenery photographed from a moving car. Stone argues that the windshield of a car is psychologically equivalent to a television screen: one sits in passivity and watches an endless stream of imagery flow past, any of it photographable.

Bea Nettles typifies the work of a number of photographers who have taken the photograph into a printmaking, or object-making mode. The photographic process is a means of resolving an image,

not merely an alternative to manual possibilities. *Sister in the Parrot Garden* shows a stuffed and assembled image; the camera record of the girl was printed on photosensitized canvas, which was then sewn, stuffed and attached to the larger photographic canvas assemblage. Not only is the tradition of the fine print completely ignored but also the use of the camera to create *photofantasies* (a descriptive term drawn from a recent exhibit of her work, at *Light* gallery) is made explicit. The camera is used to materialize private vision. The product relates to the continuing romantic American art investigation of the surreal.

Plates 123, 149 and 150 are all dependent on manipulation during processing. In *My Mother and Cow*, Alice Wells violates the silver image-forming process, in terms of traditional intentions. She achieves a "unique" print, one that cannot be duplicated as a silver print, because no matrix negative exists. The image is the result of the gesture, the moment is part of the image making. The print has been partially processed, partially "fogged," subjected to transient photo-chemical possibilities. This changes the meaning of the photograph, from a documentary record of a woman pointing to a cowk becoming in and of itself a documentary of the total gestural relationship between the photographer and the materials. B. Friedman's image is also this, and it also is a romantic illustration of a private poetry, as indicated in his title. Similar processes are used in Van Deren Coke's print, plate 123.

Robert Heinicken's photolithographic assemblage precedes the work of his student, Michael Stone, and is also concerned with the creative act of bringing together other's photographs. In this case, images from advertizing and from documentary photography of war are montaged. They are the visual texture of our time, and underline the range of possibilities existing at any one moment in this society. The photographer's act is related to collage, but the images are not glued together. They are photo-mechanically superimposed, producing an artifact difficult to examine in a purely photographic context. The resultant print is not a photographic silver print, but an ink print, produced photographically, with color and monochromatic images superimposed. The image becomes didactic. It is impossible to avoid responding to the illusionistic element. What the *original* photographer (who photographed the model wearing sunglasses) intended was a cosmetic and seductive illusion with which one could sensuously identify. The photographer Heinicken, in bringing together these images has created a new reality, one which echoes both the assemblages of H.P. Robinson, and the selection and

arrangement possibilities first stated for art in this century by Marcel Duchamp, working as R. Mutt. The selective act initiated by Duchamp defined new limits of art, which had previously been bound by the making of objects.

The social landscape mode has many practitioners who have learned to see the implications of the actions before the camera and the graphic construction of shapes in the frame all at the same time. William Doherty and Robert D'Allesandro have both made brilliant images of this sort, as well as Mark Cohen. Each of these bring their own understanding of the world to the picture. As noted earlier, in the comments on Lee Friedlander and Winogrand, the richness of the social landscape photograph is limited by the depth of understanding of the society which the photographer can bring to bear.

An extensive body of photographs exist which must be seen directly to be comprehended; reproduction seriously limits illusionistic detail, so important to their meaning. These are pictures of apparent *emptiness*, where there is nothing before the camera that means much to the viewer, except its minimal existence, and the idea the photographer held about it. Such images are terribly difficult to deal with, to catalogue, or to evaluate. They are almost purely perceptual/intuitional. The viewer must recapitulate the photographer's state of mind and attempt to enter into his interest on the basis of the most tenuous clues. They are suggestive of the *equivalent*, but are closely allied with the drug vision, which imbues otherwise inert objects and vistas with secret and esoteric meaning, presence and importance. Without such experiences, the photographs of this genre are probably unreadable. They are not to be viewed as a *photograph as a decorative object* (not a perjorative term, certainly, since it is the avowed intention of many artists), or *illustration*, but as a *psychological operator*, intended to change our awareness.

Contemporary photography has come to a state of freedom where all these possibilities exist concurrently. The photographer has placed new burdens on the viewer. He requires the viewer to discover, when he looks at the photograph, what kind of photograph he is seeing, and what area of response is relevant. If the viewer chooses not to do this, the photograph must succeed on the basis of less intellectual judgements, more immediate, traditional, and romantic, but persistent. Most photographs are still seen as a window onto a magical world, a *mirror of reality*, and a startlingly effective net in

which to capture the echoes of days and reflections of our loves. The photograph becomes an art of the highest sort when it does this and still remains personal. The place for most contemporary art photographs, according to Ralph Eugene Meatyard, was in a book. Few photographs are suitable for continuous exposure as decorative objects. The present state of the art is providing many esthetically pleasing and decorative prints, and also many contemplative images of the sort suggested by Ralph Meatyard, whose attitude was similar to that expressed by Stan Brakhage, when he said, "The photograph is an iconic object." It produces a state of belief; it causes a viewer to return to it for something like a magical insight, long after the initial impact of the illusory image has faded.

ACKNOWLEDGEMENTS (of illustrations in the Portfolio): The staff of the *International Museum of Photography* at Eastman House, Rochester, New York, has been a great help in preparing duplicate prints to represent the original images. Plates, 1, 2, 3, 4, 5 8, 9, 10, 12, 13, 14, 15, 16, 17, 18, 19, 20, 21, 22, 23, 24, 25, 26, 27, 28, 29, 30, 31, 32, 33, 35, 38, 39, 40, 41, 42, 43, 44, 46, 47, 48, 49, 50, 51, 52, 53, 54, 55, 56, 58, 61, 62, 63, 64, 65, 66, 67, , 65, 66, 67, 68, 69, 70, 75, 76, 77, 78, 79, 80, 82, 83, 84, 86, 87, 88, 99, 100, 101, 109, 112, 113, 115, 116, 120, 125, 126 are reproduced with permission. Plates 60 and 122 by permission of IMP and Doris Bry and Georgia O'Keefe; 65 by permission of IMP and Ansel Adams; 72, IMP and Paul Strand and *Aperture*; 85, IMP and the California Palace of the Legion of Honor; 90, IMP and Bill Brandt; 92, IMP and *Time-Life, Inc.*; 93, IMP and Robert Frank; 129, IMP and Barbara Morgan. The staff of the *Gernsheim Collection* University of Texas, Austin, Texas has been helpful in providing duplicate prints from their files, represented in plates 6, 7, 98, and 114, reproduced with permission. All other photographs are the property of the photographers noted in the captions, and are reproduced with permission.

photography as art: recent work 227

INDEX

(OF SUBJECTS AND TITLES)

PORTFOLIO

1. W.H.F. Talbot, Plate 22 from *The Pencil of Nature;* 1843, Talbotype

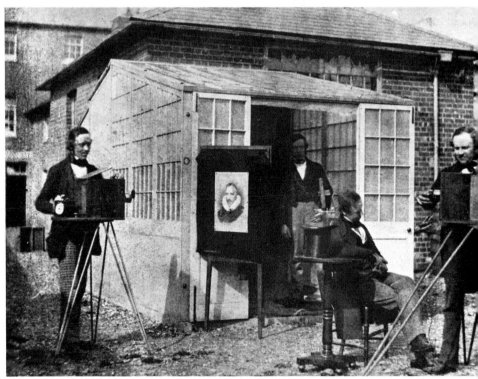

2. G.L. Chretien, *Self Portrait;* physionotrace drawing by Fouguet; engraving dated 1792. 3. W.H.F. Talbot, *Leaf Negative.* 1939, Talbotype. 6,7. W.H.F. Talbot, *Printing Establishment at Reading;* 1844, Talbotype.

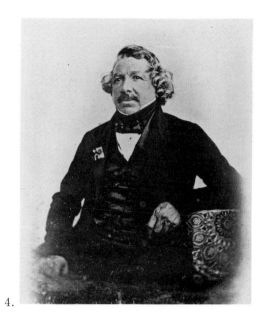

4.

5.

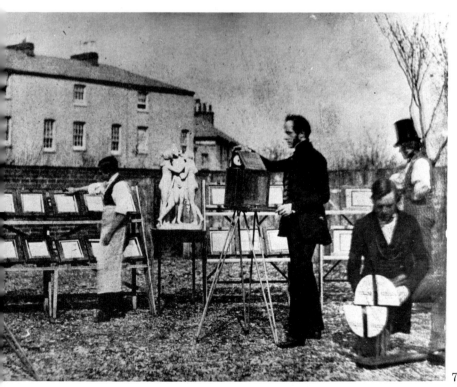

7.

4. Jean Baptiste Sabbatier-Blot, *J.L.M. Daguerre;* 1844, Daguerreotype, copied by G. Cromer. 5. J.L.M. Daguerre, *Woodland Scene;* n.d., drawing.

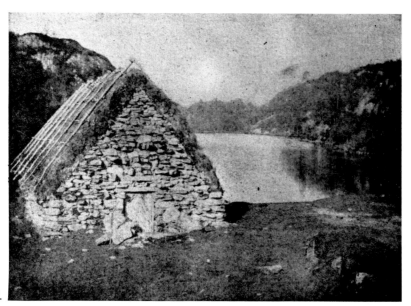

8.

9.

10.

8. Anon., *Stone Building*; n.d., Calotype. 9. *Holmes Model of Stereographic Viewer.* c.1865.
10. British Journal Almanac, *"Optimus,"* Portable Tent darkroom, 1890.

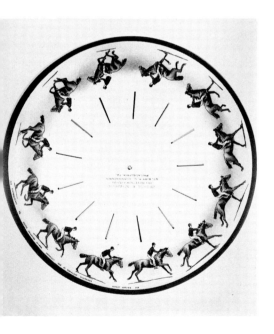

11.

13.

11. Ohio University, Dept. of Zoology, *Bird Muscle, 7,800X* electron microscope photograph, 1972. 12. E. Muybridge, 1893 *Zoopraxiscope* insert. 13. E. Edgerton, *Drum Major,* 1940 stroboflash.

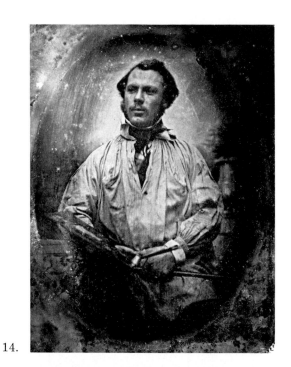

14.

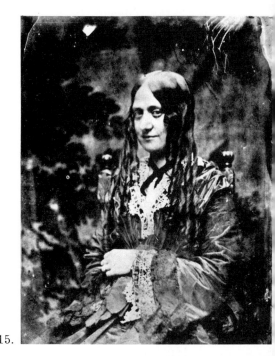

15.

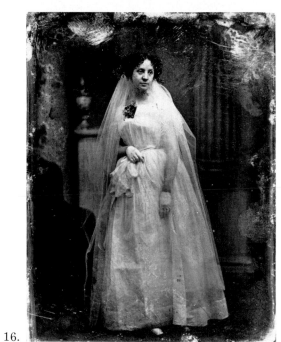

16.

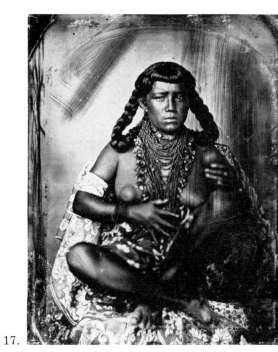

17.

14. J.L.M. Daguerre, *Unknown Painter*; c.1840. 15. Anon., *Portrait*; c.1845, Calotype. 16. Southworth and Hawes, *Woman With Veil*; c.1855, Daguerreotype. 17. Anon., American, *Indian Girl*; c.1850.

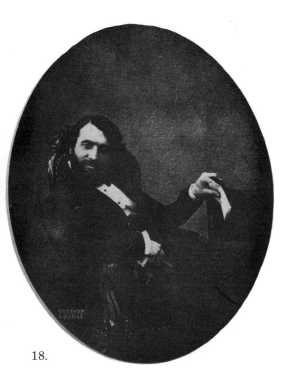

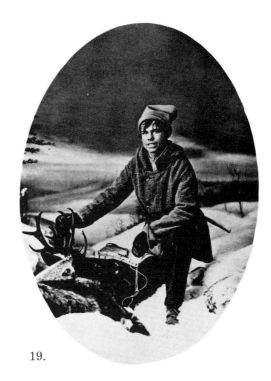

18.

19.

20

18. Gustave LeGray, *Henry LeSecq;* c.1850, waxed-paper negative. 19. W. Nottman, *Col. Rhodes Indian Boy.* c.1865, collodion (studio photograph). 20.Mathew Brady, *The Fairy Wedding*, (Mr and Mrs Tom Thumb); c.1863, stereograph.

21. Ashford Bros. Co., *John Wilkes Booth, Assassin of President Lincoln*; c.1865. 22. D.O. Hill, *The Gown and the Casket*. n.d. 23. Nadar, *Charles Baudelaire*; c.1865. 24. Etienne Carjat, *Gustave Courbet*; c.1865.

5.

26.

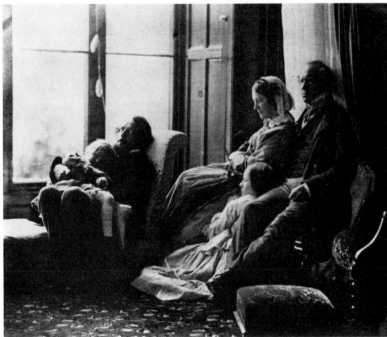

27.

25. Charles D. DeSavary, *Corot*; 1871. 26. Mulnier, *Corot*; c.1870. 27. Lewis Carroll (Dodgson), *Tennyson, Esq., and Family*; c. 1868.

EXPEDITION OF 1873.

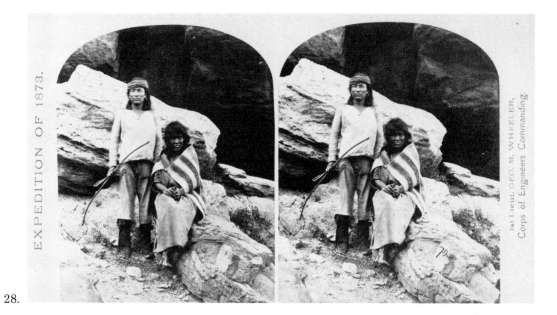

1st Lieut. GEO. M. WHEELER,
Corps of Engineers Commanding.

28.

29.

28. T. O'Sullivan, *Navaho Brave and His Mother;* 1873, collodion stereograph. 29. Anon., *Peruvian Indians;* (two prints), c.1880.

30.

31.

32.

30. Louise Ducos DuHauron, *Distortion;* c.1885. 31. Napoleon Sarony, *Oscar Wilde;* 1882.
32. Adam Clark Vroman, *Hopi Snake Priest;* c. 1900.

33.

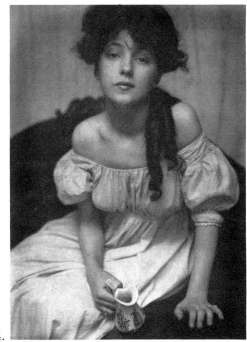

34.

35.

33. Gertrude Kasebier, *Miss N.*; 1903. 34. Frank Eugene, *Portrait*; c. 1900. 35. *Gertrude Kasebier in her Studio* from *The Photographer;* 1904.

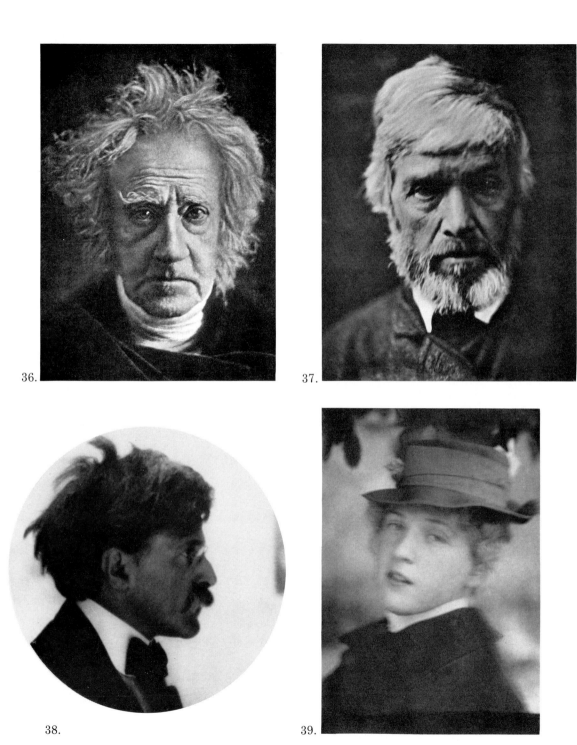

36. J.M. Cameron, *Sir John Herschel*; c. 1860. 37. J.M. Cameron, *Carlyle*; c. 1860. 38. A.L. Coburn, *Stieglitz*; 1913, Kodak no. 2. 39. A. Stieglitz, *A Portrait*, 1913.

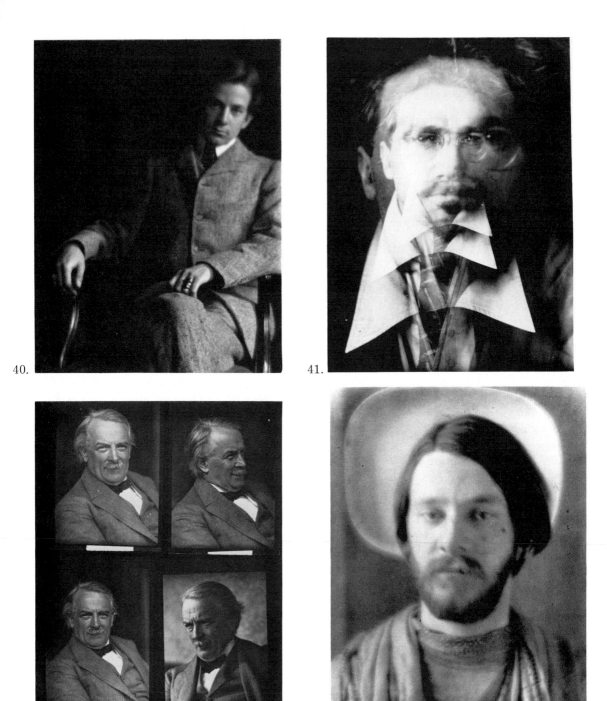

40. Frederick Evans, *Alvin Langdon Coburn*; c. 1905, platinum. 41. A.L. Coburn, *Ezra Pound*; 1917. 42. A.L. Coburn, *David Lloyd George*; 1910, contact proof. 43. F. Holland Day, *Coburn as Christ*; c.1905, platinum.

45.

46.

47.

44. Margaretha Mather, *Edward Weston (with rolls of Platinum Paper)*; 1922. 45. Imogene Cunningham, *My Father at Ninety*; 1936. 46. Kate Matthews, *Miss Kate Johnston*; n.d., c. 1920. 47. Aaron Siskind (from) *The Most Crowded Block*; 1939.

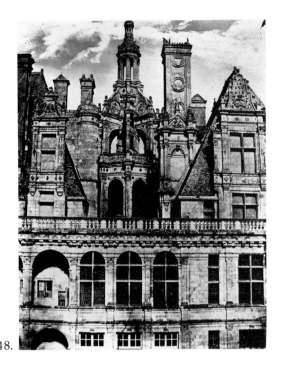

48.

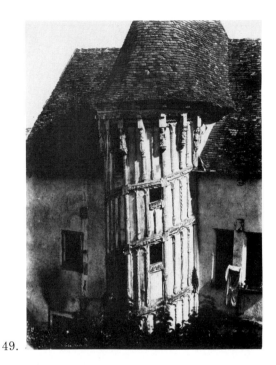

49.

50.

51.

48. Blanquart-Evrard, *Chateau de Chambord* c. 1843, albumen. 49. Henry Le Secq, *Chartres*; c. 1859, albumen. 50. Francis Frith, *Entrance to the Temple of Abu Simbel, Nubia*; 1858, albumen. 51. Maxime DuCamp, *Sculpture at the Entrance "du speos De Phre;"*

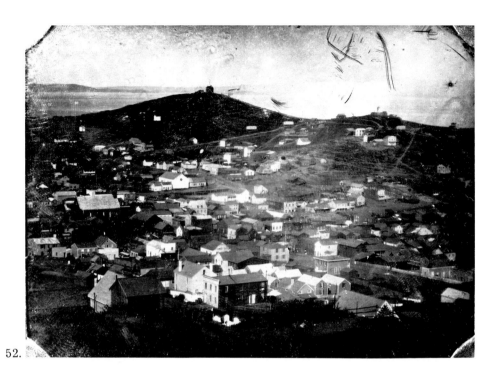

52.

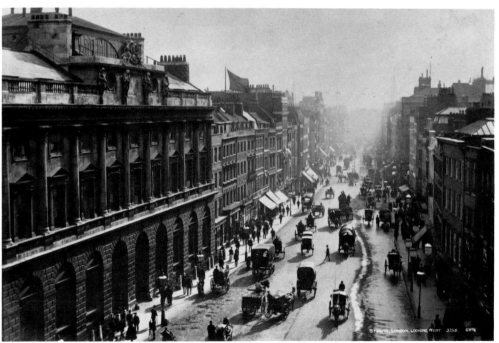

53.

52. Anon., *Daguerreotype Panorama* (1 of 5); 1854. 53. G.W. Wilson, *Strand, London*; 1865, collodion.

54.

.55.

54. **Paul Strand,** *New York (from Camera Work);* 1919. 55. F. Evans, *Stairs;* c. 1900.

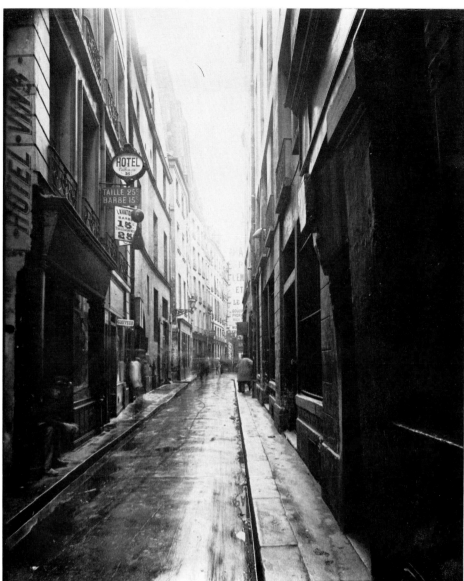

56.

56. Eugene Atget, *Rue Quin Canipoix*; c. 1920.

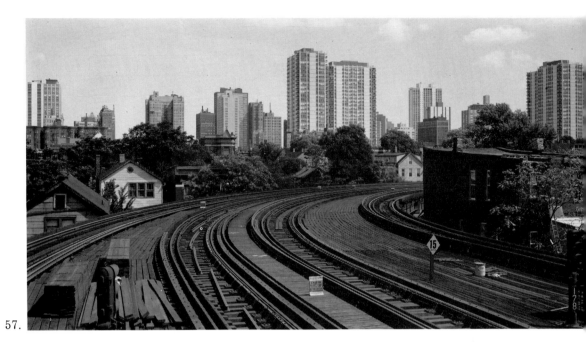

57.

58.

59.

57. Art Sinsabaugh, *Chicago No.216*; 1971 (contact print 10x19 inches). 58. Lazlo Moholy-Nagy, *Bauhaus Balconies*; 1926. 59. A.L. Coburn, *Broadway and the Singer Building by Night*; 1911.

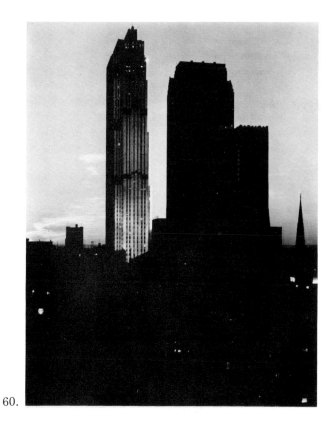

60.

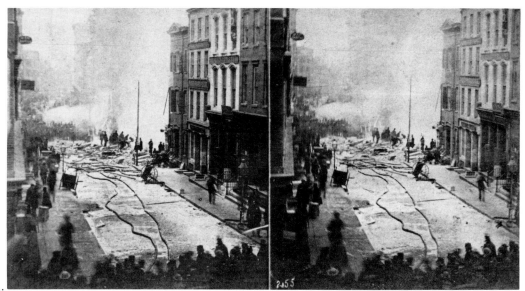

61.

60.A. Stieglitz, *From the Shelton;* c.1930. 61. E. Anthony, *Burning of Cyrus W. Field Warehouse, N.Y.* 1859, stereograph.

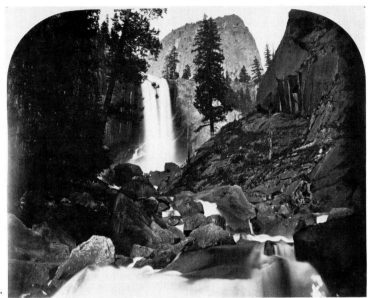

62.

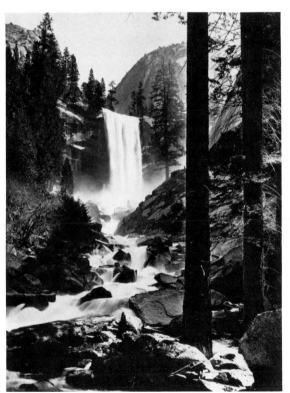

63.

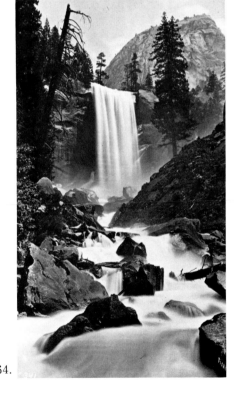

64.

62. Watkins, *Vernal Falls*; c. 1870, **63.** Vroman, *Vernal Falls*; c. 1900, **64.** G. Fiske, *Vernal Falls*; c. 1900.

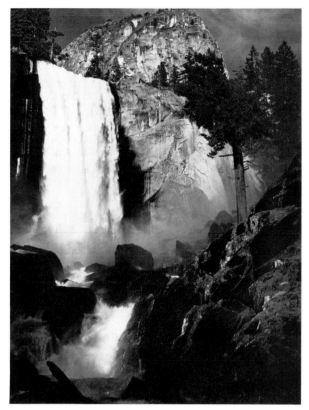

65.

66.

65. Ansel Adams, *Vernal Falls*; c. 1945. 66. A. Bierstadt, *Vernal Falls*; c. 1880, stereo.

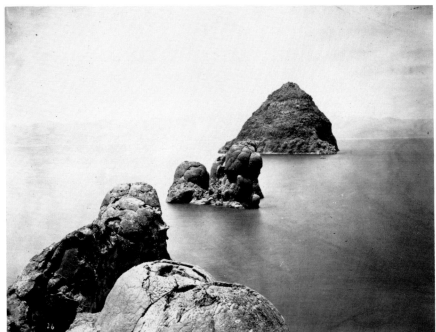

67.

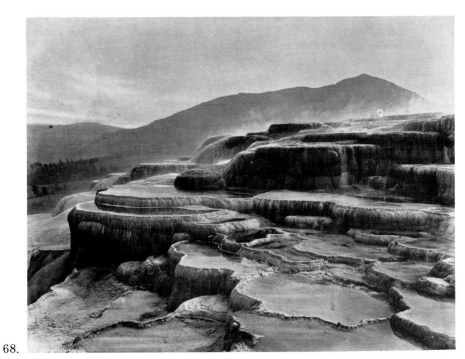

68.

67. T. O'Sullivan, *Pyramid Lake, Nevada;* 1868. 68. W.H. Jackson, *Mammoth Hot Springs, Yellowstone;* c. 1870. (Both photographs wet plate process).

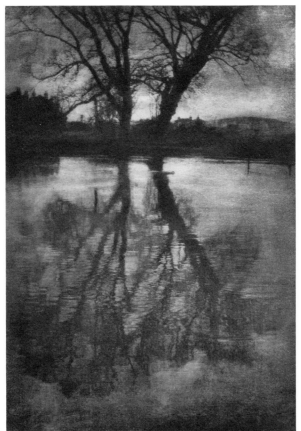

69.

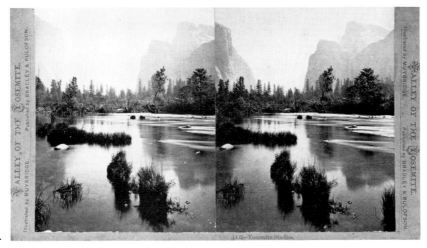

70.

69. G. Davison, *Christmas*; 1909. 70. E. Muybridge, *Yosemite Studies*; 1880, stereograph.

71.

72.

71. E. Weston, *Eroded Rock*; c. 1945. 72. Paul Strand, *Rock, Port Lorne, Nova Scotia*; 1919.

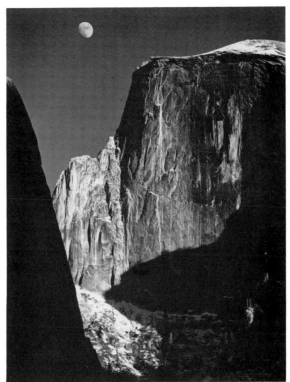

73.

74.

73. Ansel Adams, *Moon and Halfdome*; c. 1965. 74. Paul Caponigro, *Rock Wall*; c. 1965.

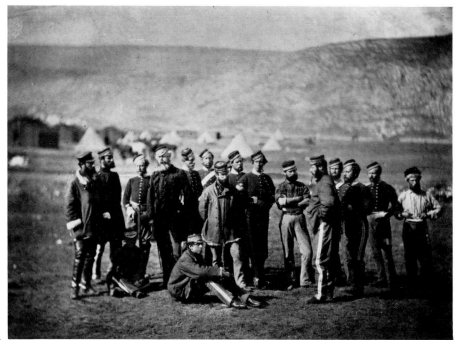

75.

76.

75. Roger Fenton, *Col. Doherty, Officers and Men, 13th Light Dragoons;* 1851. 76. James
Robertson *Barrack Battery;* 1851.

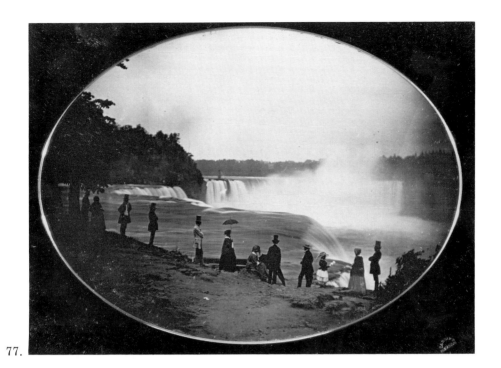

77.

78.

77. Anon., (attr. Babbitt) *Niagara Falls*; c. 1845, Daguerreotype. 78. G.N. Barnard, *Columbia*, S.C.; 1869.

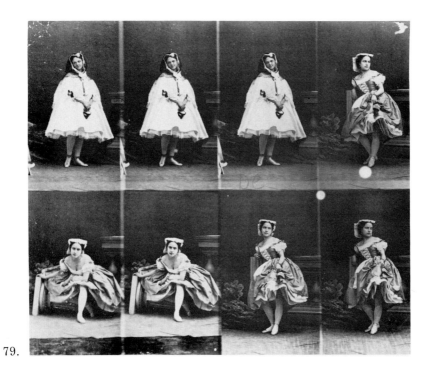

79.

80.

79. A. Disderi, *Actress*; c. 1860, uncut *carte-de-visite*. 80. T.H. O'Sullivan, *Field Where General Reynolds Fell, Gettysburg*; 1863.

81.

82.

84.

81. Anon., *Two Girls*; c. 1895, Kodak No.2. 82. Anon., *Class Game, Easthampton, Mass.*; c. 1890, Kodak No.1. 83. J. Thompson, *Recruiting Sergeants, from Street Life in London*; 1877. 84. O. Barnack, *Mobilization*; 1914, early Leica photograph.

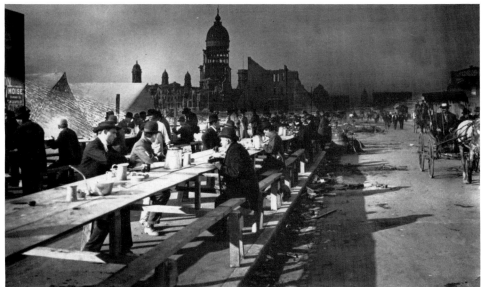

85.

86.

85. A. Genthe, *Refugees Eating, San Francisco*; 1906. 86. Eugene Atget, *Watching an Eclipse*; n.d.

87.

88.

87. Lewis Hine, *Mrs. R Cracking Nuts* c. 1900. 88. Dr. Eric Salomon, *Visit of German Statesmen to Rome*; 1931.

89.

90.

89. Emmet Gowin, *Nancy*; 1969. 90. Bill Brandt, *Parlour Maids*; 1939.

91.

92.

91. Emmet Gowin, *Edith;*1969. 92. Margaret Bourke-White, *Daughters of Pocahantas* 1937.

93.

94.

93. Robert Frank, *Julius Orlovsky and Allen Ginsberg*; 1965. 94. Steven Lieberman, *Bull Curry*; 1970.

95.

95. Gary Winogrand, *Texas State Fair;* 1964. 96. Anne Noggle, *La Fonda;* 1969.

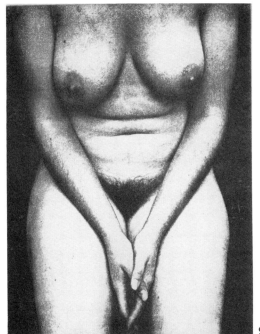

97.

98

99.

97. Eugene Groppetti, *Nude;* 1972, photogravure. 98. Nadar, *Christine Roux, the Original "Musetta;"* c. 1875. 99. Eugene Durieu, *Nude;* c. 1845, Daguerreotype.

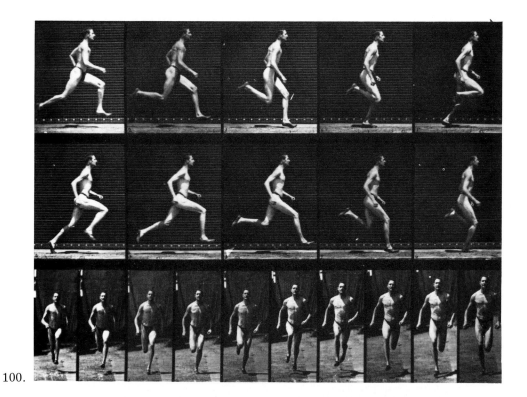

100.

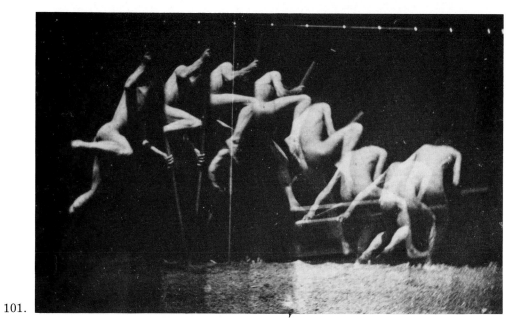

101.

100. E. Muybridge, *Running at a Half-mile Gait (shoes)*; c. 1889. 101. T. Eakins, *Jumping Figure*; c. 1889.,

102.

103.

102. Charles Swedlund, *Nude*; 1971. 103. Frank Eugene, *Nude*; 1904.

4.

5.

104. Edward Weston, *Nude*; 1936. 105. Ruth Bernhard, *Nude Like Sand-Dunes*; c. 1960.

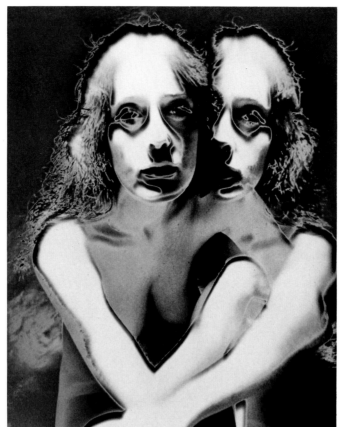

106.

107.

108.

106. Tod Walker, *Nude;* 1969, sabbatier-effect print. 107,108. Walter Chappell, *Nudes.*
c.1962.

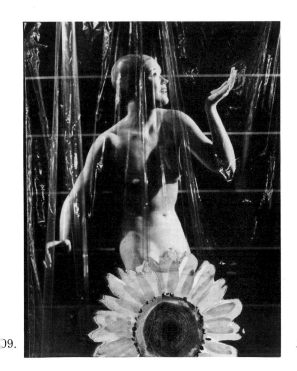

109.

110.

111.

109. Nicholas Murray, *Canon Towel Advertisement*; 1947. 110. John Pfahl, *I'm Forever*; 1971, vacuum-formed plexiglass with screened image. 111. Allen A. Dutton, *Not Quite Yet*; 1970.

112.

113.

112. G. LeGray, *Clouds and Waves*; c. 1860. 113. Charles Negre, *Arles*; c. 1850.

114.

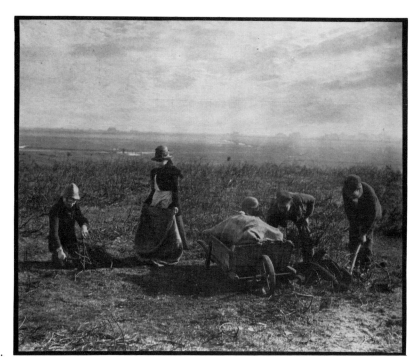

115.

114. H.P. Robinson, *Pencil Sketch with One Photograph Set In*; c. 1870. 115. P.H. Emerson, *Untitled*; 1887, platinum.

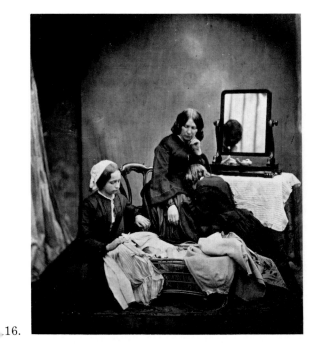

116.

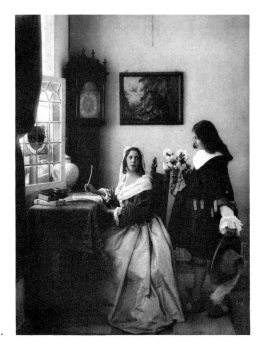

117.

18.

116. O.G. Rejlander, *Dear Child*; c.1860. 117. Guido Rey, *The Letter*; c. 1906. 118, F. Benedict Herzog, *Twixt the Cup and the Lip*; c. 1907 (pl. 117, 118, *Camera Work*).

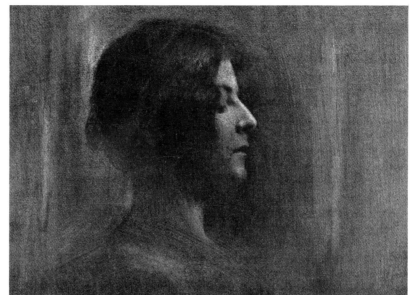

119.

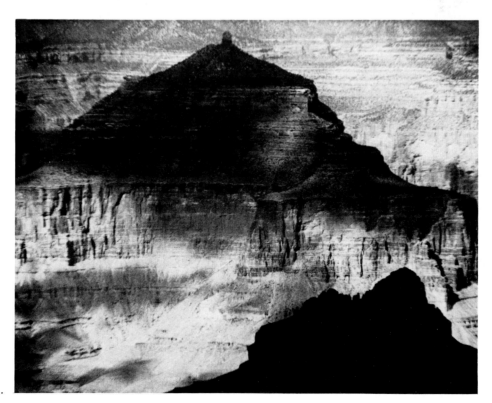

120.

119. Robert DeMachey, *Serenity;* 1904 (Camera Work). 120. **A.L. Coburn,** *The Great Temple, Grand Canyon;* 1912.

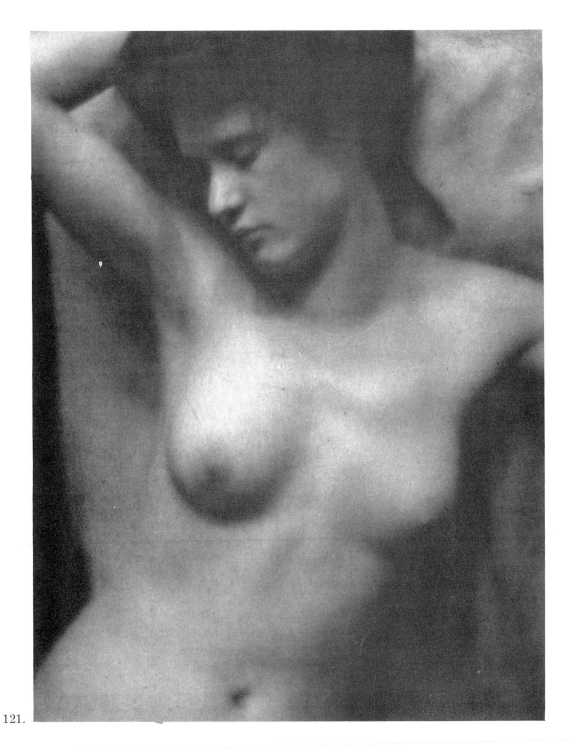

121.

121. Clarence H. White and Alfred Stieglitz, *Torso*; 1904.

122.

122. A. Stieglitz, *White Porch with Grape Vine*; 1934.

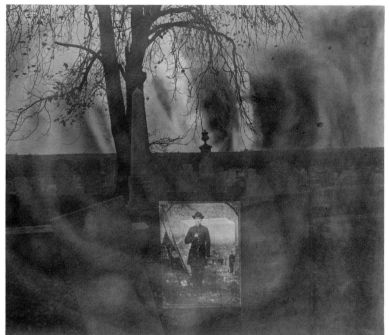

123.

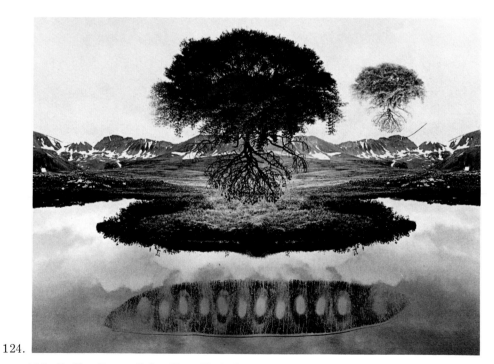

124.

123. F. Van Deren Coke, *New York Graveyard*; 1972, combination print and manipulated development. 124. Jerry N. Uelsman, *Untitled*; 1969, photomontage print.

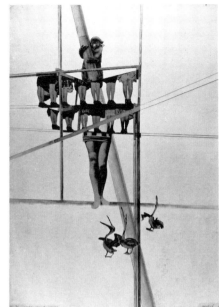

126.

127A.

127B.

125. L. Moholy-Nagy, *Untitled*; *c. 1925*, photogram. 126. L. Moholy-Nagy, *Photo-montage*; 1927, rotogravure prints and line drawing. 127A. Thomas F. Barrow, *Visor*; 1972. 127B. Thomas F. Barrow, *Game Discharge*; 1972, (both xerox matrix prints).

128.

129.

128. Henry Holmes Smith, *Mother and Son*; 1951, corn syrup and water refraction negative. 129. Barbara Morgan, *Hearst Over the People*; 1936-39, montage print.

130. Ray K. Metzger, *Photo-mural*; 1966, composite print, 30x22 inches. 131. Ray K. Metzger, *Signal Light and Utility Poles*; 1965, double frame exposure. 132. Ray K. Metzger, *Woman and Girl*; 1969, couplet (adjacent frames).

133.

134.

133. Minor White, *Navigation Marker, Cape Breton Island, Novia Scotia*; 1970. 134, Paul Caponigro, *Untitled*; 1969.

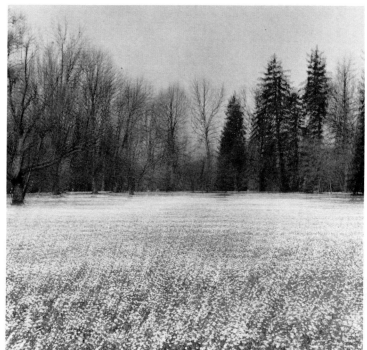

135.

136.

135.Ralph Eugene Meatyard, *No.28, Light Impression;* 1972, double exposure. 136. Aaron Siskind, *Untitled;* 1971.

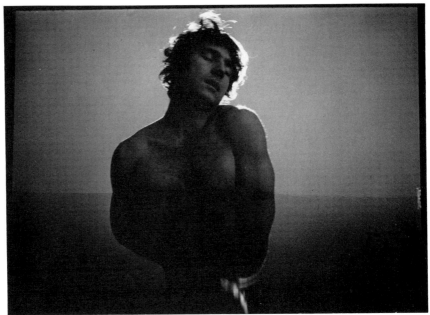

137.

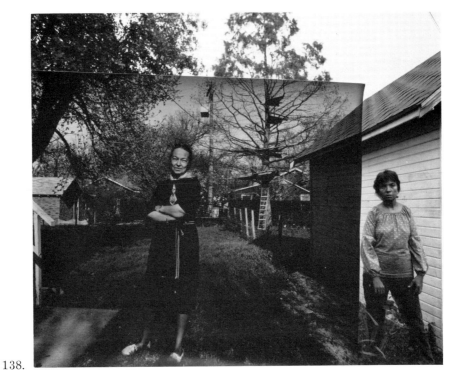

138.

137. Duane Michals, from *The Journey of the Spirit After Death*. 1971. 138. Bart Parker, *Gladys and Yvonne*; 1971, photo-montage.

140.

141.

139,140. Ralph Eugene Meatyard, from *Lucy Belle Crater*; 1971-1972. 141. Leslie Krims, from *The Incredible Stack O'Wheats Murders* portfolio; 1972.

142.

143.

142. Arnold Gassan, *Self Portrait, 1969;* split exposure. 143. F. Gohlke, *Mimi and Jessica and the Door;* 1971, double exposure.

144.

5.

144. Barbara Crane, *People of the North Portal*; 1970. 145. Jim Alinder, *Picture Spot, Great Meteor Crater, Arizona*; 1970, *Panon* camera.

146.

147.

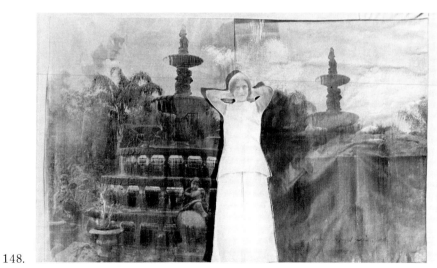

148.

146. Betty Hahn, *Processed by Kodak*; 1968, two-color gum on Rives BFK, 14x22 in. 147. Michael Stone, *Michael Stone and TV Photographs*; 1971, prints in formed plastic. 148. Bea Nettles,*Sister in the Parrot Garden.*; 1970, Rockland emulsion on cloth, 19x30 in.

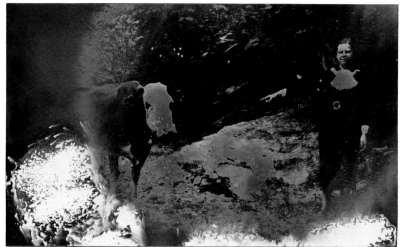

149.

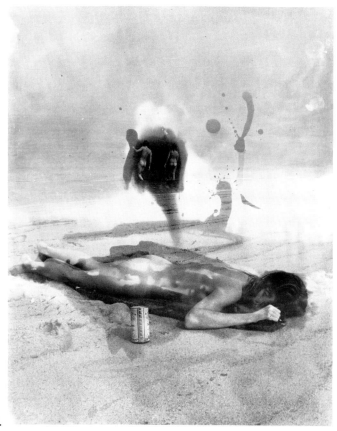

150.

149. Alice Wells, *My Mother and Cow.*; 1971, print manipulated in development. 150. Benno Friedman, *Sleeping, While Naked Christine and Jim Cautiously*; 1970, manipulated print, montage.

151. Robert Heinicken, *Composite;* 1970, magazine advertisement overprinted with news photograph from Viet Nam war (anonymous photographer).

152. Frederick Sommer, *Paracelsus;* c. 1970. Cliche verre technique.

153.

154.

153. Judy Dater, *Twinka*; 1970. 154. Jack Welpott, *Young Boy, Stinesville, Indiana*; 1966.

CHRONOLOGY

Pre-1830: 1553: *Camera obscura* described by Della Porta. 1585: Giovanni Benedetti publishes first account of *camera obscura* fitted with a lens. 1725-1727: Johann H. Schulze observes the darkening action of light on mixtures of chalk and silver nitrate. 1777: Karl W. Scheele discovers the rapid action of the blue and violet end of the spectrum of visible light in blackening of silver chloride. 1786: the *physionotrace* invented by Chretien. 1796: lithography invented by Senefelder. 1802: T. Wedgewood describes *Making Profiles by the Agency of Light.* 1806: the *camera-lucida* invented by Dr. Wollaston. 1811: Iodine discovered. 1816-1829: Nicéphore Niépce makes images on polished pewter plates. Exposure is about eight hours. 1819: Sir John Herschel discovers sodium thiosulfate (called sodium *hypo*sulfite) is a solvent for silver salts, which makes it possible to stop light-sensitive silver salts from darkening to a uniform color. 1826: bromine discovered. 1827: Niépce meets Daguerre; Niépce goes to England, shows his heliographs. 1829: Niépce and Daguerre become partners.

Births: 1813: O.G. Rejlander. 1815: Julia Margaret Cameron. 1820: Charles Nègre. 1820: Gustave LeGray. 1820: Nadar (Gaspard Felix Tournachon). 1821: Robert Adamson, Napoleon Sarony. 1822: Maxim DuCamp. 1823: Mathew Brady, George Washington Wilson. 1828: Etienne Carjat.

Decade 1830-1839: 1830: Daguerre ends partnership in Diorama with Bouton. Daguerre and Niépce sign contract on March 13.

Hector Berlioz *Symphonie Fantastique*. Donizetti *Anna Bolena*. Chopin *Concerto No. 2, in F Minor*, the first attempt to change the form of the three-movement concerto. Victor Hugo, *Hernani*. Stendahl, *Le Rouge et le Noir*. Alfred Lord Tennyson, *Poems Chiefly Lyrical*. August Comte, *Course of Positive Philosophy*. Joseph Smith, *Book of Mormon*, and first Mormon church established at Fayette, New York. Nitrates first shipped from Chile and Peru. Liverpool-Manchester Railway opened. Royal Geographic Society founded. Electromagnet discovered in 1825. First American cotton mill, Samuel Slater, Rhode Island. Bussy isolates magnesium. Births and Deaths: Robert Cecil, Marquess of Salisbury, b. William Hazlitt, d. Simon Bolivar, d. Etienne Jules Marey, b.

1831: Daguerre observes Iodine is very sensitive to light. Eugene Delacroix, *The Barricade*. H. Delaroche, *Princes in the Tower*. Barbizon school of artists, including Jean Millet and Pierre Rousseau first exhibit in the Salon. Bellini, *Norma*. Michael Faraday invents electric transformer. British Association for Advancement of Science established. R. Brown discovers nucleus in plant cell. Charles Darwin—voyage of the *Beagle*. Timothy Bailey invents power knitting frame. Separation of Belgium from Holland. Russia suppresses Polish revolt. East India Company annexes Mysore, after suppressing peasants' revolt.

Births and Deaths: Sarah Siddons, d. James Monroe, d. James Clerk Maxwell, b. George Wilhelm Frederich Hegel, d. Camille Pissarro, b. Valentine Blanchard, b. Andrew Russell, b.

1832: William Henry Fox Talbot is elected a Fellow of the Royal Society.

Donizetti,, *L'Elisir d'Amore*. Balzac, *Droll Stories*. Washington Irving, *A Town of the Prarie*. Alexander Pushkin, *Eugenie Onegin*. Tennyson, *The Lotus Eaters, The Lady of Shallott*. Goethe, *Faust*, part two. Hugo, *Le Roi s'amuse*. Interior stage setting with three continuous walls first used. Gregory XVI publishes encyclical condemning the freedom of consciense and of the press. Diastase (the first enzyme) is separated from barley. Justis Liebig investigates constitution of ether-alcohol. Marshall Hall discovers reflex action of nerve centers. Samuel F.B. Morse invents telegraph. First railway in Europe is completed (from Budweis to Linz). *Penny Magazine* founded. The Slavery Abolition Society is founded in Boston.

Births and Deaths: Manet, b. C.L. Dodgson (Lewis Carroll), b. George Crabbe, d. J.W. Goethe, d. Jeremy Bentham, d. William Crookes, b. Walter Scott, d.

1833: Isadore Niepce succeeds his father in the partnership with

Daguerre.

Mendelssohn, *Italian* symphony. N. Gogol, *The Government Inspector*, Dramatic copyright Act of 1833 in England for the first time gave the playwright authority to authorize performances of his work. *Knickerbocker Magazine* founded. First State grant for education in England. British Factory Act passed: no children under nine to work in factories; children between nine and thirteen to work no more than a nine-hour day. Births and Deaths: Johannes Brahms, b. Benjamin Harrison, b. Edward Burne-Jones, b. Alfred Nobel, b. Edwin Booth, b.

1834: W.H.F. Talbot conceives of idea of photography, while on vacation.

Berlioz, *Harold in Italy*. Schumann, *Carnaval*. Balzac, *Le Pere Goriot*. Herschel begins astronomical observations at the Cape of Good Hope. Faraday discovers electrical self-induction. Jean Dumas formulates the Law of Substitution. Louis Braille perfects a system of characters which the blind can read. The reaping machine made by Cyrus McCormick.

Births and Deaths: John Dalberg Acton, Lord Acton, b. Dimitry Mendeleev, b. Ernst Haeckel, b. William Morris, b. James Whistler, b. Edgar Degas, b. Samuel Taylor Coleridge, d. Alexander Borodin, b. T.R. Malthus, d. Charles Lamb, d.

1835: Daguerre discovers development, and the latent image, using mercury vapor. He revises the contract with Isidore. Talbot begins experiments with "photogenic drawings" on paper sensitized to light with silver chloride.

Caspar Frederich, *Rest During the Harvest*. Donizetti, *Lucia di Lammermoor*. Grimm, *German Mythology*. Hans C. Andersen, *Fairy Tales*. George Buchner, *Danton's Tod*. N. Gogol, *Dead Souls*. Samuel Colt revolver appears. Morse's telegraph first demonstrated. Experimental electrical railroad built by Thomas Davenport, Brandon, Vermont. Haley's comet appears. *New York Herald* founded as a one-cent paper.

Births and Deaths: Albert Venn Dicey, b. William Cobbett, d. Charles Camille Saint-Saens, b. Andrew Carnegie, b. Mark Twain (Samuel Langhorne Clemens), b. Samuel Butler, b.

1836: Glinka, *A Life for the Czar*. Arc de Triomphe, done. Dickens, *Sketches by Boz; Pickwick Papers*. Prix du Jockey Club first run in France. Ralph Waldo Emerson's *Nature* founds Transcendentalism. Acetyline made. First Railway in Canada opened; first train in

London. Communist league formed in Paris. Texas independence following battle of San Jacinto. Arkansas becomes 15th State. Louis Napoleon fails to create a revolt at the garrison of Strasbourg, as a first step to power, and is exiled to the United States.

Births and Deaths: Leo Delibes, b. Joseph Rowntree, b. W.S. Gilbert, b.

1837: Daguerre discovers he can "fix" the image with common salt. He revises the contract again with Isadore. The earliest Daguerreotype still in existence is made: of a still-life in Daguerre's studio.

Berlioz, *Requiem.* Dickens, *Oliver Twist.* Thomas Carlyle, *French Revolution.* R.W. Emerson,*The American Scholar.* Hegel, *Philosophy of History.* Dutrochet discovers chlorophyll in relation to photosynthesis. Issac Pitman invents shorthand. First machine-made pile carpets, by Samuel Bigelow, Boston. F.W.A. Froebel starts first kindergarten, near Blankenburg. Horace Mann begins educational reforms in Massachusetts.

Births and Deaths: Alexander Pushkin, d. William Dean Howells, b. Stephen Grover Cleveland, b. John Constable, d. Algernon C. Swinburne, b. J. Pierpont Morgan, b. John Thompson, b. Louis Ducos du Hauron, b.

1838: Daguerre and Isidore Niepce try to obtain subscriptions for the photographic processes they have invented.

National Gallery, London, founded. The Kremlin begun, in Moscow. Berlioz, *Romeo and Juliet.* Dickens, *Nicholas Nickleby.* Morike, *Poems.* Jenny Lind makes debut. Dominican order revived, France. J. Liebig demonstrates that animal heat is due to respiration, founding the science of bio-chemistry. Bruce invents type-casting machine. *Great Western* crosses the Atlantic, inaugurating regular steamship communication between the United Kingdom and the United States.

Births and Deaths: Henry Irving, b. Ferdinand Zeppelin, b. Georges Bizet, b.

1839: January 7, Arago announces the invention of the Daguerreotype to the *Academie des Sciences.* January 25, Talbot shows photogenic drawings at the Royal. January 29, Herschel recreates experiments of blackening of silver salts by light, and discovers the use of hyposulfite for "fixing" the silver image. February 21, Talbot describes his technique to the public. April 8, Jean Louis Lassaigne publishes first direct-positive process, based on Talbot's discoveries. June 24, Hippolyte Bayard exhibits paper direct positives. August

19, a public announcement of the Daguerreotype process Also in 1839—first *cliche verre*, first microphotograph—the eye of a fly—and first travel photographs, of Malta and Smyrna.

J.M.W. Turner, *Fighting Temeraire*. Lowell Institute founded to provide free public lectures by eminent scholars. Stendhal, *La Chartreuse de Parme*. E.A. Poe, *Tales of the Grotesque and Arabesque*. Henley Regatta instituted. Grand National first run at Aintree. Baseball first played. Steam hammer invented by James Nasmyth. Charles Goodyear vulcanizes rubber. First tunnel kiln made, in Denmark. The S.S. Great Britain becomes first screw-driven steamer to cross the Atlantic. Charles Darwin, *Voyage of the Beagle*.

Births and Deaths: Paul Cezanne, b. M.P. Moussorgsky, b. John D. Rockefeller, b. Walter Pater, b.

1840: Samuel F.B. Morse and Dr. John Draper make first American Daguerreotypes and perhaps the first portrait with this device. Their plate exposed 20 minutes in direct sunlight. Talbot discovers developing effects of gallic acid on the latent image, on paper sensitized with silver iodide. Lerebours publishes *Excusions Daguerrienes*—views in Italy, Egypt, Algiers and the near East. Josef M. Petzval makes first calculation of a fast achromatic objective for photographic use. A chemical photometer is described. "Quick stuff" used by Daguerreotypists First gilding of photographs.

Penny postage introduced in England.

Births: Timothy O'Sullivan, b.

1841: Talbot patents the Calotype. Experiments increase the sensitivity of Daguerre's plates. John Frederick Goddard, in England, Frans Kratochwila and the brothers, Dr. Johann and Dr. Josef Natter learn that silver chloride in combination with silver iodide increases photosensitivity.

Portraiture and landscape lenses designed by Petzval, of Vienna, manufactured by F. Voightlander, for his metal camera. Petzval's lenses are faster than Chevalier lenses, made for the Daguerre-Giroux cameras. Both Petzval's lenses consiste of a single achromatic landscape lens separated from a two-element unit. Petzval's portrait lens, f3.6, made Daguerreotype protraiture practical. Voightlander's metal camera offers a focussing glass. Hunt publishes *A Popular Treatise on the Art of Photography*, Glasgow.

1842: Talbot awarded the Rumford medal of the Royal Society. Auguste Bisson proposes using a green filter and prolonging exposures to compensate—resulting in improved reproduction of colors by reducing the effect of blue light. Solarization, the reversal of all or part of the negative image through overexposure, observed

by Ludwig Moser. Edward Anthony establishes a supply business of Daguerreotype materials in New York; later it becomes Anthony and Scovill, then Ansco, then Agfa-Ansco, then is siezed by the U.S. Government under the Alien Properties act; After the Second World War it becomes GAF. Carl Ferdinand Stelzner made Daguerreotypes of the Hamburg fire —the earliest surviving used of photography for news and documentation. Beard patented a process for coloring Daguerreotypes with powdered colors. Etienne Lechs receives a license for a water color process using powdered pigments.

London Illustrated News, founded. Uses etchings made from Daguerreotypes.

1843: John Edwin Mayall of Philadelphia makes photo illustration of *The Lord's Prayer* by Daguerreotypy. Hill and Adamson begin collaboration. Daguerre offers new method of preparing the plate: it involves a series of coatings with sublimate and rotten stone, then with iron oxide and cyanide of mercury; more iron oxide, and finally two solutions—one of gold chloride and hyposulfite of soda in distilled water, and one of platinum chloride in distilled water. Process is said to give excellent results; presumably because of the complexity there is no record or evidence of anyone else using it. S.F.B. Morse teaches Daguerre's process at $50 per student. One of the first students is Mathew Brady. Others who learn from Morse include Edward Anthony, Albert S. Southworth and Sam Broadbent. Talbot patents a process for making enlargements from his Talbotype negatives. Exposure tables are published: times in full sunlight range from ten to sixty seconds.

Electric telegraph is built between Washington and Baltimore.

Births and Deaths: William Henry Jackson, b.

1844: Brady opens a second floor loft studio on Broadway. His skylight is the first constructed in America for use by a photographer. Sir David Brewster presents a stereoscope with converging eyepieces. Talbot publishes *The Pencil of Nature.* Although Talbot took all the pictures, he was advised by his friend, the painter Henry Colleen, who was also the first professional Callotypist to practise in England. Admirers of Hill and Adamson start a "Calotype Club" in Edinburgh. Brady wins a silver medal at the first photo exhibit of the American Institute.

Births and Deaths: Ferdinand Hurter, b. Thomas Eakins, b.

1845: Brady's studio makes first of many photographs of American Presidents—Andrew Jackson in the year of his death. Views of American cities appear including Cincinnati, San Francisco, Boston.

Adolph Fischer suggests light sensitive materials be adhered to glass plates. Claude Felix Abel Niepce de Saint Victor is the first to do this. After failing with starch paste and gelatin, he coated a glass plate with albumen containing iodide of potassium; dried, it was treated with aceto-silver nitrate, washed in distilled water and exposed. Following Blanquart-Evrard's refinement of Talbotypy, he developed the plate in gallic acid. The process was named *Niepceotypy.* Fizeau and Jean Bernard Leon Foucault (at Arago's suggestion) made Daguerreotypes of the sun.

Births and Deaths: William Roentgen, b.

1846: 2,000 cameras and 500,000 silvered plates sold in Paris. Yearbooks begin to appear with the publication of Martin's *Reportorium of Photography.*

1847: Albumen plates invented by Niepce de Saint-Victor. Collodion discovered. Gustave LeGray, with P. Mathieu, introduce gold toning of positive prints on paper. Louis D. Blanquart-Evrard develops albumen paper for positive printing and also invents *amphitypes.* Carbon arc lamps used successfully in photography. Robert Hunt, in London, observes iron sulphate will develop pictures in iodide, bromide and chloride of silver. This is later important in developing wet collodion photography. Iron sulphate was not a success as a developing agent for prints. Hunt devised two processes: *ferrotype*, and *flurotype.*

Births and Deaths: Thomas A. Edison, b.

1848: T. Mayall makes six plates based upon a poem, *A Soldier's Dream*, by Thomas Campbell.

Births and Deaths: Robert Adamson, d. Vero Charles Driffeld, b.

1849: Paris produces an estimated 100,000 photographs.

Births and Deaths: Jacob Riis, b.

1850: Beginning of popularity of stereoscope photographs. *Ambrotype* appears; process similar to Daguerreotype in that it produces a *unique, direct-positive picture.* A thin negative is made on glass, bleached with bichloride of mercury, and backed with black paper or velvet so as to appear positive. G. LeGray introduces waxed paper process. The fibrous texture of Talbotype prints eliminated when Blanquart-Evrard coats paper with albumen before applying the sensitive silver salts. Brady produces a book called *Gallery of Illustrious Americans*, with twelve photographic portraits; it sold for thirty dollars.

Dickens, *David Copperfield*. The *Daguerreian Art Journal* and the *Photographic Art Journal* founded in New York.

1851: The *Societe Heliographique* founded in France, with Col. B.R. deMontfort as president. It is the first photographic society in the world. Among its forty members are Hippolyte Bayard, Henri LeSecq, Gustave LeGray, Charles Negre, Abel Niepce de Saint - Victor, Eugene Delacroix and scientists, including Edmund Becquerel and H. V. Regnault. The society published a journal, *La Lumiere*. The *Great Exhibition of the Industry of All Nations* held at the Crystal Palace, London. The first international exhibition and also the first important public display of photography. About 700 photographs from six nations shown. Gustave LeGray announces details of his waxed paper process; paper is waxed before iodizing, instead of after exposure. Frederick Scott Archer's wet collodion process introduced in March. The fastest photographic process so far devised, free from patent restrictions. Archer had experimented with an improved paper collodion film but it failed. Development of the emulsion must follow immediately on exposure, using either pyrogallic acid or ferrous sulphate. All manipulations must be carried out while the plate is still moist. Blanquart-Evrard opens a printing plant at Lille. DuCamp returns from the near East, and publishes *Egypte,Nubie, Palestine et Syrie*. Talbot claims Archer's process covered by his own Calotype patent. First successful photographs by electric light, by Talbot, in June. Talbot patented modifications of albumen-on-glass process, but his process fails to establish itself in England.

Verdi's *Rigoletto* has first performance. Hawthorne, *House of the Seven Gables* published: hero is a Daguerreotypist.

1852: F. Scott Archer and Peter W. Fry produce positive pictures from wet collodion negatives. Patented by Cutting and Rehn in 1854, these were named *ambrotypes* by Marcus A. Root. Talbot partially relinquished control of calotype patent to all except portra itists. Talbot patented a method of making permanent pictures with printing ink. His work was based on some earlier experiments by Mingo Ponton and the physicist Becquerel. Talbot called his method *Photoglyphy*. A steel plate was coated with bichromated gelatine and masked with a piece of black gauze, folded so the threads crossed at 45 degrees. It was exposed under a transparent positive; after washing out unexposed chromic salts the plate was etched. Chemists Barreswil and Davanne, working with the optician Lerebours and the printer Lemercier, succeeded in obtaining photo-
-lithographic half-tone. They revived Nicephore Niepces bitumen

process.

The Second Republic in France was replaced by the Second Empire; Louis Napoleon became the Emperor, Napoleon III.

Births: Gertrude Kasebier, b.

1853: Royal Photographic Society of England formed by Roger Fenton. It has an unbroken record from that time until now making it the oldest existing photographic society in the world. Claudet patented a folding pocket stereoscope. In autumn Russia and Turkey begin the Crimean War. The Duke of Wellington's funeral is the first public ceremony of which a photographic record was attempted. Because of weather and time of year, the effort failed. Commodore Perry's expedition to Japan has E. Brown as a daguerreotypist and apparently the first photographer on an American government expedition. Carol Pop De Szathmary, amateur artist and photographer living in Bucharest, photographed Russian general and camp scenes soon after the outbreak of the Crimean War in Wallachia in November, 1853. Later he photographed the Turks following the warfare in the Danube Valley. He is probably the first war photographer. Adolphe A. Martin describes process of making positive--appearing images on japanned metal (ferrotypes). John B. Dancer makes first two-lens stereo camera.

Verdi's *Il Trovatore*, and *La Traviata*.

Births and Deaths: Frederick Evans, b., Francois Arago, d.

1854: Marc Antoine Gaudin suggested methods of preserving collodion plates. One method involved washing away excess silver nitrate, drying the plate, then dipping the exposed plate once more in the silver bath directly before development. Another was to cool the sensitized collodion plate with hygroscopic substances which kept the coating moist. Both methods would only work for a few hours. George Swan Nottage founded the London Stereoscopic Company for the manufacture and sale of lenticular stereoscopes and the production of binocular pictures. Within two years the stereoscope was in use in all parts of the world; it was estimated that this firm alone had already sold half a million instruments. James A. Cutting secured three United States patents in photography. All three dealt with *ambrotypes*. Gauding Delamarre patented in France a parabolic reflector of silver plated copper for photographic use. The light source was an arc lamp. The eyes of the sitter were protected from glare by small concave mirror in front of the carbon points of the arc. Blue glass was used between the sitter and light to diffuse the light. Exposures were from 2-3 seconds for stereoscopic

portraits. Talbot loses case against Laroche. *Carte-de-visite* patented by Disderi. Roger Fenton makes first war photographs of the Crimean War. Poitevin discovers carbon process. He mixed powdered carbon in bichromated gelatine, spread it on paper, exposed it under a negative and after washing, there remained a picture. Lemercier published under the title *Lithophotographie* six prints, each 33 cm. x 23 cm., made by his adaptation of the bitumen process to printing.

Hard Times by Charles Dickens.

Births: George Eastman, b.

1855: August-Poitevin patented his carbon process and it was immediately successful for reproducing line drawings. French chemist Dr. J.M. Taupenot in September, 1855, a collodic-albumen process (dry plate). He coated the collodion plate with a film of iodized albumen, and then dipped it again in the silver nitrate bath. He therefore obtained two sensitive layers. The plate was dried and could be kept for several weeks. The length of exposure was about six times longer than for wet collodion. Fenton arrived at Balaclava on March 8. Robertson joins Fenton in September in the Crimean. *Interior of the Redan* among his works that came from that series. Nadar attempts balloon photographs, but fails. Retouched negative shown in Paris by Hanfstaengl. Eugene Durieu does a series of nudes as artists' studies which Delacroix admires. Courbet's first independent exhibition held under the label of Realism. The earlier *Societe Heliographique* became the new *Societe francaise de Photographie* with the purpose establishing photography as an art. It held its first exhibition. Dr. Thomas Keith—*Old Houses in Edinburgh* (photographic book).

1856: The first general treatise on the various applications of photography to the printing press was published by Georg Kessler in Berlin. In February a U.S. patent was issued to Hamilton L. Smith, a professor of natural science at Kenyon College, for *photographic pictures on japanned surfaces*. The patent described the tintype. Peter Neff had worked with Smith and bought the rights. The patent covered only the production of the photos and not the manufacture of the materials for them. Manufacturing process was a considerable problem since it involved the production of thin sheet iron and this was the problem which the Neffs succeeded in solving. Thomas Skaife patented the *pistol* camera in June. It was constructed of metal and used plates 1½" in diameter. Instantenous *shots* were taken by means of a spring shutter worked by rubber bands. The lens had a focal length of 1 inch and an aperture of 7/8 inch which could be reduced to 5/8 inch. Therefore it worked at Fl.1 or Fl.6 making it one of the fastest lens ever constructed. Gustave Le Gray *Brig Upon*

the Water made with a refined paper negative.

Births: Adam Clark Vroman, b. Frederick Ives, b.Peter Henry Emerson, b.Eugene Atget, b.

1857: Rejlander exhibits composite print *The Two Ways of Life* later purchased by Prince Albert. John Moule's *photogen* patented in February. It involved a pyrotechnic compound which gave a brilliant bluish-white light when ignited. This compound was burned in a big hexagonal lantern with glass sides. The combustion time was 15 seconds during which exposure was taken. A screen of blue glass sheltered the sitter from the dazzling light and softened the effect. Frith's Egyptian photographs. First aplanatic lens was designed and introduced by Thomas Grubb of Dublin. Wagner started work on *Tristan and Isolde* (completed in 1859). Ruskin's *Elements of Drawing* published. Ruskin relied heavily on photography both for architectural writings and research. He wanted photography to be a tool of art. He grew more antagonistic toward photography and later was to declare that *photographs are false, they are only a matter of ingenuity, while art is one of genius.* Dred Scott decision. Liszt finishes the last of twelve symphonic poems, started in 1848.

Births and Deaths: George Davison, b. Frederick Scott Archer, d.

1858: Talbot patented photoengraving employed in aquatint engraving: bichromate gelatine, and powdered resin. The plate was etched with solutions of iron perchloride. Nadar achieves a distinct though faint image from a balloon—an ambrotype from about 80 meters. The cause of the earlier failures was now evident—hydrogen sulfide escaping through the open valve fogged the collodion plates. H.P. Robinson, composite print, *Fading Away*. The first photographic rogue's gallery was established in New York City in 1858. It consisted of 450 pictures, all ambrotypes.

1859: Articles on photography by Oliver Wendell Holmes appeared in the *Atlantic Monthly*. His first was *The Stereoscope and the Stereograph* and it recommended the establishment of national and local stereographic libraries. Robert Wilhelm Bunsen, Heidelberg, and Henry Roscoe, Manchester, reported to the Royal Society on the extreme brightness and actinic qualities of burning magnesium wire and its value as a source of light for photography. C. J. Burnett exhibits the use of platinum in photographic printing at the British Association. Nadar installed Bunsen battery of 50 elements in his studio in Boulevard des Capucines. The first results were too con-

trasty. George Washington Wilson's views of Princes Street, Edinburgh and Edward Anthony's photos of street scenes with people and traffic not blurred. Some of Anthony's shots were even taken on rainy days. T. Morris showed the Photographic Society a tiny camera, measuring only 2 x 1½ inches x 1½ inches for taking pictures 3/4 inch square. The French government finally yielded to the *Societe francaise de Photographie* and declared that a salon of photography would form part of the yearly exhibitions held in the Palais de l'Industrie. The first exhibition was quiet and the reviews sympathetic. Photographically conditioned paintings exhibited that year received severe greetings in Charles Baudelaire's Salon review of 1859. He felt that photography was corrupting art and that its naturalistic influence was deadly, that photography '...must return to its real task, which is to be the servant of the sciences and of the arts, but the very humble servant, like printing and shorthand which have neither created nor supplanted literature.' Disderi was appointed Court Photographer. Nadar's *Portrait of Sarah Bernhardt* one of the few women he ever photographed. Nadar takes first pictures by electric light (in the catacombs of Paris).

Darwin: *Origin of Species.*

1860: Adolphe Bertsch showed his *chambre noire automatique* which was the first instrument that may be considered the forerunner of the modern small camera. All objects beyond distance of twenty paces (about 40 ft.) were rendered sharp. It was a 4 inch square metal box. The lens took pictures 2¼ inch square. There was no shutter; exposures were made by removing a lens cap. It was made for wet collodion process, but albumen or dry collodion plates could also be used. Samuel A. King and J.W. Black made the first successful attempt to take aerial views in America. 1,200 feet above Boston, Black made 8 exposures only one of which produced a successful picture. 11 May 1860 issue of the *Photographic News* Herschel used the term *snapshot.* Maxwell demonstrates principle of three-color photography.

O.G. Rejlander—*Nude* reflects current neo-classic painting style. Wagner completed *The Ring of the Nibelung* started in 1850.

1861: Marc A. A. Gaudin introduces a collodion emulsion for negatives. Major Charles Russell makes dry collodion plates with tannin. Josiah Johnson Hawes gives up the Daguerreotype process for glass negatives. Ernest Solvay discovers process for making sodium carbonate. Paul Eduard Johann Liesegany suggest use of green safelights in the darkroom. Mathew Brady organized the photographic documentation of the Civil War by teams of photographers in his employment. The task impoverished Brady and he was obliged to sell his collection to the United States Government in 1875. T. O'Sullivan

begins taking photographs of Civil War. Carleton E. Watkins took mule team to Yosemite Valley—one photograph taken there won first prize at the Paris International Exposition a few years later. William G. Chamberlain began making scenic views of Colorado which ended in 1881. In Paris an army of photographers spring up to exploit the boom of carte-de-visite. Not fewer that 33,000 people are stated to be making their living from the production of photographs and photographic materials. Disderi was reputed to be the richest photographer in Europe because of the carte-de-visite. Thomas Sutten introduces the first single lens reflex camera in England. Focal plane shutter is invented by William England.

Confederates open fire on Fort Sumter. Brooklyn New York Art Association established. A fine arts exhibition opened in Dublin. Charles Dickens writes *Great Expectations*.

Births and Deaths: Rabindranath Tagore, b. Poet Elizabeth B. Browning, d.

1862: Armand Sabattier discovers the solarization or reversal effect produced by action of light on an exposed negative during process of development. Ammonia is first used for developing photographs. The copyright of photographs is secured. Felix Beato photographs in Japan. Honore Daumier printed the lithograph *Nadar Raising Photography to the Height of Art*.

Manet, *Lola de Valence*. Daumier, *The Third Class Carriage*. Tolstoy, *War and Peace*. Buffalo, New York Academy of Fine Arts is incorporated.

Births and Deaths: Auguste Lumiere, pioneer in cinematography, b. O. Henry (William Sidney Porter) writer, b. Maurice Maeterlinck, writer, b. Edith Wharton, novelist, b. Claude Debussy, composer, b. Harold Dennis Taylor, b. (designed an exposure meter for photographic purposes based on the use of a standard candle). Gustave LeGray, d.

1863: Mrs. Cameron learns photography at the age of 48, on the Isle of Wight. Jakub Husnik experiments with two-tone photographs. Dr. Henry Wright photographs objects of surgical interest. H.W. Vogel founds the *Berlin Photographische Verein*.

Corner stone of the National Academy of Design is laid. A. Nadar makes ascents in his balloon *Le Geant*, and Jules Verne writes *Five Weeks in a Balloon*. Albert Bierstadt paints *Rocky Mountains*. E. Manet, *Luncheon on the Grass* and *Olympia*. Ingres, *Turkish Bath*.

Births and Deaths: Lieven Gevaert, b. Edvard Munch, b. Eugene Delacroix, d. Gabriel d'Annunzio, b.

1864: W.B. Bolton and B.J. Sace invent first workable dry collodion process, in which silver nitrate and albumen are discarded and a double salt of uranium and collodion substituted. Joseph Wilson Swan receives patent for his greatest contribution to photography—an improvement in making prints by the carbon process—as discovered by Ponton and Poitevin. Antoine Jean Francois Claudet creates a photographic method for making statuary. Walter Bentley Woodbury receives a patent for his photochemical process to which he gave the name Woodburytype. Desire Charles Emanuel van Monckhoven invents an enlarging apparatus. The light of ignited magnesium is employed for photography by Mr. Brothers in Manchester, England. Isaac W. Taber returned to San Francisco to join the firm of Bradley and Rulofson. Ducos Du Hauron, patents an apparatus for animated photographs (camera and projector) made by J. Duboscq. Vogel founds *Photographische Mittheilungen*.

Jules Verne, *Journey to the Center of the Earth*. The Historical Society of Delaware founded. Bangor (Maine) Historical Society founded. Vassar College Art Gallery founded. August Rodin, *Man with the Broken Nose*.

Births and Deaths: Simon Stampher, d., inventor of Stroboscope. Nathaniel Hawthorn, d. Alfred Stieglitz, b. Richard Strauss, b. Henri Toulouse-Lautrec, b. James Craig Annan, b.

1865: G. Wharton Simpson—positive collodio-chloride emulsion for printing-out papers, made by J.B. Obernetter. Carl August von Steinheil and his son obtain a patent for the famous distortion free symmetrical *Periskop* objective for photographic use. Frederck W. von Eglonffstein obtains patent for a halftone screen process and establishes the Heliogravure Company. John Traill Taylor introduces magnesium flash powders. Piazzi Smyth takes miniature camera to Egypt; photographs by magnesium flare.
Three paintings of F.E. Church, landscape painter, are exhibited and favorably received in London. Surrender at Appomattox by Lee. Lincoln assassinated by John Wilkes Booth. Winslow Homer, *Prisoners from the Front*. George Inness, *Delaware Valley*. Eugene Boudin, *Jetty at Trouville*. Jules Verne writes *A Trip to the Moon*. Births and Deaths: Rudyard Kipling, b., Laurence Housman, b. Robert Henri, b.

1866: M. Sanchez and J. Laurent invent Baryta coating of photographic papers. Carl August von Steinheil, a collapsible miniature camera with a plate changing device. Julia Margaret Cameron starts taking photographs of great men and beautiful women. David Octavius Hill finishes the *Founders of the Free Church of Scotland*. William Henry Jackson travels westward after a broken love affair, photographs Pawnee and Omaha Indians. Woodburytype patented. First rapid rectilinear lenses.

Louis Carroll, *Alice's Adventure in Wonderland*. Albert Bierstadt, *Valley of the Yosemite*. Claude Monet, *Camille*. Edouard Manet, *The Fifer*. Edgar Degas begins to paint scenes of ballet dancers. Yale University, Peabody Museum of Natural History, founded. Harvard University, Peabody Museum of Archaeology and Ethnology founded. Missouri Historical Society founded. New York American Watercolor Society founded. The Yale School of Fine Arts is opened.

Births and Deaths: Romain Rolland, b. H.G. Wells, b. Wassily Kandinsky, b. Benedetto Croce, d.

1867: Johanna Baptist Obernetter introduces commercial manufacture of silver chloride paper. Charles Cros describes principle of three-color separation and synthesis. H. Cook made opera-glass camera and plate change box for collodion plates. Alexander Gardner to Kansas as official photographer for Union Pacific Railroad, Eastern Division; makes stereographs of prairie, wagon trains, log cabins, peace treaties with Indians. T. O'Sullivan photographed for surveys along the 40th parallel. T. O'Sullivan starts on King Expedition. Julia Margaret Cameron photographs *Mrs. Herbert Duckworth* (mother of Virginia Woolf), and *Sir John Herschel*. John Thomson, *The Antiquities of Cambodia*.

1868: W.H. Harrison produces gelatine-bromide emulsions for chemical development. Josef Albert introduces the use of a glass support for the collodion printing process in which the relief emulsion was fastened to the glass support by an undercoat. Ducos du Hauron shows three colour photography and the various methods of achieving it; subtractive colour synthesis. T. O'Sullivan, mining pictures out West. Julia Margaret Cameron photographs *Henry Wadsworth Longfellow*. W.W. Corcoran deeds his valuable Art Gallery to trustees for public use.

Renoir and Manet begin to paint out of doors. E. Manet, *Zola*. P.A. Renoir, *Lise*. E. Degas, *L'Orchestre*. George Inness elected to National Academy of Design. Louisa May Alcott, *Little Women*.

Births: Maxim Gorkey, novelist.

1869: Robinson, *Pictorial Effect in Photography*. Ducos du Hauron and Charles Cros describe color processes. Adolf Ost introduces use of citric acid for preserving printing-out papers containing silver chloride. Ernst Leitz establishes the Ernst Leitz optical works in Wetslar, Germany. Edweard J. Muybridge moved his studio from Selleck's Gallery to Nahl's at 121 Montgomery Street, San Francisco.

John W. Powell explores Colorado River through the Grand Canyon. Robert Browning writes *The Ring and The Book*. New York American Museum of Natural History founded. National Photographic Association, Boston, founded.

Births and Deaths: Henri Matisse, b. Booth Tarkington, b. Frank Lloyd Wright, b. Edgar Lee Masters, b. Roger Fenton, d. Hector Berloiz, d.

1870: O'Sullivan working in the West. Jackson hired by Hayden to photograph in the Yellowstone area—his pictures impress Congress, the area is made into a national park. Cameron begins illustrating Tennyson.

Deaths: David Octavius Hill, d.

1871: John K. Hillers learns photography with Powell expedition in Southwest. T. O'Sullivan on 100th Meridian survey with Wheeler. T.J. Hines photographs Yellowstone—loses all in Chicago fire. Jackson enters Yellowstone from the north side. Thomas Ross patents *Wheels of Life*. Leach Maddox announces gelatin-bromide emulsion. *London Times* publishes photo messages carried by pigeons to Paris.

Cezanne, *The Railyway Cutting*.

Births and Deaths: Ernst Leitz, b. Sir John Herschel, d.

1872: Wheeler hires William Bell as photographer. President Grant makes Yellowstone first National Park. Rejlander illustrates Darwin's *The Expression of the Emotions of Man and Animals*. Muybridge photographs Leland Stanford's horse. Eder transports dry gelatin plate from Vienna to Siberia and returns before success fully processing it.

310

Monet, *Impression: Sunrise*. Cezanne, *The Halle, Aix*.

Births and Deaths: Louis Desire Blanquart Evard, d. Samuel F. B, Morse, d.

1873: O'Sullivan photographs Canyon de Chelly. General Stanley hires S.T.Morrow to photograph Northern Pacific Railway in Wyoming area. Dunmore and Critcherson on Bradford expedition to Greenland. John Thompson, *Illustrations of China and its People*. Feverback publishes *Plato's Symposium* styled after Rejlander's *Two Ways of Life*. Muybridge photographs Modoc Indian Wars. John Burgess makes commercial gelatine emulsion. *Celluloid* trade mark registered. *Daily Graphic* prints half-tone photographic illustration. Gelatin silver bromide invented by P. Mawdsley, Liverpool Dry Plate and Photographic Printing Company. William Willis patents commercial platinum printing.

1874: Pictorialist photographers revolt within the Photographic Society of London—presidency offered to Talbot and declined. Secession is achieved in Brussels, and the *Cercle d'Art Photographique* separates from the *Association Belge de Photographie*. Jackson photographs Southwest Colorado. Cameron illustrates *Idylls of the King* with 24 plates. P.J.C. Janssen, French astronomer, invents chronophotography for photographing stellar objects. Principle of optical sensitizing by dyes discovered by Hermann Vogel, Berlin; leads to orthochromatic emulsions. First Impressionist exhibit at Nadar's studio.

Cezanne, *Mme Cezanne*.

Births and Deaths: Lewis Hine, b.

1875: Leon Warmke invents stripping film and a roll film system Carjat sells his Paris studio. Jackson makes 20 x 24 inch glass plate photographs.

Gaugin, *The Seine at Pont d'Iena*. Cezanne, *Dahlias*.

Births and Deaths: O.G. Rejlander, d.

1876: Cameron begins photographing in Ceylon. Richard Kennett makes very sensitive dry plates.

Centennial Exhibition at Philadelphia.

Births and Deaths: Auguste Sander, b. Andrew Russell, d.

1877: Jackson compiles *Descriptive Catalog of Photographs of North American Indians, Miscellaneous Publication no. 9, USGS, Washington*. Jackson tries an English roll film holder. Discovery that heat increases sensitivity of gelatin emulsion. Eastman attempts photography on trip. Ducos du Hauron photographs Angouleme in color. J. Thompson, *Street Life in London*. First studio using electric light in London, owned by Henry Van der Weyde.

Monet, *Gare St. Lazare*. Cezanne, *Self Portrait*.

Births and Deaths: W.H.F. Talbot, d.

1878: Frank Haynes photographs Yellowstone. Appointed official park photographer, 1884. John Thompson *Through Cyprus With a Camera*. J.M. Cameron makes last picture, in Ceylon. Machine-coated plates made in England. Eastman makes first dry plates. Muybridge photos published in Europe.

Cezanne, *Bathers*.

1879: J.W. Swan (England) makes commercial dry plates. Last Daguerreotype made by Alva Pearsall, Brooklyn. Jackson founds business in Denver, Colorado. Muybridge invents *praxiscope*. Eakins paints. *Machine-coated plates made in England. Swan patents paints The Fairman Roger's Four-in-hands*. Machine-coated plates made in England. Swan patents ruled gelatin bromide paper for enlarging. Platino-type Company of London licenses photographers. John Carbutt makes first American commercial dry plates.

Births and Deaths: Edward J. Steichen, b. Oskar Barnack, b. J. M. Cameron, d.

1880: Muybridge starts three year lecture tour projecting moving pictures in San Francisco. Blair Camera Co. markets a small camera 'for amateur photographers, college students and artists.' Eastman obtains patent for American dry plate. R. and D. Beck construct first twin-lens camera, made for Kew Observatory.

Stephen Horgan devises first practical method of half-tone for *New York Daily Graphic*. Dry plates came into general use, slower than wet plates and costing 2 for half dozen 5x8 inches. George Eastman introduces his dry plates commercially (although he is pre-

ceded by several other manufacturers). R.&J. Beck invent the first twin-lens reflex camera. San Francisco Art Association presents Muybridge's lantern slides of galloping horse. *Zoogyroscope* invented by Muybridge for projecting motion sequences. A small 4x5 camera with lens and tripod, plus 12 Eastman Dry Plates costs $12.25.

Rodin, *The Thinker*, Cologne Cathedral finished. Dvorak, *Symphony No. 1* in D (op. 60). Tchaikovsky, *1812 Overture*. A. Sullivan, *Pirates of Penzance*. F. Dostoievsky, *The Brothers Karamazov*. H. W. Longfellow, *Ultima Thule* . G. de Maupassant, *Boule de Suif*. Francis Thompson, *The City of Dreadful Night*. Lewis Wallace, *Ben Hur*. E. Zola, *Nana*.

First Girls' high school in England. De Beers Mining Corporation formed by Cecil Rhodes. Louis Pasteur discovers streptococcus. Andrew Carnegie's first large steel furnace. Adolf van Beyer makes synthetic indigo. T.A. Edison and J.W. Swan independently make the first large steel furnace. Adolf van Beyer makes practical electric light. Beginning of street lighting by electricity in New York. Tinned salmon, meat and fruit are available.

Births and Deaths: Douglas MacArthur, b. Giles Lytton Strachey, b. Gustave Flaubert, d. Ernest Block, b. Jacques Offenbach, d. Francis Bruguire, b. Marc-Antoine Gaudin. C. Negre, d.

1881: P.J.C. Janssen discovers Law of Reciprocity failures. H. Goodwin develops glue reversal process for use in photomechanical reproduction. F.E. Ives starts commercial operation of halftone process. H.A. Steinhert manufactures an antiplanar lens. G. Eastman leaves bank job to devote full time to expanding his dry plate factory. Gelatin-Chloride paper invented by Eder & Pizzighelli.

Rodin, *Eve*. Degas, *Prancing Horse* (sculpture). C. Monet, *Sunshine and Snow*. J. Brahms, *Academic Festival* (op. 80) and *Tragic* (op. 81) overtures. G. Flaubert, *Bouvard et Pecuchet* H. James, *Portrait of a Lady*. D. G. Rossetti, *Ballads and Sonnets*. American Federation of Labor founded at Pittsburgh. Flogging is abolished in Royal Navy and British Army. University College, Liverpool, founded. Alexander II of Russia assassinated, Alexander III reigns. Austro-Serbian alliance formed. Pasteur applies vaccination principle. Jewish pogrom in Russia. Blaine and United States Government attempt closer ties with Latin America. Three Emperors' League formed. American Red Cross organized. James A. Garfield elected President. Garfield assasinated: Chester A. Arthur becomes President. "Star Route" fraud by United States Postmaster General. Electric street lighting in Philadelphia. Railroad connects Madrid and Lisbon.

Births and Deaths: William Warnecke, b. Fischer, Rudolf, b. Antoine Adam-Salomon, d. Thomas Carlyle,d. Feodor Dostoievsky, d. Ernest Bevin, b. M.P. Moussorgsky, d. Benjamin Disraeli, Earl of Beaconsfield, d. Bela Bartok, b. Alexander Fleming, b. Pablo Picasso, b. Clive Bell, b. K. Ataturk, b.

1882: Ottomar Anschutz (German), instantaneous photographs of moving animals (single camera). Etienne Jules Marey (French), invented photographic gun with disc shutter. Aime Civiale publishes a group of 41 panoramas as a geologic record of the entire range of the Alps. First portraits by electric light. All of Eastman's dry plates fail and he buys new formula in England; discovers the problem is in the gelatin. H.B. Berkeley uses sodium sulphite as a preservative in developers. A. Bertillon obtains patent for photo system of identifying criminals. E.J. Marey develops *chronophotography* apparatus to study the movement of animals. Gelatin Chloride P.O.P. invented by Abney.

Rodin, *Crouching Woman*. E. Manet, *Le Bar Aux Folies-Bergeres*. J. Brahms, *Piano Concerto No. 2*, in B flat (op. 83). N. Rimsky-Korsakov, *The Snow Maiden*. A. Sullivan, *Iolanthe*. R. Wagner *Parsival*, his last opera. Berlin Philharmonic Orchestra founded. American Baseball Association founded. Maried Women's Property Act in Britain gives married women for the first time the right of separate ownership of property of all kinds. George Kynoch's brass cartridge-case Gottlieb Daimler builds petrol engine. T.A. Edison's generating station at Pearly Street, New York, and the first hydro-electric plant at Appleton, Wisconsin. Society for Psychical Research founded, with Henry Sidgwick president. The idea of a Channel Tunnel is discussed in Britain, but military authorities disapprove. Triple Alliance of Austria, Germany, and Italy formed. Britain defeats and occupies Egypt. St. Gotthard tunnel joins Italy and Switzerland. Fifty cent head tax on immigrants to U.S. Exclusion Act bars Chinese laborers from entering U.S. U. S. Copyright law passed.

Births and Deaths: Virginia Woolf, b. F.D. Roosevelt, b. James Joyce, b. Henry Wadsworth Longfellow,d. D.G. Rossetti, d. Charles Darwin, d. Ralph Waldo Emerson, d. Guiseppe Garraddi, d., Igor Stravinsky b., Samuel Goldwyn, b., Eamon de Valera, b. Louis Blanc, d., Anthony Trollope, d., Arthur Stanley Eddington,b., Georges Braque, b., Alvin Langdon Coburn , b. John W. Draper, d., Alexander Gardner, d., Timothy H. O'Sullivan, d., Henry LeSecq, d., C.C. Kenneth, d.

1883: *The Pioneer Photographic Club of New York* formed. *Boston Camera Club* formed. Chicago Camera Club formed. Eastman builds first new factory. Chloro-bromide paper invented by Eder.

Degas, *Dancers Tying their Slippers* influenced by Muybridge Large bison herds gone from western plains. E.H. Farmer invents single solution reducer of ferricyanide. R. Schlotterhus invents machine for continuous photographic printing and finishing.

P. Cezanne, *Rocky Landscape*. A.Renoir, *Dance at Bougival*. Rosso *The Concierge*. J. Brahms, *Symphony No. 3* in F (op. 90). A.E. Chabier, *Espana Rhapsody*. A. Dvorak, *Stabat Mater* Metropolitan Opera, New York, founded. Royal College of music, London founded under George Grover. R.L. Stevenson, *Treasure Island*. Congress authorizes first steel U.S. Navy vessels. Northern Pacific Railroad reaches Pacific coast. Foundation of German colonial empire. Gold rush in Idaho. Brooklyn Bridge completed. Russian chief of secret police assassinated. England passes Epidemic Prevention Act and Bankruptcy Act. Clemenceau's motion for revision of French Constitution rejected. U.S. Mexican boundary treaty signed. U.S. Supreme Court rules that an Indian was by birth an alien and a dependent. Railroads inaugurate standard time zones. First *Wild West Show* with "Buffalo Bill" Cody. Opening of New York Metropolitan Opera House.

Births and Deaths: Clement, Lord Atlee, b. Richard Wagner, d. Karl Jaspers, b. Karl Marx, d. Walter Gropius, b. John Maynard Keynes, b. Edward Fitzgerald, d. Benito Mussolini, b. Pierre Laval, b. Imogene Cunningham, b. Charles Sheeler, b.

1884: Eastman introduces his first flexible film (emulsion paper, subsequently stripped to glass for printing). Eastman introduces American Film and machine for continuous coating of paper. J.M. Eder discovers color sensitization with erythrosine. O. Perutz, J. B. Obernetter and H. W. Vogel produce a commercial orthochromatic plate. A. Rouille-Ladeveze introduces gum prints.

Van Gogh, *Garden of the Presbytery*. *Les Vingt* exhibiting society founded by James Ensor in Brussels, supported by Georges Seurat, Paul Gauguin, Paul Cezanne and Vincent Van Gogh. G. Seurat, *Bathers at Asnieres*. E. Burne-Jones, *King Cophetua and the Beggar Maid*. A. Rodin, *Burghers of Calais*. Grieg, *Kolberg Suite*. A. Bruckner, *Symphony No. 7, and Te Deum*. C. Franck, *Les Djinns*. J. Massenet, *Manon*. C.V. Stanford, *Savonarola*. Mark Twain, *Huckleberry Finn*. Charles Parsons constructs first practical steam turbine for making electricity. Oliver Lodge discovers electrical precipitation. Hiram Maxim's recoil-operated gun. American Institute of Electrical Engineers founded. Waterman perfects fountain pen. C.A. Parsons patents steam turbine. Development of cocaine as surgical anaesthetic. Mergenthaler invents linotype. Federal troops disperse illegal Oklahoma settlers. Berlin conference on African affairs. Naval

War College established at Newport. U. S. Bureau of Labor created. Suffragettes form Equal Rights party, nominate woman for President. English Parliament passes Third Reform Bill. England passes new education code. French trade unions legalized. French Constitutional revision passed. Conference of Independent Democrats (Mugwumps).

Births and Deaths: Ivan Maisky, b. Hugo von Hofmannsthal, b., Francois Mignet, d. Sean O'Casey, b., Harry S. Truman, b. Friedrich Smetana, d. D. H. Lawrence, b.

1885: Rodin, *The Old Courtesan*. Gaudi, *Fascade Guell Palace*. J. Brahms, *Symphony No. 4* in E minor. Cesar Franck, *Symphonic Variations*, . A. Sullivan, *The Mikado*. Richard Burton, *The Arabian Nights*. G. de Maupassant, *Bel Ami*. Leo Tolstoy, *The Power of Darkness*. Emile Zola, *Germinal*. Congress probibits unauthorized fencing of public lands. Suspension of silver dollar coinage recommended. First special delivery service by U.S. Post Office. Cleveland first Democratic President since Civil War. American Marines sent to Panama. Chicago's steel Home Insurance Building inspires term "skyscraper". American Economic Association founded. Stanford University founded. Dedication of the Washington Monument.

Births and Deaths: Alban Berg, b. Friedrich Henle d. Victor Hugo, d. Ulysses Grant, d. Henry Tizard, b. George Smith Patton, b. Ezra Pound, b. Howard Coster, b. Luther H. Hale, d.

1886: Lord Rayleigh notes the effect of a coating on lenses in eliminating reflection and scatter. Louis and Max Levy develop a technique for producing photomechanical halftone screens. P. H. Emerson speaks to Camera Club of London on *Photography, a Pictorial Art*. Felix Tournachon and Paul Nadar conduct first photo--interview for *Le Journal Illustre*. Eastman first markets 'pre--sensitized' bromide paper (printing). Eastman invents a small camera (the precursor to the Kodak) which turns out to be a failure.

Degas, *The Tub*. Cezanne, *Bay from L'Estraque*. J. S. Sargent, *Carnation, Lily, Lily, Rose*. G. Seurat, *Sunday on the Island of Grande Jatte*. Eighth and last Impressionist Exhibition. J. Whistler, P. W. Steer and W. Sickert found New English Art Club. Saint Saens, *Symphony No. 3*. H. Rider Haggard, *King Solomon's Mines*. F. Nietzsche, *Beyond Good and Evil*. A. Rimbaud, *Les Illuminations*. R.L. Stevenson, *Dr. Jekyll and Mr. Hyde*. A Strindberg, *The Son of a Servant*. The element germanium discovered. Henri Moissan prepares fluorine. R. Kraft-Ebbing, *Psychopathia Sexualis*. C.A. von Welsbach invents gas mantle. Canadian Pacific Railway completed.

Niagra Falls hydo-electric installations begun. The French army is equipped with the Lebel rifle, using smokeless powder. Gold rush in the Transvaal, Heads of former reigning families banished from France. Third Gladstone ministry in England. Gladstone's first Irish Home Rule Bill defeated. Treaty of Bucharest: peace between Bulgaria and Serbia. France allows only lay teachers. First American settlement house opens in New York. France presents the Statue of Liberty to the U.S. Anarchists tried for Haymarket massacre. Presidential Succession Act provides for the succession of Cabinet members. Anti-Chinese riots in U.S. continue. Russian interference in Bulgaria. Plot against Czar discovered.

Births and Deaths: Oskar Kokoschka, b. William Edward Forster, d. Karl Barth, b. Franz Liszt, d. David Ben Gurion, b. Alexeivich Balakirev, b. Erich Solomen, b. Edward Weston, b.

1887: O. Anscheutz works on stroboscopic synthesis of serial pictures of animals in motion. E. Rausch patents shutter with blades forming a diaphragm. H. Goodwin invents negative made by coating silver bromide gelatin on flexible celluloid strips. A. Miethe and J. Gaedicke popularize magnesium flash. Stieglitz first honored in British *Amateur Photographer* contest judged by Emerson. Hanibal Goodwin files patent on transparent nitrocellulose film. Eadweard Muybridge publishes *Animal Locomotion* Blitzlitchpulver (flash light powder) invented in Germany. Exhibition of Amateur Photography in New York sponsored by New York, Boston, and Chicago Camera Clubs. Litigation between Eastman and Anthony over patents. *Melano-chromscope* invented for producing color images.

H. Toulouse-Lautrec, *Portrait of Vincent Van Gogh* J. Brahms *Con certo in A Minor* (op. 102) for violin and cello. A. Borodin, *Prince Igor*. G. Verdi, *Otello*. I. Paderewski gives first recitals in Vienna. L. Zamenhof founds 'Esperanto'. Joseph Lockyer, *The Chemistry of the Sun*. Phenacentin, an analgesic drug, discovered. Emil Fischer and Tafel synthesize fructose. Aluminum is produced electrolytically in Switzerland. Cyanide process for extracting gold and silver. Rudolf Hertz discovers that electromagnetic waves are reflected in a manner similar to light waves. Hilaire Comte de Chardonnet invents artificial silk. Emil Berliner invents his version of the gramophone. Carl Laval's turbine. H.M. Stanley discovers the Lake Albert Edward Nyanza. Canonization of Sir Thomas More, John Fisher and other English Roman Catholic martyrs. U.S. revokes reforms of the Land Commission. Electoral Count Act passed. Interstate Commerce Commission: first Federal regulatory agency. Cleveland vetoes pension bill. Hawaii grants U.S. rights to coaling station in Pearl Harbor. Anti-Polygamy Act passed. Nordenfelt invents boat submarine. Arrhenius's theory of electrolytic dissociation

Births and Deaths: Vincent Massey, b. Alexander Borodin, d. Julian Huxley, b. Alfred Krupp, d. Charles Edouard Jeanneret, b.Chiang Kai-shek, b. Viscount Bernard Montgomery, b. Thomas Annan, d. Hippolyte Bayard, d.

1888: J. Riis publishes photographs of slums. E. Mach experiments with time lapse and stroboscopic photography. L.A.A. LePrince develops cine cameras and projector. Eastman introduces the Kodak. Carbutt invents celluloid cut film. Van Hut declares Helmholtz--Young color perception theory is incorrect. Marey invents *chambre chronophotographique*, fore-runner of movies. Van Gogh's *Sunflowers, The Yellow Chair, Night Cafe, the Orchard*. P. Gauguin, *Vision After the Sermon*. G. Seurat, *Side Show*. A. Rodin, *Burghers of Calais*. N. Rimsky-Korsakov, *Scheherezade*. Richard Strauss, *Don Juan*. Gustav Mahler directs the Budapest opera. Edward Bellamy, *Looking Backwards*, 2000-1887. R. Kipling, *Plain Tales from the Hills*. A. Quiller-Couch, *Astonishing History of Troy Town*. P. Verlaine, *Amour*. E. Zola, *La Terre*. Cecil Rhodes amalgamates Kimberly diamond companies. The word 'chromosome' is first used. Pasteur Institute founded in Paris. N. Tesla invents AC electric motor, which is manufactured by George Westinghouse. J.B. Dunlop invents pneumatic tyre. Aeronautical exhibition, Vienna (Apr.). F. Nansen crosses Greenland. C.M. Doughty, *Travels in Arabia Deserta*. *Casey at the Bat* first publically recited. T.S. Edison perfects the first ''talking machine.'' Wilhelm II Kaiser of Germany. Benjamin Harrison elected President of U.S. by electoral vote while Cleveland receives popular vote. First use of Australian secret ballot in U.S. local elections. U.S. Department of Labor formed. New Jersey authorizes incorporation of holding companies. Two more attempts on the Czar's life. Berin/Baghdad railway. First Marine Biological Laboratory. First electric trolley line. Tesla patents induction motor New York adopts electrocution as capital punishment. Burroughs patents adding machine. Formation of the Amateur Athletic Union.

Births and Deaths: Matthew Arnold, d. Irving Berlin, b. T.E. Lawrence, b. Murice Chevalier, b. Katherine Mansfield (see Beauchamp, pseud. of Kathleen Murray), b. T.S. Eliot, b. Charles Cross, d. Carl Zeiss, d. Edward Anthony, d. Marcus A. Root, d.

1889: W. Denisthorpe and W. C. Crofts obtain patent for a film camera and projector. T.A. Edison starts experiments in motion film photography using strips of film. K. Schwarzschild discovers *Law of Blackening* (sensitometry). M. Carey Lea describes allotropic forms of silver. Emerson: *Naturalistic Photography*. Stieglitz, *Paula*. George Eastman first uses nitrocellulose for support for negative materials. The first Anastigmat lens, designed by Paul Rudolf, introduced by Zeiss.

318

Seurat: *Le Chahut*, influenced by Marey. Van Gogh, *Lanscape with Cypress Tree* and *Starry Night*. P. Gauguin, *The Yellow Christ*. P. Puvis de Chavannes decorates Hotel de Ville, Paris. Eiffel Tower, Paris, built. A. Dvorak, *Symphony No. 4* in G. C. Franck, *Symphony in D minor*. R. Strauss, *Death and Transfiguration*. Tchaikowsky, *Symphony No. 5* in E minor (op. 64). A. Sullivan, *The Gondoliers*. A. Gide begins *Journal*. Gerhardt Hauptmann, *Before Dawn*. W.B. Yeats, *The Wanderings of Oisin*. P.T. Barnum and J.A. Bailey's show at Olympia. G.B. Shaw, *Fabian Essays*. G. V. Schiaparelli determines the synchronous rotation of the planet Mercury. Frederick Abel invents cordite. Institution of Electrical Engineers founded. Mayo Clinic founded. Japan adopts constitution. Brazil becomes a republic. Formation of the Second Socialist International in Paris. First Pan-American conference. North and South Dakota, Montana and Washington receive statehood. Sioux yield nine million acres to U.S. Department of Agriculture given Cabinet status. Boulanger reelected in France. England passes Naval Defense Act to strengthen Navy. Bismarck's social welfare bills passed. The U.S. anti-trust law.

Births and Deaths: Arnold Toynbee, b. Charles Chaplin, b. Adolf Hitler, b. Stafford Cripps, b. Antonio Salazar, b. Jean Cocteau, b. J.P. Joule, d. George S. Kaufman, b. Phillip Henry Delamotte, d. D.M. Ferrier, d. William S. Porter, d. Robert Browning, d. G. Manley Hopkins (unpublished), d.

1890: Jacob Riis, *How the Other Half Lives*. *Photo-Chemical Investigations and a New Method of Determination of the Sensitiveness of Photographic Plates* published by Dr. F. Hurter and V.C. Driffield. Steiglitz returns to the U.S. Dr. Rudolph introduces symmetrical triplet lens.

Leighton, *The Bath of Psyche*. P. Puvis de Chavannes leads secession of artists from the Salon; exhibit in the Champ de Mars. William Morris founds Kelmscott Press. A. Borodin, *Prince Igor*, P. Mascagni, *Cavalleria Rusticana*. Tchaikovsky, *Queen of Spades*. Knut Hamsun (pseud.), *Hunger*. Leo Tolstoy, *The Kreutzer Sonata*. J.G. Whittier, *At Sundown*. L.A. Bertillon describes photographic identification of criminals. Free elementary education in England. Building entirely steel-framed erected in Chicago. J.G. Frazer, *The Golden Bough*. U.S. Weather Bureau begun. Federation of Women's Clubs founded. Navy wins first Army-Navy football game. Emily Dickinson: first printing, collected poems. Morman Church ends approval of polygamy. Daughters of the American Revolution organized. Bismarck dismissed as German chancellor. Idaho and Wyoming statehood. English agree with Germany and France over boundaries in Africa. Census numbers 62,947,714 in U.S. Sherman Silver Purchase Act. Sitting Bull killed.

Births and Deaths: Karel Capek, b. Vyacheslav Molotov, b. Anthony Fokker, b. John Henry Newman, d. Dwight D. Eisenhower, b. Cesar Franck, d. Arthur Rimbaud, d. Charles de Gaulle, b. Vincent van Gogh, d. Man Ray, b. Paul Strand, b. Guiseppe Alinari, d. Andre Adolphe Disderi, d. George Seurat, d.

1891: Alfred Stieglitz joins the Society of Amateur Photographers of New York. He photographs in the city with a hand held 4 x 5 camera. This is the first time a hand held camera is used for serious artistic work. The Vienna Camera Club has its first exhibition, of Heinrich Kuhn's photographs. Henry Hamilton Bennett photographs the Wisconsin Dells, producing panoramic prints 60 inches long, printing three 18 x 22 inch plates on a single sheet of paper. The ABC series of Kodaks introduced, all daylight loading roll-film cameras. The camera does not have to be shipped back to Kodak to be re-loaded. Dr. M. Andreson, a chemist in Berlin for *Allgemeine Gesellschaft fur Aniline Fabrihatior (AGFA)*, discovers a new developing agent, p—aminophenol (Amidol). The first telephoto lenses introduced by A. Steinheil and Thomas Ross Dallmeyer, independently. L. Gaumant of Paris makes a kite camera for Lawrence Ratch of the Blue Hill Meterological Observatory near Boston. A clockwork device triggers the shutter. The walking stick detective camera is invented. Alfred Watkins *Standard* light meter is manufactured by R. Field and Co. Light intensity is measured by pointing the end of the tube containing sensitive paper towards the light source and timing the seconds needed to darken the paper to a standard tint. Emerson, *The Death of Naturalistic Photography*. Adams & Co. of London introduce a camera concealed in a hat, fitted with an f11 lens, taking a 4¼ inch x 3¼ inch picture. Britannia Works produce Joseph Barker's gelatin silver chloride paper, using for the first time the abbreviation P.O.P. (printing-out paper). Ross & Co.'s *Dividend* twin lens camera is introduced; the smallest version compares with the *Rolleiflex*. Gabriel Lippmann presents to the Academie des Science a system of color photography based on the theory of light interferences.

Gauguin leaves for Tahiti. Winslow Homer, *The Hunter*. Pisarro, *The Market at Gisors*. Duse's debut in Vienna. William Morrison of the United St ates invents the first electric automobile. Oscar Wilde, *The Picture of Dorian Gray*. Otto Lubrenthat of Germany sails success fully in a glider. First workable copyright law passed in U.S. Johnstone Stoney introduces the term *electron*. Retrospective Vincent Van Gogh exhibition at Salon des Independents.

1892: Fourteen young pictorialists break away from the Photographic Society in Britain and form *The Linked Ring*. Members of the group include H.P. Robinson, George Davison, Horsley Hinton, J. Craig Annan, Frederick Evans, Frederick Hollyer, Alexander Keighley and H.H.H. Cameron. They all agree that ordinary silver prints were unsuitable for hanging on walls as pictures to be admired and use alternative methods—platinotypes, photo-etchings, photogravures, soft focus lenses, printing on coarse papers and gum bichromate prints. There are 30,000 professional photographers in France and over ten times that many amateurs. The *Daily Graphic* and *The Illustrated London News* begin drawing largely on photographs—but only for copy for woodcuts, not as half-tone illustrations. Marey describes to the Academie des Sciences a projector in which 60 or more positives printed on a transparent film band are projected on a screen by electric light. J.F. Clarke's *Frena*, a magazine camera, introduced. Their slogan is, 'Anyone who can ring an electric bell and turn a key can take pictures with this apparatus.' It is the first hand camera to expose a pack of celluloid cut film. Adolf Brandweiner invents rotogravure process. Eastman Kodak Co. produces Solio paper, a print-out gelatine chloride paper. Professor C.V. Boys of the Royal College of Science photographs a bullet piercing a sheet of plate glass. Georges Demeny invents the Bioscope to reproduce movement. The Scott Exposure Calculator is marketed. Frederick Ives delivers a paper on the history, principles and practice of the photochromoscope, a color process. Edison invents the Kinetoscope, using 35mm perforated Kodak film.

Jacob Riiss, *Children of the Poor*. Alexander Graham Bell makes the first telephone call between New York and Chicago. Cezanne, *The Card Players*. Renoir, *Two Girls at the Piano*, (painted with his brush strapped to his hand). Antonin Dvorak becomes director of the National Conservatory of Music, New York. *The Globe* becomes the first London newspaper to adopt the Linotype machine. Rudolf Diesel patents a petrol engine. First automatic telephone switchboard. G.J. Romanes, *Darwin and After Darwinism*. Claude Monet begins pictures of Rouen Cathedral. Henri Toulouse-Lautrec, *At the Moulin Rouge (*litho.) Emile Zola, *La Debacle*. Lottie Collins sings *Ta ra-ra-boom-de-ay* in London.

Births and Deaths: Alfred, Lord Tennyson, d. (83) Walt Whitman, d. (72).

1893: First exhibition of The Linked Ring called The London Salon, at the Dudley Gallery. The Linked Ring publishes a collection of photographs called *Photograms of the Year*. Alfred Stieglitz represented in the London Salon and published in Photograms of the Year. Ernst W. Juhl, founder of the Society for the Advancement of

Amateur Photography, organizes an international exhibit at the *Hamburg Kunsthalle*. Six thousand amateur photographs are shown. Alfred Stieglitz takes the first successful snow photographs. Edison manufactures the Kinetoscope. Alfred Stieglitz works on *American Amateur Photographer*. J. Craig Annan rediscovers the work of Hill and Adamson. Alfred Stieglitz, *The Terminal*. Edward Anthony photographs the Columbia World Exhibition in Chicago. An amateur photographer records the sinking of the British flagship the H.M.S. Victoria after its collision with H.M.S. Camperdown. Muybridge lectures on animal locomotion in the *Zoopraxographical Hall* at the Chicago World Fair. *Studio* magazine publishes *The Camera, Is it a Friend or Foe of Art*. The Nepera Chemical Co, of New York brings out *Velox* gaslight paper—a developing-out paper. Louis Boutan, a professor at the Zoological Station at Banyuls--sur-Mer, Eastern Pyrenees, explores the ocean with a camera sealed in a watertight metal box with rubber joints. Louis Boutan photographs underwater by magnesium light. Chauffour, an electrical engineer, designs the lamp. George Washington Wilson's company is the largest producer of lantern slides. Alfred Londe invents a twelve--lens camera taking 7 x 7 cm. pictures on a plate 24 x 30 cm., for recording motion. The camera is operated by an electromagnet set off by a clockwork mechanism. The *Deman* detective camera is introduced. It weighs under 3 oz., is said to defy detection, and can be concealed in a glove, watch, pocket or under the vest. The Anschutz camera manufactured by C.P. Goerz of Berlin has very short exposure times (down to 1/1000 second), a frame view-finder for taking pictures at eye level, and a focal plane shutter. First double anastigmat, *Dagor* , introduced. Levy patents screen half-tone process. William Kurtz, first acceptable three-color photo engraving producing full color picture with single-line halftone blocks.

A. Dvorak, *Symphony No. 5 (From the New World, op. 95)*. J. Sibelius, *Karelia Suite (op. 10)*. P.I. Tchaikovsky, *Symphony No. 6 in B Minor (pathetique, op. 74)*. E. Humperdinck, *Hansel and Gretel* (opera). G. Puccini, *Manon Lescaut* (opera). G. Verdi *Falstaff* (opera). A. France (pseud.) writes *La Rotisserie de la Reine Pedauge*. Oscar Wilde, *A Woman of No Importance*. Karl Benz's four-wheel car. P.H. Emerson's *On English Lagoons*. Beardsley draws *Salome and Head of John the Baptist*. Edward Munch, *The Cry*. Charles Follen McKunn, and Burnham and Root design the Chicago World's Fair as a Neo-Roman city. Stephen Crane, *Maggie, A Girl of the Streets*. The Hawaiian Islands are annexed to the United States.

Births and Deaths: Andre Kertesz, b. Peter Ilyich Tchaikovsky, d. G.W. Wilson, d. Herman Goering, b. Mary Pickford, b. Cole Porter, b. Guy de Maupassant, d.

322

1894: Gum-Bichromate process is introduced by Rouille-Ladeveze in Paris. The Salon of the Photo- Club de Paris, founded by Maurice Bucquet, affects France as the Linked Ring did England. Robert Demachy and . Commandant Emile Joachim Constant Puyo produce gum prints. Alfred Stieglitz makes the first successful rainy-day photographs. Arnold Genthe begins photographing the people and life in San Francisco's Chinatown. Clarence H. White begins photographing. Alfred Mashell and Robert Demachy exhibit gum-biochroate or gum prints in London. Alfred Stieglitz spends the summer in Europe. Por rait of Aubrey Beardsley by Frederick Evans. Parker B. Cody of the Blair Camera Co. invents the daylight-loading roll-film spool. The *Instanograph* camera is manufactured by J. Lancaster of Birmingham, permitting the insertion of the plate holder without having to remove the ground glass. Marey publishes *Le Mouvement*, an illustrated summary of chronography. Frederick Ives patents Kronscope stereo photochronoscope. T.A. Edison opens Kinetoscope Parlour, New York. The Chicago Colortype Company produces successful three-color photoengraving. The first press agency, the Journals' Photographic Supply Co., is founded. The company claims to have photographers in every part of Britain enabling them to secure any photograph within 24 hours.

Construction is started on the Louis Sullivan designed Guaranty Trust Building, Buffalo. Alfred Dreyfus arrested on treason charge. Lord Raleigh and William Ramsey discover argon. Lord Halifax opens discussions on reunion of Anglican Church with Rome. Matthew Corbett paints *Morning Glory*. Gustave Caillebotte collection of Impressionist paintings is rejected by Luxembourg Museum, Paris. Claude Debussy, *L'Apres-midi d'un Faune*. Jules Massenet, *Thais* (opera). Hugo Wolf, *Italian Serenade*. Rudyard Kipling, *The Jungle Book*. Monet, *Rouen Cathedral*. Pullman Company strike begins.

Births and Deaths: Christian Schad, b. Maxime DuCamp, d. Harold Macmillan, b. Nikita Khrushchev, b. Aldous Huxley, b. James Thurber, b. J.B. Priestly, b. Oliver Wendell Holmes, d. Robert Louis Stevenson, d.

1895: Paul Martin photographs London by night. Thomas Eakins photographs Frank Hamilton Cushing, uses the photographs as studies for the painting. An exhibition of artistic photography is held in Florence. P.H. Emerson awarded Progress Medal of the Royal Photographic Society. Vienna Camera Club becomes affiliated with The Linked Ring. Kodak produces a pocket camera taking a dozen 1½ inch x 2 inch pictures. The camera is designed by Frank A. Brownell and is the prototype for the *Brownie*, with a daylight-loading roll-film spool. The camera is made of aluminium; the shutter is set and released by one button. The first modern auto-

Co. of New York are able to produce 147,000 prints in an ordinary ten hour work day. Alfred Watkins'*Bee* exposure meter is manufactured. In the form of a watch, it has a strip of light sensitive paper. The exposure is calculated by comparing it to the Watkins speed card. Rotogravure is introduced commercially in Britain. *The Illustrated London News* becomes the first British paper to be printed by rotogravure. F.M. Lanchester devises a color system called the micro-dispersal. Henry A. Dreer of Philadelphia uses three-color line

photo-engraving for advertising. Karl Klic (1841-1926), inventor of photo-gravure made first sucessful prints by this method. First issue of the *Process Work Year Book*, forerunner to *Penrose' Annual*.

P.H. Emerson publishes *Marsh Leaves*. Professor Wilhelm Konrad Roentgen, Wurzburg University publishes a paper describing experiments with X-rays. Ambroise Vollard exhibits Cezanne's paintings, reintroducing him to Paris after a lapse of twenty years. The public is appalled by the exhibition. Stephen Crane's *The Red Badge of Courage* published. Gold discovered in the Klondike; the Gold Rush begins. General Confederation of Labor organized in France. Karl Marx, *Das Kapital*, *v. 3*. W. Roentgen discovers X-rays. J.H. Northrop's automatic loom. G. Marconi invents wireless telegraphy. Auguste and Louis Lumiere invent the cinematograph. Sigmund Freud founds psychoanalysis. A.J. Balfour, *The Foundations of Belief*. G. Mahler, *Symphony No. 2*. R. Strauss, *Till Eulenspiegel's Merry Pranks*. Joseph Conrad, *Almayer's Folly*. Henry James, *The Middle Years*. H.G. Wells, *The Time Machine*. W.B. Yeats, *Poems*. O. Wilde, *The Importance of being Earnest*.

Births and Deaths: Dorothea Lange, b. Lazlo Moholy-Nagy, d.

1896: The Empress Frederick is patroness of an international exhibition of artistic photography in the Reichstag. The Society of Amateur Photographers merges with the New York Camera Club, to become The Camera Club of New York. Frederick Evans begins photographing English cathedrals. Darius Kinsey establishes a studio, continues documentation of the logging industry. Toulouse-Lautrec photographed by Maurice Guibert. Lautrec uses Guibert's photographs for his paintings. E. Lee Ferguson of Washington D.C. attempts to organize a photographic Salon for artistic photographs. Pressure from the Camera Club of the Capitol Bicycle Club forces him to establish two classes of photographic exhibitions —photographs judged only on technique, and artistic as well as technically correct photographs. Marey perfects chronophotograph, a device for photographing motion with a single camera. *Le Physiographe*, a stereoscopic metal camera in the form of a field glass patented in Britain. E.B. Kooperman of New York manufactures

Herman Casler's *Presto* camera, in the shape of an alarm clock. A soft focus lens is designed by Thomas Lois Dallmeyer at the suggestion of J. S. Bergheim, a painter. Negatives are printed on coarse-grained paper to break up the smooth half-tones. The *New York Times* issues a Sunday edition with half-tone reproductions of photographs. Underwood and Underwood, world's largest publisher of stereographs, begins to supply newspapers and magazines with news photographs. Walter Woodbury's *Photographic Amusements* published, containing information on multiple images, unusual perspective views, etc. H.P. Robinson's *Elements of Pictorial Photography* republished. A.H. Wall's *Artistic Landscape Photography* published.

A. Becquerel discovers radioactivity. Barnum and Bailey exhibit a horseless carriage. Giacomo Puccini composes *La Boheme*. Wright brothers first flight. A Viennese physician detects a gallstone with X-ray apparatus. Count F. V. Zeppelin flies first dirigible. Henry Ford builds his first automobile. In Munich, the periodicals *Simplicissimus* and *Jugend* , which gave its name to the art movement known as *Jugendstil*. Publication of William Morris' *The Works of Geoffrey Chaucer*. First number of Alfred Harmsworth's newspaper the *Daily Mail* first paper to reach one million circulation. First number of *The Savoy*, illustrated periodical with Aubrey Beardsley, art editor. Nobel Prizes established. William Ramsey discovers helium. Ernest Rutherford's magnetic detection of electrical waves. S.P. Langley's flying machine makes successful flights. Henri Bergson writes *Matiere et Memoire*. National Portrait Gallery moved from Bethnal Green to permanent home in Westminster. J. Brahms, *Four Serious Songs(op. 121)*. R. Strauss. *Thus Spake Zarathustra (tone poem)*, T. Hardy, *Jude the Obscure*. A. Chekhov, *The Seagull*.

Births and Deaths: John Dos Passos, b. Harriet Beecher Stowe, d. John E. Millais, d. William Morris, d. Alfred Nobel, d. Jacques Henri--Lartique, b. Napolean Sarony, d. Mathew Brady, d.

1897: On January 21, *The New York Tribune* publishes a front page, half-tone illustration of Thomas C. Platt. *Sunlight and Shadow, A Book for Photographers Amateur and Professional* by W.I. Lincoln Adams printed by The Baker and Taylor Company. Alfred Stieglitz published (in *American Annual of Photography*) an article on the hand held camera as an instrument for serious artistic photographers. Robert Demachy and Alfred Maskell publish *Photo--Aquatint, or The Gum Biochromate Process*. DuHauron produces tripack color images. The National Photographic Record Association created. Object is to create permanent photographic record of contemporary life, using only permanent print methods—carbon or platinum printing. Steichen's *Lady in the Doorway* exhibited at the second Philadelphia Salon. This is the first time his work is noticed. Heinrich Kuhn introduces multiple gum prints.

The *Kammatograph* designed by Leo Kamm; it projects up to 550 tiny photographs, arranged spirally round the edge of a twelve inch disk. The running times of the projected picture is only 45 seconds.

Jacob Riss's *Battle with The Slums* is published. Paris Metro system started. Auguste Rodin, *The Kiss*. S. Coleridge-Taylor, *Hiawatha's Wedding Feast*. T. Hardy, *Wessex Poems*. H. James, *The Turn of the Screw*. H.G. Wells, *The War of the Worlds*. Wilde, *Ballad of Reading Gaol*. Shaw, *Caesar and Cleopatra* (drama). Cezanne began work on *The Great Bathers*. Sir Robert Herkomer utilizes photographs in his portrait he paints of the philosopher Herbert Spencer. Teddy Roosevelt rides up San Juan hill. Frank lloyd Wright designs his own house in Oak Park, Illinois. Antoni Gaudi designs the Colonia Guell Chapel. Gauguin, *Whence Come We? What Are We? Whither Go We?*. The United States Congress adopts a resolution declaring Cuba free and instructing the President to use the forces of the country to establish that freedom. The Spanish-American War begins.

Births and Deaths: Aubrey Beardsley, d. Ben Shahn, b. Ferdinand Hurter, d. Alfred Eisenstaedt, b. Lewis Carrol, d. Berenice Abbott, b. Gustave Moreau, b.

1899: The Illustrated Press Bureau Ltd. opens in Strand; the World's Graphic Press Agency is established in London. Alfred Stieglitz has a retrospective one-man exhibition at the Camera Club of New York. One hundred and eighty-seven prints from 1885 to 1899 are shown. In February, the Royal Academy in Berlin shows photographs in the Academy for the first time. J. Craig Annan sends calotypes by Hill and Adamson to the exhibition at Hamburg, the first time the work of Hill and Adamson is seen outside Great Britain. Philadelphia Photographic Salon has second exhibition. Only photographers are jurors. Professor R.W. Wood of Wisconsin patents a process of obtaining direct color photographs by diffraction. The ozotype is introduced. *Le Taxiphote* stereoscopic viewer is introduced. It is capable of bringing a series of 25 slides into view in succession. Muybridge republishes *Animal in Motion* by the half-tone process. September cover of the *Saturday Evening Post* is printed for the first time in three colors. In the Paris Salon the canvases of Jan Van Boers, Camillo Bellanger and Benner look like photographic images in paint.

Edward Munch begins the painting *The Dance of Life*. Henri de Toulouse-Lautrec paints a poster of Jane Avril. Frank Norris' *McTeague* is published. Federation of Trade Unions was created in Britain. John Dewey, *School and Society*. Magnetic recording of sound is devised. J. Sibelius, *Symphony No. 1 in E Minor*. Frederick Collins assembles first electric-wave wireless telephone system. The Boer War begins.

Births and Deaths: Brassai, b. Antonio Bragaglia, b. Leopold Mannes, b. Johann Strauss, d. Noel Coward, b.

1900: F. Holland Day takes work from the Philadelphia Salon to exhibit in *The New American School of Pictoral Photography*, London. He first offered the work to the Linked Ring; they refused. The Royal Photographic Society exhibit the show. Alfred Stieglitz refuses to show; he feels the exhibition does not represent the best work of the photographers. The exhibition meets with mixed reaction. F. Holland Day's religious photographs attacked by the British Press. Dissatisfied members of the Association Belge de Photographie in Brussels found the Carrole d'Art Photographique. Leading members of this artistic group of pictorialists are C. Puttemans, A. Bourgeois, M. Vanderkindere and Leonard Missone. The first international exhibition of artistic photography in Italy is held in Turin. There are 256 camera clubs or photographic societies in Britain and 99 in the United States. Britannia Works becomes *Ilford Company*. Alvin Langdon Coburn has first one man show at London Salon. Peter Henry Emerson has retrospective at Royal Photographic Society. Henry Robinson is elected Honorary Fellow at Royal Photographic Society. Edward Steichen is exhibited at the Royal Photographic Society. Edward Steichen meets Alfred Stieglitz in New York. At the Paris Exposition Universelle it is estimated that for each 100 persons passing through the turnstiles, 17 carry portable cameras. On certain days there could have been 51,000 cameras being used inside the exhibition grounds. The 2¼ inch x 3¼ inch negative size is first introduced with the Kodak No. 1 *Panorama* camera. The Stamp camera is introduced. It takes nine 7/8 x 1 1/8 inch size photographs simultaneously. The *Spido* camera is introduced by L. Gaumant and Cie of Paris. It has a F. 8 anastigmatic lens, a pneumatic shutter and a frame view-finder. It is popular for press photography.

Frank Lloyd Wright designs Ward Willitts House. Van Zeppelin of Germany pilots his first rigid type dirigible in a trial flight at Lake Constance. The Boxer Rebellion in China. Theodore Dreiser's *Sister Carrie* published. William Crookes separates uranium. R.A. Fessenden first transmits speech by wireless. Sigmund Freud, *The Interpretation of Dreams*. Paul Cezanne, *Still Life with Onions*. Claude Monet, *Water Lilies, Harmony in Rose*. Auguste Renoir, *Nude in the Sun* (pastel). J.S. Sargent, *The Sitwell Family*. Toulouse-Lautrec, *La Modiste*. Gustave Charpentier, *Louise*. G. Mahler, *Fourth Symphony*. G. Puccini, *Tosca*. Conrad, *Lord Jim*. A. Chekhov, *Uncle Vanya*.

Births and Deaths: John Ruskin, Frederick Nietzche, Oscar Wilde, Hannibal Goodwin, d. Barbara Morgan, Herbert Bayer, Aaron Copeland, WEEGEE (nee A. Fellig), Leopold Godowsky, b.

1901: Photographic Postcards first printed by Rotary Photographic Co. (England). H.C. Shelley shows lantern slides of Boer War to the Royal Photographic Society. Frederic Ives publishes *The Optics of Trichromatic Photography*. Imogene Cunningham begins to photograph at age eighteen, influenced by Gertrude Kasebier. She goes to Dresden on a scholarship to study physical chemistry as applied to photography. Sadakichi Hartman publishes two volume survey, *A History of American Art*.

President William McKinley, while attending a reception at the Pan-American Exposition in Buffalo, New York, is shot by Leon Czolgosz, an anarchist. Maillol, *The Mediterranean*. Picasso, *The 14th of July, Montmartre*. Paul Gauguin, *The Gold in Their Bodies*. Edvard Munch, *Girls on the Bridge*. A. Dvorak, *Russalka*. E. Elgar, *Overture Cockaigne*. Rachmaninov, *Piano Concerto, No. 2*. S. Butler, *Erewhon Revisited*. R. Kipling, *Kim*. Selma Lagerlof, *Jerusalem*. M. Maeterlinck, *Life of the Bee*. Thomas Mann, *Buddenbrooks*. J.P. Morgan founds United States Steel Corporation. Max Planck, *Laws of Radiation*. W. Normann discovers process for hardening liquid fats. Adrenalin is manufactured. G. Marconi transmits messages by wireless telegraphy from Cornwall to Newfoundland. First motor-bicycle. Trans-Siberian Railway reaches Port Arthur. S. Freud, *The Psychology of Everyday Life*. *The Five Civilized Tribes* (Indian) are admitted to U.S. Citizenship. The Rockefeller Institute of Medical Research is founded in New York.

Births and Deaths: Arnold Boecklin, d. Giuseppe Verdi, d. Benjamin Harrison, d. William Stibbs, d. George von Siemens, d. Andre Malraux, b. Walt Disney, b. Margaret Mead, b. Toulouse-Lautrec, d. Queen Victoria, d. Elliot Porter, B. Valentine Blanchard, d. Josiah John Hawes, d. John J.E. Mayall, d. H.P. Robinson, d.

1902: Stieglitz gathers a group of young workers (Clarence H. White, Frank Eugene, Gertrude Kasebier, Eduard J. Steichen, Alvin Langdon Coburn, and others) together, and with Edmund Sterling and John Francis Strauss forms the Photo-Secession. The American correspondent of The Linked Ring in London, it consists of a mixture of pictorialism and "straight" photography, and is dedicated to bringing photography to an equality to the older arts. The Fifteenth Annual Exhibition of the Yorkshire Union of Artists in Leeds, England; for the first time a critical agent in England recognizes the artistic possibilities of photographs shown side by side with paintings. Stieglitz sends 29 pictorial photos. They are well received. First issue of *Camera Work*. The firms of Anthony and Scoville merge. The Tessar anastigmat lens designed by Paul Rudolf, distributed by Zeiss. Lewis Hine begins to photograph, age 37. Steiglitz, *Spring Showers*. Jacob Riis publishes *Battle with the Slums*. Edward Weston gets first camera. Electrical alarm clock invented for timing

film exposures and development. 400 line halftone screen made by Max Levy. Steichen wins highest honors ($200.00) in the Eastman Kodak competition, prints pictures on Velox paper from negatives taken with a Kodak. There were 18,000 other competitors. Prices for Stieglitz's proofs (10x12 or larger) are about $15.00.

F. Delius, *Appalachia*. H. Belloc, *The Path to Rome*. J. Conrad, *Youth*. A. Conan Doyle, *The Hound of the Baskervilles*. A. Gide, *The Immoralist*. R. Kipling, *Just So Stories*. Georges Milies films *A Trip to the Moon*. Oliver Heaviside states his conception of a layer in the atmosphere to aid conduction of wireless waves. A. Cushing begins work on the pituitary body. William Bayliss and Ernest Starling discover hormones. F. Poulsen's arc generator. J. M. Beacon crosses Irish Channel in Balloon.

Births and Deaths: John Steinbeck, b. Cecil Rhodes, d. William Walton, b. Lord David Cecil, b. amuel Butler, d. Lord Acton, d. Henry Cabot Lodge, b. G.A. Henty, d. R.A. Butler, b. Ansel Adams, b. John G. Bullock, b. Paul Gauguin, d. Richard Maddox, d. Emile Zola, d. George N. Barnard, d.

1903: The film *The Great Train Robbery*. Frederick Evans, *Sea of Steps*. J.H. Lartigue gets his first camera at age 7. Membership in Royal Society drops to 59 (from a high of 85 in 1900). M. Maeterlinck writes introduction to Steichen issue of *Camera Work*.

Matisse, *Slave*. Klee, *Two Men Meet Each Supposing the Other to be of Higher Rank*. National Art Collections Fund formed to prevent works of art leaving Britain. New York Chamber of Commerce, and Stock Elchange built. F. Delius, *Sea Drift*. S. Butler, *The Way of All Flesh* (posth.) Hugo von Hofmannsthal, *Electra*. Henry James, *The Ambassadors*. B. Croce founds *La Critica*. Oscar Hammerstein builds Drury Lane Theater, New York (later the Manhattan Opera House). Arthur Schnitzler, *Reigen*. G.B. Shaw, *Man and Superman*. The Muckrakers disclose dishonesty and corruption in politics and business and social evils in the slums. W. Ramsay discovers the gases krypton and xenon in the atmosphere. J.J. Thomson, *The Conduction of Electricity Through Gases*. Wright's make flight in aircraft, with a petrol engine. G.E. Moore, *Principia Ethica*.

Births and Deaths: Hugo Wolf, d. James Whistler, d. Louis Leakey, b. Evelyn Waugh, b. Theodor Mommsen, d. Herbert Spencer, d. Camille Pissarro, d. Harold E. Edgerton, b. Walker Evans, b. Aaron Siskind, b. Russell Lee, b. Hans Warzek, d.

1904: *The Daily Mirror*, the first daily newspaper illustrated exclusively with photographs, published. J. Riis publishes *Children of the Tenements* and *Theodore Roosevelt, the Citizen*. Over 1500 lantern

slides are submitted to Royal annual. R. DeMachy portfolio in *Camera Work*. The Bausch and Lomb (Optical Co.) Quarter-Century Competition awards the grand prize ($300) to Alfred Stieglitz. Eastman Kodak has a competition—$500.00 in prizes for pictures made with their new Kodoid Plates and non-curling films. The *Salon d'Automne de Paris* includes photos for the first time.

Picasso, *Woman Ironing, Frugal Repast*. Cezanne, *Pines and Rocks*. Rouault, *Head of a Tragic Clown*. Rhodes scholarships for study at Oxford are initiated by Britain. J. Conrad, *Nostromo*. W. H. Hudson, *Green Mansions*. Jack London, *Sea* Wolf. Romain Rolland *Jean-Christophe*. J. M. Barrie, *Peter Pan*. A. Chekhov, *The Cherry Orchard*. T. Hardy, *The Dynasts*. J. M. Synge, *Riders to the Sea*. J.P.L.T. Elster devises photo-electric cell. Safety razor blades. Work on Panama Canal begins. Broadway Subway opens, with electric trains from City Hall. Rolls-Royce is founded. Henry Adams, *Mont St. Michel and Chartres*.

Births and Deaths: George Balanchine, b. Leslie Stephen, d. Anton Dvorak, d. H.M. Stanley, d. G.F. Watts, d. Anton Chekhov, d. Ralph Bunche, b. Christopher Isherwood, b. Graham Greene, b. Marlene Dietrich, b. Alexei Nikoaevich Kosygin, b. Margaret Bourke-White, b. Etienne Jules Marey, d. Edweard Muybridge, d.

1905: The Photo-Secession, unable to secure gallery accommodations in New York (for their planned big exhibition of pictorial photography from D.O. Hill to the present), secures a small gallery at 291 Fifth Avenue, New York City. The Photo-Secession plans to make these rooms at 291 headquarters for all Photo-Secession exhibits; they are called the *Little Galleries*. The first *Nikleodeon* just opened McKeesport, Pennsylvania. J. Craig Annan presents Hill and Adamson in *Camera Work*. Stieglitz publishes 10 prints in *Camera Work*. The new Dr. Mietre three-color camera (three color exposures) is available for the general public, at a cost of $50.00. Edward Weston, in California, canvasses from door to door, using a post card camera and taking pictures at a dollar a dozen. Platinum paper costs $2.65 per dozen for 10 x 12 inch sheets. Kodak's new tank developer makes daylight developing a cartridge-film possible. In the *Salon d'Automne*, a room of paintings by Matisse, Vlaminck, Rouault, among others, occasions the name of *les fauves*. Ernst Ludwig Kirchner, Erich Heckel, and others form an association known as *Die Bruke* in Dresden (later Berlin), Germany.

C. Debussy, *La Mer*. F. Delius, *A Mass of Life*. F. Lehar, *The Merry Widow*. R. Strauss, *Salome*. First European production of an American opera. A. Schweitzer, *J.S. Bach, the Musician Poet*. Albert Einstein publishes *Special Theory of Relativity*.

Births and Deaths: Adolf Menzel, d. Serge Lifar, b. Arthur Koestler, b. Greta Garbo, b. Henry Irving, d. C.P. Snow, b. Dag Hammarskjold, b. Clarence J. Laughlin, b. Angus McBean, b. Todd Webb, b. Sam Shere, b.

1906: *Little Galleries* opens with an exhibit of 100 Photo-Secession prints as well as *Modern Art not necessarily photographic.* The 12th Annual London Photographic Salon, held at the Gallery of the Royal Society of Water-Colours, contains 75 Photo-Secession prints. An historian suggests that The Linked Ring of London has outlived its usefulness, due to the excellent quality of American pictorial photographs recently sent to Europe. Arnold Genthe makes documentary photographs of San Francisco's earthquake damage. Clarence H. White delivers a series of lectures at Columbia University on pictorial photography. Columbia is the first important educational institution to recognize pictorial photography.

Picasso paints *La Toilette, Self Portrait, Two Nudes.* Braque, *Landscape near Antwerp.* Frank Lloyd Wright, *Unity Temple.* A. Derain, *Port of London.* G.Rouault, *At the Mirror.* Aristide Maillol, *Chained Action.* The first *Bruke* exhibition, marking German Expressionism An unknown element later called the *Vitamin* is discovered in a Cambridge University laboratory. The Pure Food and Drugs Act passed by Congress. The vacuum tube invented by Lee De Forest. J.J. Thomson undertakes work on gamma rays. Automatic railway coupling first used. Beginnings of Zuider Zee drainage. Simplon Tunnel (begun in 1898) is opened. H.M.S. Dreadnought is launched.

Births and Deaths: Hugo Gaitskell, b. Pierre Curie, d. Henrik Ibsen, d. Dmitry Shostakovich, b. Samuel Beckett, b. Paul Cezanne, d. Andreas Feininger, b. Philippe Halsman, b. Willard Van Dyke, b. Gyorgy Kepes, b. Bill Brandt, b. Cecil Beaton, b. Etienne Carjat, d.

1907: The Photo-Secession received 197 invitations to contribute collections to various places around the world since mid-1906. The Lumieres, France, manufacture the first practical and inexpensive color plate, the *Autochrome* process. Steiglitz photographs the *Steerage.* The Anthony and Scoville Co. becomes *Ansco.* J.M. Bowles pleads for color photography in *Camera Work.* Coburn writes "photography is not one of the graphic arts but it is a fine art...more allied to architecture than painting.."

Maillol, *Portrait Head of Renoir.* Matisse, *Blue Nude.* Braque, *The Bather.* Derain, *Crouching Man.* Rouault, *Odalisque.* Exhibition of Cubist paintings, Paris. P. Picasso, *Les Demoiselles d'Avignon.* E. Munch, *Amor and Psyche* H. Rousseau, *The Snake Charmer.* F. Delius, *A Village Romeo and Juliet.* E. Elgar, *Pomp and Circumstance.* R. Strauss, *Elektra.* J. Conrad, *Secret Agent.* M. Gorki,

Mother. R. Baden-Powell founds Boy Scouts. United States restricts immigration. Henry Deterding founds Royal Dutch Shell Group. Alexis Pavlov studies conditional reflexes. Richard Anschutz and Max Schuler perfect the gyro-compass. Leo Bakeland invents Bakelite. S.S. *Lusitania* launched. G. B. Shaw, *Major Barbara*. J.M. Synge, *Playboy of the Western World*.

Births and Deaths: Dmitry Mendeleev, d. J.K. Huysmans, d. Frank Whittle, b. Joseph Joachim, d. Edvard Grieg, d. Louis Macneice, b. Alberto Moravia, b. William Thompson, Lord Kelvin, d. Christopher Fry, b. W.H. Auden, b. Joseph Joachim, d.

1908: *291* Galleries exhibits 58 original drawings by M.A. Rodin. It is the first time that New Yorkers see original Rodin drawings. The Speed Kodak (1/1000 of a second shutter), $50.00. The *Little Galleries* closes because of a rental increase. It moves across the hallway. Edward Weston begins commercial photography. Lumiere autochrome plates (6½ x 8½ inches) cost $12.00 a piece. The magazine *Charities and Commons* publishes Lewis Hine's pictures showing living conditions of poor people. Stieglitz is ejected by *The Camera Club*. He sues for reinstatement, wins, and then resigns.

George Stubs, RA, shows animal paintings influenced by Muybridge. Maillol, *Young Cyclists*. Matisse, *Le Luxe II*. Braque, *Houses at L'Estaque*. Vuillard, *Place Vintimille*. *Blue Mountain*, by Kandinsky. Mondrian, *Red Treee, Blue Chrysanthemum*. *Futurism* (which is first a literary concept) is born in the mind of the poet and propagandist Filippo Tommaso Marinetti; is propagated in a series of manifestos. Fauvism as a movement ceases to exist. Picasso pastes a small piece of paper on the center of a drawing to make what is probably the first collage. The first free outdoor art show in America, Washington Square, Greenwich Village, New York. William Howard Taft, Republican, defeats William J. Bryan for the Presidency. The making of animated cartoons begins. The Intelligence Quotient (IQ) test originates in France, designed by Alfred Binet and Thomas Simon. B. Bartok, *First String Quartet*. E. Elgar, *Symphony No. 1* in A flat (op. 55). Olympic Games held in London. Jack Johnson becomes the first Negro world boxing champion.

Births and Deaths: Simone de Beauvoir, b. Henry Campbell--Bannerman, d. Ian Fleming, b. Nicolai Rimsky-Korsakov, d. Stephen Grover Cleveland, d. Joel Chandler Harris ('Uncle Remus'), d. Nelson Rockefeller, b. Henri Becquerel, d. Lyndon Baines Johnson, b.

1909: The *Little Galleries* exhibits eight Steichen photographs made by moonlight, of Rodin's *Balzac*. These photographs by Steichen are a *tour de force*, considering the materials available. Marsden Hartley

exhibits his impressionist paintings at *291.* **E d w a r d** Weston marries. Isadora Duncan dances Beethoven Seventh Symphony. Exhibit of *International Photography* at the National Arts Club, shows D.O. Hill prints, made by Coburn, Demachey and others. John Marin and Henri Matisse exhibits at *291*.

Picasso, *Portrait of Braque* Matisse, *Harmony in Red, La Serpentine.* Braque, *Guitar and Compote.* O. Kokoschka, *Princess Montesquieu-Rohan.* H. Rousseau, *Flowers in a Vase.* E. Munch, *Mural* for Oslo University. Antoine Bourdelle, *Hercules the Archer.* G. Mahler, *Symphony No 9.* Ralph Vaugh Williams, *Fantasia on a Theme by Thomas Tallis.* Frank Lloyd Wright's "prarie style" masterpiece, the *Robie House,* constructed in Chicago. The *Mohorovicu discontinuity* discovered by Russian scientist: it is the boundary between the earth's crust and mantle. Henry Ford introduces first assembly line in automobile industry; makes the low priced Model T cars possible. Louis Bleriot crosses the English Channel by monoplane. R.E. Perry reaches North Pole.

Births and Deaths: Barry Goldwater, b. Dean Rusk, b. Stephen Spender, b. Algernon Swinburne, d. George Meredith, d. Kwame Nkrumah, b. Edwin H. Land, b. Charles R. Savage, d.

1910: Clarence H. White conducts classes in photography at Sequinland, Maine; cost of $15.00 per week, open to the public. The Buffalo Fine Arts Academy (Albright Art Gallery) in Buffalo, New York, holds *An International Exhibition of Pictorial Photography,* under the arrangement of the Photo-Secession. This exhibit is comprehensive, and retrospective (beginning with D.O. Hill). It exhibits approximately 500 pictorial photographs, 280 for sale. 65 are sold, for a total of about $1,500.00. The most paid for one print is $100.00. Museums purchase fifteen photos for permanent collections. Over 15,000 visit the exhibit. Photography, it seems, wins its battle for official and distinguished recognition under the leadership of Alfred Stieglitz. John Marin at the *Little Galleries. Camera Work* ad reads, *The magazine without an "if"—fearless, independent—without favor.* Whistler espouses photography as an art, in *Camera Work.*

Redon, *Roger and Angelica.* Braque, *Violin and Palette.* Kees van Dogen, *Female Acrobat.* Vlaminck, *Self Portrait.* Picasso, *Girl with Mandolin.* Nolde, *Christ Among the Children.* Kandinsky, *Composition No. 2. Futurist Manifesto* signed by V. Boccioni, Carra, Balla and Severini. Mrs. Eddy's fortune is in excess of two million dollars. The independent show (no jury) of *The Eight* in midtown Manhattan. Mexican revolution against D. Diaz begins. Wassily Kandinsky produces his first non-representational work, separating painting from subject matter and creating mood by the psycho-

logical impact of only color and line. Arthur Evans excavates Knossos, on Crete. B. Russell and A.W. Whitehead, *Principia Mathematica*. A. Schweitzer, *The Quest of the Historical Jesus*. E. Underhill, *Mysticism*.

Births and Deaths: Mark Twain (Samuel Langhorne Clemens), d. John Hunt, b. Jean Anouilh, b. Florence Nightingale, d. William James, d. William Holman Hunt, d. Julia Ward Howe, d. Leo Tolstoy, d. Mary Baker Eddy, d. Francis Bacon, b. Nadar (Tournachon), d.

1911: Rome Exhibition of *Photography of Movement* financed by F.T. Marnetti, one of the founders of Futurism 'so that all the Futurists could become acquainted with various parallels between painting and photography.' Bragaglia: 'Time exposures of moving objects which proved the futurist doctrine in the destruction of form by motions and showed how the continuity of action could be made static in a dynamic graphic record. Balla, *Dynamism of a Dog on a Leash*, *(Leash in Motion)*. The Lartigue family moves to Paris. Jimmy Hare takes first photograph made from an airplane. Alvin Langdon Coburn photographs Mt. Wilson and the Grand Canyon. Edward Steichen: .fashion photographs in color for *Art et Decoration*.

Lehmbruck, *Kneeling Woman* (bronze). Ernest Barlach, *Man Drawing a Sword*. Picasso, *Still Life*, a collage which marked the beginning of a new phase in Cubism. Marc Chagall, *I and the Village*, a Cubist fairytale. M. Duchamp, *Nude Descending the Staircase*, reveals relationship between Italian Futurist painters and the photographs of Marey. Griffith, *Enoch Ardan*, the first Biograph double reel. Ezra Pound, *Canzoni* (poems); Edith Wharton, *Ethan Frome*. Stravinsky's *Petrouchka* produced by Ballet Russe in Paris; Bartok, *Allegro Barbaro* for piano. Strauss, *Der Rosenkavalier*. Superconductivity is discovered. Astronomers at Mt. Wilson Observatory experimenting with infra-red plates, discover several stars unseen by human vision. First transcontinental airplane flight (time in air 82 hours, 4 minutes). Captain R. Amundsen, Norwegian explorer, reaches South Pole.

Births and Deaths: Eliot Elisofon, b. Brett Weston, b.

1912: Exhibition at Montross Galleries, New York, *Straight Photography* by Alvin Langdon Coburn, Gertrude Kasebier, Clarence White and 27 others. Coburn, *The Octopus, House of a Thousand Windows, The Singer Building, The Flat Iron Building*. Francis Brugiere, painter turned photographer and a member of the Photo--Secession after meeting Stieglitz, experiments with multiple exposures. Herbert Ponting brings back documentary record of Captain Scott's second and last South Pole expedition (1910-1912). Jimmy Hare photographs Balkan War. A. Kertesz office worker in

the Budapest Stock Exchange buys his first camera. Lartigue, *The Lartigue Family on Tour in Their New Peugeot. Camera Work, Special Number* articles by Gertrude Stein: one on Matisse, the other on Picasso.

Bella, *Girl Running on a Balcony*, Gleizes, *Le Port*; Picabia joins the *Section d'Or* Cubists; Sarah Bernardt makes film version of her *Queen Elizabeth* (four reels). Griffith, *Man's Genesis*, a film about the controversial theory of man's evolution. Outbreak of the First Balkan War: Bulgaria, Serbia and Greece against Turkey. *Daphnis and Chloe*, ballet. Jacques E. Brandenberger invents a machine for the mass production of cellophane, which he had invented. Alexis Carrel wins Nobel Prize in physiology and medicine for his achievements in vascular surgery and transplantation of organs. The magnitude and variation of the Cepheid variable stars is related to provide a method of measuring astronomical distances. First of the vitamins is isolated.

1913: The Armory Show— and A. Stieglitz exhibits his own photographs at "291". Coburn moves to Paris. Photographs *Roofs*, also portraits of Gertrude Stein, and Henri Matisse. *Men of Mark* published. Coburn working on it for ten years; photogravure illustrations made on his own presses. Baron de Meyer photographs for *Vogue*. Charles Sheeler paints and photographs in Bucks County. Paul Strand, *Blind*, and other people on the streets of New York. *International Exhibition of Modern Art organized by Association of American Painters and Sculptors*, (Armory show), shows 1,600 works. Malevich invents Suprematism. Boccioni, *Single Form of Continuity in Space*. Balla, *Swifts: Paths of Movement*, shows influence of Bragaglia's photographs. *Standing Youth* by Wilhilm Lehmbruck *Self Portrait*, Oscar Kohoschka; related to *The Bridge*, but not a member.

March 30, Treaty of London, ending the First Balkan War. June 29 to July 30, Second Balkan War. September 23, invasion of Albania by the Serbs. Woodrow Wilson is President.

Sigmund Freud, *Totem and Taboo*. D. H. Lawrence, *Sons and Lovers*. Marcel Proust begins *Remembrance of Things Past*. Bernard Shaw, *Pygmalion* (play). First performance of Stravinsky's *Le Sacre du Printemps* in Paris. Schoenberg, *Kammersymphonie No. 1, op. 9.* Income tax becomes a law. Federal Reserve System created. Frederick Soddy discovers isotopes. Rasmussen's exploration of the Arctic. Niels Bohr establishes that the electrons orbit around the atom's nucleus in definite groups.

Births and Deaths: Robert Capa, b. Richard Nixon, b.

1914: Coburn continues to make portraits of distinguished people of his time: Jacob Epstein, Augustus John, Feodor Chaliapin. Begins photographing musicians intended for a book, *Musicians of Mark* (which was never realized). Stieglitz, portrait of Konrad Cramer. Charles Sheeler, *Stair Well*. Steichen, *Heavy Roses*. Andre Kertesz takes *candid* photographs while serving in Hungarian army, (used glass plates). The newly constituted Royal Flying Corps takes its first air photographs of the war over enemy positions at the Battle of the Aisne. *Mid-Week Pictorial* founded by *New York Times* as an outlet for the war photographs. Kodachrome color film first appears. Eastman Kodak settles with Ansco for five million dollars. *Camera Work*, No. 47, no photographs. Stieglitz devotes it to articles from 68 contributors whom he has asked: *what 291 means to me?* *Making a Living* Chaplin's first film. Oscar Barnack finishes an experimental model of the Leica.

June 28, assassination of Archduke Francis Ferdinand. July 23, Austrian ultimatim to Belgrade. July 28, Austria declares war on Serbia. July 29, Germany declares war on Russia. On August 3, France begins invasion of Belgium. August 4, Britain declares war on Germany. August 6, Austria declares war on Russia. April 21, United States marines land in Vera Cruz, Mexico. Wilson refuses to recognize the Huerta regime. August 15, Panama Canal formally opened. Robert Frost, *North of Boston*. James Joyce, *Dubliners*. Wyndham Lewis founded movement named by Ezra Pound, *Vorticist*. The military tank invented in England.

Births and Deaths: Joseph T. Keiley, d. Jacob Riis, d.

1915: *Old Masters of Photography* Exhibition at the Albright Gallery. Prints by Hill and Adamson, Dr. Thomas Keith, Julia Margaret Cameron, Lewis Carroll—Alvin Langdon Coburn made prints from the original negatives. Coburn, portrait of Maurice Maeterlinck. Paul Strand, *Morningside Heights*. Weston sees the San Francisco Fair, is introduced to Modern Art. Dorothea Lange studies under Arnold Genthe. Man Ray meets Marcel Duchamp and begins work in collage. Steichen, portrait of Alfred Stieglitz. An experimental R.F.C. photographic unit formed at Pinehurst. Griffith, *Birth of a Nation*; twelve reels long (almost three hours) with a score performed by a symphony orchestra.

German submarine sinks the Lusitania with loss of 139 American lives. Sir William H. Bragg and his son win Nobel Prize for their work in developing a method of studying the molecular structure of crystals with X-rays. Jess Willard becomes heavyweight champion.

336

Franz Kafka, *Metamorphosis*. Edgar Lee Masters, *Spoon River Anthology*. W. Somerset Maugham, *Of Human Bondage*. Virginia Woolf, *The Voyage Out*. Manuel de Falla, *El Amor Brujo*. Sibelius, *Fifth Symphony* in E-flat major.

Births and Deaths: Alexander Scriabin, A.Driffeld, d. Arthur Rothstein, b. Otto Steinert, b.

1916: *The Future of Pictorial Photography* Coburn. Coburn devises the *vortiscope* . Adams makes first photographs of Yosemite. Paul Strand, *The White Fence*. Charles Sheeler, *Bucks County Barn*. Stieglitz, portrait of John Marin. *Photographs of New York and Other Places* by Paul Strand, the only exhibition of photographs at *291* since Stieglitz had shown his own work in 1913.

Dadaism launched by Duchamp. The declared purpose was to make clear all established values are rendered meaningless by the catastrophe of the Great War. *The Forum Exhibition of Modern American Painters* at the Anderson Gallery, New York. Griffith, *Intolerance*; four separate stories from four different eras interlocked by a single unifying theme. President Wilson sends General John J. Pershing and a punitive expedition against Villa. James Joyce, *Portrait of the Artist as a Young Man*. Carl Sandburg, *Chicago Poems*. Bernard Shaw, *Androcles and the Lion* (Alvin Langdon Coburn photographed rehearsal scenes from this play). Booth Tarkington, *Sixteen*. William Butler Yeats, *Responsibilities*. Albert Einstein's general theory of relativity. Archeological excavation of Vaxactum. Rasputin killed in Petrograd.

Births and Deaths: H.H. Munro (Saki), d. Thomas Eakins, d. David Douglas Duncan, b. Adam Clark Vroman, d.

1917: Coburn's one-man show at the Camera Club in London, 13 paintings and 18 vortographs, taken by the vortoscope: three mirrors fastened together in the form of a triangle through which the lens sees. Moholy-Nagy recovering from wounds, helped found *Jelenkor*, a magazine of art. Kertesz' first published photographs. Atget, *Girl in Doorway of Brothel*. Paul Strand in *Camera Work* No. 49-50. (last issues). May 23-July 25 Georgia O'Keefe, last exhibition at *291*. Mondrian and Theo van Doesburg start the magazine *de Stijl*. It gives a name to a movement in art. Constructivist Movement (to 1922) in Russia. Picasso, *Fisherman*. *Easy Street*, Charlie Chaplin.

Sigmund Freud, *Introductory Lectures on Psychoanalysis*. Upton Sinclair, *King Coal*. Puccini, *La Rondine*. Respighi, *The Fountains of Rome*. January 31, unrestricted submarine warfare renewed by Germany in violation of the agreement of May 4, 1916. February 3, United States diplomatic relations with Germany severed. April,

U.S. declares war on Germany. May 18, U.S. Selective Service Act passed. November 7, Bolshevik Revolution in Russia.

Births and Deaths: Man O' War, b. (Fairplay, out of Makubah). Irving Penn, b. Edgar Degas, d. John F. Kennedy, b.

1918: Francis Brugiere published first book *San Francisco*. Strand becomes X-ray technician in U.S. Army. Charles Sheeler's photographs of African Negro masks. Lewis W. Hine photographs American Red Cross relief programs in Europe. *Schadographs* are invented by Christian Schad, a member of Zurich Dada group who photographs without a camera—cutout paper and objects are laid on photographic paper. Malevich, *Suprematist Composition: White on White*.

Booth Tarkington, *The Magnificent Ambersons*. Willa Cather, *My Antonia*. Bolsheviks murder the Czar and family. Armistice signed; hostilities cease on the West Front. Influenza kills estimated 20 million. M. Planck receives Nobel Prize in physics for the study of radiant energy. His theory is that radiation is contained in discrete bundles, known as *quanta*. Fritz Haber wins Nobel Prize for development of a commercial process for the synthesis of ammonia.

Births and Deaths: Harry Callahan, b. Arnold Newman, b. W. Eugene Smith, b.

1919: Brugiere returns to New York: opens studio; works on Theater Guild Productions; uses stage lighting to photograph actors, rather than simulating scenes with studio lights. Dorothea Lange opens portrait studio in San Francisco. Steichen becomes commander, Photographic Division Air Service, Army Expeditionary Forces. Paul Strand, *Rock*, Port Lorne, Nova Scotia. Stieglitz, *Georgia O'Keefe's Hands* placed on a steer's skull.

Fernand Leger, *The City*. Constantin Brancusi, *Bird in Space*. Robert Wiene, *The Cabinet of Dr. Caligari*. Sigmund Freud, *Beyond the Pleasure Principle*. Hermann Hesse, *Demian*. Franz Kafka, *In the Penal Colony*. W. Somerset Maugham, *The Moon and Sixpence*. Treaty of Versailles. Foundation of the Third International (Communist) for the propagation of the Communist doctrine to promote world revolution. Formation of the First *Fascio di Combattimento* by Benito Mussolini. Covenant of the League of Nations. Adoption of the Weimar Constitution. U.S. Senate refuses to ratify the Versailles Treaty. Polish-Russian War. Sir Ernest Rutherford observes that alpha particles of radioactive materials are capable of disintegrating atomic nuclei. DePalma sets land speed record of 149.845 m.p.h., in a Packard.

Births and Deaths: Theodore Roosevelt, d.

1920: Edward Steichen repudiates gum prints, abandons painting in order to master pure photographic processes. Edward Weston honored by election to the London Salon begins critical re-examination of his work. Kertesz's *Circus*, Budapest; *Kiss*, Budapest, *Buda* Hungary. Moholy-Nagy sympathetic to German Expressionism goes to Vienna and Berlin. Man Ray begins photography.

D.H. Lawrence, *Women in Love*. Sinclair Lewis, *Main Street*. Carl Sandburg, *Smoke and Steel*. August 28, U.S. nineteenth amendment permits women suffrage. Commercial radio broadcasting initiated by station KDKA in Pittsburgh, Pennsylvania. Prohibition becomes law. League of Nations begins at Geneva. Sacco and Vanzetti accussed of murder. Jean Arp, *TorsoNavel, Mountain*. George Groz *The Engineer Heartfield*. Marcel Duchamp, *Rotative Placques*.

Births and Deaths: Ducos du Hauron, d.

1921: F.T. Powers of Powers Photo Engraving Company of New York negotiates U.S. rights to Uvachrome process of color photography. Pablo Picasso completes *The Three Musicians*. Paul Strand and Charles Sheeler, film *Manhatta*. The first Technicolor movie, *Toll of the Sea*. Man Ray completes first successful Rayographs with three dimensional opaque and translucent objects. Max Beckmann works for space relationship similar to Gothic to heighten tension in work. H. Walter Barnett in London, photographic portraits of society people and celebrities. Edward Steichen, series of photographs of Isadora Duncan and her troop in Athens, Greece. Man Ray joins Marcel Duchamp, later becomes founding member of *Societe Anonyme*.

Italy suspends emigration to U.S. Martial law declared in Ireland. U.S. Court in Buffalo orders decree for dissolution of Eastman Kodak Company. Harding inaugurated. Samuel Gompers elected president of Pan-American Federation of Labor. Aerial bombs destroy ex-German destroyer in Navy test. Duke of Westminister sells Gainsborough's *Blueboy* and *Mrs. Siddons as the Tragic Muse* for $1,000,000.

Births and Deaths: Jane Russell, Ernst Haas, b. John Thompson, d.

1922. Steichen burns canvases that remain in Voulangis studio and renounces painting. The *Contessa Nettel Diaphot* Light Calculator incorporates set of tables from which exposure can be determined. Lazlo Moholy-Nagy executes first photograms. Alvin Langdon Coburn, *More Men of Mark*. The English color camera *Trist* placed

on the market. Moholy-Nagy holds first exhibition in Berlin at Herwarth Walden's Dur Sturm Gallery. Edward Weston travels to Ohio and New York City, meets Strand, Sheeler and Stieglitz in New York City. Georges Braque exhibits in the Salon d'Automne.

Paul Klee, instructor at Bauhaus. *International Dada Exhibition*, in Paris. Wassily Kandinsky becomes instructor at Bauhaus. Diego Rivera returns from Europe to Mexico after Mexican Civil War. Frank Lloyd Wright completes Imperial Hotel in Toyko, which is designed to resist earthquakes. Joan Miro completes *The Form*, linear arabesques and flat color areas. German movie with spoken word shown in Berlin. DeValera resigns as President of Ireland. Cardinal Ratti elected pope. Anti-evolutionists lose fight in Kentucky house of representatives 42-41. Coal strike ordered by United Mine Workers. Ulster Free State Pact signed in London. Armand Jeannes for betraying Edith Cavell to Germans is fined 11,500 francs and condemned to death. Russo-German Trade Pact signed. Fluorescent light invented by Prof. E.N. Harvey. President Harding extends Immigration Act for two years. U.S. Supreme Court declares Federal Child Labor Law unconstitutional. 3,000 inducted into the Ku Klux Klan in Plainfield, Ohio. Radar invented by Taylor and Young. Insulin and Vitamin D discovered. Fatty Arbuckle acquitted of manslaughter.

1923. Steichen begins work for Conde' Nast publications as chief photographer for *Vogue* and *Vanity Fair*. Steichen starts doing advertising photography for J. Walter Thompson Co. Moholy-Nagy founds photography department at Bauhaus. Alfred Stieglitz names *equivalent*. Max Hofstettercomes to U.S. to work with Powers Photo Engraving Company. One shot color camera offered under name Butler Tri-Color Camera. Edward Weston travels to Mexico City, opens studio, received as master artist by Mexican artists Rivera, Orozco, and Charlot. Moholy-Nagy starts a class on photography at the Bauhaus to explore photography as painting, poster art, textile design. Dorothea Lange, *Hopi Indian*, *N.M.* Moholy-Nagy first Bauhaus exhibition shows "Space Segments," metal constructivist work.

Jose Clemente Orozco begins first important mural assignment, in Mexico City. Kandinsky's naturalism-in-form appears in work done at Bauhaus. Forms conform to structural law of "Inner Necessity," for example, *Composition VIII*. Marcel Duchamp completes *The Bride Stripped Bare by Her Bachelors, Even, or the Large Glass*. Discovery of King Tutaknamen's tomb. Bills passed forbidding the KKK members from wearing masks in publici forbidding the KKK members from wearing masks in public in Iowa and Minnesota. Florida passes law prohibiting the teaching of Darwinism and atheism. The play *God of Vengence* ruled immoral on the New York

stage. U.S. Supreme court nullifies law in Ohio and Iowa which made it illegal to teach any language but English. Pancho Villa assassinated. "Red" Sunday in Germany causes 9 deaths in Communist riot. President Harding dies. Food riots in Berlin. Governor Walton of Oklahoma is impeached. Mexican revolution spreads to Tampico. The wind tunnel invented.

Births and Deaths: Richard Avedon, b. Wilhelm Roentgen, d. Sarah Bernhardt, d.

1924: Stieglitz marries Georgia O'Keefe. First color picture transmitted under supervision of Dr. Herbert E. Ives. Ermanox Camera with Ernostar F2 lens ;*What you can see, you can photograph*. Andre Breton's first *Surrealist Manifesto*. Mrs. Lille P. Bliss converts her collection into a foundation. It froms the nucleus of the New York *Museum of Modern Art*.

Max Ernst joins surrealist movement in Paris. Picasso's cubist work becomes more subdued, *The Red Tablecloth*. Feininger, Kandinsky, Klee and Jawlensky form the *Blue Four* exhibit in Mexico and Soviet Russia. Woodrow Wilson dies. Adolf Hitler sentenced to five years imprisonment for "Beer Hall Revolution." RCA sends photograph across the Atlantic by Hall Revolution." U.S. bars immigration of Japanese. RCA sends photograph across the Atlantic by wireless telegraphy.

Births and Deaths: Don Worth, b. David Vestal, b. Warclaw Nowak, b. Jack Wellpott, b. Marlon Brando, b.

1925: The Leica is marketed. Edward Weston exhibits first objective landscapes. Moholy-Nagy publishes *Malerei, Photographie, Film*, in which ideas on the combination of abstract art, photography, and music are explained. Stieglitz opens the *Intimate Gallery*. Hugo Erfurth working with gum and oil pigment portrays German intelligentsia with knowledgable artistic conception. Edward Weston moves studio to California.

Picasso finishes Neo-classic phase. Giorgio de Chirico meets Andre Breton and other surrealists who regard him as a forerunner of their movement. Walter Gropius resigns from Bauhaus. Bauhaus moves from Wiemer to Dessau. George Bernard Shaw wins Nobel Prize for Literature. Field Marshall Paul Von Hindenburg elected president of Germany. Britain restores the gold standard. Snake found in Ireland disputing St. Patrick's banishment of reptiles from the island. William Jennings Bryant testifies against John T. Scopes, on trial for teaching evolution. Scopes found guilty. Venezuela bans radio receiving sets because they keep people from working. Col. Billy Mitchell, court martialed for insubordination. New short waves

more powerful than X-ray or gamma rays discovered by Prof. R.A. Millikan. France returns the body of Baron Manfred Von. Richthofen. Col. Billy Mitchell found guilty.

Births and Deaths: Clarence White, d. George Bellows, d. Johnny Carson, b. Rock Hudson, b. Paul Newman, b.

1926: Paul Strand works with close up investigation of machinery, rock formations, and plants. Edward Weston, *Niel, Nude*. Kodak Aluminum Vest Pocket Automatic camera marketed. Man Ray makes surrealistic film *Emak Bakia*.

Piet Mondrian first exhibited in U.S., at Brooklyn Museum. Orozco, *The Trench, Destruction of the Old Order, The Strike, and the Revolutionary Trinity*. Rene Magritte, *The Menaced Assassin*. Yves Tanguy, *Storm* mysterious manifestations of primordial life. Kandinsky, *From Point and Line to the Plane*. Paul Klee *Around the Fish*. Schwitters *O'Kola*. George Braque, *Nude Woman with Basket of Fruit*. Joan Miro *Dog Barking at the Moon*. Dali expelled from Escuela de San Fernando. Alexander Calder completes first sculpture, in Paris. Alberto Giacometti, *Two Personages*. Hemingway, *The Sun Also Rises*. Mussolini reviews 50,000 black shirts on seventh anniversary of Fascism. Hirohito becomes Emperor of Japan. Rudolph Valentino dies of appendicitis. Bloody May Day riot caused by Communists in Berlin. General strike in Great Britain. Sinclair Lewis refuses the Pulitzer Prize for novel *Arrowsmith*. Lt. Com. Richard E. Byrd flies over North Pole. Pilsudski gains control of the Polish government. Dr. Robert H. Goodard's gasoline powered rocket travels 184 feet in 2.5 seconds.

Births and Deaths: Jerry Lewis, b. Mary Cassett, d. Charles Russell, d.

1927: Sheeler, Ford *River Rouge* plant. The book, *Achievement* published by American Photo- Engraver. 457 of the 649 illustrations printed in two or more colors. William Gamble publishes method of rapid color printing in article "Multi or Wet Color Printing As It Is Done Today." Bernice Abbott *Hands of Jean Cocteau*. Edward Weston *Two Shells*.

Picasso, drawings and etching on the theme of the painter and his model. Rivera completes decoration of the Chapel in National School of Agriculture at Chapingo. Chaim Soutine, first major show. Oskar Kokoschka, landscapes with decorative quality in an impressionistic sense. Henri Matisse, *Figure Against Ornamental Background*. Rene Magritte, *Man with Newspaper*. Yves Tanguey, *Mama, Papa is Wounded*. *The Jazz Singer*, with Al Jolson. Chinese Nationalists capture Nanking and Chunkiang. Chiang Kai-Shek's Cantonese

342

arrive in Shanghi. Television demonstrated in New York City. Norway discards prohibition after ten years of dryness. Lindbergh flies solo from United States to France. Sacco and Vanzetti executions. George Herman "Babe" Ruth hits 60th home run. Communist Party of Soviet Russia expells Leon Trotsky, at the insistance of Joseph Stalin.

Births and Deaths: Jean-Eugene-August Atget, d. Juan Gris, d.

1928: Renger-Patzsch publishes *Die Welt Ist Schoon*, isolated close--up views of objects. Moholy-Nagy *View from Radio Tower, Berlin*. Imogen Cunningham, working in Edward Weston's studio, completes nude *Triangles*. Edward Weston opens studio in San Francisco with son, Brett. Dr. E. Saloman smuggles camera in an attache case, takes exclusive pictures of a murder trial. Reinhold Heidecke invents *Rolleiflex* (twin-lens reflex camera).

Le Corbusier constructs furniture *L'Esprit Nouveau* (chair from steel tubing). The *Lange House* completed by Mies Van Der Rohe. Henry Moore receives first major commission, *The North Wind*. John Stuart Curry completes *Baptism in Kansas*. Charles Demuth *I Saw the Figure Five in Gold*. *The Harvest Wagon* by Thomas Gainsborough sells for $360,000.000. 3½ ton pie baked at Denby, England. The Iron Lung, Teletype, Radio Beacon and hardwater soap invented. U.S. signs Arbitration Treaty with France. Bar Association comes out against 18th Amendment (Prohibition).Egypt signs Geneva Convention on the abolition of slavery. Capt. Malcolm Campbell drives car at 205.95+ mph in Daytona, Florida. All German women postal employees must wear skirts eight inches below knees. Graf Zeppelinmakes maiden voyage over Atlantic. Amelia Earhart flies to England. Herbert Hoover elected president of United State.

1929: Strand working at Gaspe. Moholy-Nagy teaching new ways of usingphotography at the Bauhaus. Stieglitz opens *An American Place*. The Packard light meter is introduced. *Film and Foto:* Steichen, Sheeler, Cunningham, Bernice Abbott, and Edward Weston. August Sander's *Antlitz der Zeit* applies new objectivity to portraiture. Werner Graff publishes *Es Kommit der Neve Fotograf* in which the new vision of the photograph is aided by miniature cameras. First Finlay Color reproduced in America. Rolleiflex marketed. Moholy-Nagy publishes *Von Malerie zu Architektur*. Dali embarks on transcription of dreams and paranoic visions. Max Ernst writes *Femme 100 tetes*. Walter Gropius constructs the Siemensstadt in Berlin. Mies Van Der Rohe exhibits *Barcelona Chair* at the German Pavilion. Man Ray shows first investigation into creative solarization. Karl Blossfield *Uniforman Der Kunst* explores forms in close-up photographs of plants.

Second Surrealist Manifesto. Herman Hesse, *Steppenwolf*. St. Valentines Day massacre. Museum of Modern Art in New York founded. Ernest Hemingway, *A Farewell to Arms*. Penicillin discovered. Franklin D.Roosevelt sworn in as Governor of New York. Over 2,000,000 unemployed in Germany. Hoover inaugurated. Labor party wins in Great Britain. The Soviet Supreme Council announces a 360 day work year with 5 holidays. Stocks crash with 14,410,030 sales. Commander Richard E. Byrd flies over South Pole.

Births and Deaths: Hugh Hefner, b. Robert Henre, d.

1930: Steichen publishes his first picture-book *Everyday Things for Babies*. Ansel Adams meets Paul Strand. Salomon's pictures called "candid." Electric flashbulb on market. Walker Evans begins series of Victorian architecture.

Jean Arp *Head with Three Annoying Objects*. Calder meets Mondrian and Miro and turns to abstract sculpture. Edward Hopper completes *Early Sunday Morning*. Ben Shahn holds first one man show. Grant Wood *American Gothic*. Gandhi released after nine months in prison. King Alfonso of Spain restores freedom of press, speech, and assembly. Hitlerites and Nationalist boycott Reichstag. President Hindenburg establishes dictatorship. St. Louis defeats Philadelphia A's to win World Series. Chiang Kai-Chek resigns as premier of Nationalist China.

1931: Dr. Erich Salomon uses Ermanox camera for candid snapshots of statesmen. Alfred Eisenstaedt uses miniature camera in reportage and documentation. Walter Hege's photographs of German cathedrals play important role in the development of artistic photography in Europe. Louis W. Hine photographs construction of the Empire State Building.

First photoelectric exposure meter. Cristiani, of Italy, produces color prints by projecting color separation negatives onto sheets of light sensitive celophane. The sheets are dyed proper color and then superimposed. They were either mounted and viewed as prints, or projected onto a screen. Same process described in 1933 *Science News*; however, the later article attributed the process to R. M. Reeve. Alfred Eisenstaedt photographs *La Scala Opera House* with 35mm camera and existing light. Charlie Chaplin, *City Lights*; Boris Karloff, *Frankenstein*. Spike-Dufay natural color process.

Rockefeller Center under construction. R.C.A. Building nears completion. Drastic wage cuts: foreclosure actions: disintegration of established estates throughout the Corn Belt: people starving or on bread lines. Piet Mondrian paints abstractions. *De Stijl* group splits. E. Hopper paints *Route 6 Eastham*. O.P. Kaner isolates vitamin A.

344

Births and Deaths: Thomas Edison, d. George Davison, d.

1932: Weston Electric Instrument Co. introduces first photoelectric light meter. Cartier-Bresson begins to photograph. Walker Evans, *Front Street*. Felix Man, Kurt Hubachmann and Umbro of Germany are working in new reportage style; Man presents intimate picture series of famous personalities, *A Day With Mussolini*. Brassai reveals Parisian life. Paul Strand, in Mexico, Manuel Alvarez Bravo. Willard van Dyke, a cinematographer, forms the *F:64* Group with Edward Weston and Imogene Cunningham. *Art of Edward Weston* published, (first book presentation of Weston's work). Professors H.F. Edgerton and K.J. Germeshausen use a stroboscopic light to photograph rapidly moving objects at 1/500,000 of a second exposure time.

Aldous Huxley, *Brave New World*. Ernest Hemingway, *Death in the Afternoon*. Duke Ellington recognized as the first composer of jazz. First Tarzan film is released; Shirley Temple's first film. Edwin Land invents the synthetic light polarizing screen. Vitamin D is discovered. Sharecroppers in cotton belt suffer more than any other group in America. President Herbert Hoover creates The Emergency Relief Act.

Births and Deaths: George Eastman, d.

1933: Photographers (such as Louis Hine) find employment with new agencies initiated by Roosevelt. Henri Cartier-Bresson photographs of Spain. Paul Strand appointed chief of photography and cinema to the Mexico Department of Fine Arts. Ansel Adams abstracts nature in close-up photographs, *Pine-Cone and Eucalyptus Leaves*. Yousuf Karsh opens portrait studio in Ottawa. Walt Disney takes full advantage of the three color process with added sound and music in *Silly Symphonies*. Eastman Kodak introduced two new films, Super Sensitive Pan and Panatomic film, both roll films designed for the Rolleiflex camera. R.G. Tugwell placed in charge of the Rural Resettlement Administration, Department of Agriculture. He enlists Roy Stryker to head Photographic Section of the Information Division. The RRA was later known as the Farm Security Administration. *F:64* held their final show and soon afterward disbanded. Walter Howey invents a device that made engravings electrically for newspaper halftones.

Paul Klee expelled from teaching position, leaves Germany for Switzerland. Sculptor Jean Arp, *Configurations*. Herbert Read, *Art Now*. Stock market at its lowest during depression. Franklin Roosevelt inaugurated as president. Farmers Relief and Rehabilitation, Conservation Corps, National Recovery Act, Tennessee

Valley Authority and the Public Works Administration developed. The German Reichstag places absolute power in the hands of Adolf Hitler.

1934: In England Stefan Lorant founds *Weekly Illustrated*. Felix Mann is staff photographer. Ansel Adams, *Ice and Cliffs* at Kaweah Gap. Andre Kertesz works on distortion studies of nudes.

Scott Ftizgerald, *Tender is the Night*. Jean Cocteau, *La Machine Infernal. The Scarlet Pimpernel*, with Leslie Howard, released. Reichstein makes pure Vitamin C. President Roosevelt creates the Civil Works Administration and the Federal Emergency Relief Administration.

Births and Deaths: Gertrude Kasebier, d.

1935: Ansel Adams, *Making a Photograph*. Margaret Bourke-White publishes *You Should See Their Faces*. James Agee and Walker Evans complete *Let Us Now Praise Famous Men*. Walker Evans photographs Appalachian coal mining towns. F.H. Snyder and H.W. Rimbach invent the Chromatone Process. Color separation negatives are printed on a gelatin-colodian stripping film that is extremely stable dimensionally though only 1/1000 of an inch thick. Prints are toned and then assembled in register. E. Heisenberg discovers an emulsion for direct positives and prints. M. Laporte developes electronic flash with white light. Mannes and Godowsky successfully develop subtractive three-color separation and synthesis on the same film with superimposed emulsions; the color couplers being added to the developers. (Kodachrome process.) Alfred Eisenstaedt, Ethiopian series. L. Moholy-Nagy works with space modulators. Cecil Beaton makes portraits with the sitter forming part of an imaginative decor.

Salvador Dali, *Giraffe on Fire*. Pierce becomes the first woman to be granted a Guggenheim Fellowship. Erskine Caldwell, *Tobacco Road*. Newspaper reports by Frazier Hunt opens the nations eyes to the misery of the sharecropper. Roosevelt initiates the Emergency Public Act, Social Security Act, Federal Housing Act, and the Works Progress Administration in assisting theatre, photography, writing and building.

1936: Roy Stryker heads section of photography for the Farm Security Administration with photographers Ben Shahn, Walker Evans, Dorothea Lange, Arthur Rothstein, John Vachon, Carl Mydans, Marjorie Collins, Russell Lee, Gordon Parks, Marian Post-Welcott and Jack Delano. F.S.A. photography section continued until 1940. *Life* magazine, with photographers Margaret Bourke-White, Alfred Eisenstaedt, Thomas McEvoy and Peter Stackpole.

346

Paul Strand works on production of U.S. documentary film *The Plow That Broke the Plains*. Bernice Abbott documents New York. Robert Capa photographs Spanish Civil War. Bill Brandt publishes *The English At Home*. Weston photographs sand dunes and nudes at Oceano. Color couplers introduced into the emulsion of color film in Agfacolor reversal process. Robert Koslowsky discovers increase in sensitivity of emulsions through addition of aurous thiocyanite. Kodachrome marketed. Moholy-Nagy, *Light Painting*.

P. Mondrian, *Composition in Red and Blue*. John Steinbeck writes *The Grapes of Wrath*. John Dos Passos completes trilogy, *U.S.A.*. B.B.C. starts television service from Alexander Palace. The Ford Foundation is established.

Births and Deaths: Oskar Barnack, d. Peter Henry Emerson, d.

1937: Ansel Adams publishes *The John Muir Trail*. Eliot Porter starts working in color photography. First edition of *Popular Photography*. First edition of *Modern Photography*. First edition of *Look*. Edward Weston becomes first photographer to receive Guggenheim Fellowship. Paul Strand, Gaspe series. Gygory Kepes is co-founder with Moholy-Nagy of the New Bauhaus in Chicago. Alfred Stieglitz makes last photographs. Stieglitz shows Ansel Adams photographs at *An American Place*.

Picasso, *Guernica*. The "pretzel" intersection of Grand Central Parkway, Grand Central Parkway Extension, Union Turnpike, Interboro Parkway and Queeens Boulevard in New York City is completed. Golden Gate Bridge is completed. Walter Lippmann writes *The Good Society*. Aneurin synthesizes Vitamin B. Hindenburg dirigible burns at mooring.

Births and Deaths: Frederick Ives, d.1938: Ansel Adams photographs in Northwest for W.P.A. Walker Evans has one man show at MOMA, and the book *American Photographs* *Newsweek* magazine fires Eugene Smith for using a miniature camera. Smith joins Black Star Agency and does first work for *Life, Colliers* and *Harpers Bazaar*. Harry Callahan begins photography. Edward Steichen retires from photography because of too much time spent in management. Frederick Sommer does first photography with an 8 x 10 camera. Bradford Washburn does aerial photographs in Alaska. Dorothea Lange photographs for F.S.A. in California and New Mexico. Super-X film, twice as fast as any other on the market. The first panthermic, fine grain developer announced in July, 1938. The Standards Council of the American Standards Association met to standardize the rating and classification of photographic materials. First publication of *U.S. Camera. Picture Post* magazine published by Stefan Lorant in England. David Smith presents *Still Life* and Alex-

ander Calder presents *Mobile*.

Roosevelt creates Rural Electrification Administration. Nazi tanks roll into Austria.

Births and Deaths: Robert DeMachy, d.

1939: Lange and Taylor publish *An American Exodus: A Record of Human Erosion*. Eugene Smith joins *Life*. Eliot Porter shown at *An American Place*. He is the second and last photographer to be shown at the gallery (which opened in 1929). Russel Lee does series in Texas for F.S.A. Arthur Rothstein photographs in Colorado for F.S.A. Bernice Abbott publishes *Changing New York*. Edgerton, stroboscopic photos of tennis player. Herbert Matter, motion study of Calder mobile in motion.

Grandma Moses becomes famous. *Finnegans Wake* completed by James Joyce. Hahn and Strassman discover nuclear fission. Paul Muller invents D.D.T. Walter Zapp develops the Minox. German troops invade Czechoslovakia; Franco captures Madrid; Japan claims Spratly Islands; Mussolini takes Albania; Soviets invade Finland.

1940: Weston makes prints for *California and the West*. Ansel Adams assists Beaumont Newhall in establishing the Department of Photography at The Museum of Modern Art. Ansel Adams, *Surf Sequences*. Arthur Rothstein in California for F.S.A. Walt Disney, *Fantasia*. Rowland Potter (Defender Photo Supply) and Frank Penwick (Ilford Limited) perfect multi-contrast papers. Strand produces *Photography of Mexico*, a portfolio of fine gravure reproductions. Steichen receives the Art Directors Club Medal. Henri Cartier-Bresson is a corporal in film and photo unit in Army; captured Armistice Day, he spends three years as a prisoner in Germany. Imogene Cunningham, *A Pageant of Photography* Golden Gate International Exposition, San Francisco (group show). Walker Evans Guggenheim Fellowship. 1940 and 1941—Record photographs of contemporary American subjects. Bill Brandt photographs the *Christ Church Crypt*, Stepney, and also *Dylan Thomas* and *Henry Moore*.

Richard Wright (1908-1960) U.S. writer and novelist writes *Native Son*. Hemingway *For Whom the Bell Tolls*. William Faulkner, *The Hamlet*. Charlie Chaplin's first talking picture *The Great Dictator*. Salvador Dali goes to U.S., has a retrospective exhibition at the Museum of Modern Art. Augustus John (1878-1961) reelected a royal academician. Nazi troops overrun Denmark and move into France, Holland and Belgium. Roosevelt exchanges arms for land with Churchill. Stock market's physical volume of American industrial 1929.

Births and Deaths: Lewis Hine, d. Paul Klee, d. Leon Trotsky, d. J.E. Vuillard, d. Marcus Garvey, d.

1940: Edward Weston photographed illustrations for edition of Walt Whitman's *Leaves of Grass*. Project cut short by Pearl Harbor attack. Yousef Karsh, *Winston Churchill*. National Television System Committe recommends 525-line image definition standard. Kodak introduces the "Medalist I" 35mm roll film camera. Phenidone recommended as a developing agent by J.D. Kendall. Rare Earth optical Glass introduced by Kodak. Kodacolor color negative film introduced by Mees with accompanying paper print process. Kodak Ltd. introduced "Airgraph System" of mail delivery. Kodachrome enlargements on transparency film shown. Eliot Porter, Guggenheim Fellowship, 1941 and 1946—to record in black and white and color certain species of birds in the United States.. Aaron Siskind, *Taber nacle City* at Photo League. Left League shortly thereafter. Siskind has first exhibition at Museum of Modern Art, *Image of Freedom*.

1941: Ansel Adams appointed photo-muralist to U.S. Department of the Interior; photographing landscapes characteristic of various regions; *Moonrise, Hernandez New Mexico*. Project interrupted by World War II and never revived. Henri Cartier-Bresson corporal in French Army. Dorothea Lange received Guggenheim Fellowship, but resigned it after the Japanese attack on Pearl Harbor. Edward Steichen refused entry into Army Air Force because of age; accepted by Navy and commissioned as Lt. Commander. Organized aviation photo unit.

Lend-Lease Act. Pearl Harbor attacked. Chemex Coffeemaker designed. Germany invaded Russia. Moss Hart, writes *Lady in the Dark*. John Crow Ransom writes *The New Criticism*. Gertrude Stein writes *Ida*. Births and Deaths: Henry Bergson, d. Gutzon Borghun, d. James Joyce, d. J.J. Paderewski, d. Virginia Woolf, d.

1942: Kodacolor film made available to give negative color pictures by direct color development. First samples of Agfa color paper demonstrated at the meeting of the German Cinetechnical Society in Dresden. Ansco Color Reversible film released to the U.S. armed forces. Werner Bischof's photographs appear in the magazine *Du*. David Seymour (Chim) begins work in photographic interpretation. Weston serves as a plane spotter at his home near Carmel. Weston has traveling exhibition shipped by Office of War Information. "V-Mail" used for the first time in sending and receiving letters from U.S. servicemen; microfilm process on 16mm. Edward Steichen directed *The Road to Victory*; text by brother-in-law Carl Sandburg.

Artists for Victory show of paintings and drawings at the New York Metropolitan Museum. Artists received a total of $52,000 for their works...largest sum ever distributed in a single exhibition of contemporary American art. Gordon Parks is photographer for OWI Overseas Division. Eliot Elisofan covers the War for *Life* with Alfred Einstadt, Robert Capa, Margaret Bourke-White, David Douglas Duncan. Brett Weston serves in the Army Signal Corps as photographer. Wright Morris, Guggenheim Fellow, 1942-1946—*The Inhabitants*.

Albert Camus, *The Stranger* and *The Myth of Sisyphus*. Joyce Cary, *To Be A Pilgrim*. Aaron Copland, the ballet *Rodeo*. Salvador Dali, *The Secret Life of Salvador Dali*. John Steinbeck, writes *The Moon is Down* and *Bombs Away*. Manhattan Project authorized by the War Department for atomic weapon research.

Births and Deaths: William Henry Jackson, d. Michael Fokine, d. Grant Wood, d. Stefan Zweig, d.

1943: Robert Capa photographs the Allied Victory in Nicosia. Ansel Adams photographs *Mount Williamson* and *Manzanar*. Ansco-Color is introduced to industry. Eastman Kodak produces Kodacolor Aero Reversible film for military use. Ozalid introduces a film duplicating machine in which either 16 or 35mm film could be copied on diazotype film. Shutterless strip camera designed for Air Force coastal mapping. Alpa Reflex 35mm camera introduced by Swiss. Portable darkroom designed for Army with all materials for processing and enlarging in two cubic feet. Irving Penn hired at *Vogue* magazine, eventually makes 150 cover photographs. Paul Strand travels to Vermont. Aaron Siskind summers at Martha's Vineyard; begins work on organic objects in geometrical setting. H. Cartier-Bresson escapes from German prison, works with underground. Steichen aboard U.S.S. Lexington in Gilbert and Marshal Islands.

1943: Thornton Wilder, Pulitzer Prize for *The Skin of Our Teeth*. Peggy Guggenheim gives Jackson Pollack one-man show in New York. Sir Herbert Read writes *Education Through Art*. From 1943 Robert Frost serves as the Ticknor Fellow in the humanities at Dartmouth, is awarded the Pulitzer Prize for Poetry. H.L. Mencken writes the last section of autographical trilogy, *Heathen Days*. Otto Stern wins the Nobel Prize (U.S.) for the discovery of the magnetic moment of the proton. *Oklahoma!* on Broadway. Italy surrenders unconditionally. J.R. Oppenheimer directs the Los Alamos Laboratory for atomic weapon research. Canned goods, meats, fats and cheese rationed in U.S. U.S. government seizes coal mines as 530,000 miners defied the War Labor Board and strike.

Births and Deaths: Frederick Evans, d. Chaim Sontive, d. Oskar Schlemmer, d. Beatrix Potter, d.

1944: Robert Capa photographs D-Day. Signal Corps receives 300,000 feet of negative film per month from U.S. camera teams. *Baptism of Fire* shows battlefield psychosis upon first contact with the enemy. Erich Salomon last heard of May 24 enroute to the extermination camp at Auschwitz. Edward Steichen structures *Power in the Pacific* at the Museum of Modern Art. Ansel Adams is civilian consultant to armed services, publishes *Born Free and Equal*, and an exhibition *Manzanar*. Electronic flash marketed by Kodak; called "Speedlamp." D-19 film developer introduced by Kodak, contained hydrazine sulfate. Ansco introduced 16mm color reversal film and Printon color paper. Commander Steichen shows reel of air battles on Kodachrome film at Kodak Camera Club. Edward Weston has a one-man show at the University of Oklahoma.

Par Fabian Lagerkvist, *The Dwarf*. Tennesee Williams, *The Glass Menagerie*. Peggy Guggenheim gives Robert Motherwell and Hans Hoffmann one-man shows in New York. Gyorgy Kepes, *The Language of Vision*. Joyce Cary, *The Horse's Mouth*. Ernst Cassirer, *An Essay on Man*. Malinowski's *A Scientific Theory of Culture* is published. June 6, 1944-landing in Normandy, D-Day. September 8, 1944—launching of the first true guided missile, the German V-2. December 1944, the Battle of the Bulge. Roosevelt and Truman won over Dewey and Bricker. Servicemen's Readjustment Act (GI Bill of Rights). Streptomycin discovered.

Births and Deaths: Erich Salomon, d. W. Kandinsky, d. Romain Rolland, d. E. Munch, d.

1945: Margaret Bourke-White photographs Buchenwald victims. Robert Capa photographs Dead U.S. soldier killed by a sniper during the last hours of WWII. Steichen named director of U.S. Navy Photographic Institute and placed in command of all Navy Combat Photography by James Forrestal, Secretary of Navy. He is awarded Distinguished Service Medal, and receives honorary fellowship P.S.A. Cartier-Bresson makes film for U.S. Office of War Information, *Le Retour*. Paul Strand has one-man retrospective exhibition, Museum of Modern Art, New York. Ansco Color in 16mm becomes available. Santa Barbara Museum of Art opens gallery dedicated exclusively to photography. Kodak introduces D-85 developer, used in making half-tone screen negatives. Kodak Dye Transfer color process introduced.

Sinclair Lewis writes *Cass Timberlaine*. Second World War ends. Henry Miller, *The Air-Conditioned Nightmare*. Gabriela Mistral (Chilean poet), Nobel Prize for Literature. Picasso, The Charnel House; he joins the Communist Party. John Steinbeck, *Cannery Row*. *The Dynamics of Culture Change* by Malinowski is published. Richard Wright writes *Black Boy*. April 12, 1945, Roosevelt dies.

Harry S. Truman becomes President. Surrender of German Army to the Allies (May 7). U.S. Government revealed that Nazis had exterminated 80% of German Jews. War Production Board authorized ten automobile companies to produce 691,018 passenger cars. United Nations Charter signed by 50 nations in San Francisco (June 26). Hiroshima, Aug. 6, Nagasaki, Aug. 9. Japan initiates surrender negotiations Aug. 10. Formal surrender to the Allies Sept. 2. U.S. Terminates all rationing programs Nov. 23.

Births and Deaths: Jerome Kern, d. K. Kollwitz, d. Ernie Pyle, d. Paul Valery, d. H. Wolfflin, d.

1946: Photograph of underwater atomic explosion at Bikini. Arnold Newman photographs Igor Stravinsky. Todd Webb photographs *The Storefront Church, Harlem*. Ansel Adams receives the first of two Guggenheim Foundation grants to photograph the national parks and monuments in Alaska and Hawaii. Margaret Bourke-White photographs Mahatma Gandhi. Eastman Kodak Co. introduces Ektachrome film. Kidder-Smith, Guggenheim Fellow, 1946, to survey modern architecture in the countries of Sweden and Switzerland. Variation of the miniature camera introduced under the names Stereo-Realist Camera and Tri-Vision Haneel Stereo Camera. Kodak Ltd. (England) introduces Bromide Foil Cord, a non-stretch printing material for use in map making. Film containing dispersed couplers is introduced under the name Ektachrome. Kodachrome 16mm commercial film introduced. National Press Photographers Association founded. Andre Kertesz, one-man show at the Art Institute of Chicago. Paul Strand collaborates with Nancy Newhall, *Time in New England*. Henri Cartier-Bresson has one-man show at the Museum of Modern Art. Ansel Adams starts teaching photography as profession at the California School of Fine Arts; Richard Avedon works for *Harper's Bazaar*, under A. Brodovitch. Hydroquinone produced synthetically. Brett Weston, Guggenheim Fellowship, 1946, to photograph social, economic and physical aspects of Southeastern Alaska. Minor White meets Edward Weston in California; studies with Ansel Adams.

Museum of Modern Art honors first woman artist by exhibiting the paintings of Georgia O'Keefe. Buckminster Fuller produces a full scale model house, dome-shaped and suspended from a central mast. Thermopane double insulated glass introduced. Gian Carlo Menotti composes *The Medium*. Henry Moore exhibition at the Museum of Modern Art, New York. Jean Paul Sartre writes *No Exit* and *Existen tialism and Humanism*. Atomic Energy Commission, a civilian group, established to administer atomic research and development. Tupperware marketed.

Births and Deaths: James Craig Annan, d. Baron A. Demeyer, d.

Lazlo Moholy-Nagy, d. Alfred Stieglitz, d. S. Hart, d. W.C. Fields, d. Gertrude Stein, d.

1947: Robert Capa, with David Seymour and Henri Cartier-Bresson establishes Magnum Photos, the international cooperative agency for photo journalists. Margaret Bourke-White photographs *Money-lender's Home*, India. Eastman Kodak introduces a contact printing paper for amateurs under the name Velite. Edward Steichen becomes director, photography department, Museum of Modern Art. Moholy-Nagy publishes *Vision in Motion*. Polaroid Corporation announced new type of camera and film, designed to yield a finished monochrome print in one minute after the camera exposure. Edward Weston works in color, while on location with Willard Van Dyke for the movie, *An American Photographer*, for the State Department. Merle Armitage designed and arranged publication of *50 Photographs: Edward Weston*. Wayne Miller, Guggenheim Fellowship, 1946 and 1947, on the *Life of the Northern Negro in the United States*. Siskind, first exhibition at Egan Gallery.

New York Museums collaborate to ease financial problems by dividing exhibit responsibilities: Museum of Modern Art—Contemporary American and Foreign Art; Whitney—Contemporary American Art; Metropolitan—Classical Art. "Artists Equity" formed, to avoid political and esthetic controversies and establish fair practices with museums and dealers. U.S. State Department sent 79 paintings abroad of American Modernists; show is recalled by Congress, who deem it "too advanced" and controversial. Art Institute of Chicago exhibit nothing but abstractions in its annual show. Grandma Moses exhibited at Galerie St. Etienne, New York. Carl Jung writes *Essays on Contemporary Events*. Sinclair Lewis writes *Kingsblood Royal*. Gian Carlo Menotti writes *The Telephone*. Arthur Miller, *All My Sons*. Tennesse Williams wins the New York Drama Critics Circle Award four times for *The Glass Menagerie* and *Cat on a Hot Tin Roof*. John Steinbeck, *The Wayward Bus*. Constitution of the United States amended for the 22nd time, limiting the President to two terms of office. Price of soap increased 50% after removal of Price Control. Vitamin A synthesized.

Births and Deaths: Henry Ford, d. Alfred North Whitehead, d.

1948: Robert Capa photographs the birth of Israel. Gordon Parks, portrait of *Red Jackson*. James Fitzsimmons, Guggenheim Fellowship, for creative and experimental studies in color photography. Margaret Bourke-White photographs *Vultures, Calcutta*. Brett Weston issues *White Sands Portfolio*. Ansel Adams receives Guggenheim Fellowship to complete work on the National Parks; produces *Portfolio One, Portfolio Two: The National Parks*—original prints in editions of 100. Basic Photo-Books present his philosophy and the

"Zone System." Edward Weston stricken with Parkinson's Disease. Paul Strand travels to France. Eastman Kodak introduces single contrast papers for commercial photo inishing with roll printers and continuous processing machines. Polaroid Corporation announces the Pola-color process. The Ansco Color Densitometer is introduced in the U.S. Man Ray, *Self Portrait*. Harry Callahan, *Elenor*. Philippe Halsman, *Albert Einstein*. Sergei Eisenstein's film *Ivan the Terrible* is banned. Bischof photographs the Winter Olympic Games at St. Moritz for *Life* magazine. Xerographic process for copying documents cheaply and rapidly on ordinary bond paper introduced. Ertacol sheet film is developed. Siskind visits Chicago, meets Harry Callahan. Exhibitions at MOMA: Edward Steichen *In and Out of Focus; 50 Photographs by 50 Photographers; Photo-Secession Group; Four Photographers, Lisette Model, Bill Brandt, Ted Croner, and Harry Callahan*. Ansel Adams, from 1948 to 1950, published *Basic Photo Books: Camera and Lens, The Negative, The Print*; new illustrated editions of *John Muir, Yosemite and the High Sierra* and *Land of Little Rain*; facsimile reproductions: *My Camera in Yosemite Valley* and *My Camera in the National Parks; Portfolio One, In Memory of Alfred Stieglitz; Portfolio Two, The National Parks*.

William de Kooning has first one-man show in New York. Malinowski publishes *Magic, Science and Religion*. Giacometti works on portraits of his brother in *City Square*. William Faulkner writes *Intruder in the Dust*. Dwight Eisenhower writes *Crusade in Europe*. Sidney Janis opens gallery in New York. Paul Hermann Muller is awarded the Nobel Prize in Physiology and Medicine for discovering DDT. Television was in 6,485 homes in 1946; 1947, 178,571, and 1948, 750,000. Alfred Kinsey writes *Sexual Behavior in the Human Male*. Thornton Wilder writes *The Ides of March*. The World Council of Churches is formed which "...accept Jesus Christ our Lord as God and Savior." Marshall Plan enacted. Columbia Records introduces the high-fidelity long-playing record.

Births and Deaths: Kurt Schwitters, d. Arshile Gorky, d..

1949: Ektacolor negative packaged in professional sheet film sizes by Kodak. The Chromart process, a negative-positive motion picture process, demonstated, England. DuPont makes positive release film for printing from separation negatives. Angus McBean makes photograph *Surrealist Composition Including Self Portrait*. Steichen receives U.S. Camera Award for the "most outstanding contribution to photography by an individual." Exhibitions during the year: *The Exact Instant. Roots of Photography: Hill and Adamson, Cameron. Realism in Photography: Ralph Steiner, Wayne Miller, Tosh Matsumoto, Frederick Sommer. Six Women Photographers:*

354

Bourke-White, Helen Levitt, Dorothea Lange, Tana Hoisan, Hazel Larsen and Frieda Larsen. *Roots of French Photography*. S.E.I. Photometer made; first precision "spot" meter, incorporating telescopic sight—extinction-type meter. Hasselblad introduces first camera. Homer Page wins Guggenheim Fellowship in Creative Photography.

Grandma Moses visits President Truman at White House. Frank Lloyd Wright, *Morris Store*, San Francisco, and the *Johnson Research Tower*, Racine; he publishes a controversial critique of Le Courbusier and Gropius. Arthur Miller writes *Death of a Salesman*. William Faulkner receives Nobel Prize. Russians explode first atomic bomb. India, Pakistan, Burma, Ceylon and Indonesia become independent. Chinese Communists win control of China.

Births and Deaths: Margaret Mitchell, d. Jose Clemente Orozoco, d. Richard Strauss, d.

1950: E. Weston, *My Camera on Point Lobos*. Robert Doisneau, begins publishing pictures of the people of Paris. Steichen has retrospective exhibition at American Institute of Architects headquarters, Washington, D.C. AIA awards him Fine Art Medal. Paul Strand publishes *Time in New England*.

Dr. Klaus Fuchs, British physicist, confesses he fed atomic secrets to the Soviet Union. President Truman announces work on H-Bomb. Communist North Korea invades South Korea. Major General William F. Dean lands in Pusan, South Korea. Air-Raid drills in case of atomic attack. Committee to Investigate Organized Crime. Congress passes the Social Security Act. Korean War. Senator Joseph McCarthy speaks out on the Communist issue. Gian Carlo Menotti writes *The Consul*. Picasso, *Goat*. Oskar Kokoschka, *Prometheus Saga*. Disney produces *Cinderella*.

Births and Deaths: Al Jolson, d. George B. Shaw, d. Harold Laski, d. Alfred Korzybski, d. V. Nijinsky, d. Kurt Weill, d.

My Camera in the National Parks by A. Adams. Photo-Kina fair in Cologne, Germany; 500,000 square feet of displays, 340 German firms participating; 14 countries represented. Sylvania announced that in 1937, 6,600,000 flash bulbs were manufactured whereas in 1951 four hundred million bulbs were sold. Polaroid demonstrates film with an index of 3,000. Printing papers by Kodak include Medalist, Ektalure, Mural Paper, Repreo-Negative Paper. Ansco introduces Indiatone Brilliant and Dupont introduces High Speed Varigam. W. Eugene Smith photographs at Deleitosa, Spain for *Life*. Type C color prints available. The Parkins-Elmer Corporation in-

stalls a 5,000 pound telescopic camera for photography of meteors at the Harvard meteor station near Las Cruces, New Mexico. Super XX film now rated 100. Graflex introduced the 4x5 polaroid back for use on 4x5 Speed Graphic and view cameras. Ansel Adams publishes *My Camera in Yosemite Valley*. Dr. E.H. Land publishes *One Step Photography* in the *Photo Journal*. Aaron Siskind starts teaching at Trenton Junior College, New Jersey. Gernsheim, *Masterpieces of Victorian Photography*. Werner Bischof goes to Italy, France and Iceland. Man Ray returns to Paris. Ansel Adams publishes Volume 2, Basic Photo Series: *The Negative*.

Julius and Ethel Rosenberg given death sentence for spying. President Truman relieves General Douglas MacArthur. Ninety cadets dismissed from West Point for violations of the Academy's honor system. The United States ends the state of war with Germany. Winston Churchill becomes Prime Minister.

Births and Deaths: John Sloan, d.

1952: Following the Aspen Photographic Conference, Dorothea Lange, Nancy Newhall, Ansel Adams, Beaumont Newhall, Barbara Morgan, Ernest Louie, Melton Ferris, Dodie Warren, and Minor White found *Aperture*, a quarterly of photography. Minor White chosen editor and production manager. Polaroid makes a plastic coating to increase the life of polaroid prints. Graflex designs a special combat camera for the army; it uses 70mm film, makes fifty exposures on a fifteen foot reel of film. Barbar Morgan, *Summer's Children*. Henri C. Bresson, *The Decisive Moment*. W. Eugene Smith, *Life in a Spanish Village*. David Douglas Duncan publishes *This is War*. Otto Steinert, *Subjective Fotografie*. Bill Brandt, *Literary Britain*. Aaron Siskind teaches at the Institute of Design, Chicago. Werner Bischof goes to Asia. Ernst Haas comes to America. Harry Callahan teaches at Black Mountain College.

The "Comet" begins the world's first jet airliner service. President Truman dedicates the *Nautilus*, world's first atomic submarine. The Olympic Games open at Helsinki, Finland. The U.S.A.F. announce that "flying saucers" are only "natural phenomena." General Eisenhower declares he is available for the Republican nomination. Great Britain announces the successful detonation of her first atomic weapon at the Monte Bello Islands off northwest Australia. A test of the first H bomb was reported by the United States at Eniwetok. General Eisenhower elected President of the United States.

Births and Deaths: Sir Stafford Cripps, d.

1953: William Mortensen in *The Camera Magazine*. "Did the judges of the Baltimore Salon retreat so far from the 'Salon Art' that they

backed themselves off this planet? I packed four of my best prints and sent them...I don't mind telling you everyone of those prints came back...now that I have seen the pictures selected I prefer the company of those that were not..." Minor White moves to Rochester as assistant curator, George Eastman House. Ilford introduces Phenidone. The Heiland Co. introduces the first Strobonar. Yousuf Karsh prints portraits of Abraham Lincoln from glass plate negatives discovered in 1952. Bernice Abbott, *New Guide to Better Photography*. Robert Frank meets Edward Steichen. Bernice Abbott, *View Camera Made Simple*. *Life* publishes the first color essay by E. Haas. Weegee (A. Fellig),*Naked Hollywood*. Roy de Carava wins Guggenheim Fellowship in photography. Alfred Eisenstadt, portraits of English notables in *Life*. Cartier- Bresson, *The Decisive Moment*. Dorothea Lange, *Photographing the Familiar, Aperture*. Paul Strand*La France de Profil*. Brett and Edward Weston print the *50th Anniversary Portfolio*. Ansel Adams publishes Vol. 3 of the *Basic Photo Series: The Print*. Super Highspeed Royalpan index is ASA 160.

The Knoedler Galleries in New York sell out an Andrew Wyeth show. Mount Everest conquered by a British expedition. Elizabeth II of England crowned. Egypt proclaimed a republic, with Major General Naguib as President and Premier. Julius and Ethel Rosenberg executed. Senator McCarthy investigations of the Voice of America program. Georgi M. Malenkov head of the Soviet Government.

Births and Deaths: Joseph Stalin, d. Queen Mary, d. Y. Kuniyoshi, d. John Marin, d.

1954: July 12, 100th anniversary of the birth of George Eastman. United States public spent 442 million dollars in 1954 on photography, amateur and professional. 400% increase over 1943. Improved High Speed Super XX film, index ASA 200. The Hycon, developed to make exposures of 1/10th of a millionth of a second. 200,000 visitors to the fourth Photo-Kina, Cologne. Leitz introduces the Leica M3. Zeiss-Ikon Contax introduces a 21mm lens. Popular Photography publishes a tribute to Robert Capa, written by John Steinbeck. Robert Frank a Guggenheim Fellow, to photograph America. Todd Webb, Guggenheim Fellow, to photograph pioneer routes in America. Cartier-Bresson, *The Europeans*. Cartier-Bresson,
of Moscow. Dover re-releases Muybridges' *Animals in Motion*. Steichen presents *The Family of Man*. Aaron Siskind goes to Mexico. Ansel Adams begins postwar Yosemite Workshops, discontinued in 1941. W. Eugene Smith quits *Life*. Minor White appointed lecturer at RIT. Henry Holmes Smith becomes Associate Editor of the *College Art Journal*. Andreas Feininger, *The Face of New York*. H. Gernsheim, *Roger Fenton*. Max Ernst won first prize at the Venice

Biennale. John Marin wins Gold Medal of Honor at the Pennsylvania Academy' 149th Annual. President Eisenhower signs a bill making Communists illegal. The New York Giants win the World Series. The Senate condemns Senator McCarthy. The world's largest aircraft--carrier, USS *Forrestal* launched.

Deaths: Robert Capa, Henri Matisse, August Lumiere.

1955: *The Family of Man* from January to May at the Museum of Modern Art. Robert Raushenberg uses photographic fragments in his work. The Hasselblad 500 C was introduced. *Photo Maxima* printed for the first time. Super High Speed Ansco color film ASA 100. Andreas Feininger, *The Creative Photographer*. Roy De Carava, *The Sweet Flypaper of Life*. Paul Strand, *Un Paese*. Tri X "ultra high speed" panchromatic film, 200 ASA. Super-fast Ektachrome, ASA 32, available in 35mm. Kodak introduces Royal X Pan, ASA rating of 650. Poly Contrast Rapid printing paper becomes available. Robert Frank wins second Guggenheim. William Garnett wins second Guggenheim. W. Eugene Smith wins second Guggenheim. Todd Webb wins second Guggenheim. Agfa releases first postwar light- cell controlled camera, the Automatic 66. Margaret Bourke--White, *Report on the American Jesuit*. *Brett Weston Photographs* published by Merle Armitage. Minor White discusses the life of the small photogallery in *Image*. H. Gernsheim *History of Photography*. Andreas Feininger, *Creative Photographer*. Nancy Newhall publishes *Degas* letters on photography in *Image*. Bernice Abbott personally prints *Atget Portfolio*. Eastman House releases the first traveling show, *Lyrical and Accurate*. Robert Hollingsworth, Van Deren Coke, Jerome Liebling exhibit at Eastman House. Walter Chappell to Rochester to study with Minor White. Louise Haz publishes *Image Arrangement*. Dorothea Lange and Pirkle Jones photograph *The Death of a Valley*. Harry Callahan receives the Graham Foundation award of $10,000. Minor White starts the Portland, Oregon workshop in conjunction with the Portland Museum. Ansel Adams publishes Volume 3 of the *Basic Photo Series: The Print*. Whitney show *The New Decade*, emphasizing different artists. San Francisco Museum of Art holds large Cezanne show. 82 persons killed in a race track accident at LeMans, France. Nobel Prize winners call for the renunciation of atomic warfare. Cambodia declares independence. Gamal Nasser announced that Egypt purchased arms from Czechoslovakia. The anti-proton was discovered. The AFL and CIO merge.

Births and Deaths: Albert Einstein, d.

1956: *The Focal Encyclopedia of Photography* published. Bartlett H. Hayes, *The Naked Truth and Personal Vision*. Electronic flash units operated from dry cells marketed. MOMA presented *Masters of British Painting, 1800-1950* including most of the pre-Raphaelites.

The North Carolina State Museum opened in Raleigh and was the first U.S. museum created by state legislature and given public funds to acquire a public art collection. Ground was broken for Wright's *Guggenheim Museum*. The first telephone cable across the Atlantic opened. The United States budget for 1956 showed a surplus of 1,754 million dollars. Egypt broke diplomatic relations with France and Great Britain. Their assets seized. Eisenhower reelected with a plurality of over nine million votes. Summer Olympic Games in Melbourne.

Deaths: Lyonel Feininger, Bertolt Brecht.

1957: Honeywell Heiland marketed the Strobonar Electronic Flash. Mail order forms for Kodak processing of Kodachrome II, ASA 25, on sale. Robert Frank's *Les Americains* refused publication in the United States, published in France. John Collier, Jr., Guggenheim Fellow. W. Eugene Smith receives another Guggenheim, for work on Pittsburgh. Cecil Beaton publishes *The Face of the World*. Minor White publishes trial version, *The Zone System Manual*. Dover reprints *The Human Figure in Motion* by Muybridge. John Szarkowski publishes *The Idea of Louis Sullivan*. Phillip Hyde, Dody Warren, Dorothy Norman and Don Worth exhibit at Eastman House. Ansel Adams, article on short-run three-color photo-process in *Image*. Beaumont Newhall replaces Minor White as editor of *Image*. Walter Chappell becomes Curator of Prints and Exhibitions at George Eastman House. He exhibits *Gestures of Infinity* which appears also in *Aperture*. Ruth Bernhard publishes *The Big Heart*. Aaron Siskind prepares *Abstract Photography* exhibition for the State Department. Paul Caponigro studies photography with Minor White. *Some Methods of Reading Photographs* published in *Aperture*. Alvin Langdon Coburn has 3rd one-man show at the Royal Photographic Society.

The Soviet Union launched Sputnik. Atlas intercontinental ballistic missile successfully fired. President Eisenhower sends 1,000 paratroopers to Little Rock. Britain became the world's third hydrogen bomb power.

Births and Deaths: C. Brancusi, d. Nikos Kazantzakis, d. Joseph McCarthy, d.

1958: David Douglas Duncan publishes *The Private World of Pablo Picasso*. Robert Frank, *Les Americains*. Ansel Adams, *The Islands of Hawaii*. The Newhalls, *Masters of Photography*. Charles A. Wilson (candid photographer of the 1880's in Scotland) dies. John Szarkowski, *Face of Minnesota*. Jerome Liebling becomes Associate Professor of Art, University of Minnesota. Paul Caponigro becomes teaching assistant to Minor White. Bernice Abbott joins the Physical

Science Study Committee of Educational Services, New York City. Peter Pollack, *The Picture History of Photography*. Nikon S 3 introduced. Polaroid celebrates 10th anniversary with seven films now available. Phillippe Halsman, *Psychological Portraiture*. G.B. Wright, *Nikon Manual* (followed by manuals for about every camera made.) "Will the Russians Beat Us to a Fully Automated Camera?" (*Popular Photography*) *Popular Photography* magazine sends out ballots to 465 outstanding photographers, editors, picture editors, art directors, critics and teachers in an attempt to determine the "World's Ten Greatest Photographers." They admit that "great" is different things to different people, and the results (from 243 replies) indicate values of the period: Ansel Adams, Richard Avedon, Henri Cartier-Bresson, Alfred Eisenstaedt, Ernst Haas, Philippe Halsman, Yousuf Karsh, Gjon Mili, Irving Penn and W. Eugene Smith.

The Smithsonian Institute organizes several large traveling shows, *Dutch Master Drawings* and *Swedish Textiles*. The UNESCO Art Center opens in Paris. France sponsors an exhibit based on the independence of cultures. MOMA has a Seurat show. First jet-powered transatlantic air service. The Chicago Art Institute opens ten new galleries of Oriental art. Boris Pasternak awarded the Nobel Prize for literature, for *Dr. Zhivago*, but refuses the prize. Angelo Guiseppe Cardinal Roncalli was elected Pope John XXIII. Charles de Gaulle elected first president of the French Fifth Republic. U.S. satellite, Explorer 1, fired into orbit. Nikita Krushchev unanimously elected to succeed Nikolai Bulganing as chairman of Council of Ministers. Van Cliburn of Texas wins 1st prize in the international Tchaikovsky piano competition, Moscow. Arkansas granted a two year delay in integration. Alaska becomes a state.

Deaths: Pope Pius XII, d. Edward Weston, d. Georges Rouault, d. Maurice de Vlaminck, d.

1959: Ansel Adams wins third Guggenheim fellowship. Walker Evans wins third Guggenheim fellowship. Helen Levitt wins fellowship from the Guggenheim foundation. Richard Avedon, *Observations: Photographs*. Polaroid Corporation releases ASA 3000 film. Ansel Adams, *Yosemite Valley*. Robert Frank, English edition of *The Americans*. Karsh, *Portraits of Greatness*. Nancy Newhall writes on Albert Ranger-Patzsch in *Image* *Aaron Siskind: Photographs* published. *Pittsburgh*, by W. Eugene Smith, published in 1959 *Photography Annual*. Weegee, *Weegee's Creative Camera*. *Image* celebrates 10th anniversary. *Infinity* article on "lost photographic masterpieces" indicating failure to protect great negatives. George Eastman House announces *Photography at Mid Century exhibition*. Carl Mydans, *More Than Meets the Eye*. Wynn Bullock head of Photography Department, San Francisco State College. Robert Frank, *Pull My Daisy*. Ansel Adams, *Volume 4: Basic Photo*

Series: Natural Light Photography. Bell and Howell introduce an "electric eye" controlled small camera. The San Francisco Museum shows photographs by Wynn Bullock. "Did the Russians Fake the Moon Photos?" article in *Popular Photography*. E.A. Hamilton and Charles Preston *Our Land, Our Peoples*. Carl Siembab Gallery opens, Boston. The Gateway Gallery opens, San Francisco. Ektachrome now ASA 50.

Joan Miro, major retrospective at the MOMA. Winslow Homer, exhibition of oils, watercolors and drawings at the Metropolitan Museum. The United States State Department cancels *black list*—had prohibited sending abroad works by artists who might have been politically radical in the 1930's. The Solomon Guggenheim Museum at 1071 Fifth Avenue in New York opened, designed by F. L. Wright. Fidel Castro takes Cuba. The Belgian Congo riots. Laos complains to the UN that North Vietnamese troops had moved in. The Vatican prohibits Roman Catholics from voting for Communists. The St. Lawrence Seaway opens. John Foster Dulles dies. Premier David Ben-Gurion resigns. The first nuclear-powered merchant vessel, the U.S. *Savannah* launched at Camden, New Jersey. Installment buying introduced into the Soviet Union. The Soviet Union announced that Lunik III photographed the far side of the moon. Patrice Lumumba arrested in the Belgian Congo.

Deaths: Frank Lloyd Wright, Bernard Berenson, Dan Weiner.

1960: E.P. Dutton, *The World of Werner Bischof. Polaroid Portfolio No. 1* published. Exhibition, *The Sense of Abstraction* MOMA. Edward Steichen marries Joanna Taub. Brett Weston sails for Europe. Dorothea Lange goes to Venezuela. Paul Strand goes to Rumania. *Photography in the Fine Arts* under the direction of Ivan Dimitri of the Metropolitan Museum of Art, in conjunction with the *Saturday Review of Literature*. Avowed purpose of the exhibition is "...a serious and sustained effort to have photography accepted as a fine art." Steichen calls it, "...the most damaging thing that has ever happened to photography," a feeling shared by many photographers and photohistorians. In open letter to Dimitri, Steichen notes he personally sold photographs to European art museums more than fifty years earlier; that the Museum of Modern Art had held over 70 photographic exhibits since 1932. There were no photographers among the judges; the photographs were gathered from groups and organizations rather than individuals; the judging was completed in one afternoon. The feeling was that the Metropolitan, regarding photography with condescension, felt only it had the power to elevate photography to "art." Lyons, Labrot, Chappell, *Under the Sun*.

Beginning with Volume 7 Number 3 *Aperture* produced in Rochester. *Steichen the Photographer*, with text by Carl Sandburg. Irving

Penn, *Moments Preserved*.

Research into the principles of color vision by E.H. Land suggest need to revise the ideas of Young and Helmholtz. Cedric Wright, *Words of the Earth*. The 100th anniversary of the death of Diego de Silva Y Velasquez commemorated with an exhibition of 90% of the artist's surviving works. The 100th birthday of America's Grandma Moses is occasion for a centenary exhibition *My Life's History* at the IBM Gallery in New York. The MOMA and the Los Angeles County Museum sponsor joint exhibit, *Seasons and Moments*, the work of Monet. *Abstract Expressionism* or the *New York School* established; leaders are Jackson Pollock, Willem de Kooning, Franz Kline. The Louvre has showing of two thirds of the entire work of Nicolas Poussin. The Tate Gallery in London has Picasso show in which ten works never before shown outside of the Soviet Union are exhibited. Senator John F. Kennedy is elected President of the United States; race so close that a definitive result is not known until the following day. Vice President Nixon is other candidate. The U.S. N. *Trieste* bathyscaphe makes seven mile dive. Princess Margaret marries photographer Antony Armstrong. Lunch counters in San Antonio, Texas integrated peacefully. Pope John XXIII raises the first African, Japanese, and Filipino to the rank of Cardinal. The first successful launching of a Polaris missile from a submerged submarine announced. An American U-2 shot down over the USSR. Martin Luther King and 50 other demonstrators jailed in Atlanta, Georgia.

Deaths: Ira Wright Martin, d.

1961: Aaron Siskind appointed Head of Photography, Institute of Design, Illinois Institute of Technology. Harry Callahan becomes Associate Professor in Photography at Rhode Island School of Design. Ansel Adams awarded honorary degree of DFA by University of California. Bruce Davidson, Guggenheim Fellowship for a photographic study of youth in America. John Szarkowski, Guggenheim Fellowship. *Daybooks of Edward Weston, Volume I, Mexico*, ed. by Nancy Newhall, published by GEH. *Perspective of Nudes* by Bill Brandt published. General Aniline and Film develops special Ansco super high speed color film for use by astronauts in U.S. space program. David Douglas Duncan, *This is War*. Philippe Halsman, *Halsman on the Creation of Photographic Ideas*. Mathew Brady, *Civil War Photographs* (from the Library of Congress). W. Eugene Smith, commissioned by Japanese industrial firm, Hitachi, Ltd. to photograph its operations. Retrospective exhibition of Edward Steichen at MOMA. Minor White awards first prize in the Boston Arts Festival to Paul Caponigro, assisted in judging by Walter Chappell and Dorothy Jackson. White completes manuscript of *Canons of Camerawork*. Todd Webb, photographs of Western America, *Gold Strikes and Ghost Towns*. Irving Penn, *Moments Pre-*

served: *Eight Essays in Photographs and Words*. Walker Evans, *Let Us Now Praise Famous Men* (new ed. of 1941, with James Agee). Robert Doty, *Photo Secession: Photography as a Fine Art*. Brassai, *Graffitti*. Ansel Adams, Nancy Newhall, *This American Earth*. Harry Callahan, *On My Eyes* (poetry by Larry Eigner). Robert Frank, *The Sin of Jesus*. Aaron Siskind, *Photographs by Professors*. Dorothy Norman, *Alfred Stieglitz*. Wynn Bullock, *The Photograph as Poetry*.

Andy Warhol using silkscreen reproduction technique. USSR puts first man into space (Gagarin). Birth control pills marketed. Claes Oldenburg, *The Store*. *La Dolce Vita*, Frederico Fellini. *Breathless*, Godard. United States breaks with Cuba. J.F. Kennedy becomes 35th President. Peace Corps established. Attempted invasion of Cuba fails. T.V. programming described as "a vast wasteland by Newton Minow. De Gaulle assassination attempt fails. Soviet astronaut orbits earth, returns safely. U.S. Army rebukes General Edwin A. Walker for naming Americans as "Pinks."

Deaths: Ernest Hemingway, James Thurber.

1962: Edward Steichen retires as Director, Department of Photography, Museum of Modern Art. Lee Friedlander, second Guggenheim Fellowship, for photographic studies of the changing American scene. Geraldine Sharpe, Guggenheim Fellowship for photographic studies of certain social groups. *Tir A'Mhurain* by Paul Strand. Albert Boni, *Photographic Literature*. Eliot Porter, *In Wildness is Preservation of the World*. Ansel Adams, *Death Valley and the Creek Called Furnace*. Edward Weston, *Daybooks Vol. 2*. Erwin Fieger, *London, City of Any Dream*. *In Search of Greatness* by Yousuf Karsh. Polaroid Corporation and Minnesota Mining and Manufacturing Co., independently announce new color processes. Brett Weston, *15 Photographs*. E. Steichen, fifth one-man show at MOMA, in honor of his 82nd birthday. Harry Callahan becomes associate professor at Rhode Island School of Design. Robert Frank goes to Europe. Van Deren Coke, one-man show at GEH. Release of Polaroid 4 x 5 film with reusable negative. *These We Inherit*, by Ansel Adams, published for the Sierra Club. Teaching conference (basis of Society for Photographic Education) sponsored by the George Eastman House; veteran teachers say it could not have been held 10 years before. Man Ray exhibition *L'Oeuvre Photographique Bibliothique Nationale*, Paris. Aaron Siskind, co-editor of *Choice*, a magazine of poetry and photography.

United States enters Vietnam. The Beatles, *Love Me Do*. Pop artists have first major shows— Lichtenstein, Jim Dine, Andy Warhol, Jim Rosenquist, Claes Oldenburg. *Flaming Creatures*, Jack Smith. *Dog Star Man*, Brakhage. *Last Year at Marienbad* Alain Resnais. John Glenn, first American in space orbit. Telstar. Cuban missle crisis.

T.V. quiz sentences suspended, judge says, "humiliation was evident on all the contestant's faces." United States resumes nuclear tests in atmosphere.

Deaths: Edward Estline Cummings, d. William Faulkner, d. Herman Hesse, d. Yves Klein, d. Franz Kline, d. Morris Louis, d.

1963: Edward Steichen and Dr. Edwin Land are presented the Presidential Medal of Freedom. Ansel Adams, *Eloquent Light*, major retrospective exhibition of his photographs, largest ever given a photographer, at M. H. de Young Museum, San Francisco.*Society for Photographic Education* founded; founders include Nathan Lyons, Aaron Siskind, Henry Holmes Smith, Jerry N. Uelsmann, Minor White. W. Eugene Smith completes photo-essay *Colossus of the Orient*. Diane Arbus, Guggenheim Fellowship for photographic studies of the human condition in the United States. *Zone System Manual* (revision of *Exposure with the Zone System, 1956)*, by Minor White. General Aniline and Film announces Anscochrome 200, color film developed for orbital flight of Gordon Cooper for use in low level light and high temperature conditions. Kodak introduces Instamatic cameras. *Heliographers Association* founded, including Uelsman, Scott Hyde, Caponigro, Labrot, Chappell. Nathan Lyons is first chairman of the Society for Photography education. *The Eloquent Light*, by Nancy Newhall, and Ansel Adams. Polacolor dye--diffusion color process release. Brett Weston, *12 Photographs* portfolio. *Photography-63* Nathan Lyons director, N.Y. State Exposition and GEH sponsors. Henri Cartier- Bresson goes to Cuba. Minor white, first Cleveland workshop, and several others including Denver, San Francisco, Portland. Second conference of the Society for Photographic Education. *Aperture, Inc.* established as a non--profit corporation, by efforts of Gerald Robinson. Bernice Abbott furnishes photographs by Atget to Arthur D. Trottenberg, who publishes *A Vision of Paris*.

Scorpio Rising, Kenneth Anger; *Sleep*, Andy warhol; *8½*, Fellini. United States death toll in Vietnam is 30. United States atom bomb tests resumed. USSR accepts "hot line" plan. 200,000 demonstrate in Washington for Negro rights. Vietnam government overthrown. President John F. Kennedy assassinated.

Deaths: George Braque , Jean Cocteau, Robert Frost, Aldous Huxley, Jacques Villon, Antonio Bragaglia.

1964: Robert Adelman, Guggenheim Fellowship for photographic studies in the context of contemporary affluence. William R. Current, Guggenheim Fellowship for photographic studies of prehistoric sites in the American Southwest. Dave Heath, Guggenheim Fellowship renewed. Gary Winogrand, Guggenheim Fellowship for

photographic studies of American life. Bernice Abbott, *The World of Atget. Images of War* by Robert Capa published. CIBA markets *CibachromePrint*, stable silver dye- bleach process for color prints. P. Lacey, *The History of the Nude in Photography*. Harry Callahan, *Photographs: Harry Callahans,*. Abbott, *The World of Atget*. Peter Blake, *God's Own Junkyard*. Richard Avedon, James Baldwin, *Nothing Personal*. A. Feininger, *The World Through My Eyes*. John Szarkowski, *A. Kertesz, Photographer*. George Elliot, *Dorothea Lange*. Dorothea Lange, *Remembrance of Asia*. 200 print show, *The Photographer's Eye* by John Szarkowski. 21st Annual *Pictures of the Year* Competition draws nearly 7,000 entries from 625 photographers across the country. 2nd large exhibition by the *Association of Heliographers. Navajo Madonna* collection of photographs by Barry Goldwater, published in a limited edition of 1,000 copies and sold as a source of campaign funds at a minimum cost of $1,500 a copy. Color printing time reduced from 33 to 8 minutes by high temperature processing. Vesicular process, a non-silver practically grainless process, useful for motion picture and microfilm prints. Kodak sponsors exhibit at World's Fair. 200 print show of Harry Callahan at the Hallmark Gallery. At MOMA, the Edward Steichen Photography Center—permanent photographic gallery on the 3rd floor. Aaron Siskind is member of the Board of Trustees of the Gallery of Contemporary Art, Chicago. *Sixteen Jackies* photo--silkscreen by Andy Warhol.

A Hard Day's Night, Richard Lester. *Dr. Strangelove*, Stanley Kubrick. 1,387 United States casualties in Vietnam. Race riots in New York City, New Jersey, Chicago, Philadelphia. Warren Commission finds Kennedy assassination work of one man. Khrushchev ousted from power. Robert Rauschenberg becomes first American to win the Venice Biennale's Grand International Prize. Charles Sheeler remarks at retrospective historical photography exhibition: "Isn't it remarkable how photography has advanced without improving?" U.S. Ranger-7 transmits first close-up photographs of moon surface. Mariner I transmits 21 pictures of Mars. Supreme Court voids obscenity charges against *Tropic of Cancer*.

Deaths: Stuart Davis, Nat Herz, August Sander.

1965: Nathan Lyons appointed Associate Director and Curator of Photography at George Eastman House. Minor White chosen to head new Department of Photography at Massachusetts Institute of Technology. Scott Hyde, Guggenheim Fellowship for experimental studies in color photography. Lisette Model, Guggenheim Fellow.

The Complete Photographer, Andrea Feininger published. *Three Banners of China* by Marc Riboud. Eastman Kodak introduces new format 8mm cine film; other manufacturers con-

struct new cameras and projectors to use the film. Man Ray in group exhibition, *Pop Pop Corn Corny*. Michael Hoffman publisher of *Aperture*. Robert Frank, in production of film based on Allen Ginsberg's narrative poem, *Kaddish*.

Ranger IX transmits first live pictures of moon's surface. Watts Riots in Los Angeles. Hemlines bare women's knees. Lyndon Johnson's state of the union address coins the "Great Society." Malcolm X killed. Plot uncovered to bomb United States monuments. Air Force Academy cheating scandal. Silverless coins. Queen Elizabeth honors Beatles with Order of the British Empire.

Deaths: Winston Churchill, T.S. Elliot, Dorothea Lange, Le Corbusier, W. Somerset Maugham, Charles Sheeler, David Smith.

1966: Peter C. Bunnell named Curatorial Associate in Department of Photography, Museum of Modern Art. Thomas Barrow appointed Assistant Curator, Extension Activities, George Eastman House. *Contemporary Photographers Toward a Social Landscape* at GEH includes: Bruce Davidson, Lee Friedlander, Danny Lyon, Duane Michals, Garry Winogrand. Paul Caponigro, Guggenheim Fellowship. Marie Cosindas, Guggenheim Fellowship. William Gedneh, Guggenheim Fellowship. *Photographers on Photography*, ed. by Nathan Lyons. Focus Gallery opens. New Whitney Museum opens. *Fund for Concerned Photography* established by C. Capa. Flashcube model Kodak Instamatic available. New super-8 home movie camera ma rketed. Type 2475 recording film available, with ASA of 1600. Graflex XL-"module" camera. Gernsheim collection purchased by University of Texas, Austin. *Four decades of the Photo-Essay* at MOMA .*Dorothea Lange* retrospective exhibition, MOMA. Aaron Siskind, Guggenheim Fellowship. Production of *Aperture* moved to New York. Guggenheim Museum stages small exhibition of works based on the *Photographic Image*.

Gordon Parks, *A Choice of Weapons*. Sam Haskins, *Cowboy Kate.* Johnston, *The Hampton Album*. Nathan Lyons, *Photographers on Photography*. Ken Heyman, *This is America (with LBJ)*. Marc Riboud, *Three Banners of China*. David Douglas Duncan, *Yankee Nomad*. A. Eisenstaedt, *Witness to Our Time*. Eliot Porter, *Summer Island*. James D. Horan, *Timothy O'Sullivan*. John Szarkowski, *The Photographer's Eye*. Bill Brandt, *Shadow of Light*.

Italy floods, Florence devastated. Orbiter II transmits first detailed photographs of the moon's far side and the first photograph of the earth taken from the moon. Surveyor program transmit first photographs from the moon's surface; photographs made through tricolor filters gave first color reading of the moon's surface. 10,000 May

anti-war demonstrators. 8 student nurses slain in Chicago. President Johnson undergoes double operation. Alabama State troopers club Negroes in Selma protest march. Timothy Leary forms LSD religion.

Deaths: Jean Arp, Alvin Langdon Coburn, Alberto Giacometti, Hans Hoffman, Frank E. (Pappy) Noel.

1967: Edward Steichen awarded honorary degree of DFA from Fairfield University. Ansel Adams founds *Friends of Photography*. Henri Cartier-Bresson has second one-man show at Musee des Arts Decoratifs of the Louvre. *The Persistence of Vision* exhibit at GEH. Paul Schutzer, staff photographer of *Life* magazine is first casualty of the Israeli-Arab short war. Jerry Uelsmann, Guggenheim Fellowship for experiments in multiple print techniques in photography. The *Latent Image* by Beaumont Newhall. Paul Stand's *Mexico Portfolio* republished. Parke-Bernet Galleries auction of *Rare Photographs, Cameras, and Related Devices*, raises price levels. *The Concerned Photographers* show. *Man and His World*, computer generated-animated film by Stan Van Der Beek and Ken Knowlton. *A Declaration of Conscience* states that "...legal, moral, and artistic ownership of photographs, copyright rights, and all residual rights rest initially and ultimately with their creator, the photographer."

Representative Frank Thompson of New Jersey calls for the halt of "sinister spread" of hallucinogenic banana peel smoking. *Hamburger Monument*, Claes Oldenburg. *Sleeping Man*, Andy Warhol. Washington's National Gallery pays record sum of over 5 million for da Vinci's *Ginerva dei Benci*. EXPO '67 opens, Montreal, Canada.

Deaths: Edward Hopper, Ad Reinhardt, Carl Sandburg, Walt Disney, Rene Magritte.

1968: Exposure Gallery opens. W. Eugene Smith, third Guggenheim Fellowship. *Art and Photography* by Aaron Scharf published. David Douglas Duncan coins "essays-of-the-air," still photographs and Duncan's own words appearing the same day on screen. *Harlem on My Mind* at the Metropolitan Museum employs a variety of techniques incorporating photographs, film, television. National Conference on Visual Literacy at the University of Rochester in March. MOMA exhibit, *The World of Cartier-Bresson*. Establishment of an Edward Steichen Archive. Ray Metzker, show at MOMA: investigation of synthesis. Bernice Abbott moves from New York to Maine; sells Atget collection to the Museum of Modern Art; publishes *A Portrait of Maine*.

Paris peace talks. Three United States astronauts orbit moon and return. Rev. Dr. Martin Luther King Jr. assassinated. *Hair* opens on Broadway. 50th Anniversary of the founding of the Bauhaus.

MOMA, *The Art of the Real.* "White-Out," a protest in which an artist covers his work on display in a gallery with a sheet.

Deaths: Marcel Duchamp, Upton Sinclair, John Steinbeck, Arthur Fellig (WEEGEE).

1969: Nathan Lyons starts *Visual Studies Workshop. Vision and Expression* exhibit at GEH; Emmett Gowin begins teaching at The School of the Dayton Art Institute. Witkin Gallery opens. Art Sinsabaugh, Guggenheim Fellowship. Gary Winogrand, *The Animals.* Multi-color holograms produced. *Photography as Printmaking, The Destruction of Lower Manhattan, Conscience, The Ultimate Weapon, Eyewitness, Czechoslavakia 1938-August 1968.* (prepared 10 days within Soviet occupation of Prague). *Brassai-Photographs, The Circular Image, The Black Panthers.* Minor White attempts to establish archival standards of permanancy for *Light* ⁷ exhibit prints; establishes permanent collection of photographs for MIT. Imogen Cunningham show at Smithsonian, first in series featuring women. *Towards a New Vision of the Universe* exhibit of color photographs of the earth and moon taken by Apollo 10 astronauts, at George Eastman House. Ralph Graves, managing editor of *Life* returns to idea of pictures being prime means of communication, words secondary.

Sesame Street begins television broadcast. *Pornography Fair* opens in Denmark. Columbia Pictures pays record sum of 1.5 million dollars for screen rights to Jacqueline Susann's novel, *The Love Machine.* Woodstock Music Festival draws a crowd of over one-quarter million. Song My incident (My Lai 4) revelations cause worldwide reaction. Army brings My Lai Massacre charges. DDT banned in residential areas. UFO study ends. New Haven Panther trial. Girl dead in Kennedy car plunge at Chappaquiddick. First draft lottery since World War I. Hippopotamuses kill 9 by overturning boats on the Namwala River. Nixon elected 37th President of the United States. United States astronauts orbit the moon 10 times. Student riots close many college campuses. De Gaulle resigns. Nixon proposes gradual United States troop withdrawal from Vietnam.

Deaths: Alvin Langdon Coburn.

1970: Van Deren Coke appointed Deputy Director, George Eastman House. *Be-ing Without Clothes* exhibit at MIT. *Photographs,* by Bernice Abbott. *East 100th Street,* by Bruce Davidson. *Sequences,* by Duane Michals. Portfolio of nine photographs by Les Krims published. Bernice Abbott exhibition in Hall of Photography, the Smithsonian Institute, *Time-Life Library of Photography* issued in separate volumes. Expo-1970, Osaka; U.S.A. pavilion has photographs by Ansel Adams, Gary Winogrand, William Garnett, Diane

Arbus, Bruce Davidson, Lee Friedlander, Paul Vanderbilt, Andre Kertesz, Duane Michals, Joel Meyerowitz. Alfons Schilling, uses lenticular lens screen causing images to flicker. Presents *Richard J. Daley*, *Pig City*, and animations of early animation done by Edweard Muybridge. Georgia O'Keefe retrospective at University of New Mexico. Philippe Halsman makes hundredth cover for *Life*. June issue of *Infinity* explores erotica. Karen Holmes exhibits photographs of male nudes at Exposure Gallery. Bernice Abbott has exhibition at MOMA; *Bernice Abbott: Photographs*, published.

Twenty Daily Photographs 1969/1970, Donald Blumberg. They are photographs seen as response to the society, as captured in the daily newspaper. *Figurations*, painters' show in galleries, dependent on photographic verisimilitude: Charles Close ("the camera is not aware of what it is looking at...it just gets it all down.") Malcolm Morley, Richard Estes, John Clem Clarke, Alfred Leslie, Lowell Nesbit and Francis Bacon are also shown.

Four students shot by National Guard at Kent State University, Ohio. Boeing 747 service starts. Plane seats about 300. New York passes Abortion Reform Bill. United States invades Cambodia.

Deaths: E.M. Forster, Francois Mauriac, John Dos Passos, Erich Maria Remarque, Bertrand Russell, Charles de Gaulle, Mark Rothko, Percy Westmore.

RESEARCH ASSISTANTS: The members of the graduate classes— 1971 and 1972—at Ohio University, Department of Photography; a special note of thanks to Ray Whiting, Steve Lewis, Bonnie Ursin, A.J. Meek and David Tait for their help.

A SELECTED BIBLIOGRAPHY

Agee, J. and Evans, W., *Let Us Now Praise Famous Men*. Houghton Mifflin, New York, 1960. Anderson, George K. and Holznecht, Karl J., *The Literature of England*. Chicago, 1953. Andrews, Ralph W. *Picture Gallery Pioneers*. Seattle: Superior Publishing Co., 1964. Armason, H H. *History of Modern Art*, Harry N. Abrams, New York, 1963. Arnold, H.J.P., *Photographer of the World*. Hutchinson and Co., London, 1969. *Art Since 1945*. Harry N. Abrams, Inc. 1958. Bailey, Henry Turner, *Photography and Fine Art*. The Davis Press, Worcester, Mass., 1918. Booth, Arthur H. *William Henry Fox Talbot, Father of Photography*. Arthur Baker Limited, London, 1965. Bruce, Maurice. *The Shaping of the Modern World: 1870-1939*, Vol. I. London, Hutchinson & Co. Ltd, 1958. Bruun, Geoffrey. *A Survey of European Civilization — Part Two — Since 1660*. New York, 1962. Bry, Doris. *Alfred Stieglitz Photographer*. Boston, Museum of Fine Arts, 1965. Bullock, Wynn. *Bullock*. San Francisco, Scrimshaw, 1971. Canaday, John. *Mainstreams of Modern Art*. Holt, Rinehart, and Winston, New York, 1961. Cahill, Holger, and Alfred H. Barr Jr. *Art in America*. New York, Reynal and Hitchcock, 1935. Clark, Kenneth. *The Nude*. London, John Murray, 1956. Clark, Kenneth. *Landscape into Art*. Boston, Beacon, 1961. Clark, Larry. *Tulsa*. New York, Lustrum Press, 1971. Coburn, Alvin Langdon. *Alvin Langdon Coburn, Photographer, an Auto biography*. New York, Frederick A. Praeger. Publishers, New York, 1966. Coburn, Alvin Langdon. *Alvin Langdon Coburn Photographer*, ed. by Helmut and Alison Gernsheim. London, Faber & Faber, 1966. Coke, Van Deren. *The Painter and the Photograph*, The University of New Mexico Press, 1964. Collingwood, R.G. *The Principles of Art*. New York, Oxford (Galaxy Book), 1958. Cordasco, Francesco, ed. *Jacob Riis Revisited*. Garden City, Anchor Books, 1968. DeMare, Eric. *Colour Photography*. Great Britain, Hozell Watson and Viney, Ltd., 1968. DeMare, Eric. *Photography*. Great Britain, Cox and Wyman Ltd., 1968. Doty, Robert. *Photo Secession, Photography as a Fine Art*. Rochester, N.Y., George Eastman House, Inc., 1960. Eder, Josef Maria, Edward Epstean, trans. *History of Photography*. New York, Columbia University Press, 1945. Eisenstein, Sergei. *Film Form, Film Sense*. New York, Meridian, 1957. Elsen, Albert E. *Purposes of Art*. New York, Holt Rinehart and Winston, New York, 1967.

Ewen, David. *Composers since 1900*. New York, The H.W. Wilson Company, 1969. Friedlander, Max. *On Art and Connoisseurship*. Boston, Beacon, 1960. Focillon, Henri. *The Life of Forms in Art*, Trans., Hogan. New York, Wittenborn, 1966. Gardner, Helen. *Art Through the Ages*. New York, Harcourt Brace and World, Inc., 1959. Gassan, Arnold. *A Handbook for Contemporary Photography*.

Athens, Handbook Company, 1971. Gernsheim, Helmut and Alison. *A Concise History of Photography*. New York, Grosset and Dunlap, 1965. Gernsheim. Helmut and Alison. *Creative Photograph 1826 to the Present*. Detroit, Wayne State University Press, 1963. Gernsheim, Helmut. *The History of Photography: From the Camera Obscura to the Beginning of the Modern Era*. New York, McGraw -Hill Book Company, 1969. Gross, Harry I. *Antique and Classic Cameras*. Philadelphia, Chilton Books, 1965. Gaunt, William *Impressionism*. New York, Praeger Publishers, 1970. Hauser, Arnold. *The Philosophy of Art History*. New York, Meridian, 1963. Hauser, Arnold. *The Social History of Art*. New Yoirk, Vintage. *Hayden's Dictionary of Dates*. Franklin Square, Harper and Brothers, 1887. Holme, Charles, ed. *Art in Photography*. New York, The Studio, MCMV. Hood, Robert E. *12 at War, Great Photographers under Fire*. New York, G.P. Putnam's Sons, 1967. Horan, James D. *Mathew Brady, Historian with a Camera*. New York, Crown Publishers, 1955. Janson, H.W. *History of Art*. Englewood Cliffs, Prentice Hall, Inc., 1962. Kahler, Erich. *The Disintegration of Form in the Arts*. New York, Brazillier, 1968. Klee, Paul. *The Thinking Eye*. New York Wittenborn, 1961. Knight, Arthur. *The Liveliest Art*. New York, Macmillan Company, 1957. Kubler, George. *The Shape of Time*. New Haven, Yale, 1962. Lacey, Peter. *The History of the Nude in Photography*. N ew York, Bantam Books, 1964. Langer, William L. *An Encyclopedia of World History*. Boston, Houghton Mifflin Co., 1968. Lippend, Lucy R. edit. *Dadas on Art*. Englewood Cliffs, Prentice Hall, 1971. Lippend, Lucy R. edit. *Surrealist on Art*. Englewood Cliffs, Prentice Hall, Inc., 1970. Little, Charles E. *Cyclopedia of Classified Dates*. New York, Funk and Wagnalls Co., 1900. Lyons, Nathan. *Photographers on Photography*. Rochester, George Eastman House, 1966. Lyons, Nathan. *Photography in the Twentieth Century*. New York, Horizon Press, 1967. Magill, Frank N., ed. *Cyclopedia of World Authors*. New York, Harper and Brothers, 1958. Mann, Margery. *Imogene Cunningham—Photographs*. Seattle, University of Washington Press, 1970. Mast, Gerald. *A Short History of the Movies*. New York, Pegasus, 1971. McLanathan, Richard. *The American Tradition in the Arts*. New York, Harcourt, Brace & World, Inc., 1968. Meatyard, Ralph Eugene. *Ralph Eugene Meatyard*. Lexington, Gnomon Press, 1970.

Melchinger, Siegfried. *The Concise Encyclopedia of Modern Drama*. New York, Horizon Press, 1964. Mees, C.F. Kenneth. *From Dryplates to Ektachrome Film*. New York, Ziff—Davis Publishing Company, 1961. Morris, Richard B. *Encyclopedia of American History*. New York, Harper and Brothers, 1953. Murray, Peter and Linda. *A Dictionary of Art and Artists*. Frederick A. Praeger, Publishers, New York, 1965. The Museum of Modern Art. *Andre Kertesz, Photographer* New York, Plantin Press, 1964. Myers, Bernard S. *Encyclopedia of Painting*. New York, Crown Publishers Inc.,

1955. Newhall, Beaumont. *Latent Image*. Garden City, Doubleday, 1967. Newhall, Beaumont. *The History of Photography*. New York, The Museum of Modern Art, 1964. Newhall, Beaumont and Nancy. *Masters of Photography*. New York, George Braziller Inc., 1958. Newhall, Beaumont. *On Photography*. Watkins Glen, N.Y., Century House, 1956. Newhall, Nancy, edit. *The Daybooks of Edward Weston*. New York, Horizon Press, 1961. Newhall, Nancy. *Paul Strand*. New York, Museum of Modern Art, 1945. Niver, Kemp R. *The First Twenty Years*. Los Angeles, Artisan Press, 1968. Norman, Dorothy. *Alfred Stieglitz*. New York, Duell, Sloan and Pearce, 1960. Pollack, Peter. *The Picture History of Photography: From the Earliest Beginings to thePresent Day*. New York, Harry N. Abrams, 1969. Potonniee, Georges, Edward Epstean, trans. *The History of the Discovery of Photography*. New York, Tennant and Ward, 1936. Ray, Man. *Self Portrait*. Boston, Little Brown and Company, 1963. Read, Herbert. *A Concise History of Modern Painting*. New York, Frederick A. Praeger, Publishers, 1959. Rosenberg, Harold. *The Tradition of the New*. New York, McGraw-Hill, 1965. Sell, William B., ed. *Encyclopedia of the Sciences*. New York, Doubleday and Company, Ibc., 1963. Scharf, Arnold. *Art and Photography*. Baltimore, Allen Lane The Penguin Press, 1969. Sipley, Louis W. *A Half Century of Color*. New York, The Macmillan Company, 1951. Sipley, Louis W. *Photography's Great Inventors*. Philadelphia, American Museum of Photography, 1965. Slavin, Neal. *Portugal*. Lustrum, 1971. Steichen, Edward. *The Family of Man* Jerry Mason, ed. New York, Museum of Modern Art, 1955. Steichen, Edward. *A Life in Photography*. Garden City, Doubleday and Co., 1963. Stenger, Prof. Dr. Erich, Edward Epstean, trans. *The March of Photography*. New York, Focal Press, 1958.

Stieglitz, Alfred. *Camera Work, a Photographic Quarterly*. U.S.A. Kraus Reprint, 1969. Strand, Paul. *A Retrospective Monograph* (2 vol.). New York, Aperture, 1971. Sypher, Wylie. *Art History, An Anthology of Modern Criticism*. New York, Vintage, 1963. Sypher, Wylie. *Rococo to Cubism in Art and Literature*. New York, Random House, 1960. Szarkowski, John. *The Photographer's Eye*. New York, Museum of Modern Art, 1966. Szarkowski, John, ed. *The Photographer and the American Landscape*. New York, Doubleday & Company, 1966. Taft, Robert. *Photography and the American Scene—A Social History, 1839-1889*. New York, 1942. *The Studio*. Time-Life Library of Photography, Time, Inc., 1971. *This Fabulous Century* , Volume VI. Time-Life Books, New York, 1970. *The New International Yearbook*. New York, Funk and Wagnalls Co. 1942 to 1951. Venturi, Lionello. *History of Art Criticism*, trans Marriott. New York, Dutton, 1964. Weston, Edward. *The Daybooks of Edward Weston* (2 vol.). New York, Horizon, 1961. Winningham, Geoff. *Friday Night in the Coliseum*. Rochester, Allison Press, 1972. Winters, Yvor. *In Defense of Reason*. Denver, Swallow, 1947.

ACKNOWLEDGEMENTS (of quotations on page viii). Arnold Hauser, *The Social History of Art, Vol. 3*, pp.219-229, quoted with the permission of Vintage Books (Random House). Sir Kenneth Clark, *Landscape into Art*, p.86, with permission, Beacon Press. James Agee, *Let Us Now Praise Famous Men*, p.11, with permission, Houghton Mifflin, Riverside Press.

The death of Ralph Eugene Meatyard on May 7, 1972, brings close the knowledge of mortality which we put aside between encounters. The work we do survives us sometimes if it is good, and if we speak from the heart so that other hearts listen, and are moved. Jonathan Williams introduced me to 'Gene, telling me I ought to meet him because "he is a poet, and makes things." These visions poets have change our lives, and we must honor them.

acknowledgements; in memoriam 373